SCOTTISH HOUSES
AND GARDENS

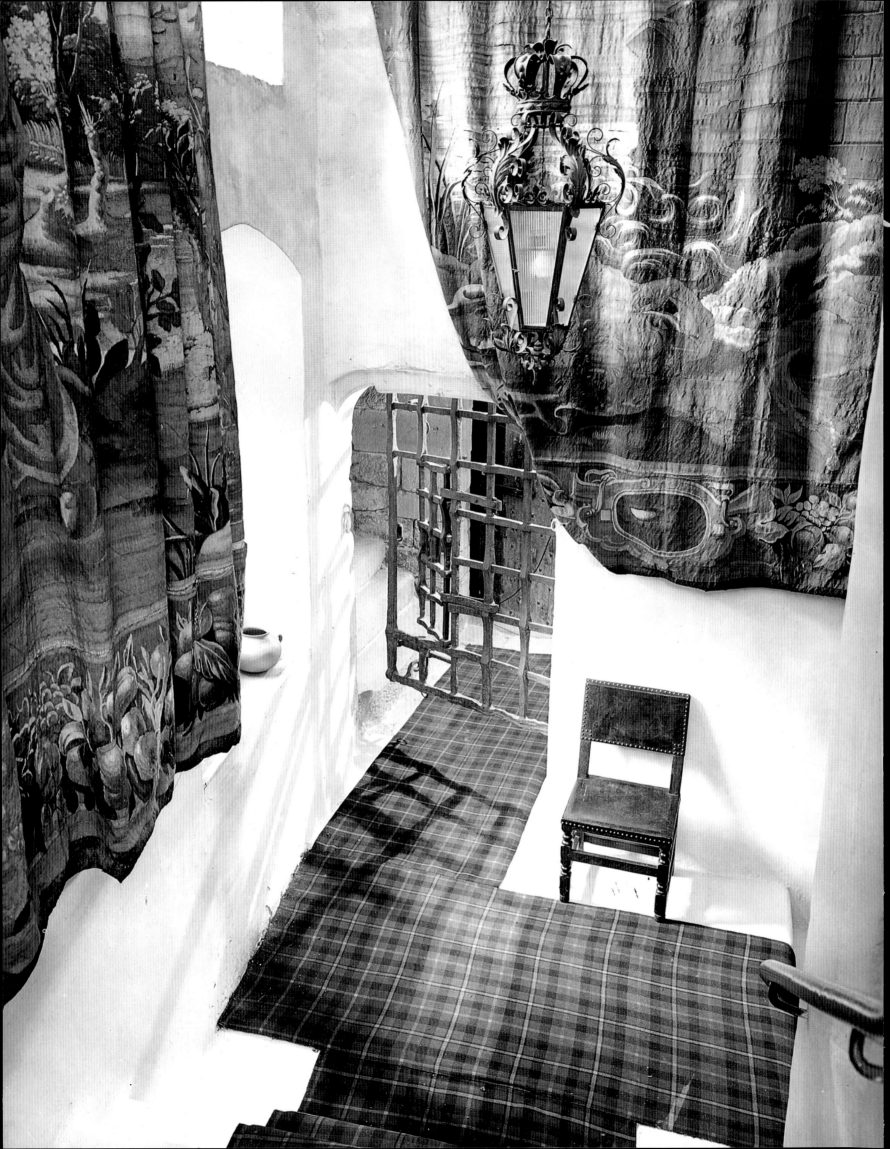

SCOTTISH HOUSES AND GARDENS

FROM THE ARCHIVES OF COUNTRY LIFE

IAN GOW

For John and Michael who write about Scotland in *Country Life*

and Robert who reads it

Published in 1997; this paperback edition first published 2007
by Aurum Press Limited, 7 Greenland Street, London NW1 0ND
www.aurumpress.co.uk

A CIP record for this book is available from the British Library.

ISBN-10 1 85413 289 0
ISBN-13 978 1 84513 289 7
6 5 4 3 2 1
2012 2011 2010 2009 2008 2007

Designed by James Campus

Printed in China

Frontispiece: *One of Scotland's distinctive wrought-iron yetts,
photographed at Cawdor Castle in 1945.*

INTRODUCTION

The *Country Life* Picture Library holds a complete set of modern prints made from
the original glass-plate negatives and a card index which, from about 1919, usually
records the name of the photographer. *Country Life* publishes a cumulative index of all
articles on country houses and gardens featured since 1897, which is updated annually.
A particularly useful Scottish index is also to be found in Michael Holmes, *The Country
House Described* (Victoria and Albert Museum, 1986, pp.299–325). In addition the
magazine has been indexed in the catalogue of the National Monuments Record of
Scotland, John Sinclair House, 16 Bernard Terrace, Edinburgh EH8 9NX (*Tel:* 0131
662 1456, *Fax:* 0131 662 1499), and the NMRS is currently preparing an index to the
individual glass-plate negatives of Scottish subjects. Other important sources for the
history of *Country Life* are: Michael Hall's *The English Country House: From the
Archives of* Country Life *1897–1939* (1994), which also has references to the many
historiographic articles published by the magazine; and John Cornforth's *The Search
for a Style: Country Life and Architecture 1897–1935* (1988).

HOUSES

The following is a list of the *Country Life* articles on the Scottish houses and gardens
included in this book.

In the following key, the name of the photographer is given first (where known),
then the date of the article, followed by the author.

Arniston House: F. W. Westley, August 15 and 22, 1925, Christopher Hussey.
Balmanno Castle: Arthur Gill, March 21 and 28, 1931, Christopher Hussey.
Caroline Park: Unknown, August 19, 1911, Lawrence Weaver.
Craigievar Castle: Frederick Evans, February 3, 1906, Lawrence Weaver;
 A. E. Henson, January 1, 1938, Christopher Hussey.
Culzean Castle: Unknown, September 4 and 11, 1915, A. T. Bolton.
Dalkeith Palace: Unknown, October 7, 1911, Lawrence Weaver; (Furniture:
 February 3, 1912).
The Drum: Unknown, October 9, 1915, A. T. Bolton.
Drummond Castle: Unknown, July 26 and August 2, 1902, Thomas North Dick
 Lauder.
Earlshall Castle: Frederick Evans (?), July 1, 1905, Lawrence Weaver.
Glamis Castle: Valentine, September 18, 1897, John Leyland; Frederick Evans (?),
 August 18, 1906, Lawrence Weaver; Unknown, August 8, 1914, Lawrence Weaver.
Gribloch: F. W. Westley, January 12 and 19, 1951, Arthur Oswald.

Hamilton Palace: A. E. Henson, June 7, 14 and 21, 1919, H. Avray Tipping,
 (Paintings: October 18 and 25, 1919).
Holyroodhouse: F. C. Inglis, July 15 and 22, 1911, Andrew Lang and Lawrence
 Weaver.
Inveraray Castle: Arthur Gill, July 30, 1927, Christopher Hussey.
Kellie Castle: Frederick Evans (?), July 28, 1906, Lawrence Weaver.
Kinross House: Unknown, July 13 and 20, 1912, Lawrence Weaver.
Mar Lodge: A. E. Henson, July 17, 1937, Christopher Hussey.
Melville House: Unknown, December 30, 1911, Lawrence Weaver.
Newhailes House: Unknown, September 8, 1917, Lawrence Weaver.
Pinkie House: Unknown, August 12, 1911, Lawrence Weaver.

THE COUNTRY LIFE PICTURE LIBRARY

The Library may be visited by appointment, and prints of any negatives it holds can
be supplied by post.

For further information, please contact the Librarian, at *Country Life*,
Blue Fin Building, 110 Southwark Street, London SE1 0SU (*Tel:* 020 3148 4474).

ACKNOWLEDGEMENTS

I was delighted to be asked by Michael Hall, the Architectural Editor of *Country Life*,
to write this book and have benefited greatly from his expert advice and depth of
knowledge of the magazine's history. I would like to thank John Cornforth and Alistair
Rowan, who kindly supplied their own memories of writing about Scottish houses for
Country Life and I regret that, for reasons of space, so little of what they imparted
has appeared here. Margaret Richardson and Susan Palmer at the Soane Museum
supplied valuable guidance about A. T. Bolton's activities. Alan Powers was able to fill
in a great deal of detail about Oliver Hill's book on Scottish castles. Moray Simpson
and the Special Collections staff of Edinburgh University Library have made available
Sir Robert Lorimer's office files in their care. Jane Thomas, Assistant Curator of
Collections at the National Monuments Record of Scotland, located key letters from
Weaver to Lorimer and Lorimer to Hussey and we discovered Lorimer's typescript list
of 'Suggested Scotch Houses' for *Country Life* sent to Weaver on 22 February, 1922.
I owe a special debt to David Walker junior, who helped locate the elusive *Country Life*
'Lorimer Supplement' at Whytock and Reid in Edinburgh, and I am grateful to
David Reid for allowing me to study it before the late Stuart Matthew traced
Sir Robert's own copy and permitted the NMRS to acquire it. The selection of
photographs from the *Country Life* Picture Library was helped by the wide knowledge,
both photographic and historical, of the Librarian Camilla Costello, most ably
supported by Joyce Warren and Olive Waller. At the NMRS I am especially grateful
to Veronica Steele.

For help with individual houses I am indebted to the following owners, friends and
colleagues: David Anderson; Jane Anderson; Her Grace the Duchess of Buccleuch;
Duncan Bull; Patrick Childs; Timothy and Jane Clifford; Mary Cosh; Kitty Cruft;
Lady Antonia Dalrymple; Sheila Dempster; Susanna Dunbar; Althea Dundas-Bekker;
Richard Emerson; John Gifford; Christopher Hartley; Dr Eileen Harris; Peter Hood;
James Holloway; Dr Deborah Howard; Fiona Jamieson; Susanna Kerr; Tim Knox;
Jill Lever; Caroline MacGregor; David Mackay; Professor Charles McKean;
Joan Matthew; Professor Sir James Dunbar-Nasmith; Alan and Patrea More Nisbett;
Sebastian Pryke; Harriet Richardson; Hugh Roberts; Joe Rock; James Simpson;
Helen Smailes; Dr Peter Savage; Cindy Shaw-Stewart; Margaret Stewart; Charles
Strang; Margaret Swain; Professor David Walker; Nancy Walker; Donald Wickes; and
Lucy Wood. I am especially grateful to my friends, John and Betty Leviner of
Williamsburg, Virginia, without whom there would have been no book at all.

The Reference Department of Hamilton District Libraries is the primary source for
Hamilton Palace and holds a more complete set of prints even than *Country Life* itself.
I am grateful to all my colleagues on the National Trust for Scotland's Craigievar
Sub-committee.

CONTENTS

INTRODUCTION 6

GLAMIS CASTLE 26

CRAIGIEVAR CASTLE 34

PINKIE HOUSE 42

KELLIE CASTLE 48

HOLYROODHOUSE 56

KINROSS HOUSE 62

CAROLINE PARK 70

MELVILLE HOUSE 76

DALKEITH PALACE 82

ARNISTON HOUSE 88

THE DRUM 96

NEWHAILES HOUSE 104

INVERARAY CASTLE 110

CULZEAN CASTLE 120

HAMILTON PALACE 128

DRUMMOND CASTLE 148

MAR LODGE 158

EARLSHALL 166

BALMANNO CASTLE 174

GRIBLOCH 184

INDEX 192

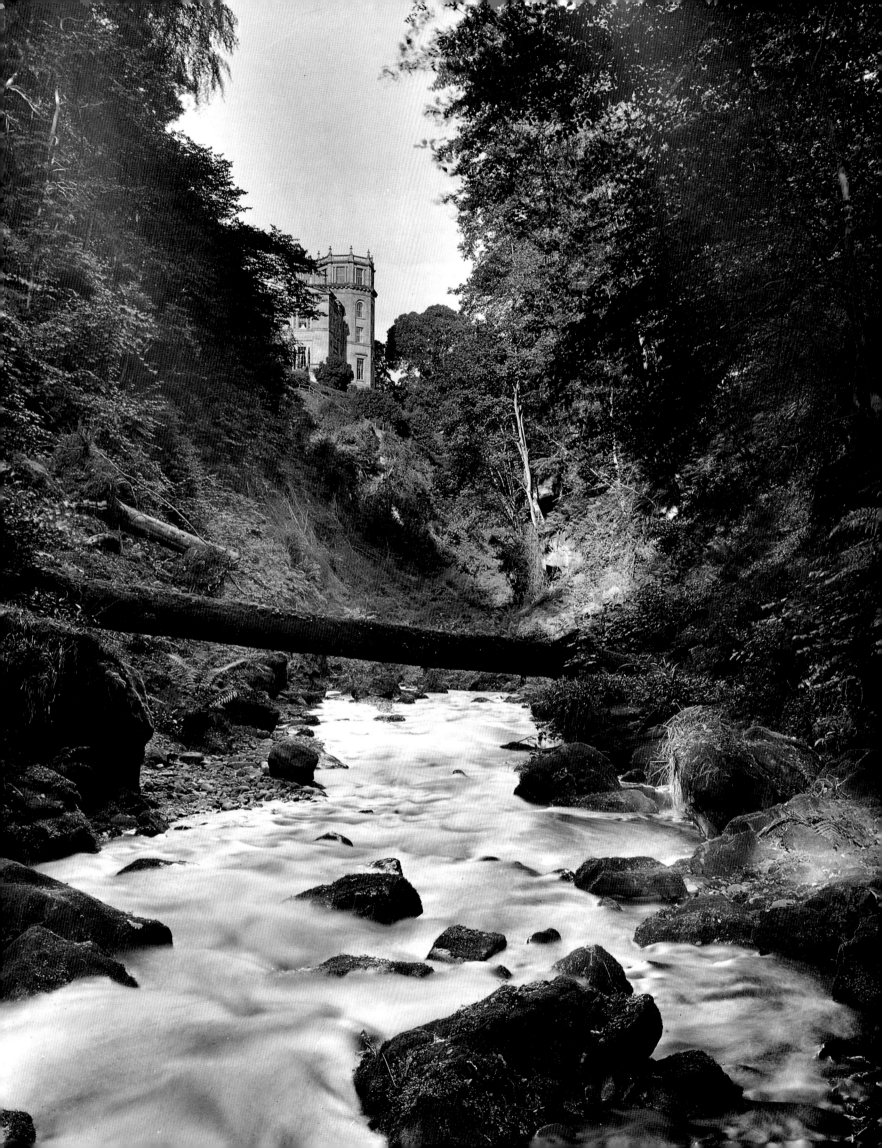

'The English architectural critic, on crossing the Tweed, travels into what is almost a foreign land.'

Lawrence Weaver, 1911

THIS book celebrates the outstanding contribution that the quintessentially English weekly magazine *Country Life,* founded in 1897, made to the photographic recording of Scotland's historic architecture during the first fifty years of the magazine's existence.

From the outset the chief feature of the paper was the country house article, and so week by week a vast collection of almost fifty thousand glass negatives was amassed, from which this selection has been drawn, and which continues to grow today as modern transparencies.

The rapidity with which a London-based magazine rustled up articles on Scotland's romantic castles may now seem surprising, especially when none of the founders had any particular connection with Scotland. The first issue of *Country Life* was published on 8 January, 1897 and within a matter of weeks, the first two articles on Scottish castles appeared. The first was on Cawdor, on 16 July, followed closely on its heels by the second, on Glamis, on 8 September.

According to legend, the idea for *Country Life* came to Edward Hudson and George Riddell on a Home Counties golf course. The setting may have contributed a subliminal Scottish element to its conception and one which was to typify the particular leisure and holiday-orientated facets of Scottish life that the magazine aimed to capture photographically for its new readers.

Photography was the lifeblood of *Country Life*. The magazine owed its inception to recent technological advances which had made it possible, for the first time, to reproduce the detail and immediacy of a photograph, through halftone photographic blocks alongside editorial letterpress, on a commercially viable scale. Its rapid emergence as a national institution was a result of the publishing experience, as well as the vision, of its founders. Edward Hudson's family firm, Hudson and Kearns, were blockmakers and printers, which must have fired his pursuit of technical perfection, while George Riddell was a solicitor who had gained his experience of the newspaper world, and a popular touch, as legal adviser to the *News of the World*, published by George Newnes Limited.

Edward Hudson, one of England's great romantics, whose awkward personality was to achieve fulfilment in his creation of *Country Life*, forged in the image of his own interests and enthusiasms, is now too well known as the patron of both Lutyens and Gertrude Jekyll to require detailed biographical repetition in a book that is primarily concerned with his activities north of the Tweed. Hudson's total control and involvement in every aspect of

Westley's 1925 dramatic photograph of Dunglass towering above the river bed. The house was gutted in 1947 and later demolished.

the magazine is manifest during any trawl through the magazine's photographic archive. If images of Hudson himself are absent, his possessions are very much present, and include photographs of his motor cars and antique collections – one photograph of a piece of what may be Sheffield Plate is labelled 'Mr Hudson's Cruet' – as well as his private homes.

The country house article was certainly Hudson's invention, as Bernard Darwin recalled in *Fifty Years of Country Life* (1947):

The genesis of these country house articles is interesting. Edward Hudson had a brother Henry, who was not strong and inclined to consumption. So Edward made a habit of taking him on driving expeditions for the good of his health, and these came to have as their regular object the looking at some notable house. So that which had in a measure begun as good natured sight seeing on Edward Hudson's part became a passionate interest.

Hudson's memory of houses he had seen, and even the placing of individual pieces of particularly Picturesque furniture within them, became another *Country Life* legend.

If the idea of the central country house article was not original in itself, and had its origins in English antiquarianism and dozens of monographs by local squires and vicars, Hudson was to transform it into a very superior thoroughbred. Hudson's creation had to be achieved through intermediaries because he is not known to have ever written a single word himself, although he did make up notebooks detailing precisely the viewpoints from which photographs were to be taken by his photographers, and actively interfered with the printing of the negatives. The fully perfected specimen of the country house article also had aspects of a guidebook, another English speciality, and increasingly included plans to complete the reader's grasp of the spatial aspects of an unfamiliar house.

If *Country Life* has been particularly concerned with places, however far-flung these places may be, they are interlinked by the relatively small band of people who put the magazine together. Because of Scotland's relative remoteness and idiosyncratic institutions, *Country Life*'s coverage has always required the support of local collaborators. If even such a marked Scotophile as Sir Lawrence Weaver was to declare that the country was a 'foreign land' in 1906, it is a measure of the problem that the magazine faced.

The apparent ease with which the first Scottish articles appeared is readily explained because the photographs preceded the magazine and thus came readily to hand. Both the photographs of Cawdor and Glamis came from the extensive stock of Valentine of Dundee, one of the leading producers of photographic souvenirs for Scotland's well-off tourists to paste into their albums. The novelty of magazines like *Country Life* lay in a newly-perfected printing technique and so at first it was the medium alone, rather than the originality of the message, that mattered.

Hudson was obsessed with perfecting the reproduction of the photographs, and he pursued this through the acquisition of the most effective American presses and the best English paper, so that

even Valentine's rather lacklustre prints invite closer inspection by magnifying glass when reproduced across the pages of *Country Life*. This is manifest in the extraordinary way that the large landscape views, as in the Cawdor and Glamis articles, were printed sideways-on across whole pages, requiring the reader to turn the magazine 90 degrees. The resulting look of the pages recalls, as Michael Hall, the current Architectural Editor of *Country Life*, has pointed out, the individual tourist photograph albums. The National Monuments Record of Scotland has an extensive collection of these albums, which frequently include Cawdor.

Valentine's photographs were intended to be sold at the individual castles they depict, and the purchase would have been made after a visit, pasted into albums, and used to entertain the immediate family circle. Hudson was so to perfect this kind of photographic survey of his carefully selected houses that his *Country Life* articles became a satisfactory vicarious substitute for the actual experience at grand private houses which few of his readers had any real hope of seeing.

The choice of Cawdor and Glamis for the first Scottish country house articles was no accident. Valentine's catalogue had sets rather than individual photographs, because the two castles had many potential tourist purchasers, inspired by Shakespeare's use of both of them in *Macbeth*. Since nothing in the form of visible 'stone and lime' (the peculiar Scottish expression for bricks and mortar, as *Country Life* was once later moved to explain to its readers) survived from such an impossibly remote early period, the owners of both castles had politely tried to oblige their burgeoning visitors by playing up their genuinely historic seats with sufficient old oak, rubble and weaponry to ensure that they matched up to expectations. They thus emerged as hard-boiled 'Scotch Baronial' classics.

The Scotch Baronial idiom was Scotland's unique brand of the Picturesque and was sufficiently distinct to be her most improbable export. *Country Life*'s conventional tourist image of Scotland was thus both an outsider's view and a wholly artificial visual construct, artfully composed from narrow areas of Scotland's cultural history.

Country Life's initially limited interest in Scotland's architectural history is just another indication of the extent to which it was rooted in a Picturesque aesthetic. The inclusion of Scottish castles was necessary to ensure a comprehensive coverage of the genre, in much the same way as stereotypical images of French Gothic châteaux, Moorish gardens of Spain and Italian villas were used. Astute publishers had long been aware of the marriage between reproducing evocative images of Scotland and making money.

By the end of the eighteenth century, there was a growing sense in Scotland that traditional Scottish patterns of life were passing and this promoted the first stirrings of antiquarian topography. Francis Grose is remembered not only for his *Antiquities of Scotland*, 1789-92, with its copper-plate views of disintegrating abbeys and castles, but also for attracting ridicule in a poem by his friend Robert Burns. Burns's own transcriptions of old Scottish songs were inspired by the same desire to record uniquely Scottish forms of expression.

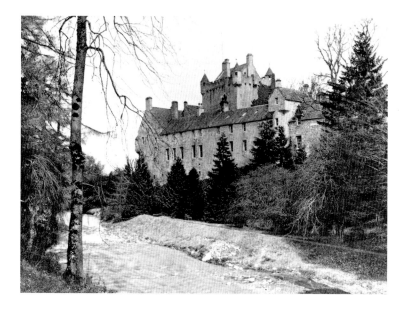

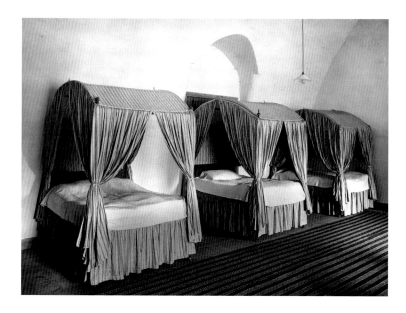

Above: *In 1897 for* Country Life's *first Scottish castle article on Cawdor, Hudson relied on Valentine's commercially available photographs* (top), *but rejected their view of the bogus 'King Duncan's Room'* (centre).
By 1945 an interest in the more recent past prevailed in Scotland's castles and Oliver Hill's eye was attracted to this line of eighteenth-century 'Barrack Room' beds at Cawdor (bottom).

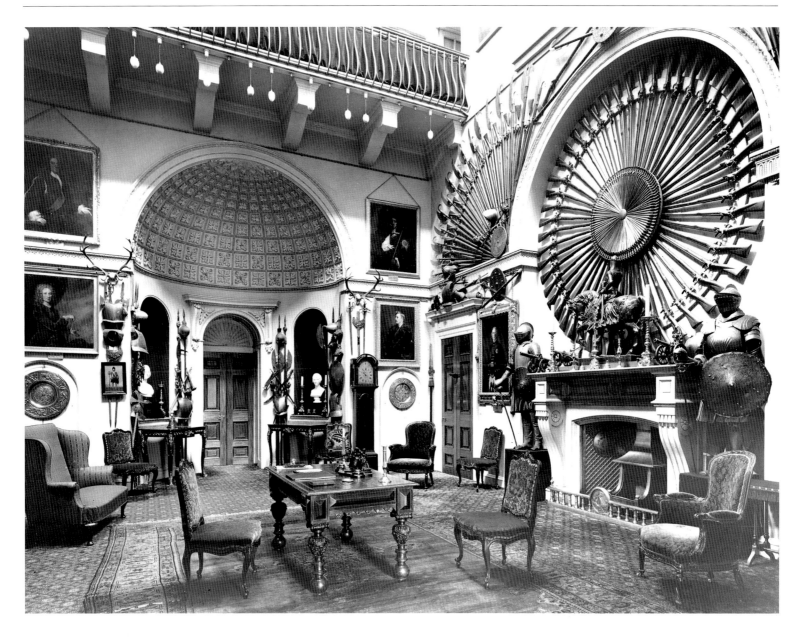

The classical detail of Inveraray's central clerestoried Hall was increasingly overlaid by Scotch Baronial weaponry. An unpublished photograph of 1927.

Sir Walter Scott's imagination had also been fired, and through his poems and novels he singlehandedly made Scotland one of the most desirable tourist destinations in Europe. Scott had the good fortune to have readers all too willing to be enchanted by the Scottish idyll. The delights of Scotland's romantic and rugged landscape of mountains, glens and lochs, often offset by an ancient castle tumbling into decay, had already begun to be celebrated in the late eighteenth century by travellers in pursuit of the Picturesque.

Scotland's colourful and often violent history also helped to enliven this landscape and tinge it with romanticized Jacobitism. Nineteenth-century visitors to ancient buildings expected to be thrilled by lurid accounts of far-off events as part of an experience that was not solely visual. The most popular tourist attraction in Scotland *c*.1760 was Mary Queen of Scots' Bedchamber at Holy-roodhouse in Edinburgh, where tourists were encouraged to retrace the steps of the murderers of Rizzio and inspect his bloodstains.

Sir Walter Scott certainly stage-managed the state visit of George IV in 1822, who became the first British sovereign to hold court in the palace which Charles II had so carefully planned. The King delighted his Scottish subjects by donning the tartan that his ancestor had proscribed. Scott's thoroughness extended to the invention of a suitable new national style of architecture for his beloved Abbotsford, where a deliberate and self-conscious Scottish character was grafted onto a Gothick framework.

As popular demand grew for a more specifically Scottish set of architectural allusions, culminating in the Scotch Baronial revival, there was an urgent professional demand for detailed architectural information about Scotland's castles. The most beautiful book ever devoted to Scotland's historic architecture is R.W. Billings's *The Baronial and Ecclesiastical Architecture of Scotland*, 1845-52, published by Blackwood. The precision of his plates reflects his own delight in the buildings he discovered and drew on his travels, and also the care with which he supervised the finest London engravers. Queen Victoria headed the list of subscribers to this sumptuous volume, which was rapidly established as the bible of the Baronial

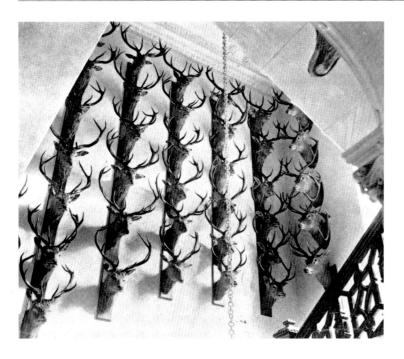

The Scotch Baronial interior of Brodick Castle on Arran was published in 1898 as part of the magazine's campaign to attract advertisements for sporting estates.

revival. Through her acquisition of the Balmoral estate on Royal Deeside, the Queen immediately became a most enthusiastic, if unexpected, patron of both Scotch Baronial architecture and its support trades of taxidermists, granite polishers and tartan carpet weavers. Balmoral rapidly eclipsed even Abbotsford as the most frequently depicted Scottish castle.

This new enthusiasm for the Scotch Baronial revival was to have profound implications for Scottish architecture – not only for new buildings but also for the existing stock of country houses and castles. For over a century and a half, Scotland's architects had been busily engaged in reflecting classicized Holyroodhouse in Scotland's ancient tower houses, giving them a symmetrical regularity by hacking off their pepperpots and roofworks. Now, however, their patrons asked them to swing into reverse mode with visual results and complicated rooflines that were to be repented at leisure by their twentieth-century owners beset by more slender resources.

Country Life thus had to extend minimal effort after 1897 to identify suitably Picturesque subject matter from a wealth of existing illustrated literature. The difficulties for the outsider in distinguishing between superficially genuinely old castles and the modern Scotch Baronial imitations were facilitated by the first stirrings of a more scientific antiquarianism of which the most famous is David MacGibbon and Thomas Ross's *Castellated and Domestic Architecture of Scotland*, 1887-92. MacGibbon and Ross wrote their celebrated book in moments of leisure snatched from their busy architectural practice. Although they made extensive use of photographs during their researches, these had to be converted into line drawings for publication.

The text of both the Cawdor and Glamis articles was supplied by John Leyland, effectively a fixture in the *Country Life*'s London office, because he also provided Hudson with the text for the English country house articles in the series. His account of Cawdor suggests, on balance, that he had actually visited the castle. Neither castle was then 'presented' to their visitors in a particularly sophisticated manner and so it is gratifying to note Leyland's attempt to cut through the bogus in his first paragraph on Cawdor, which had inevitably commenced with a dose of Shakespeare. His text showed, too, that the new fraternity of 'readers of *Country Life*' was expected to share Hudson's sophisticated interest in the more rational aesthetic pleasures of Picturesque old buildings.

The sandwiching of an article on Floors Castle on 4 September between Cawdor and Glamis provides a further example of the *Country Life* point of view, for it was a social rather than architectural article because of the modernity of the castle. The occasion for the article was the coming of age of the Duke of Roxburghe, but the young Duke and his guests were photographed outside Floors, which had been transformed between 1837 and 1847 by the Edinburgh architect William Henry Playfair. Other magazines, however, did publish a readily available view of Playfair's capacious early Victorian ballroom, decorated with exotic flora from the castle's extensive glasshouses for the celebrations.

The first Scottish country house article to bear J. Byam Shaw's distinctive art-nouveau heading was devoted to Inveraray on 9 September, 1899 but, as at Floors, the photographer was under instruction to confine his attention to the exterior and the Picturesque gardens, and was not encouraged to enter a Gothic

Scottish Country Life, first published in February 1914, replaced Hudson's society ladies in couture frocks with clan chiefs in full Highland Dress.

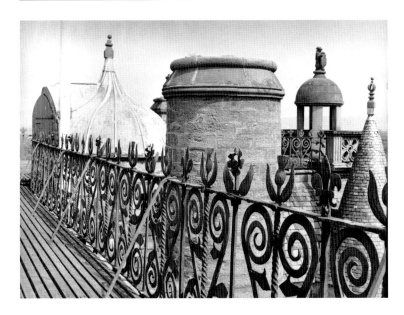

A 1906 view by Frederick Evans of the spirited-Scottish wrought-iron balustrade on the roof-walk at Glamis.

castles in Speyside. This hearty sporting ethos projected by *Country Life* must have also been intended to attract advertisements from estate agents anxious to assist with the sale of bloodsports Baronial real estate. The importance of the advertisers to the health of any successful magazine becomes apparent from the parallel experience of George Eyre-Todd. A journalist with many years experience in the periodical publishing world of both London and Glasgow, he had the impertinence to bring out the first issue of *Scottish Country Life* in February 1914. As he recalled in his autobiography:

Among the things I did not know was the fact that the months of February and March were the worst in the year for securing the support of advertisers. My first number appeared in February, and though, from the reader's point of view, it was excellent value for the sixpence – far too good, in fact; to the eye of the expert in these matters, from the fewness of the advertisements which it contained it appeared to furnish the sure promise of an early demise.... But a journal does not live by its literary quality or its circulation alone. Its advertisements provide a large part of the sinews of war.

Although it is perfectly clear that Hudson did take legal action in the face of this unflattering imitation of his magazine, it must have been obvious from Eyre-Todd's enslavement to a lower form of advertising life that *Scottish Country Life* was never a real threat.

The sporting side of *Country Life* in its early years, however, could occasionally tip the balance of its architectural judgement: the modern Scotch Baronial main staircase at Brodick was illustrated in 1898, solely on account of its massed ranks of mounted stag heads: 'The effect of stuffing the heads is pretty; but the results too often spoiled by moth and dust in a few years'. A fine head, 'a splendid nine-pointer shot by Mrs J E Platt' merited a photo on the Letters Page under the banner 'A Lady's Trophy' in December 1898. *Country Life*'s enthusiasm for the taxidermist's art was to reach its apotheosis in the magazine's sponsorship of an exhibition, whose catalogue, *British Deer Heads: An Illustrated Record of the Exhibition Organised by Country Life, June 26-July 10 1913*, was also published by the magazine.

The leading Scottish contributor in the early years was Charles Reid of Wishaw, a celebrated photographer of animals. His article on the famous wild cattle of Cadzow Forest appeared in the first issue of *Country Life*. The cattle were genuinely wild and their behaviour, as Reid explained, could be unpredictable – they showed a disconcerting tendency to follow retreating visitors at an identical pace, breaking into a trot if the intruder became nervous and ran for cover. Reid explained how his close-up photographs were obtained by means of decoys. His talents met the country house article in a feature on the livestock of the Hopetoun estate. At its heart lay one of Scotland's most important country houses, designed by Sir William Bruce and transformed into a Baroque palace by William Adam but, since the magazine then disdained 'Neo-classic' eighteenth-century architecture, the house remained firmly in the distance. Reid clearly had no eye for architecture, which must have

revival castle rebuilt as recently as 1744, as the text made clear: 'It must be admitted that Inveraray has not the character or grandeur of such castles as Glamis'. It was a sentiment shared by earlier Picturesque tourists, including Dorothy Wordsworth, who also had remained firmly out of doors because she: 'did not think that what we should see would repay us for the trouble.... If there had been any reliques of the ancient costume of the castle of a Highland chieftain, we should have been sorry to have passed it'. The dominance of the Picturesque aesthetic thus had a severely narrowing effect, editorially, on the subjects that were deemed appropriate for *Country Life*'s country house articles.

Country Life's interest in Scotland extended beyond the confines of the central country house article. Ethnography was perhaps just another aspect of the Picturesque, but the magazine's sporting origins also drew its attention to the north. Both were also associated with holidays and leisure, as befitted a magazine which was then published on a Saturday; this credo was restated by an editorial of 31 July, 1926:

This number of *Country Life* is both a Scottish and a Shooting Number, for though, perhaps, only a fortunate minority of us find our way to Scotland or the Yorkshire moors in time for the opening of the shooting season, hundreds more go north to fish, paint, tour in motor cars or climb. It is remarkable how the sporting side of Scotland has developed into a seasonal convention. The up-to-date shops display every kind of holiday luxury or necessity in clothes and ingenious devices of every description. Sprigs of heather and shiny guns lie alluringly on bolts of tweed, and even the most incongruous articles have been seen gaily labelled "For the Moors".

These musings on the holidays of *Country Life*'s readers are also a reminder of how aspirational the magazine has always been. Ostensibly concerned with the mores of the idle rich, Hudson was well aware that many of his readers could only dream of owning

Country Life's survey of the Scotch Baronial Garden in 1901-02 recorded many now-vanished garden ornaments, including these painted lead figures, which once adorned the gate to the walled garden at Tyninghame.

seemed boringly static after the Cadzow cattle and required no skilful restraint and patience.

After these uncertain beginnings, *Country Life* and Scotland's true potential suddenly came into synchronicity in 1901 when Hudson brought his resources to bear in a major series on the peculiarly Scottish taste for Neo-Baroque formal gardens. The calibre of the photographs show that they were specially commissioned and for the first time the negatives were despatched to London for careful preservation. An article by Sir Herbert Maxwell in 1900 on the extensive formal landscape garden at Castle Kennedy, where the skeletal early eighteenth-century plan was helped along later by Loudon, may have been a dummy run for the main series. This unusual rounding up of the freelance photographers' negatives had sound commercial motives, because it enabled the magazine's specially-commissioned photographs to earn their keep by being

recycled as books; it is revealing of Hudson's far-sightedness and commercial flair.

Over a hundred Scottish negatives were taken during this foray, by an as yet unidentified photographer, of eight romantically Picturesque formal gardens: Dalzell, Drummond, Balcarres, Tyninghame, Drumlanrig, Biel, Barncluith and Newbattle. Although all these gardens were in proximity to old castles (or an abbey in Newbattle's case), they were all effectively nineteenth-century creations. At both Dalzell and Newbattle, the photographer was sent indoors to record ancient rubble vaults as though to bolster the effect of antiquity in houses, which to superficial inspection are of modern appearance. The spectacular hanging terraces and intersecting alleys, designed by two generations of the Kennedy family beneath the walls of Drummond Castle in Perthshire merited treatment over two articles. The article on Biel alone is signed with initials which allow their author to be identified as Thomas North Dick Lauder, who is remembered in his well-known Scottish family as a contributor to *Country Life*.

After this almost weekly exposure of the readership to Scottish

gardens throughout 1902, it is perhaps surprising that there were not complaints on the Letters Page as the delights of ducal carpet-bedding at Drumlanrig and elsewhere began to pall. A lull followed that was to last two years.

Then suddenly on 1 July, 1905, a miracle occurred when *Country Life* suddenly acquired the golden key to a previously undetected door in the Scottish wall that was to open up a secret garden of dreamlike castles of fairy-tale beauty. It was as though stage-designers and set-dressers had been busy throughout 1903 and 1904, building and decorating patinated houses surrounded by topiary and flowers, with fan-tailed doves fluttering overhead, expressly to match up to Hudson's most exacting brief for admission to his magazine and providing the extreme contrast to such rubblemaniacal Baronial old boilers as Cawdor and Glamis, worn out through inspection by so many tourists. Frederick Evans, the most gifted of Hudson's photographers, was almost certainly involved.

The first, unsigned, article was on Earlshall, an old abandoned tower house newly and photogenically restored by an unnamed architect. Then on 3 February, 1906 came a set of such romantic photographs of Craigievar, which had been completed between 1610 and 1626, that they established it for ever after as Scotland's favourite and most perfect tower house. It was followed on 28 July, 1906 by Kellie Castle whose surfaces of decaying plaster and embroideries created Vermeer-like effects. Weaver's article on Kellie mentioned Robert Lorimer, for the first time, as being the restorer of Earlshall.

On 11 August even the Kellie reverie was surpassed visually by a series of photographs of Traquair, where time had apparently stopped still at the moment when its famous Bear Gates were locked against the return of the Stuarts. It was again almost certainly the work of Frederick Evans. Reappraisals of Cawdor followed Cullen, a new entrant to *Country Life*'s ancient castles list.

The author of the Earlshall article and thus, presumably, the series was Lawrence Weaver (1876-1930), who became Architectural Editor of *Country Life* in 1910. His boundless energy and enthusiasm for historic architecture and living architects were to make him a key figure in the history of the magazine until his death. The article on Earlshall was of crucial importance for his career because it was the first he ever wrote for *Country Life*. Weaver had been brought up in Bristol by his mother in straitened circumstances and seems to have had some brief experience in a local architects' office before joining the staff of a Birmingham ironmonger. He was employed to compile catalogues of architectural fittings, which seems to have been the springboard for his first articles on their historical equivalents in early leadwork. *The Annotated Bibliography* (1989) of his writings runs to over forty pages.

Weaver appears to have had no particular connections with Scotland, although in his introduction to *The Story of the Royal Scots* (1916), a series he edited for *Country Life*, he explained his affection for the Regiment: 'It is also a result of my long delight in reading Scottish history, and of much writing about the delightful

fabric presented by the building of that history into the walls of Scottish castles'. This delight was communicated to his readers through his sparkling prose, both in this early series and the magisterial survey of Scotland's castles and classical country houses that followed between 1911 and 1917. Weaver has no rivals in his ability to bring to life the killingly boring early genealogical detail which *Country Life*'s readers, reared on Victorian antiquarianism, appeared to expect. His approach could not have been more romantic

The dog-eared cover of Sir Robert Lorimer's own copy of the Country Life *Lorimer Supplement of September 1913.*

and thus would have appealed to Hudson. He saw Scotland's castles as a medium through which to make direct contact with their former occupants, and he relished the Scots' dialect which was quoted at length for purely poetic effect. Alongside this, however, went a hard-nosed boning-up from secondary and published primary sources, which perhaps reveals his individualism as a self-taught historian. Weaver was not readily duped by the bogus, which the Scotch Baronial contributed to so many genuinely old castles.

The Earlshall article is usually explained away as a conjunction between Weaver's leanings to Scotland and Lorimer's English experience, which had embraced a spell in Bodley's office. Sir Robert Lorimer (1864-1929) had a great deal in common with Hudson's aims for *Country Life*, as Peter Savage's biography, *Lorimer and the Edinburgh Craft Designers* (1980), makes plain. But Lorimer was no shrinking violet when it came to generating publicity, gleefully scanning the newspapers for accounts of country

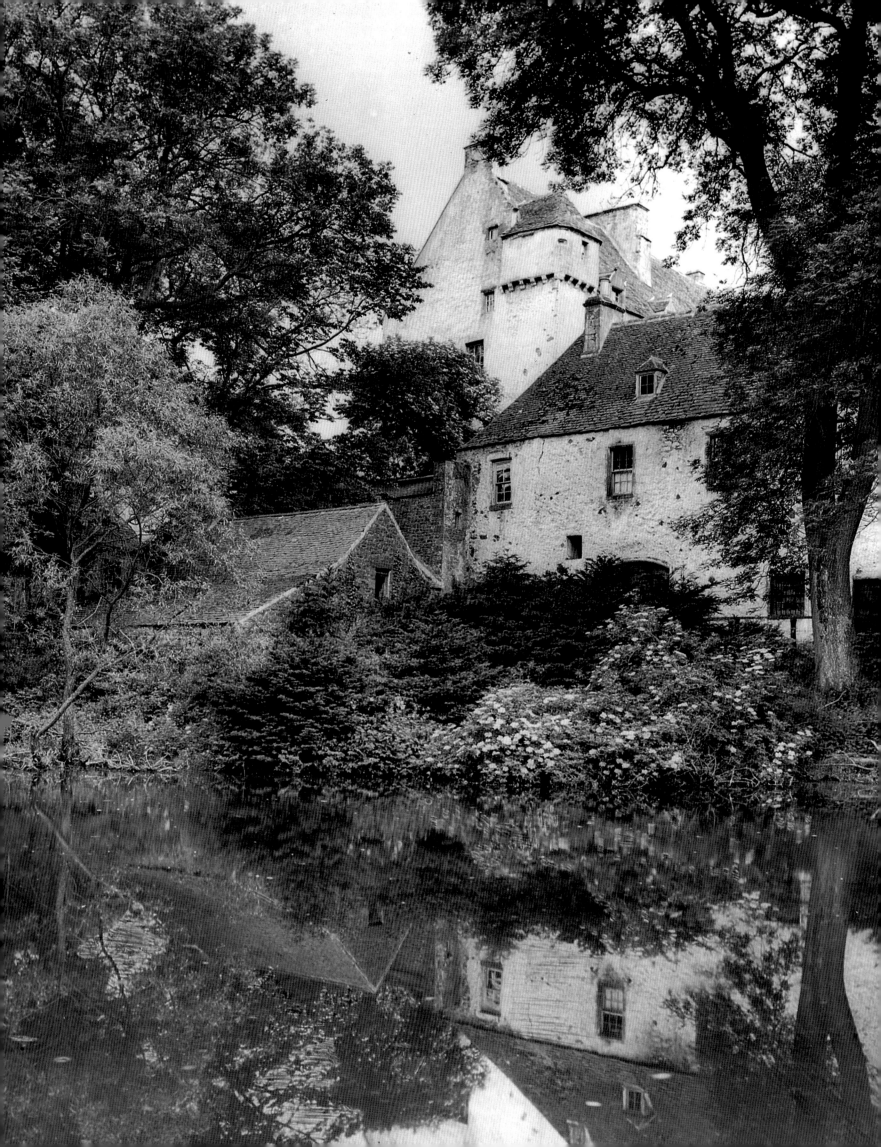

house fires. As the son of a Professor of Law at Edinburgh University, Lorimer may have turned more readily to the advocacy of language in his public relations activities to disguise a lack of confidence. The birth of *Country Life*, a quality, illustrated paper with a focus on architecture, delivered weekly to just the kind of patrons he cultivated would certainly not have passed him by, and he is as likely to have sought Weaver out.

He had been brought up at Kellie Castle which his father had rented in 1878 from the Earl of Mar and Kellie. As the Earl would only grant a lease and refused to sell, Professor Lorimer's restoration of it was very conservative. The house had a profound effect on both Robert and his elder brother John, who became a painter. Because Kellie was a romantic tower house with later Baroque decorations, it was natural for his own designs to blend the Gothic and the Classical just ahead of the moment when the orders of architecture were returning to fashion in the south. Lorimer, like Hudson, was never out of antique shops and used particularly handsome pieces of furniture as starting points for his own highly-refined variants, often with a surer sense of line than the originals.

Country Life's scrapbook character would also have had an immediate appeal to Lorimer. John Cornforth in his *The Search for a Style* has shown how early twentieth-century architects, such as Lutyens, used to crib from newly published *Country Life* photographs, particularly for interior detail. Lorimer responded, magpie-like, by picking up and cutting out, and pasting anything that caught his eye on visual grounds straight into his sketchbook. Later, as a knighted architect, he would have albums specially bound by Edinburgh's most fashionable stationers.

Lorimer was older than Weaver but they clearly got on well. As Patrick Nuttgens has written in his *Memoir of Weaver as an Architectural Writer*:

If Lutyens became the most celebrated of his subjects, it was Lorimer who personified everything Weaver liked most about architecture and was the most profound influence on his judgement. He admired everything Lorimer stood for – the crafts, romantic grandeur and history built into the ideas of the buildings. Scotland seemed to bring together the themes he was most moved by and best understood.

If Lorimer was a gift to *Country Life* as an architect, with taste almost perfectly attuned to the magazine's ethos and a rising figure in Scottish architecture when the magazine was founded, *Country Life* in Scotland became strongly identified with Lorimer's office and his soubriquet 'the Scottish Lutyens' reflects the way his reputation was coloured by Hudson's creation.

But Lorimer must have already been in the *Country Life* orbit before 1905 because he had become friends with the formidable Gertrude Jekyll, Hudson's leading lady and gardening guru. Lorimer also knew Lutyens, who was to write to him: 'I hear praise

Left: Frederick Evans's 1906 unsurpassed photographs of Traquair convey the romantic atmosphere of one of Scotland's most beautiful houses.

of your Thistle everywhere. I hope it will spread as thistles generally do'. Lorimer's Thistle Chapel, for which he was knighted, was noticed in 1911 when it was inaugurated by George V and Queen Mary on the first state visit to Scotland after their coronation. Lorimer also contributed articles to the magazine, including an architectural appreciation of the rapid expansion of Gretna during the First World War, when it became a centre of cordite production for the war effort, and houses, churches and a cinema were required at breakneck speed.

If *Country Life* readers had been treated in 1905-06 to a fresh and radical view of the Scotland they thought they knew, this was to pale into insignificance compared to the organized attack Weaver was to mount as Architectural Editor after 1910, when Scottish architectural history was to be shaken and stirred out of its antiquarian slumber. Weaver's other preoccupations between 1906 and his editorship inevitably saw Scotland neglected. An article on both the castle and the town of Stirling by Sir Herbert Maxwell was an attempt to plug the gap.

Weaver's second campaign proceeded on three fronts. First, Lorimer was given star billing in a series of articles on his designs, culminating in a special supplement devoted to his work, published with the issue of 27 September, 1913. Second, Weaver took a broad interest in the work of young architects throughout Britain; for him the Tweed was no barrier. Third, and possibly influenced by his southern thinking about Wren, his *Country Life* articles moved forward to tackle Scottish classicism in the work of Sir William Bruce and James Smith. It was a comprehensive survey of such impressive thoroughness that it comes as no surprise to learn that the series was planned, from the outset, as a book (sadly never realized).

The Lorimer articles began with Ardkinglas, a very large house opposite Inveraray on Loch Fyne designed for Sir Andrew Noble who was both elderly and in a hurry. As though recapitulating his 1905-06 series, but also hinting at the way in which Weaver was beginning to think about a broader view of Scottish architecture, he summarized the influence of Kellie on Lorimer's later architecture. The article included detailed plans which were specially drawn for reproduction in the magazine by Lorimer's office.

Although many of Lorimer's houses were to appear in *Country Life*, and his final work, the Scottish National War Memorial was to have its praises eloquently sung by Weaver in a monograph, the real promotional meat was reserved for the 1913 Lorimer Supplement. This required a major photographic survey of Lorimer's executed works. Lorimer's direct involvement is revealed through the survival in a pupil's scrapbook of a discarded and creased 'proof' photograph of Monzie Castle – much as a photographer would use a Polaroid today to set up his shot – on which Lorimer had suggested some rearrangement of the furnishings and commanded the removal of some of his clients' distracting bric-à-brac held to be in dubious taste. A few surviving letters from Weaver to Lorimer, now in the National Monuments Record of Scotland, show how deeply Lorimer

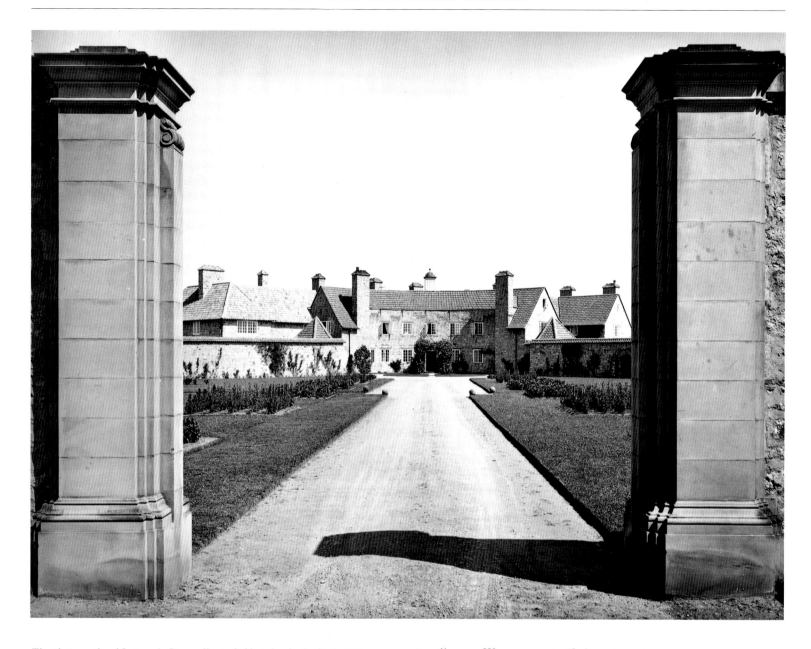

The photographs of Lutyens's Greywalls, probably taken by Inglis in 1911, failed to do justice to its entrancing spatial geometry.

was absorbed in the creation of something that was served up as measured criticism. This puffery, of course, was courtesy of the advertisers and not the least interesting aspect of the letters is Weaver's direct involvement in drumming them up.

Although Lorimer's letters have not survived, his concern seems to have been more with the look and tone of the advertisements and his sensibilities were doubtless soothed by Weaver's promised veto of one potential threat: 'These people have all been told that their coloured pictures must be approved by us, as I certainly would not allow a horrible coloured picture of a jester, which Hall's Distemper has used in *Country Life* before'.

The late Stuart Matthew, son of Lorimer's partner, John Matthew, always maintained that Lorimer had designed the published advertisements as well as the houses included in the supplement, and this is supported by the surviving papers. Editor and architect were certainly sensitive about the fine line they were

treading, as Weaver wrote: 'I do not want your name to appear on any advertisements; I do not think it looks well from any point of view. Names of jobs are another thing'.

The importance and subject of the colour cover were a further source of anxiety, but show Weaver's dazzling ability to keep a number of balls in the air and the commercial flair and powers of persuasion that made him a godsend to *Country Life*: 'Of one thing be assured, people are more likely to keep the Supplement if it has got a pretty coloured picture on the outside, and that is for the benefit not only of the advertisers but also of your noble self'. Weaver's belief 'that this Supplement will be in every important Scottish castle and mansion house permanently' has certainly not been fulfilled because it is now an exceptionally rare collector's item.

Weaver's treatment of the activities of Lorimer's brother architects in Scotland inevitably deferred to mainstream *Country Life* preoccupations by including Lutyens's Greywalls in 1911, built overlooking Muirfield Golf Course. It was perhaps a casualty of having to employ freelance Scottish photographers, unused to Lutyens's complex spatial geometry, that the captivating charm of

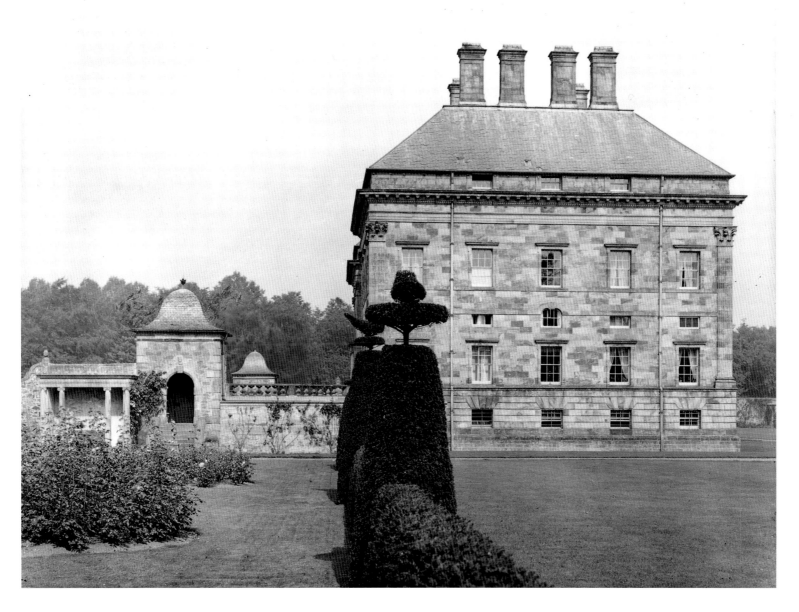

Weaver's study of Scotland's great Classical houses, such as Sir William Bruce's own house at Kinross, were a revelation to those Scots reared on the Baronial.

Greywalls in the flesh did not come across in its pictures. The Architectural Editor ingeniously married it off to a rather maverick article by the unidentified 'JK' (could it have been John Kinross?) the week before on Robert Adam's Gosford, which also owed its existence to its owner the Earl of Wemyss's fondness for golf in the late eighteenth century.

The series on historic Scottish architecture began with the Palace of Holyroodhouse on account of King George V and Queen Mary's state visit to Scotland after their coronation. This necessarily involved Weaver in an assessment of Bruce's true worth and was grounded in his knowledge of Kinross, which he had visited on behalf of *Country Life*'s readers. What now seems so remarkable about Weaver's series of Scottish articles is how many of the houses he chose to visit at this time are still regarded as seminal turning points in Scottish architectural history. *Country Life*'s interest in country houses has sometimes been dismissed as snobbish, but

Weaver's choice of subjects from 1910 to 1917 was more often selected to fit his academic, almost scientific, analysis of Scottish architecture. It was tragic that the projected book that the articles were to build up into never appeared. A handsomely produced volume with first-rate reproductions testifying to the merit and quality of Scotland's classical architecture, could not but have had an impact in shifting popular taste away from the national obsession with the crude medievalism inherent in the Scotch Baronial style.

John Cornforth has written in *The Search for a Style* that Weaver's thinking in terms of books as much as series of articles might have been a crucial factor in establishing Country Life Books as a publishing house. Weaver's missing Scottish volume could still be reconstituted from the negatives because happily a lecture he read to the Architectural Association in 1912, entitled *Some Scottish Houses of the Renaissance*, looks like a draft of the main text and was reported in *The Builder* for 19 April. From the safe distance of London he challenged, as perhaps only Weaver then could, not just the English view of Scottish architecture, but also that of the Scots themselves:

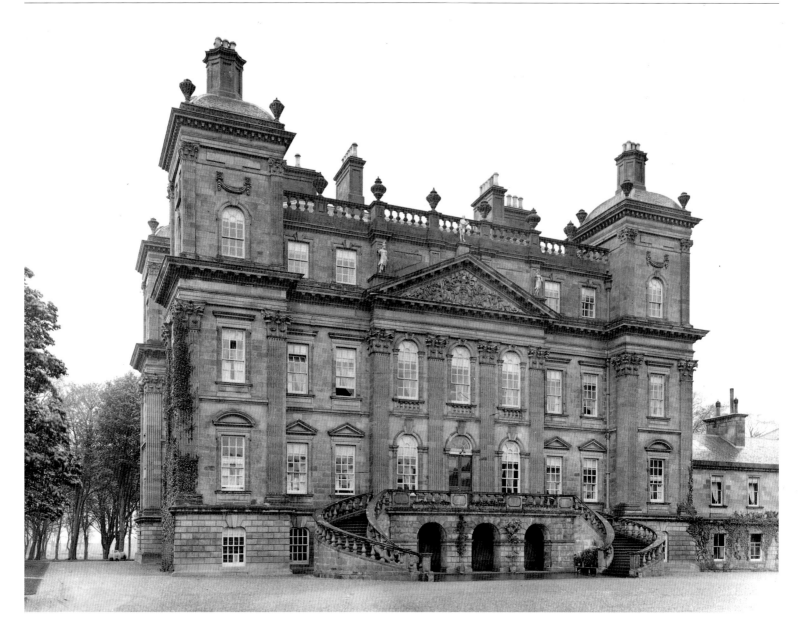

They had generally looked on Scottish architecture as being a somewhat limited affair, which began and ended with what was known as the baronial building, and that idea had to a large extent arisen because the literature of Scottish architecture was limited. There was one very notable book by MacGibbon and Ross, but the authors were very Gothic in spirit and somewhat lacking in sympathy with the full Renaissance. They touched very slightly on the Renaissance buildings introduced by Sir William Bruce, and the result was that it had been rather felt that there was nothing in Scotland except the ordinary baronial house.

He proposed to show that evening that this was somewhat of a misunderstanding, and that: 'although there was nobody at all to take the place of Inigo Jones and Wren, and the big men who followed them in England, yet there was a very serious school of neo-Classic architecture in Scotland started by Sir William Bruce'.

Weaver's lecture still seems astonishingly fresh and full of acute observations from his knowledge of the buildings and familiarity with published documentary sources. The Renaissance, in Weaver's view, had begun in Scotland in 1539 at Falkland; Hamilton of Finnart, Master of Works to James V, was identified as a key figure.

Weaver's reassessment based on his *Country Life* articles, which were ingeniously strung together, is also a reminder of how important and persuasive the detailed architectural photographs taken by the magazine were in promoting the process of evaluation. They had no equivalent in Scotland and thus Hudson's creation had been instrumental in helping Scots to see aspects of Scotland which at best had been taken for granted, if they had been assessed at all.

Weaver went on to state that the photographs he had shown were merely the spoils of one visit to Scotland, and that he had since had photographs taken of a great many other houses, which included several by William Adam. This explains the presence of a number of unpublished photographs of Duff House near Banff and of The Drum in the *Country Life* archives.

If his interest in Adam was to have formed the conclusion to his projected book, Borthwick Castle showed Weaver pushing back to the late medieval period. Borthwick owed its remarkable state of preservation to a long spell when it was uninhabited before the family moved back in 1892. They returned with an enthusiasm for its discomfort but without Hudson's taste in furniture; as a result a

second more anodyne set of photographs was commissioned before publication, and even then a great deal of retouching had to be done. Had Weaver not been planning a book, the interior of Borthwick would have disqualified it for *Country Life*.

The tower houses needed rounding off to set the scene for the onset of classicism. Weaver cast his net wide and included not only the well-known, such as Crathes and Midmar, but also a group of lesser-known tower houses, of which the enchanting, diminutive Stobhall, set in its topiary parterres, was clearly a favourite. But it was symptomatic of his sense of re-evaluation that for *Country Life*'s third visit to Glamis, Weaver could write in 1914: 'It is significant of the peculiar interest of Glamis that a return visit, after eight years, revealed all manner of beauties which escaped illustration in these pages in August 1906'.

The survey had a particular focus on those transitional buildings with Renaissance detail that bridged the late sixteenth and early seventeenth centuries between the Baronial and classicism of Bruce. Pinkie is particularly interesting because of its marked horizontality, and Weaver's study of Winton is a model of scholarship in its careful relation of the building to the published building accounts.

To round off his treatment of Bruce, his earlier house at Balcaskie was visited as well as Kinross. Weaver also rediscovered the then obscure architect James Smith, by visits to both Dalkeith Palace and Melville. His sure grasp of the period led him to score a bull's-eye with the suggestion that Smith might also have been the architect of untouched Newhailes.

Because Weaver, rather unusually, combined his interest in historic architecture with his writing about contemporary architects, he was perhaps especially susceptible to the naive charms of those Scottish Baroque houses, such as Caroline Park and Kelburne, which lack the polish of Bruce and Smith's mature works.

The connections of Weaver's multifarious activities and the socially web-like world of *Country Life* are exemplified in the 1914 article on Lennoxlove, which was both an old and important tower house even before it was restored by Lorimer. Its visual character also owed a great deal to the advice of Percy Macquoid, an expert adviser to many collectors of old furniture and inheritors of heavily Victorianized houses. Macquoid was to be a key figure in Country Life Books' ambitious *Dictionary of English Furniture*, a grand

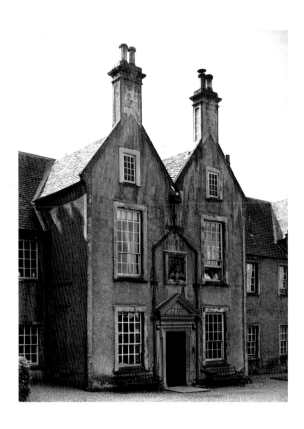

Weaver relished the more naive fringes of the Scottish Baroque, such as the 1st Earl of Glasgow's Kelburne Castle of 1700. The young ladies at the window were touched out and have not appeared in print until now.

project that was dear to Hudson; its requirements are reflected in the manner in which photographers of country house articles began to take isolated detail shots of important pieces of furniture.

Unfortunately, very little is known of the freelance photographers who were retained by the magazine for the Scottish articles. In Weaver's correspondence with Lorimer during the putting together of the 1913 Lorimer Supplement, the former referred to 'your man Inglis', identifying the photographer for what was probably the bulk of the 1910-17 articles as Francis Caird Inglis, from the second generation of an Edinburgh firm which held the Royal Warrant.

What one actually sees in the published articles in *Country Life* is only part of the story. The vertical emphasis in the ceiling shots of Craigievar in 1905 is partly a result of a tradition of antiquarian emphasis on early ceilings rather than later panelling. However, the family's own photograph albums at Craigievar confirm that the neck-craning photographs were also a reaction to the young

Left: *This photograph, showing William Adam's masterpiece, Duff House, is among a portfolio of photographs of the architect's works commissioned by Weaver in 1912, but never published.*

Above: *An unpublished view of the Hall at Borthwick Castle, taken in 1913.*

Lady Sempill's adoption of the latest fashionable taste for the exaggeratedly Picturesque room arrangement.

This kind of carefully constructed clutter was anathema to the educational thrust of Hudson's visual appraisal of old buildings and the pains he took to reproduce his specially-commissioned photographs to the highest technical standards. Unlike the antiquarian artist, who could simply omit inappropriate contents, as both Billings and MacGibbon and Ross did, the camera itself could not lie, but there were degrees of avoiding action. Some houses, like the borderline Borthwick Castle, were simply unsuitable for photography by *Country Life*. Antiquarian ceiling and fireplace details were popular in the early years, as at Craigievar, but this may have been because the furnishing fashion was then at its zenith. Caroline Park, then leased for offices by the Duke of Buccleuch, was also photographed in the same style.

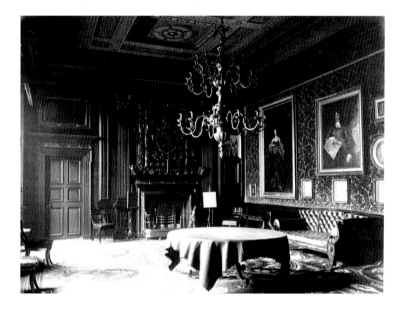

View by Lafayette c.1910 of Smith's Great Dining Room at Hamilton Palace, with the 10th Duke's early nineteenth-century Breakfast Room furniture.

It remains debatable how much *Country Life* was responsible for 'thinning down' the interiors of country houses in much the same way as ivy and creepers began to be stripped from exteriors in order to reveal external architecture. As the magazine grew in prestige and self-confidence, more owners became as pliable as Mrs Lorimer at Kellie and agreed to a temporary rearrangement of furniture. In the short term, however, photographs of Scottish houses demanded a great deal of retouching-out of the nineteenth century, which removed from the magazine's pages inappropriate wallpapers at Borthwick, stencilling in the Chapel at Drumlanrig, the sentimental painting of a dog at Earlshall, and the Great Staircase lantern at Holyroodhouse, among others details.

In some ways the thinning-out process was partially an exercise in a connoisseurship which preferred a period room to have coeval furnishings, representing the revival of an early Picturesque ideal that a house designed in a single historic style must be decorated and

furnished in that same style. The drive for clarity of interior effect was another area in which Lorimer was a gift to *Country Life,* with his taste for bare floorboards, tastefully juxtaposed pieces of furniture with clear lines and a detestation of frills.

Sadly, the First World War left Weaver with less time to pursue his interests in Scotland, but he may also have felt a sense of a task completed in spite of the non-publication of his projected volume. Such was Weaver's sense of timing, however, that there was no gap in Scottish coverage because A.T. Bolton was obliged to turn his attention northwards to present a fully-rounded picture of the careers of the Adam brothers. It appeared as *The Architecture of Robert and James Adam, 1758-1794* in 1922.

Although he produced a superb photographic survey between 1915 and 1917 of buildings by the Adam family, Bolton was ill at ease in Scotland for a variety of reasons. A letter in the Soane Museum shows that he certainly had help from Charles Gourlay, a Glasgow architect with a particular interest in history, but he did not warm to the task. Although both Culzean and Mellerstain had just emerged from an Adam-revival phase, which had reinstated much of their original elegance, other houses, such as Newliston, were still in a rather hostile aesthetic with lincrusta, stag heads and oak graining. Mellerstain and Culzean are both celebrated as seminal examples of Adam's Castle style, which he developed in response to their rugged settings, but Bolton was no admirer of this aspect of Adam in Scotland.

In bringing together Weaver and architecture north of the Tweed, *Country Life* had already been a substantial contribution to Scottish cultural life, but in 1919 it alone was in a position to carry out an important task for which Scotland should be forever grateful: the ambitious photographic survey of Hamilton Palace before it was levelled with the dust.

Country Life's ability to tackle so large a subject effectively reflects the way in which, post-Weaver, Scotland was brought back into the mainstream of the magazine's staff. The Hamilton Palace articles were written by H. Avray Tipping, who had been writing the central country house articles at *Country Life* since 1907, and in their references to William Adam's *Vitruvius Scoticus* they form a creditable addition to a Scottish genre that Weaver had perfected.

But it was the photography that marked the real departure. For the first time in Scotland this was the work of A.E Henson, who had joined the staff in 1918 and remained in post until he retired in 1957. The advantage of a staff photographer is immediately apparent in the quality of the Hamilton Palace photographs; in Henson *Country Life* had found a perfectionist for whom nothing was too much trouble. But the sheer quantity of the glass-plate negatives is perhaps also indicative of the change in working practice – not that the magazine was ever extravagantly run. At least one hundred and thirty three negatives were taken, and the extent of the record was also a function

Right: *Newliston, photographed in 1917, shows how even one of Robert Adam's most elegant Scottish houses succumbed to Scotch Baronial fervour.*

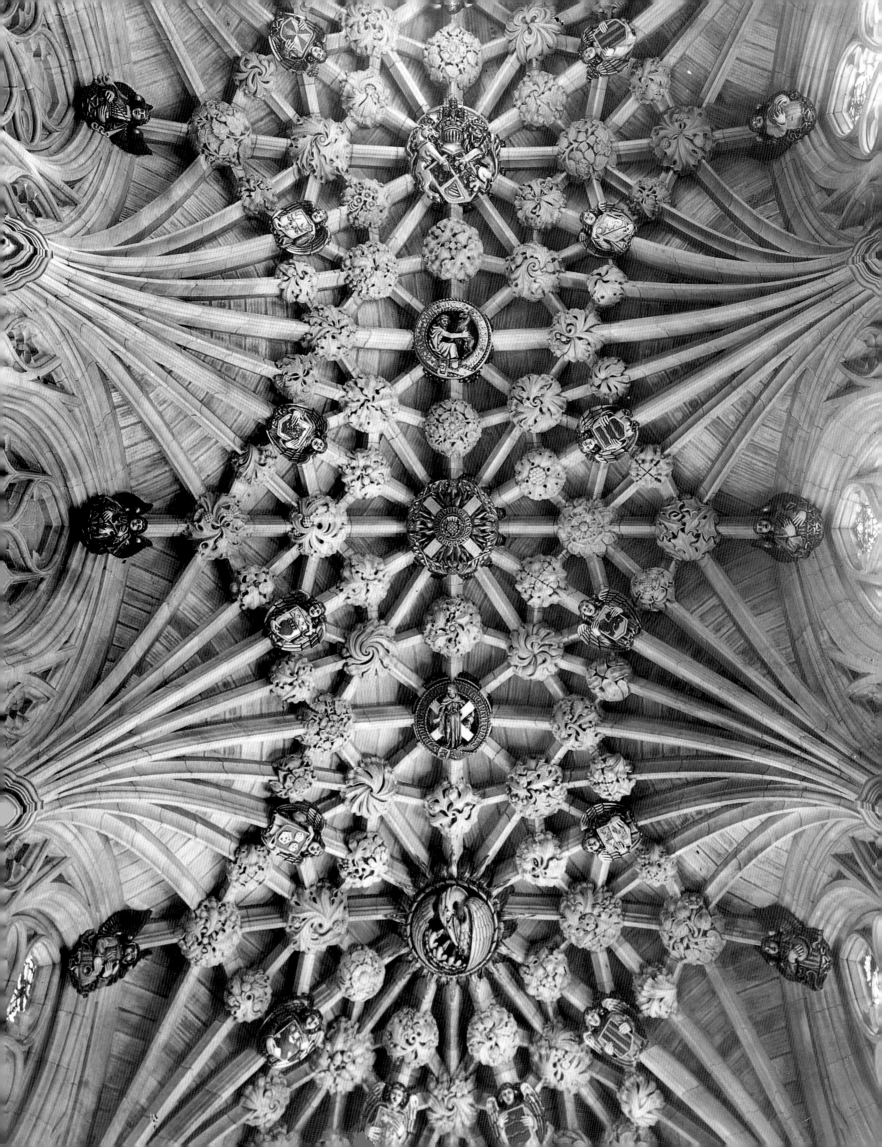

of the palaces's terminal state since almost everything was going to go, as the re-use of *Country Life*'s photographs in the sale catalogue underlines. Bernard Darwin in his *Fifty Years of Country Life* (1947) attributes to a Cabinet minister the remark that *Country Life* had become 'The Keeper of the architectural conscience of the Nation'.

In 1921 Christopher Hussey joined the staff of *Country Life* and soon found himself responsible for Scotland. His parents were friends of H. Avray Tipping and he had Scottish relations. It seems likely that he fitted in at least some of his Scottish articles with his holiday arrangements. Hussey is such a major figure in British architectural history as to need no introduction here. His principal contribution in Scotland was to steer the country house articles through the eighteenth century with a much surer touch than A.T. Bolton could manage. There were articles on such major houses as Arniston and Inveraray and superb photography by Westley and Gill, who had joined Henson as staff photographers.

The most famous image from Hussey's Scottish forays is the dramatic picturesque view of Dunglass towering above the river bed, with the effect intensified by the drama of a fallen tree. This photograph not only encapsulates the way in which the house was designed to maximum landscape impact from sketches by the artist Alexander Nasmyth, but shows an effect to which Hussey was particularly susceptible, because his own family's country house at Scotney in Kent had been designed on identical Picturesque principles, in an aesthetic he was to repopularize through his major study of the genre in 1927.

Hussey also continued to nurture the Lorimer connection with *Country Life* which was to culminate, after the architect's death in 1929, in his biography *The Work of Sir Robert Lorimer* (1931), which drew on its extensive photograph banks.

Lorimer's most recent biographer, Peter Savage, has been understandably critical of what to modern scholars must seem Hussey's hasty judgements, and Hussey had been reprimanded by Lorimer himself for this. In 1925 Sir Robert had collected the proofs of Hussey's article on Marchmont, which Lorimer had transformed for Robert McEwan in 1913. On 24 January, 1925 a thunderbolt in the form of four closely-typed foolscap pages was despatched to the young Hussey from the architect's Edinburgh office:

A man like myself, who must have been a practising architect, producing work long before you were born, spends several years on the designs and superintending the carrying out of the work for a place like Marchmont; then a young spark like you, who has never been ground through the architectural mill, spends a few hours roaming around the place and taking a few notes, then months after when the whole impression has faded, starts to write up an article and thinks he is in a position to make a reasoned criticism of the character of the work.

Left: Lorimer was so fond of this dramatic study of the enriched vault in his Thistle Chapel, taken by Inglis in 1911, that he had a large blown-up version framed in his office.

As in all the fiercest arguments the dispute hinged on a question of taste in that the young Hussey saw an interesting eighteenth-century house with superb plasterwork – the drawing room is one of the finest rococo interiors in Scotland with its curvaceous ceiling and sunburst fire-surround – but to the older Lorimer the existing house had been aesthetically worthless. To ram home his point, in a PS to this letter (now in the National Monuments Record of Scotland), Lorimer tore out the photograph of the house in the sale catalogue to enable Hussey to judge 'whether the opinion of those who say the house has been spoilt requires to be taken seriously'.

Hussey's Mar Lodge articles in 1931, recording a Victorian royal shooting lodge with a run of antlers, shot by the crowned heads of Europe stretching back to 1797, also signifies a change in taste, although the exterior was recorded from the safe distance of about a mile away. But photographs taken on the house's completion for HRH the Duchess of Fife, daughter of the future Edward VII, in the 1890s show how drastically its interiors had been modernized – making it a suitable subject for *Country Life*.

Hussey dutifully kept up a flow of castle articles which readers still expected to find in a Scottish Number of *Country Life*, but it is remarkable how even Cawdor and Glamis had begun to take on a sunnier aspect than the lurid antiquarian gloom they usually evoked. Hussey's illustrations show that the more bogus Scotch Baronial trappings were being largely weeded out of these castles.

In 1928 Arthur Oswald joined the magazine and helped Hussey with Scotland in particular. The unsigned article on Yester may be his work and it seems no coincidence that one of his first signed articles was on Auchencruive, designed by Robert Adam for the Oswald family, suggesting that he had Scottish links.

Arthur Oswald's 1951 articles on Gribloch, Scotland's most important modern country house, seem an obvious point at which to terminate this visual survey of the first half century of *Country Life*'s relationship with Scotland. The strength of the magazine's photographic reserves was also demonstrated in two contemporary publications by Country Life Books, both of which, in their different ways, were only possible because of the sure foundations laid by Lawrence Weaver. Oliver Hill's *Scottish Castles of the Sixteenth and Seventeenth Centuries* (1953) was a remarkable achievement and Hill, an architect of outstanding ability, brought to it an infectious enthusiasm for Scotland. John Fleming's *Scottish Country Houses and Gardens Open to the Public* (1954) made available, in a modest and economical form, the most important photographic survey of Scottish architecture to date. It enjoyed a much wider circulation than Hill's sumptuous book. These books also mark an important photographic watershed for *Country Life*, as technology saw the glass-plate negative superceded by film.

A secure repository for the fragile glass-plate archive was found during the late 1980s, when *Country Life*, in partnership with the National Monuments Record of the Royal Commission on Historical Monuments (England), made a duplicate set of the copy negatives and transferred the original plates to the controlled environment of

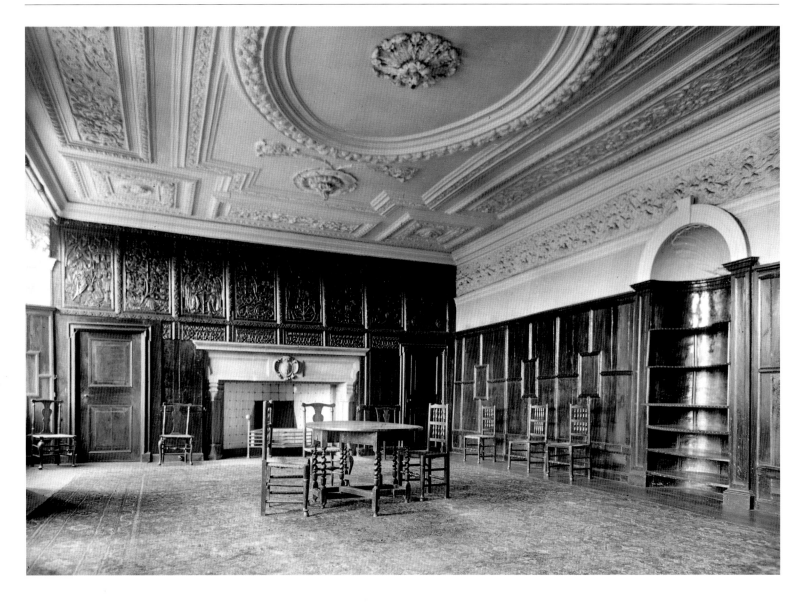

The Great Dining Room at the now demolished Balfour House in Fife, showing the 'Beaton panels' on the fireplace wall.

the Commission's purpose-built photographic archives at Swindon. Two sets of contact prints were made from the copy negatives: one set is housed in the *Country Life* Picture Library in London, and the other at the National Monuments Record. At the time of writing, the Scottish collections are being transferred to the National Monuments Record of Scotland at the Royal Commission on the Ancient and Historical Monuments in Edinburgh.

In preparing this book, I have had the considerable pleasure of going through the entire archive of Scottish material. So economically was the magazine run, that there are far fewer unpublished negatives than might be expected. But the most important of these are a set of views of the Great Dining Room of the now demolished Balfour House in Fife showing the 'Beaton Panels' – a particularly celebrated example of early Scottish oak woodwork, now in the care of the National Museum of Scotland.

If the number of negatives of Scottish subjects commissioned by *Country Life* is relatively manageable in comparison to the thousands of English plates, it has still been a painful process to

edit them down to fit a single volume. It seemed desirable to try to jigsaw the original articles together to create an historical survey of Scotland's architecture and recreate something of the flavour of Weaver's proposed book *c.*1913. The Hamilton Palace photographs are obviously the highlight of the Scottish collection and it seemed important to show the magazine's championing of Sir Robert Lorimer, A.T. Bolton's coverage of the Adam family, and the great Scotch Baronial Garden campaign of 1901-1902. It would be impossible to miss out Mar Lodge or Gribloch. Inevitably, it is difficult to be entirely objective and the series of luminous photographs of Inveraray are a particularly personal choice. *Country Life* has been recording the country houses of the British Isles for exactly one hundred years. The result is an unrivalled archive of architectural photographs, which capture the finest houses in their prime. This book is intended to draw attention to this quite extraordinary resource.

Right: Lorimer published this view of the Gothic Dining Room at 54 Melville Street, Edinburgh, anonymously in the 1913 Supplement.

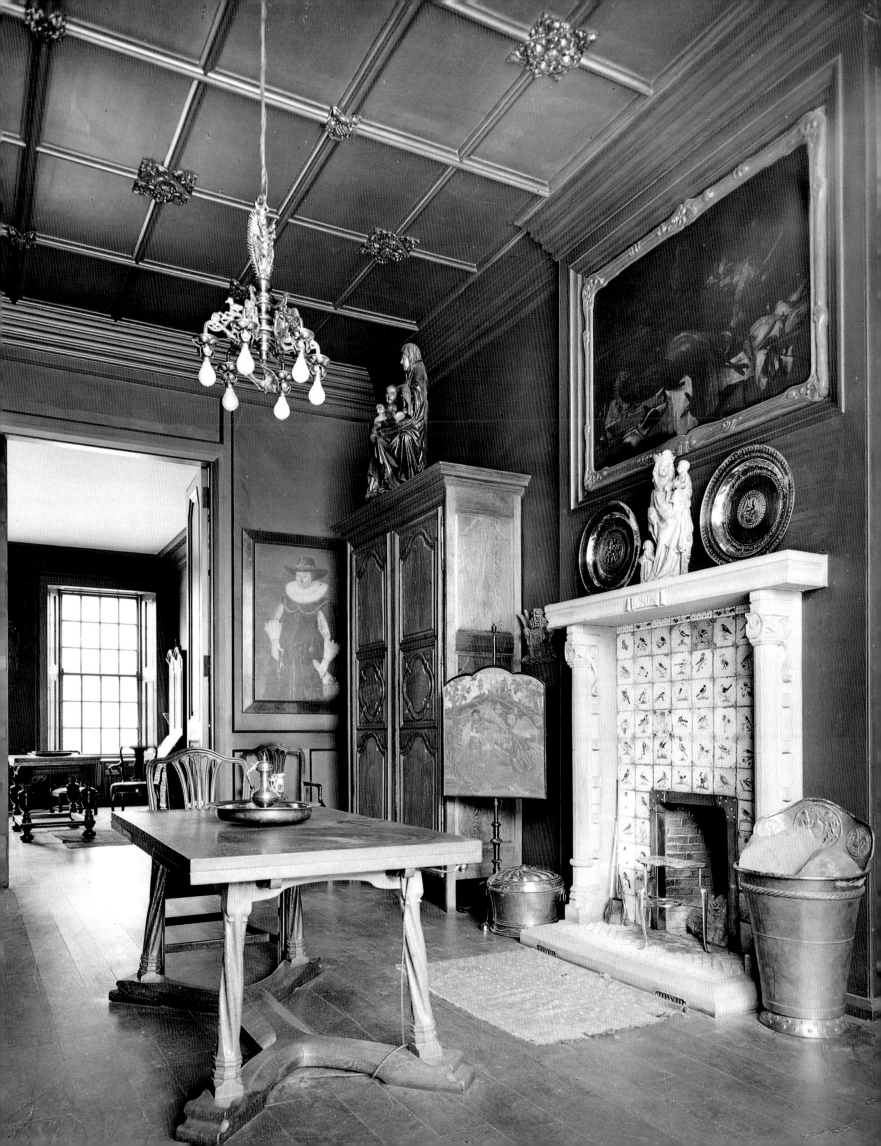

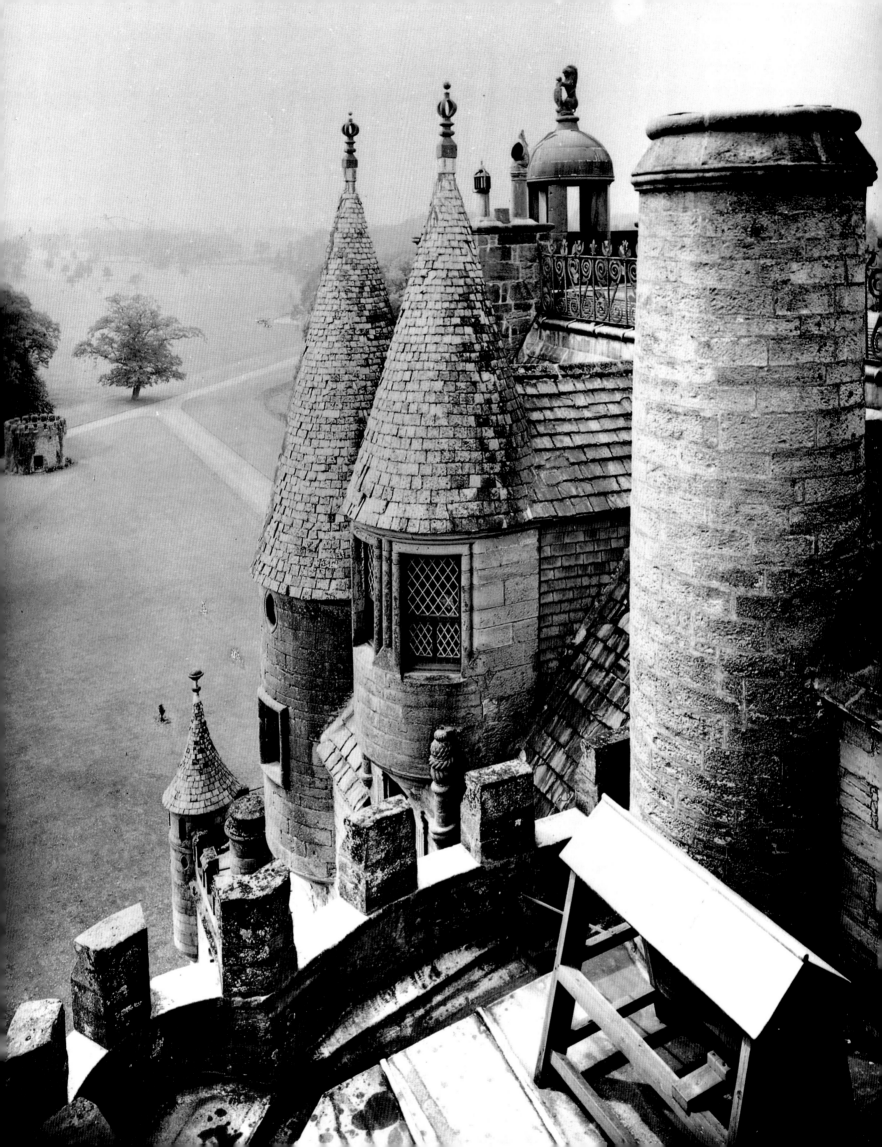

GLAMIS CASTLE

FORFARSHIRE

Glamis has appeared more frequently in *Country Life* than any other Scottish house. Both Glamis and Cawdor owed their celebrity as prime Victorian tourist attractions to Shakespeare's allusions to them in *Macbeth*. Both castles were therefore somewhat wrong-footed by literary-inspired tourists, who came in the expectation of a visual gratification that would live up to a gruesome play – this in spite of the fact that nothing standing could possibly remain on either spot from such an early period of history.

Such was the potency of *Macbeth* that their nineteenth-century owners, inspired by Victorian Scotch Baronial zeal, had tried very hard to conjure up the remote past of the castles and distract attention from their more recent Baroque remodelling. At Glamis exterior harl and plaster were stripped away to reveal expanses of medieval rubble that were deemed essential to the Scotch Baronial aesthetic.

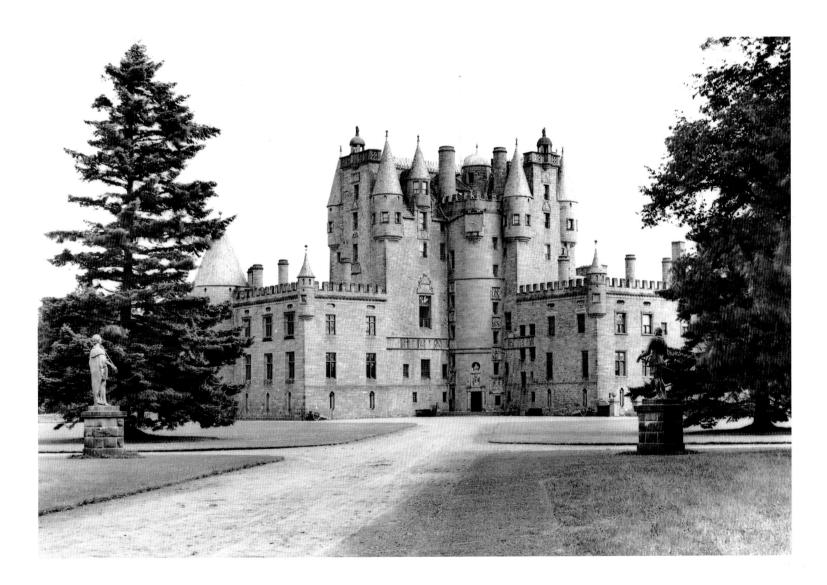

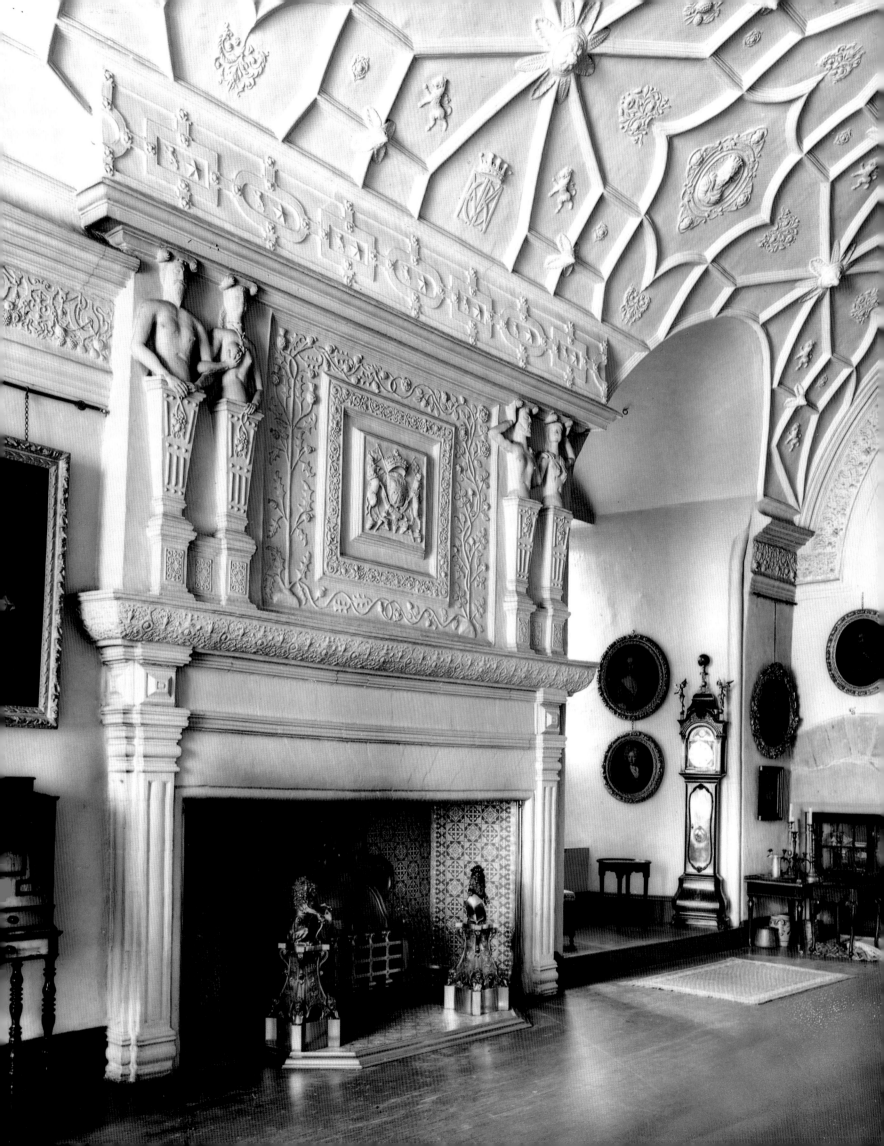

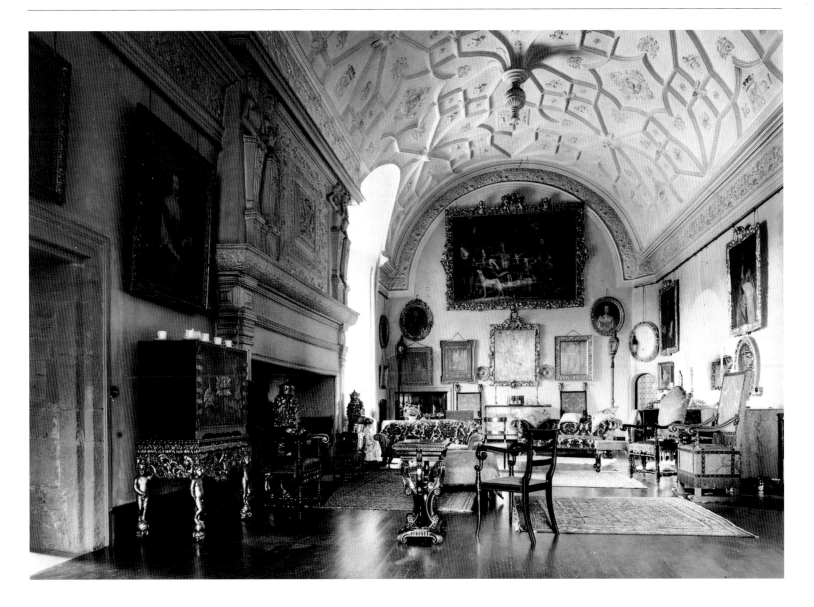

The castle filled up with suits of armour, weapons, taxidermy and quantities of ancient oak as black as Lady Macbeth's heart.

It is fascinating to see how in the successive *Country Life* articles on Glamis this carefully cultivated antiquarian gloom retreated and attention began to shift towards a new appreciation of the castle's seventeenth-century Baroque decorations and grand furniture.

After *Country Life*'s first visit to Glamis in 1897, Weaver went to Glamis in 1906, and his delight in explaining Scottish family history ran away with him, leaving him little remaining space to describe the building. He could not stop himself from slipping in

Preceding pages (right): *This distant view of Glamis shows the Baroque effect of the diagonal wings with Quellin's statues of James VI and Charles I flanking the drive.*
(left): *A dramatic view of the park glimpsed from the Castle's highly-ornamented roof-works, taken in 1906 by Frederick Evans.*

In 1906 Frederick Evans only showed a detail of the Great Hall chimney-piece with its Jacobean plasterwork, dated 1621 (left). By 1914 the room had been refurnished as the Drawing Room to show off the Baroque furnishings, allowing Country Life *to take a wider view of the entire room, with the portrait of the Earl of Strathmore and his sons in pride of place high up on the end wall* (above).

a reference to the castle's 'dread secret which, on the faith of all tale tellers by winter fires, passes, generation by generation, with the ancient barony'. But once again the clarity of the photography, which may have been by Frederick Evans, told a different story, and a new photograph of the Crypt, when compared to that by Valentine published in 1897, shows the first evidence of a recent pruning of taxidermy and potted palms, although it is unclear to what extent this was due to *Country Life*'s intervention or reflected a more permanent change.

Weaver returned with fresh eyes in 1914 and his broader view of Scottish architecture and an appreciation of its later Baroque decorations was reflected in the photographs. This shift in perception must have been promoted also by the publication in 1890 of the Glamis *Book of Record*, which was a remarkable diary kept by Patrick, Earl of Strathmore and Kinghorne between 1684 and 1689. It shows the Earl overcoming the financial vicissitudes he inherited and gradually establishing himself in the kind of Baroque splendour that the Scots made their own, with new tapestries and grand furniture.

Weaver was enchanted by the *Book of Record* not only for the detail it provided on Earl Patrick's building activities at both

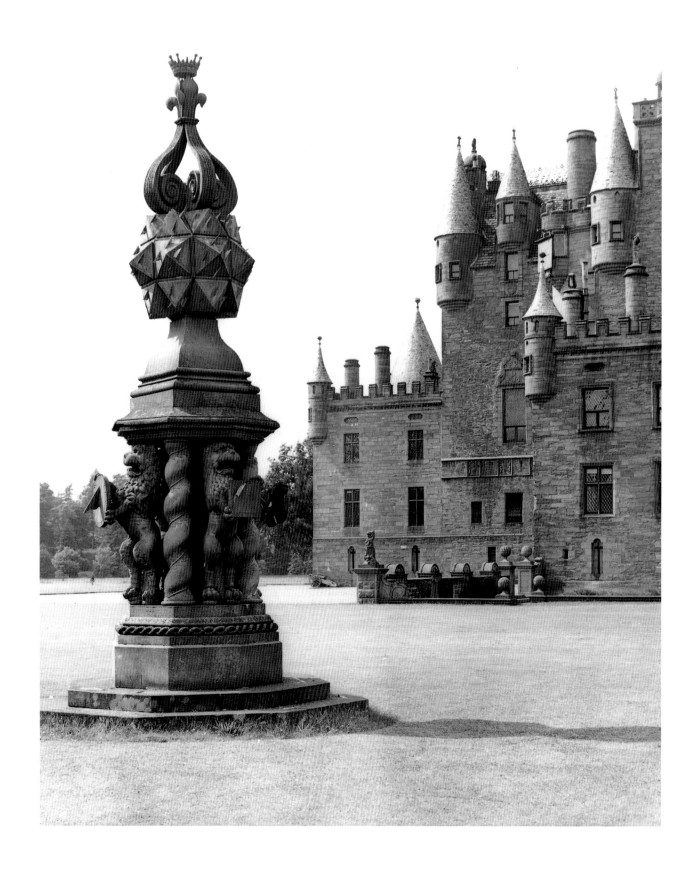

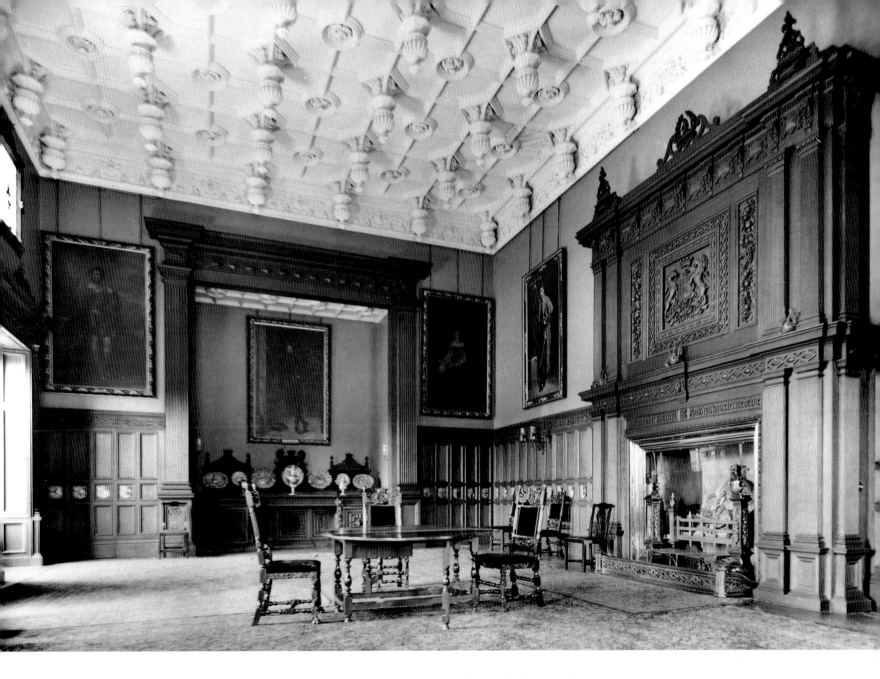

Glamis and Castle Huntly, but also for the insights it offered into the Earl's own thinking. Weaver had to 'restrain the temptation to quote at large, and give only some short extracts', but his choice of these reveals as much about Weaver as it does about the seventeenth century. The Earl's architectural pursuits were of a do-it-yourself character dispensing with expensive professional advice: 'I never judged anything of my own small endeavours worthie to make such a noise as to call or invite to either of my houses skilled public architects'. If the architectural shell of Glamis often appears idiosyncratic, like many Scottish nobles of the time the Earl spent extravagant amounts on the imported, ostentatious furniture that provided the foreground in his interiors: 'I acknowledge a great dale of weakness in my humour that way, inclining to be very profuse upon all things of ornament for my houses'.

Left: A detail of Glamis's Baroque heraldic sundial, with proud lions bearing individual dial plates separated by barley-sugar columns, photographed by Frederick Evans in 1906.

Above: As the Dining Room was one of the finest Scotch Baronial revival interiors, this photograph was not published by Country Life.

The Earl's Baroque furniture was now given pride of place and the old oak was forced into the background. Weaver's 1914 view of the Great Hall showed the full expanse of the Jacobean plaster-work, dated 1621, across the vault. Earlier photographs of the room reveal that a vast Victorian oak bookcase had filled the end wall, beneath the great portrait of the Earl and his sons, which the photographer in 1906 must have been at pains to keep out of camera range. Displayed along the top of this enormous bookcase, and rising to the frame of the group portrait, had been an entire Chinese export dinner service.

Weaver also had individual photographs taken of the Baroque cabinets on their highly-sculptured stands, and he expressed the hope that these were the very ones whose purchase had been recorded in the Glamis *Book of Record*. Weaver was attracted by the Earl's account of a particular cabinet: 'I caused bring home a verie fine cabinet, – which the better was not found in the Kingdome in these days, – which I never told my wyf of till her comeing home, and upon her first comeing into her owne chamber I presented her with the keyes to the cabinet'. But by 1914 the family had clearly taken to heart the message of the published Book

and regrouped their possessions accordingly. Although a new element was added with the introduction of Italian lamps and brocade chairs, reflecting the family's Italianate taste, the Baroque furniture had pride of place in 'The Drawing Room', as the Great Hall was now named, and the high-backed old oak 'Mary Queen of Scots Chairs' had been removed.

How far Hudson's *Country Life* should be held responsible for this re-evaluation of country houses has often been debated. But the real contribution of *Country Life* in Scotland was in presenting a selection of superb photographs, which, when they were studied with scientific detachment away from the romantic distractions of the castles themselves, showed that however impetuous the behaviour of the Scots in their castles in the remote and undocumented past, in more recent centuries they had been discriminating patrons of architecture.

Although Weaver's return to Glamis must have been inspired by the need to obtain better photographs for his projected book on Scottish architecture, the invitation may have been extended by the Strathmores to celebrate their improvements. A view of the Scotch Baronial Dining Room remained unpublished; it can now be

recognized as a particularly fine example of the type, with *en suite* chairs and sideboard. The introduction of the single Chippendale chair next to the lofty oak chimney-piece shows that its natural habitat was already under threat.

During the twentieth century Glamis continued to appear regularly in the pages of *Country Life*, but found a new role in national consciousness as the childhood home of Queen Elizabeth, the Queen Mother.

Below: *In the nineteenth century the Crypt was stripped of its plaster to create a timeless effect, with medieval rubble, old oak and taxidermy, but Frederick Evans's 1906 photograph shows evidence of a recent pruning.*

Right: *A detail of the entrance front of Glamis, with its blocked-up openings and straight joints, reveals how frequently the ancient Castle had been altered before being recast to create the Castle's great Baroque front.*

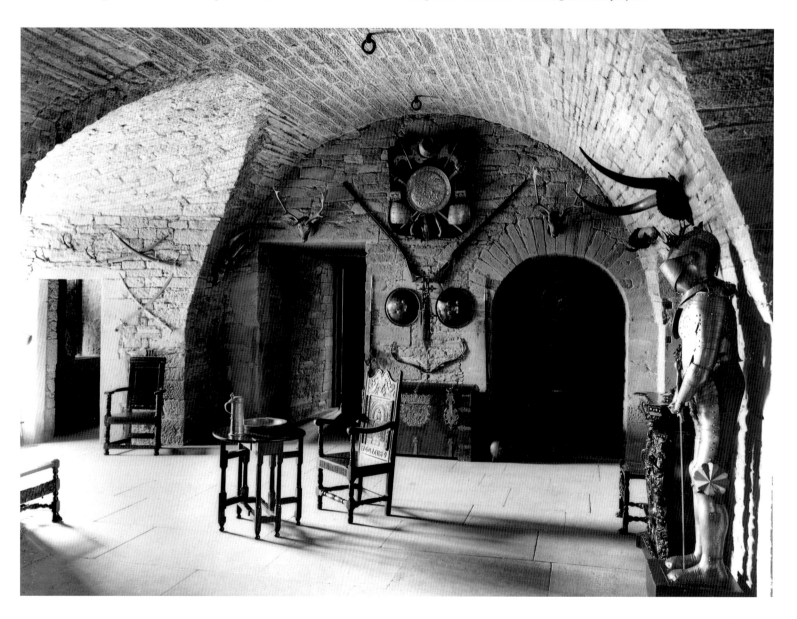

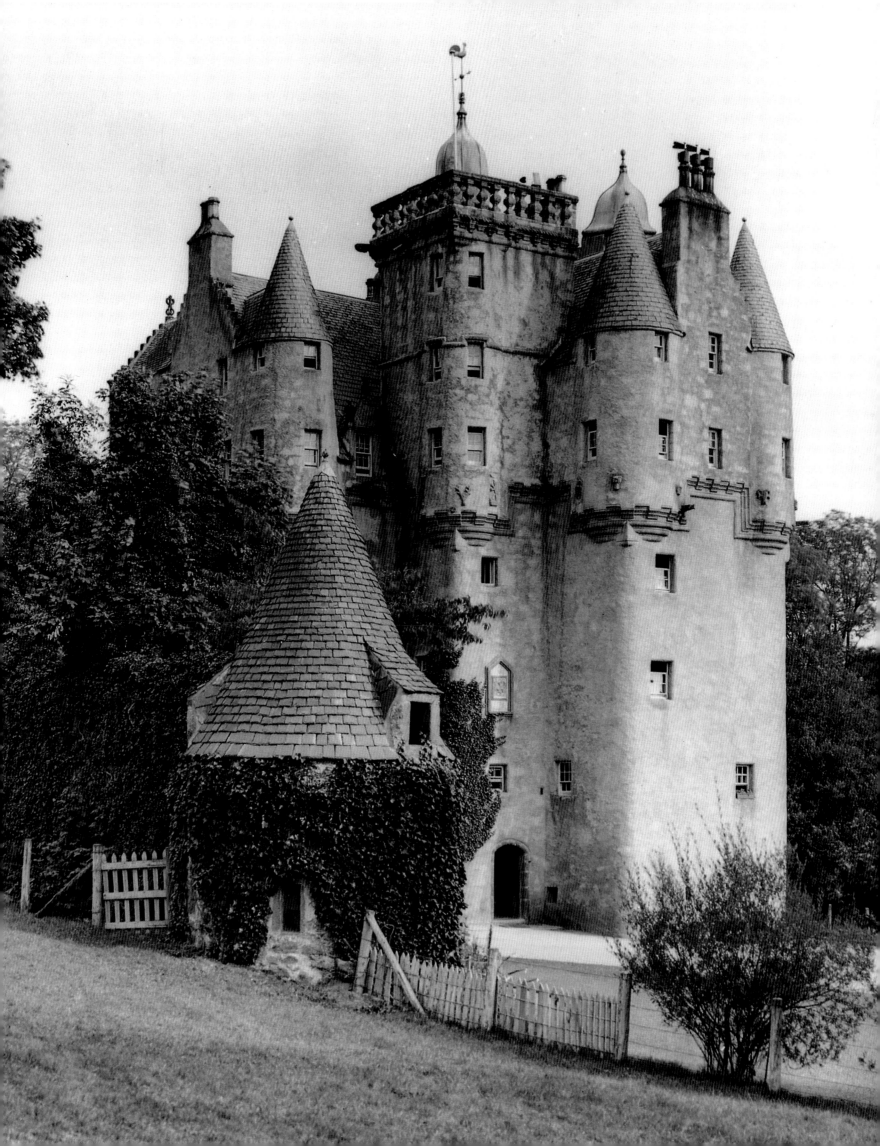

CRAIGIEVAR CASTLE

ABERDEENSHIRE

Craigievar's run-away popularity as Scotland's most-loved tower house was promoted by the outstanding calibre of *Country Life*'s two photographic campaigns in 1906 and 1938. The first set of photographs was almost certainly taken by Frederick Evans, the most famous of Hudson's freelance photographers, and the second by A.E. Henson, *Country Life*'s perfectionist staff photographer. The lands of Craigievar were acquired in 1610 by William Forbes, a younger son of a local family who made his fortune in the Baltic trade. By 1625-26, the dates inscribed on its sumptuous and innovative plaster ceilings, he had transformed an existing stronghold into the most perfect expression of the distinctive Scottish tower house. Craigievar's exceptional preservation is due, in part, to its remoteness.

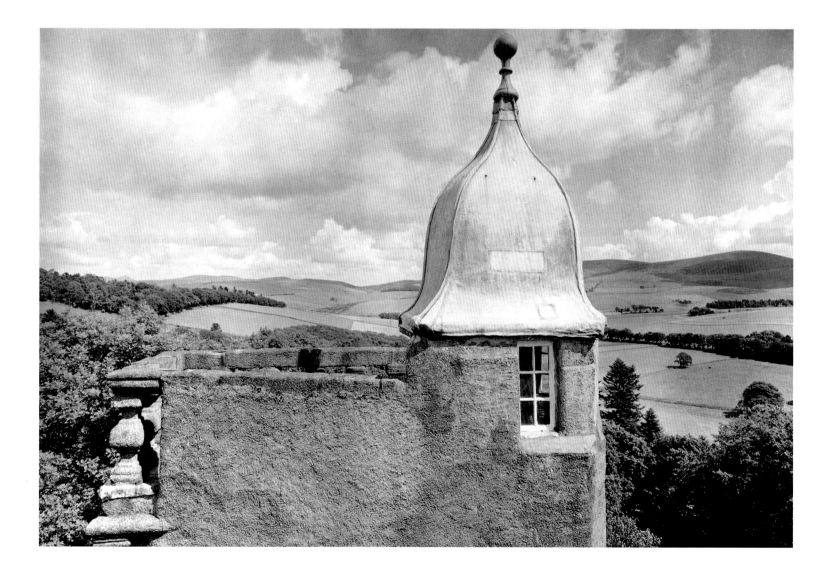

Not only does a section of the outer enclosing barmkin wall still survive, with a circular corner tower, later adapted as a dog kennel, but there are large expanses of original carved oak-panelling and even some early furniture, such as the Hall table with its handsome baluster legs. Craigievar's state of suspended animation also reflected the practical preference of later members of the Forbes family for Fintray, another family property much closer to Aberdeen.

The crucial moment of decision for the two seats came in 1824 when Sir John Forbes, another younger son, returned from service as a judge with the East India Company after the death of his older brother, Arthur, to take over the management of the family estates, which had been brought to the brink of disaster by a disastrous Dickensian trust and Arthur's compulsive extravagance. The Aberdeen architect John Smith was asked to report on the condition of Craigievar and wrote to Sir John: 'I beg leave to add that the Castle is well worth being preserved as it is one of the finest specimens of architecture in this Country of the age and style in which it is built'. Sir John accepted Smith's visionary conservationist advice and Craigievar was given a new roof and other modest necessary repairs; it was Fintray that was rebuilt

instead by Smith, to the designs of William Burn, to supply all the home comforts required by a Scottish late-Georgian laird. Craigievar was now used only as a summer and autumn holiday house, where roughing it was part of the fun. It never needed extensive service accommodation and its single door continued to serve for both 'master and servant'.

Craigievar's self-conscious state of preservation equipped it for a new role as a tourist attraction, enhanced by its proximity to Balmoral and Royal Deeside – as the castle's Visitors' Book, which runs from 1848 to 1908, demonstrates. Queen Victoria came twice in 1879 and 1896, but because her first visit was incognito, the Queen-Empress signed the Visitors' Book on the second occasion: 'Victoria R in remembrance of my visit to Craigievar in 1879'.

Preceding pages (left): *Frederick Evans's 1906 study captures the Picturesque qualities of this most sculptural of early seventeenth-century tower houses.* (right): *Among the many excitements of Craigievar are the two spiral staircases with ogee lead caps that ascend to balustraded roof-top viewing platforms.*

Right and below: *The plasterwork of the groined-vault of the Great Hall bears the date 1626. Although the panelling had to be reset when the architect John Smith lowered the windows to form a more conventional dining room in 1825, Craigievar remains exceptionally rich in early woodwork.*

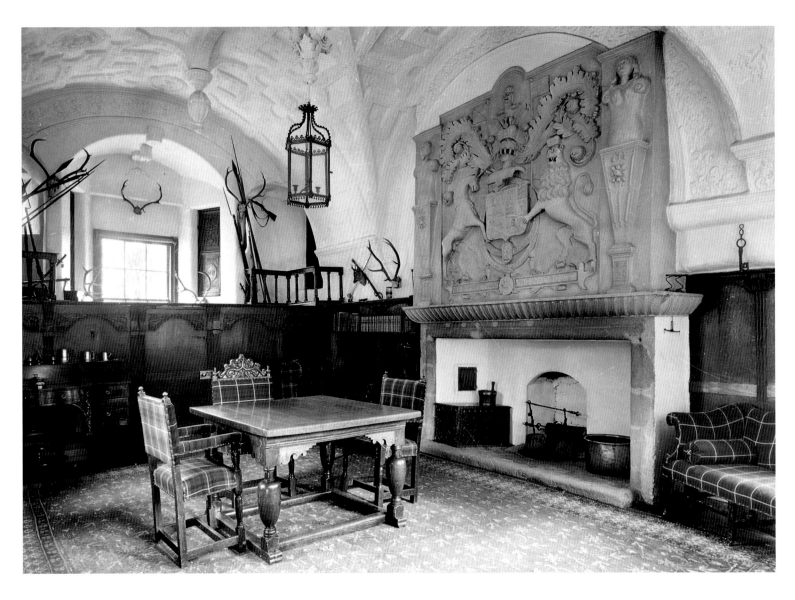

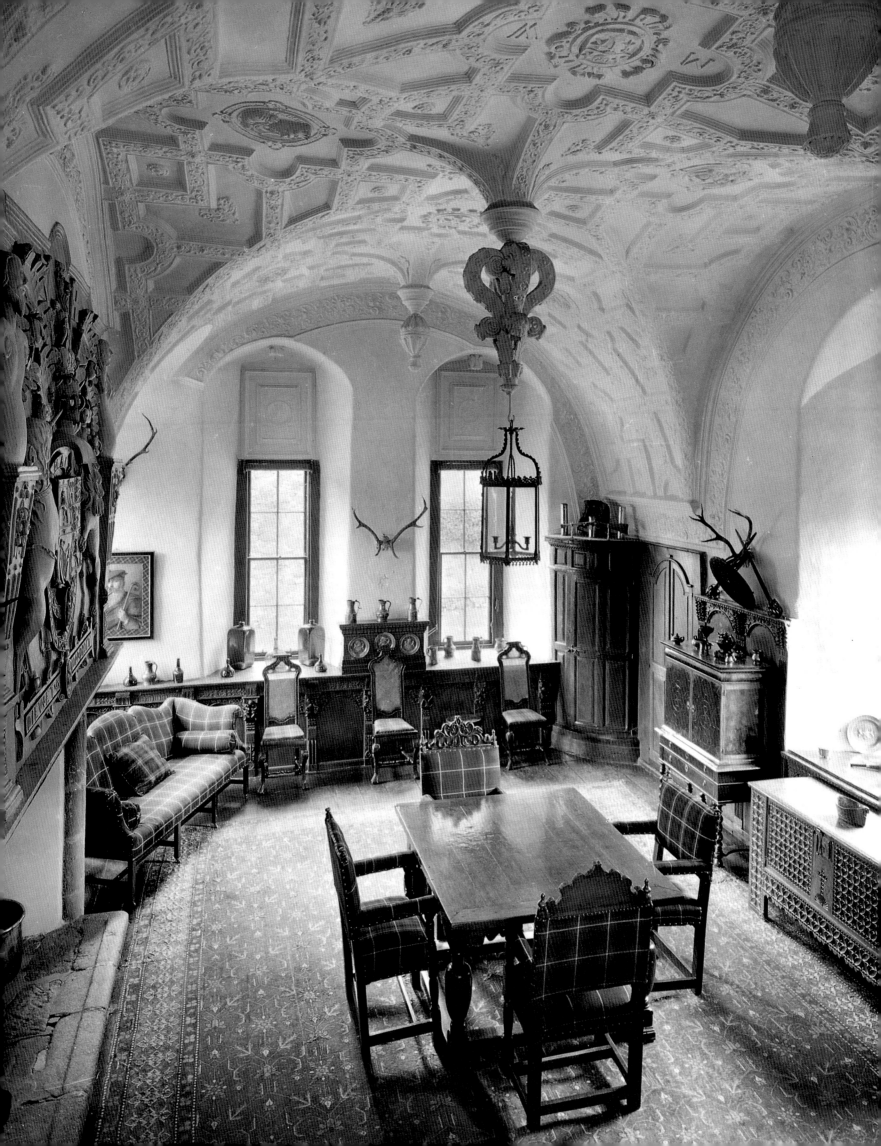

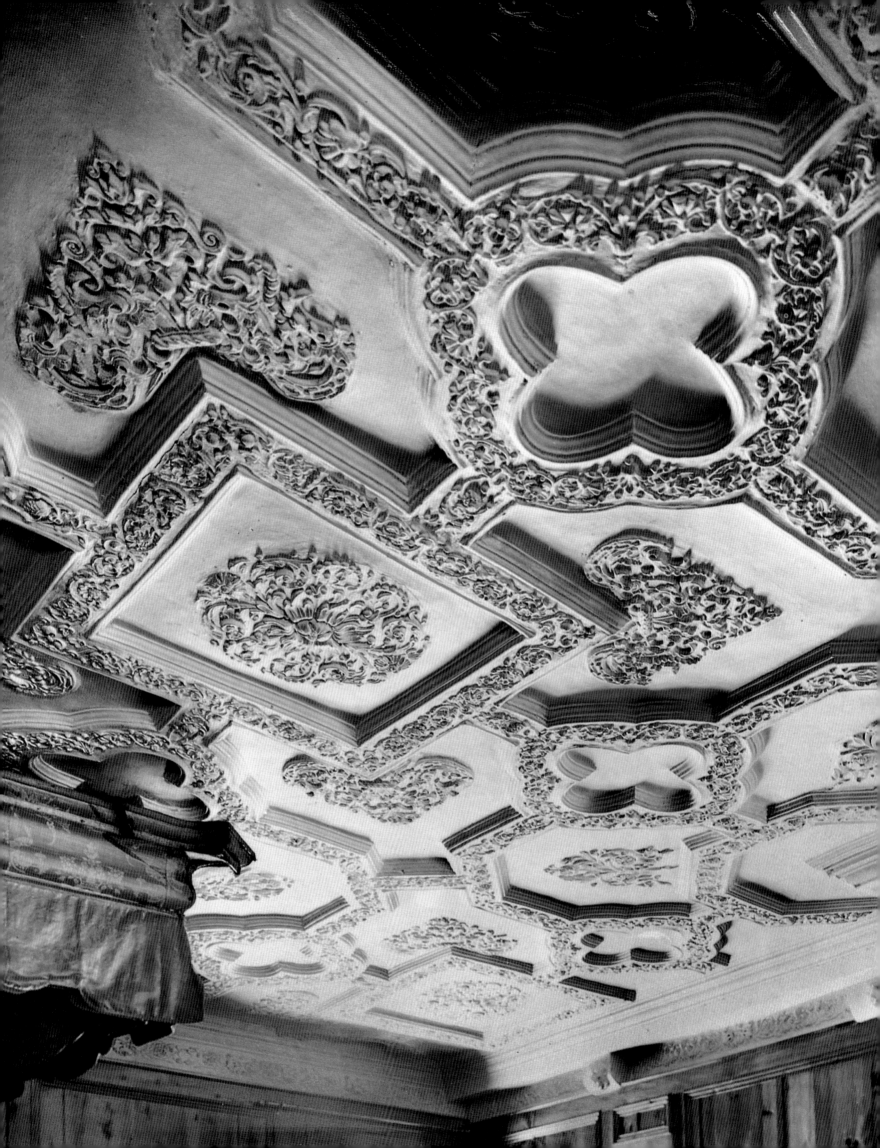

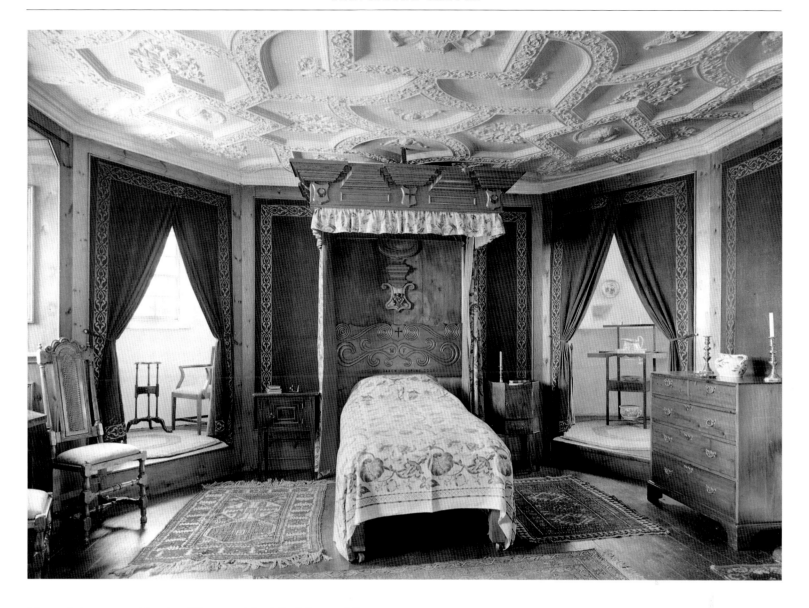

Many of the crowned heads of Europe visited Craigievar while staying at Balmoral. Nineteenth-century guidebooks characterize the castle as 'a grim old Flemish building' and tours of the castle were peppered with lurid tales that now seem incongruous with its present day serenity.

Sir John's eldest son, William, succeeded in 1884, through his grandmother, to the ancient Scottish title of Lord Sempill. Sir William also inherited his uncle Arthur's extravagance, and the estates were never less than £30,000 in debt, exacerbated by William's expensive divorce from his first wife. As a result Fintray often had to be let and the family spent more time at Craigievar, requiring the abandonment of certain archaisms, such as the ranks of built-in box-beds, in favour of more conventional creature comforts and plumbing. When Sir William had first stayed at the castle with his father in 1842, the Hall had been strewn with freshly-gathered rushes every day. Sir William's improvements were in Scotch Baronial mode and his new panelling and bedsteads carefully followed the profiles of earlier prototypes.

In 1890 Lord Sempill had resolved to marry for a third time and chose Miss Mary Sherbrooke as his bride. When Lord Semphill's heir and the agent impressed the true state of his finances on

In 1906 Frederick Evans focused on Craigievar's splendid plaster ceilings (left), but happily just caught the corner of the tester of one of the Castle's two Baroque Angel beds. The Blue Room (top) high up in the Castle has late seventeenth-century closets in the bays of the corner turrets. The tester is a late nineteenth-century restoration, stripped of its silk. One of the smaller bedrooms (above) has early nineteenth-century painted furniture.

39

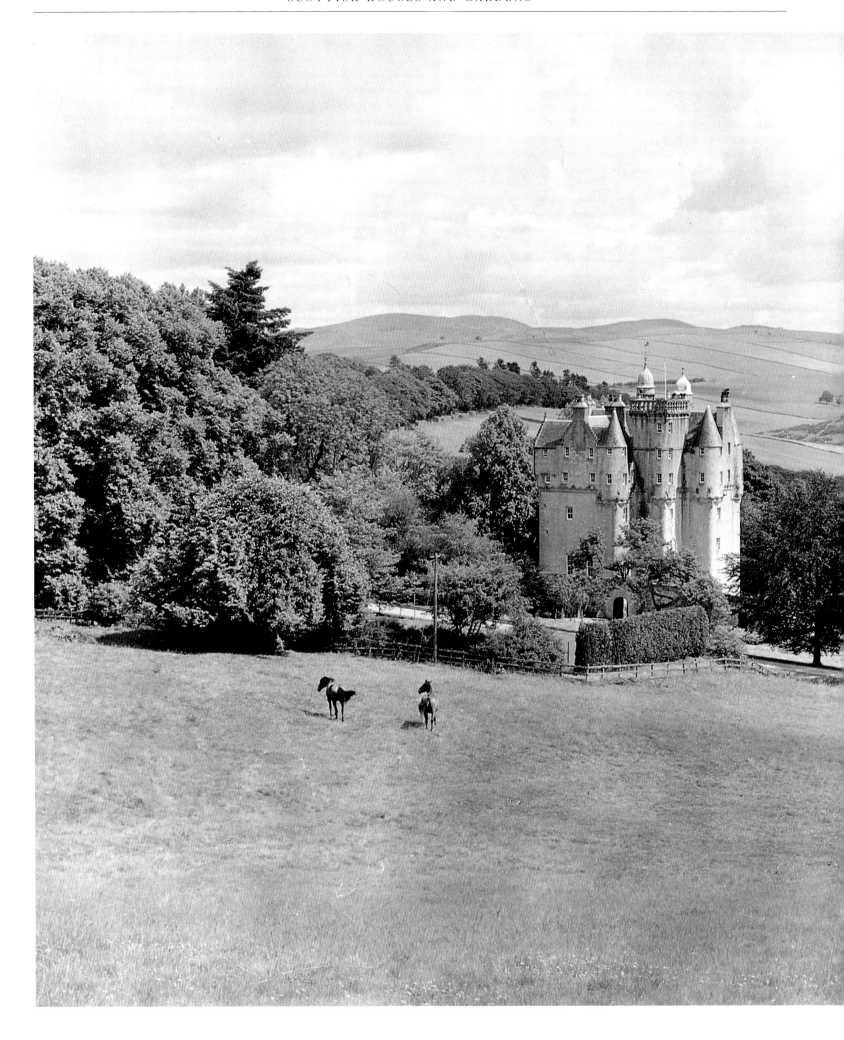

Miss Sherbrooke, she was unperturbed, responding that 'she had been quite accustomed to live on an impoverished estate and does not require a maid and many other things'. As Lady Sempill, she rearranged the rooms at Craigievar in a cheap, cheerful and exaggeratedly Picturesque style, with extra comfortable basket chairs and a mass of potted plants, which may explain why Evans's camera lens remained firmly trained on the plaster ceilings, the chief glory of Craigievar indoors. By the time of Hussey's visit in 1938 the contents of the rooms had been refined, with an emphasis on antique furniture, by Gwendolen, Lady Sempill, but the castle had had to be let following the death of her husband in 1934.

During the Second World War, Fintray was requisitioned, and the family never returned. Craigievar was now their only seat. The 19th Lord Semphill and his wife, Cecilia (who had previously known Craigievar only through Hussey's *Country Life* article because the castle had been let), had the delicate task of deciding which of the family relics and portraits could be accommodated in the castle's tiny spaces.

Craigievar's established fame made it the appropriate choice to decorate the dustjacket of Oliver Hill's *Scottish Houses of the Sixteenth and Seventeenth Centuries*, published by Country Life Books in 1953. Although Hill had been a highly successful architect before the Second World War, his commissions then dried up. Perhaps as a distraction, his friend Christopher Hussey encouraged him to write about Scottish castles for *Country Life*, which resulted in a series of articles, drawing on its photographic archives.

John Cornforth, who was later to collaborate with Hill on the *Caroline* volume of the *Country Life* series, recalls that he had 'the best eye of anyone I have ever known'. From this modest beginning, Hill's book expanded into a *tour de force*, which for the first time related architecture to contemporary costume, painting, silver and furniture. Hill's romantic view of Scotland's traditional architecture made him a worthy successor to the spirit of Hudson and Weaver. For him, Craigievar was 'incomparably lovely' and he described it as follows. 'The first impression is overwhelming: the tower, as it comes into view looks like a great while galleon in full sail'. In 1963, when the future of Craigievar seemed uncertain, it was purchased by the National Trust for Scotland so that it might be preserved for ever.

The Castle sits high up on a ridge and commands magnificent views across the countryside of Aberdeenshire. Craigievar's self-conscious state of preservation from 1825 precluded a conventional gentleman's park, and there are no gate lodges.

PINKIE HOUSE

MUSSELBURGH

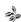

Pinkie is a prime example of the problems that arose when Weaver needed to include unphotogenic houses in an illustrated magazine
renowned for its beautiful photographs, as part of a grand design for his projected book on Scottish architecture.
He described the house as follows: 'As Pinkie is today, the grey stone and blue slates, with the ornamental features, give it
a strong dour look very characteristic of the country'.
Despite its 'dour' appearance, Pinkie, a villa near Edinburgh, was essential to Weaver's histiography, because it had been
acquired in 1597 by Alexander Seton, Earl of Dunfermline, who had been the key Scottish statesman in 1603 when James VI
of Scotland had attained his life-long ambition to ascend the throne of England.

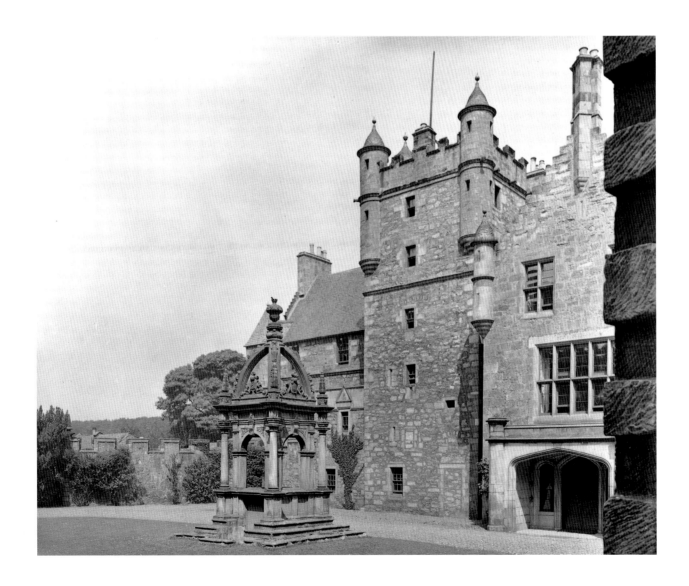

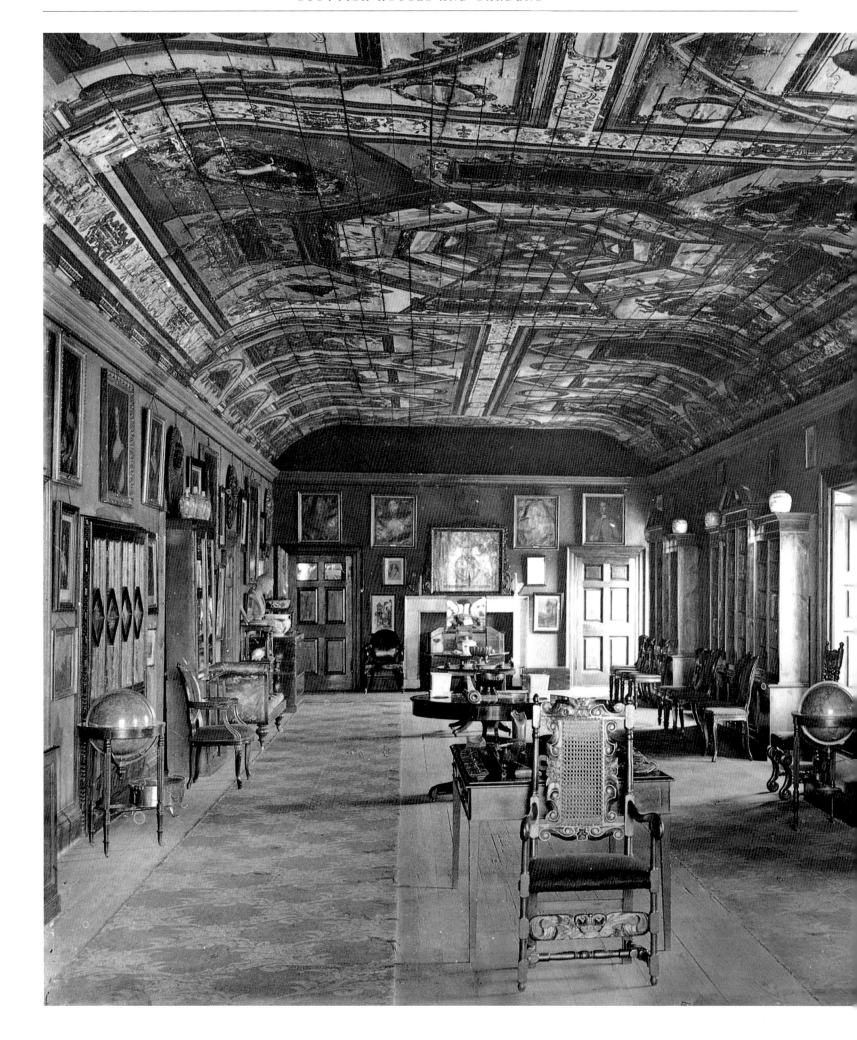

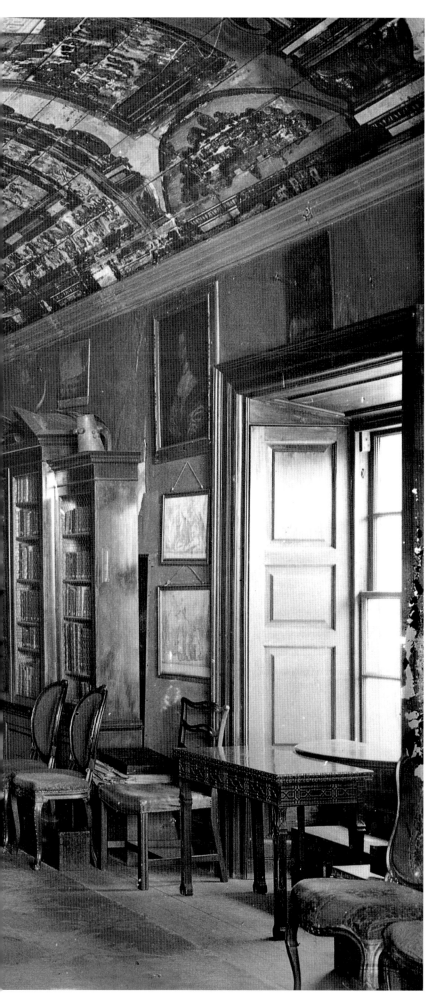

Because Seton's hobby was architecture – in 1912 Weaver also wrote up his extensive activities in rendering Fyvie Castle symmetrical – Pinkie was, perhaps inevitably, seen as the barometer of Seton's enthusiastic adoption of imported ideas, gleaned during his necessary professional exposure to English taste:

Altogether in the great array of noble Scottish houses, Pinkie takes its own distinctive and excellent place. It stands at the parting of the ways between the distinctive early baronial work of Scotland and such works of the high Renaissance as Kinross House, designed by Sir William Bruce, which shows the complete triumph of the Palladian idea in Scotland. It should be said, however, that Scottish architecture pursued its own course of development during the seventeenth century affected singularly little by the importation of such English ideas as Seton worked out at Pinkie.

Weaver fantasized that Seton, with his passion for architecture, would have compared notes on his home improvements with England's Cecil: 'We have seen that Seton was in London in 1604 and a close associate of Cecil. No doubt the two statesmen in their leisure hours did not omit to discuss the art which entertained them both so much. Hatfield House, as we see it today was built in 1606, and Cecil's mind must have already been busy with its scheme'.

The photographic evidence that *Country Life* chose to present appeared persuasive, and a view entitled 'Turrets and Chimneys' demonstrated a dramatic shift on Pinkie's East front from the vertical bias of Scotland's traditional Baronial design to the English Elizabethan horizontal. The argument lost some force in the companion photographs which reveal that Seton had remodelled an existing tower house, whose original style was reinstated with some force in a Neo-Baronial phase initiated by William Burn in 1825. To Weaver, Burn's porch was 'unfortunate' but he conceded that his staircase was 'rather good'.

To earlier Scottish Victorian critics, of an antiquarian bias, Seton's new-fangled innovations, like his well-head with its Mannerist, almost wholly-detached angle columns bearing Seton's beloved obelisks, were seen as evidence of a withdrawal from the Baronial style and looked foreign. Weaver responded: 'It has been suggested that the well-head in the forecourt of Pinkie was done by Italian workmen, and that it shows Italian features. Such an idea, however, may be confidently dismissed. The design is in the direct line of ordinary Jacobean architecture...'

Preceding pages (left): *The charm of the garden's distinctive obelisk sundial was caught by* Country Life's *unknown photographer in 1911.*
(right): *In the magazine's original published photograph of 1911, Seton's classical well-head obscured William Burn's 1825 porch.*

Left: *The Long Gallery has one of the best preserved examples of Scotland's distinctive tempera painted ceilings and had been furnished as a Library by 1911.*

Weaver came unstuck in his discussion of Pinkie's greatest glory, the painted ceiling of the Long Gallery. Although it had counterparts in the prodigy houses of the south, its painted decoration did not: 'The only thing that may well have been done by an Italian is the painting of the Gallery ceiling. This shows a grasp of perspective and a note of bravura in its treatment which does not suggest the Scotsman'. Certainly, the fanciful fictive domes and illusionistic pictures hanging from their nails are rather more ambitious than the small scale geometric diaper patterns of the Earlshall Gallery ceiling, but there seems no reason to doubt their common nationality today. This modern view depends on a much greater familiarity with the genre, as many more examples have been uncovered. Weaver wrote admiringly, 'the painted ceiling of the gallery has been admirably preserved; the colours are still strong, and one loses nothing of the gay arabesque scroll along the middle line, into which every sort of bird and flower has been cunningly woven'.

The Pinkie Gallery ceiling was one of the very rare examples that had remained exposed to view, and the *Country Life* photograph shows that it had been transformed into a grand classical Scottish country house Library along the lines of nearby Newhailes and Arniston, by the addition of fitted pedimented cases.

Pinkie played a part in a later debate about Scottishness versus Englishness because of its proximity to the site of the Battle of Prestonpans. Bonnie Prince Charlie is said to have slept in the King's Room. The Gallery then served as a military hospital for the wounded and, it was alleged in the kind of gruesome detail beloved by early guidebooks, that the once matching painted walls were so disfigured by the wounded that they had to be plain plastered. Pinkie has now found a more peaceful purpose as part of Loretto School.

Above: The plaster ceiling of the King's Room shows how the Scottish tradition of painted ceilings began to be superseded by a new fashion for plasterwork inspired by English models after 1617. Country Life *cropped the Chippendale bed cornice for the published photograph.*

Right: In this dramatic photograph originally entitled, 'Turrets and Chimneys', Weaver's unknown photographer must have been under instructions to emphasize the allegedly 'English' horizontality of Seton's additions to Pinkie.

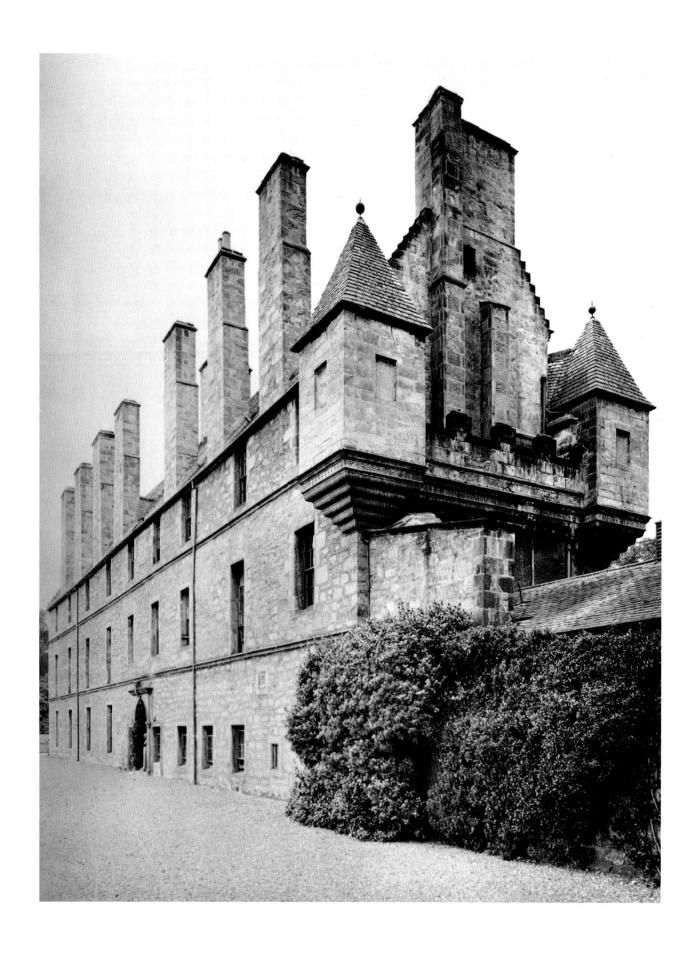

KELLIE CASTLE

FIFE

The 1906 photographs of Kellie were the most poetic views of a Scottish house published by *Country Life* because, just as in a modern magazine shoot, a professional stylist was actively involved – Robert Lorimer, the architect youngest son of the castle. The photographer was almost certainly Frederick Evans. Lorimer's childhood at Kellie was crucial for his later artistic development, as Weaver explained in his 1911 article on Ardkinglas, the largest modern house that Lorimer had designed. Kellie was important to Lorimer's mature style because it blended happily all the external romantic characteristics of Scotch Baronial architecture with a series of flamboyantly decorative Baroque interiors, flooded by sunlight from large sash windows, dating to the third quarter of the seventeenth century in the classical style popularized by the architect Sir William Bruce.

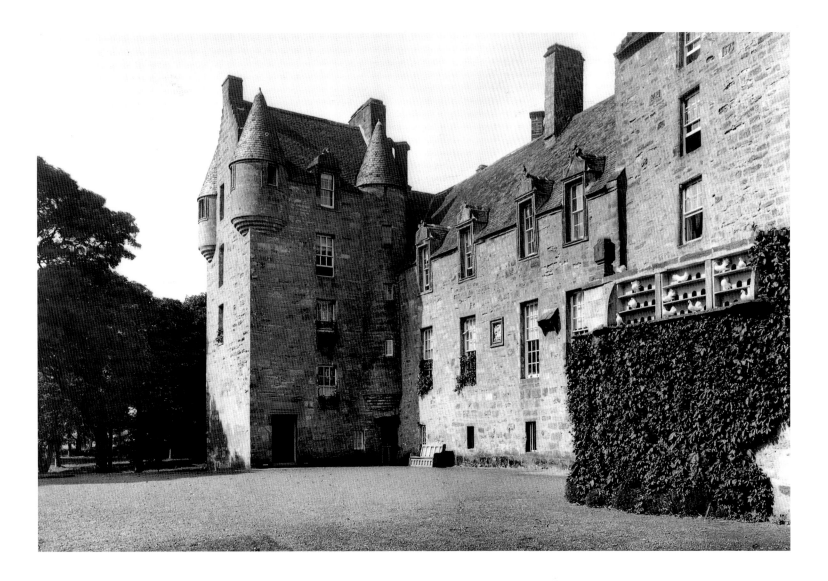

Kellie was a stronghold of the Oliphant family until 1613 when it was purchased by Thomas Erskine, created Earl of Kellie in 1619.

The idyllic quality that the Lorimers developed at Kellie was also a function of the unusual terms on which they held their dream home. Remarkably, three of the children were to become artists: Robert's elder brother, John, was a painter while a sister also showed considerable gifts. Their landlord, the Earl of Mar and Kellie, although sentimentally attached to the castle's important place in his family history, could not afford to allow the ruined castle to become yet another drain on his resources, and he was thus anxious to grant a repairing lease on the most favourable terms his agent could secure. They met their match in Robert's father, a Professor of Law at Edinburgh University, who rewrote the lease to reflect his disadvantageous lack of security of tenure, as Harriet Richardson has shown. The result of this stand-off was an unusually conservative 'restoration' by the standards of 1878. The lack of home comforts was a matter of little importance to the Lorimers because Kellie was their summer holiday house and their permanent home was Brunstfield in Edinburgh. There was always the threat that if Kellie was made too comfortable, it might be coveted by their landlord.

The running repairs were carried out by a local architect, John Currie of Elie. The Lorimers' attitude to Kellie was summed up in the Latin inscription carved over the entrance door, which Weaver translated as 'This dwelling snatched from rooks and owls is dedicated to honest ease in the midst of labours'. Much of the fascination of Kellie derives from the many layers of family taste and talent. The Professor was attracted to the castle's earlier history but was surprisingly tolerant of later interpolations, such as the Adamesque late eighteenth-century chimney-pieces which he described as 'Queen Anne'. It was the Professor who favoured the dark-stained wood floors with rugs in a look he regarded as 'Continental'. Robert designed Arts and Crafts inspired bed-hangings in the late 1880s which were executed by Louise Lorimer and the Postmistress. The Lorimers created an idyllic, old-fashioned garden within the existing walled enclosure. Weaver wrote that:

the restored, reclaimed and beautified garden recalled an "epoch" before grounds had been invented. The day of the magenta-coloured rhododendron – the specimen tree, the monkey puzzle – was not yet.

Preceding pages (left): *Corners of the earliest tower retained a timeless quality that obviously appealed to the photographer Frederick Evans.*
(right): *The south front of Kellie, with fluttering doves, photographed in 1906 by Frederick Evans. The bench at the front door was made by the young Robert Lorimer.*

Right: *An unpublished photograph of the Drawing Room, which had been the Great Dining Room of the late seventeenth-century state apartment decorated in the style of Sir William Bruce. In 1897, Robert and John Lorimer reinstated the late seventeenth-century Baroque panelling. As in all Lorimer's drawing rooms, the panelling was painted white.*

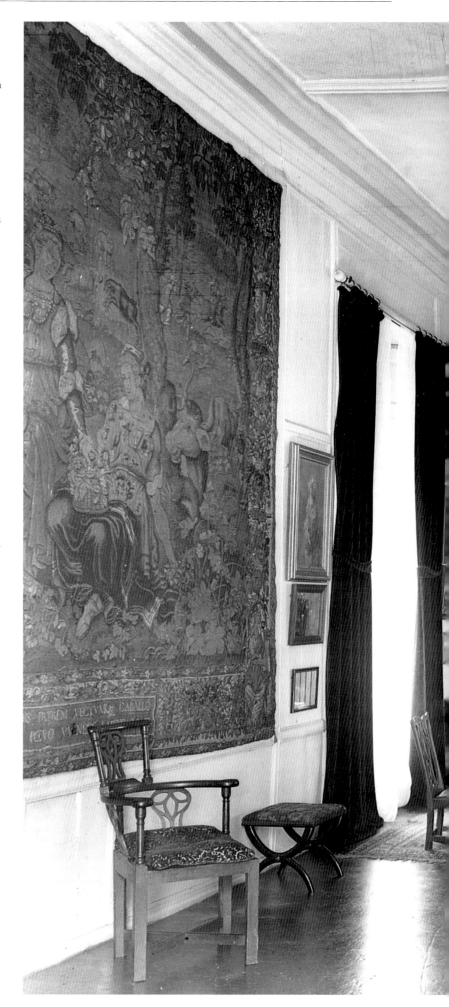

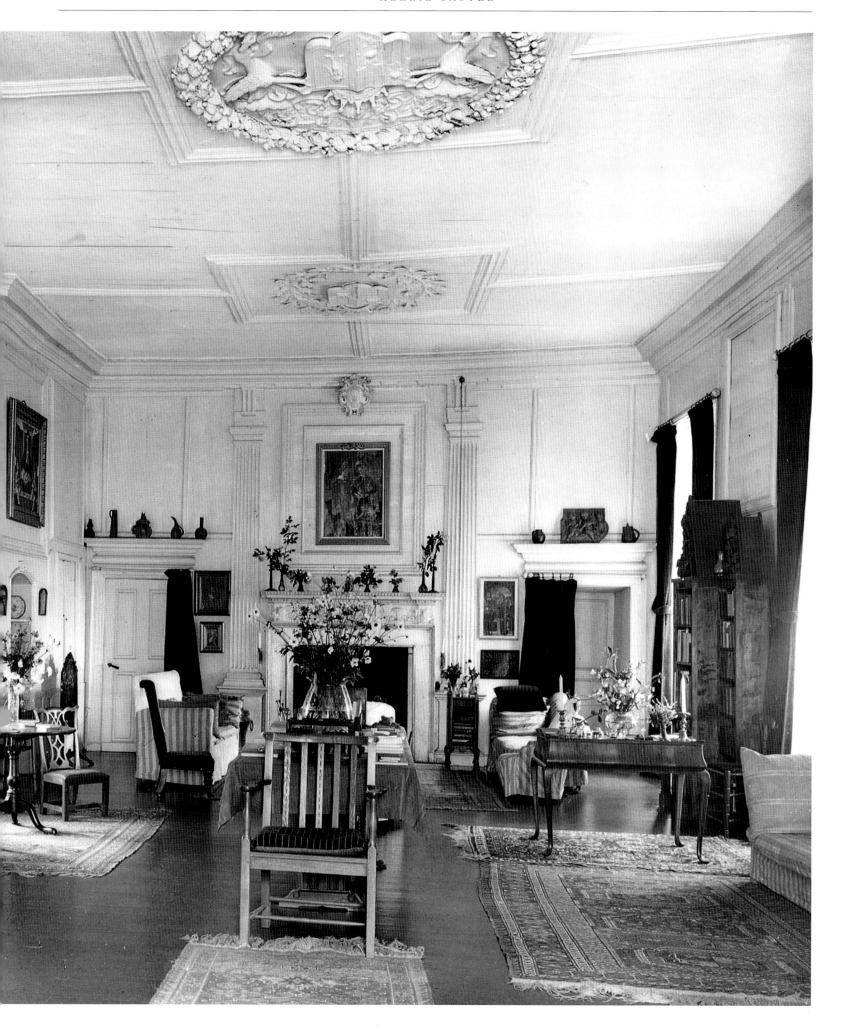

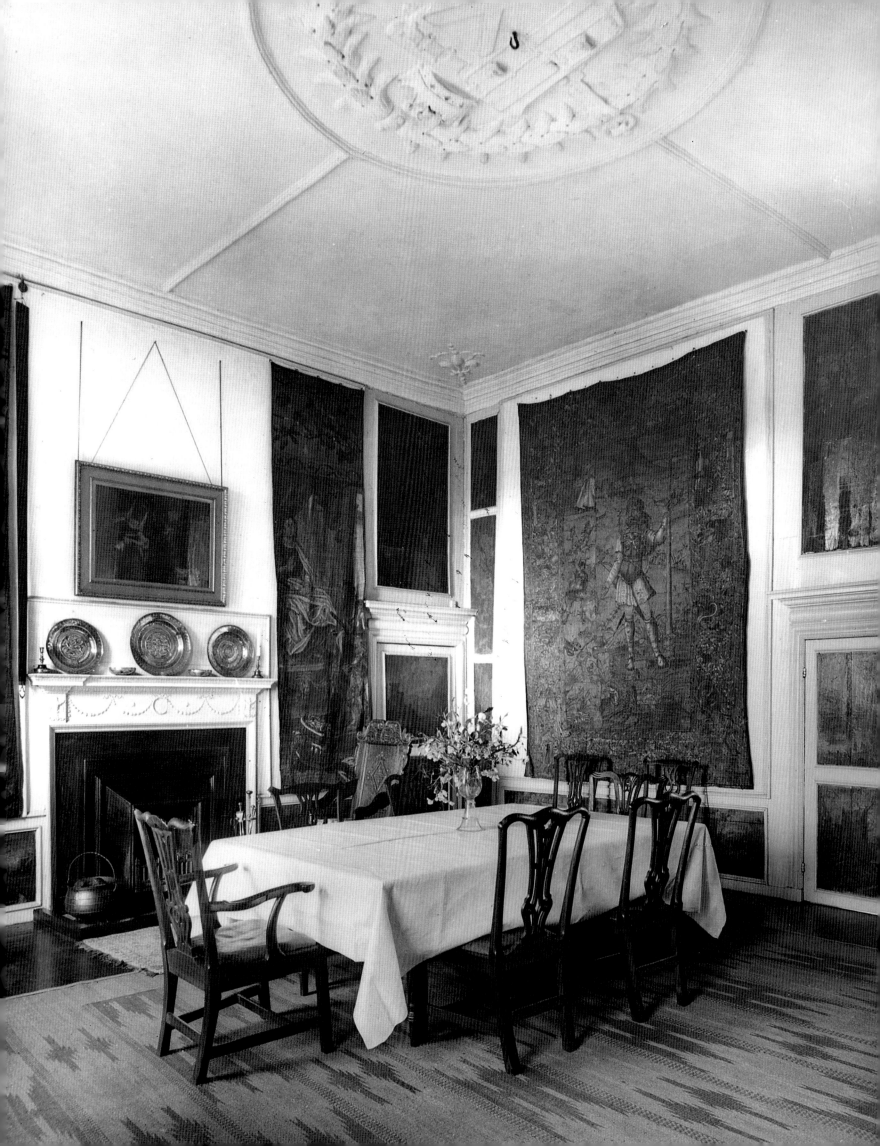

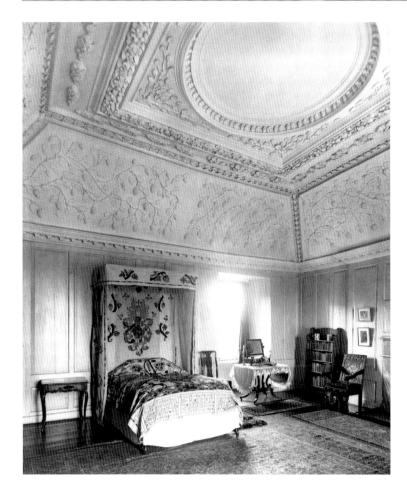

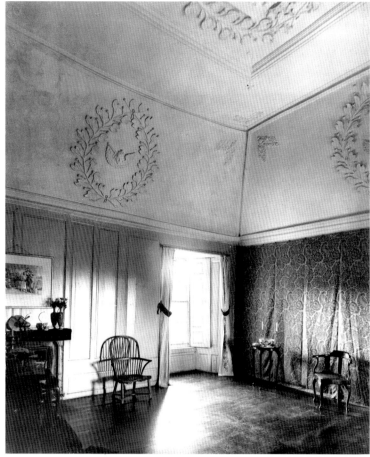

Instead from the light and shadow of the rooms, you step direct into the gaiety and brightness of the garden enclosed, as into an outer chamber – a chamber roofed by heaven – then outside this charmed space – the park – where the rooks are calling in the waving tree tops. The garden under notice is a real Scotch garden with flowers, fruit and vegetables sharing the same domain.

After the Professor's death in 1890, his widow passed most of her time at Kellie and her sons began to dilute their father's antiquarian effects of tapestry and old oak furniture by playing up the Baroque decorations. In 1897 Robert wrote, 'We got sick of that yellow paper pasted over the panelling [in the Great Hall that had become his parents' Drawing Room] so resolved to have it off. Had a man along who tore off the whole thing and disclosed panelling most of it the consistency of buttery oak cakes'. The missing areas of panelling were reinstated by the Wheelers, Lorimer's tame local craftsmen, and painted white, but the new

Above left: The celebrated Vine Room, with its deep cove rising up into the roof-space, has Kellie's finest Baroque plasterwork. Robert Lorimer designed the embroidered Arts and Crafts bedhangings. In 1918 John Lorimer bought back Jacob De Wet's circular ceiling painting from a house in Ireland.

Above right: The Earl's Room. Printing the 1906 negative in its entirety reveals that the furniture was specially rearranged for the photograph, removing Mrs Lorimer's old-fashioned clutter.

Left: The Dining Room with its early eighteenth-century Norie-esque painted panels and harlequin set of modish Chippendale chairs.

cartouche over the chimney-piece was carved by the Clow brothers, who carried out his most important commissions. The Dining Room was the castle's original Withdrawing Room and has classical landscapes painted in its panels in the style now generically associated with the Norie family. The unmatched harlequin set of Chippendale chairs and the strip rag-rugs (a Turkey carpet was the convention in Victorian dining rooms) reflect the up-to-date taste of the younger generation.

The photographs, taken by Frederick Evans, perfectly capture these two aspects of the ancient and the modern at Kellie. It is fascinating to compare the plates in the *Country Life* archive with those which were actually published, as they suggest that Hudson had a preference for the ancient, since the Drawing Room and Dining Room views did not appear in the article. Frederick Evans was by far and away the most gifted of the magazine's freelance photographers and his photographs elevated the documentary recording of architecture into an independent art form. The best account of Evans's exacting approach to photography is set out in Marcus Binney's companion volume in this series: *The Châteaux of France* (1994). Evans's work is infused with a romantic, painterly quality and he was the master of the oblique view, which perfectly caught the sculptural quality of Scotland's castles.

Robert Lorimer's active involvement in the photography for the article on Kellie is revealed when the full plate of the Earl's Room is printed. The simple Windsor chair and a chorus line of cabriole legs have pushed Mrs Lorimer's earlier Aesthetic clutter

to the left-hand side of the room (and was trimmed from the published view).

The overall effect of Kellie, with its almost folk-art idiom and sense of an intrinsically Scottish past, bears comparison with the much more famous holiday house created by the artists Carl and Karin Larsson in Sweden – a comparison that is followed through in the genre scenes set in the rooms of the castle and its gardens by John Lorimer. It was John, a bachelor, who took over the lease of Kellie. Remarkably, in 1918 he was able to buy back the circular ceiling painting by Jacob De Wet that had been removed from the centre of the Vine Room ceiling and installed in a house in Ireland. After John's death in 1937, Sir Robert's sculptor son, Hew, was able to purchase the castle outright in 1948. When Kellie was acquired by the National Trust for Scotland in 1970, it was Hew Lorimer's intention that it should be preserved as a memorial to the taste of his wife and fellow-artist, Mary McLeod Wylie, who had recaptured the visual poetry of the castle in its rooms.

The Lorimers created an old-fashioned garden within the existing walled enclosure. Weaver wrote that, 'the garden under notice is a real Scotch garden, flowers, fruit and vegetables sharing the same domain'.

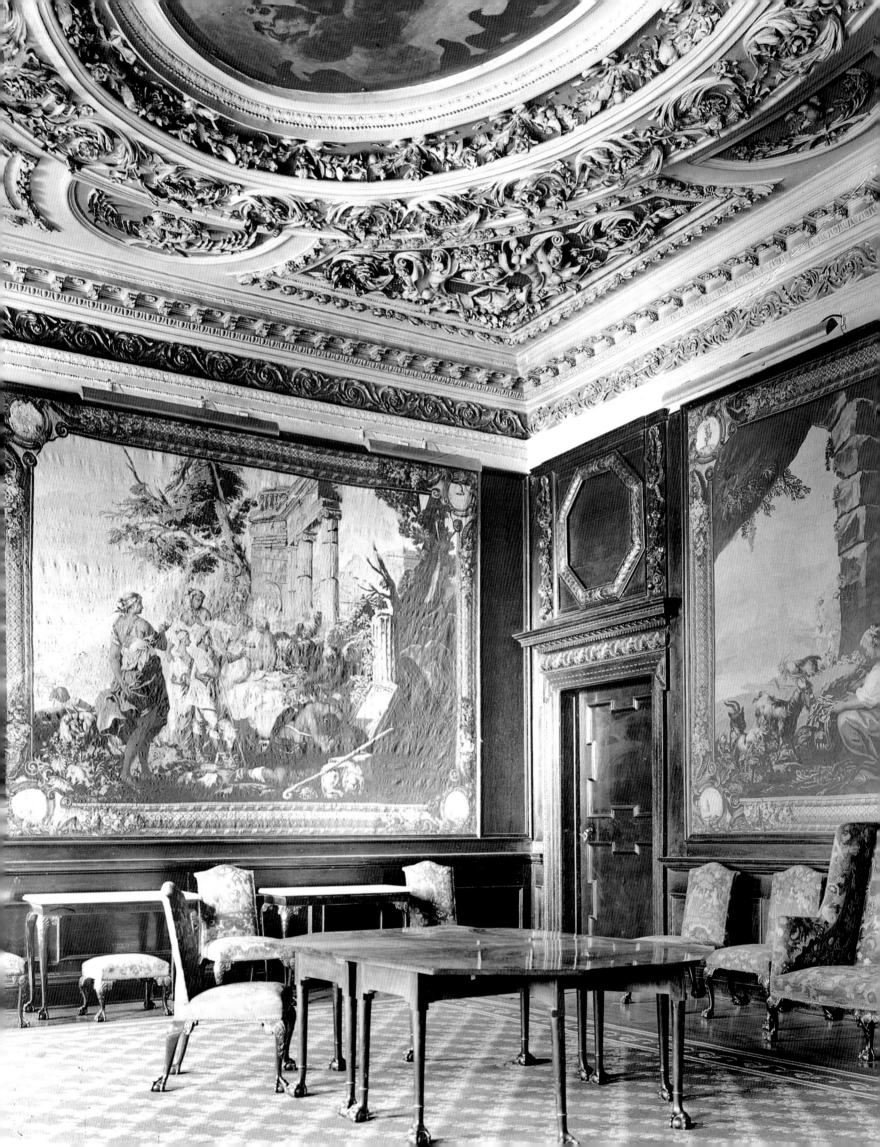

HOLYROODHOUSE

EDINBURGH

Country Life dutifully reported the state visit of King George V and Queen Mary to their ancient Scottish Palace of Holyroodhouse during 1911 in an issue which also recorded their inauguration of Lorimer's new Thistle Chapel at St Giles. The duality of interest at Holyroodhouse was reflected in two articles. The first, by Andrew Lang, dwelt on the 'Greek tragedy' of 'the doomed Stuart line' with particular reference to Mary Queen of Scots. The second, by Lawrence Weaver, homed in on Charles II's sumptuous Baroque state rooms. Inglis's photographs of the Charles II interiors paced out both articles. Weaver's Holyroodhouse article was central to his reassessment of Scottish classicism in general, and the role of Sir William Bruce in particular, but was also seminal to a renewed appreciation of the palace as the key Scottish building of its age.

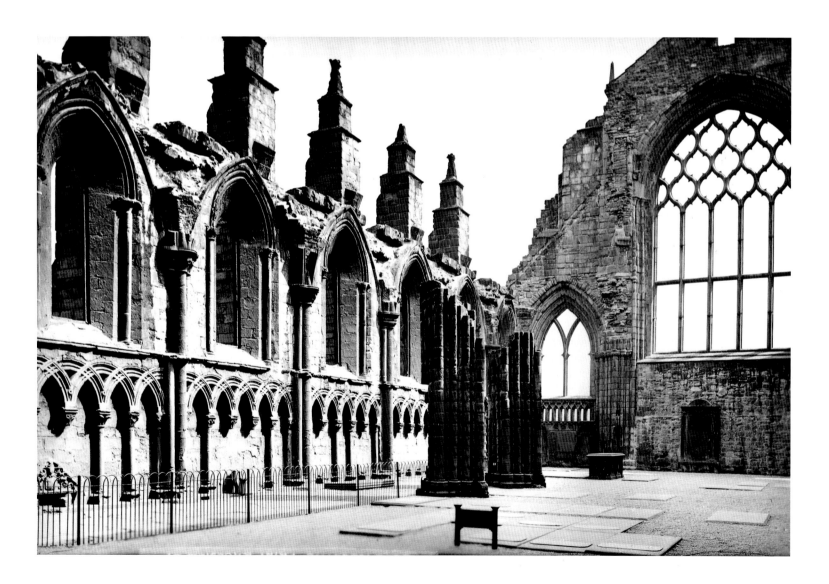

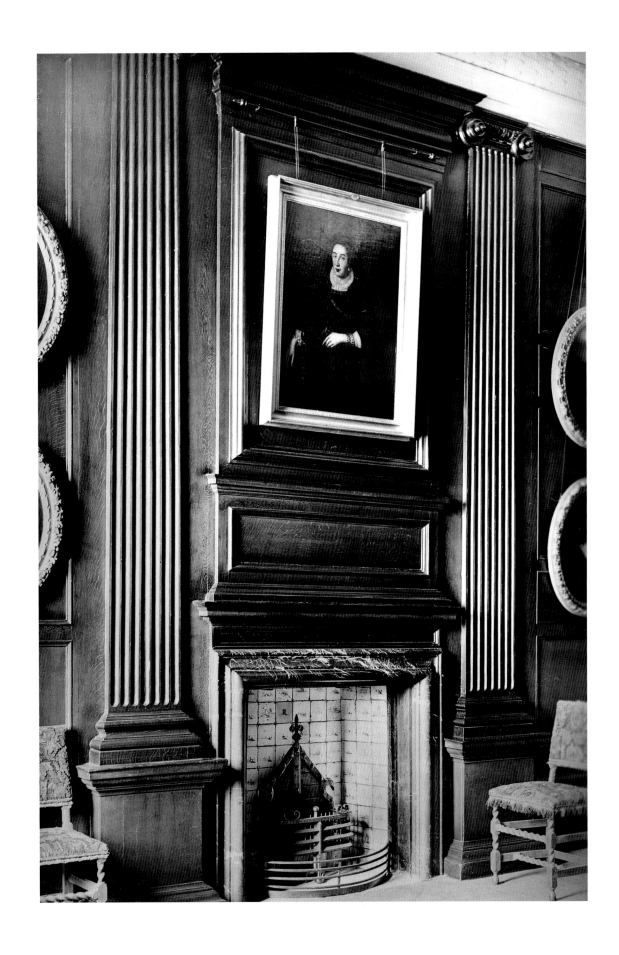

This duality of the palace was a direct result of Charles II's decision in 1671 to rebuild Holyroodhouse so that it would demonstrate the antiquity of the restored Stuart dynasty in the new expressive language of the Baroque. James V's tower with the old Royal Apartments of 1528-32 was duplicated by Bruce, and the two towers were connected by a magnificent suite of modern state rooms, whose severe classicism was tempered by deeply-enriched oak carving and plaster ceilings which were intended to be completed by a programme of decorative painting. The state apartment interiors set a new standard for Scotland and probably reflect the taste of the Duke of Lauderdale, who had a personal interest in the improvements at the palace because the King had commanded that the no less lofty second floor should be fitted up to provide accommodation for the great officers of state. Just as the new-fangled plasterwork installed for the homecoming of James VI and I at Edinburgh Castle in 1617 was immediately copied in Scottish castles, such as Glamis and Craigievar, the King's Apartment at Holyroodhouse set the standard for the panelling at Hamilton Palace and Melville.

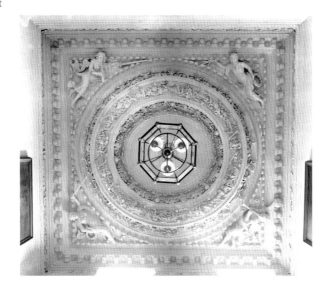

Because James V's Tower had been carefully preserved by Charles II, during the late eighteenth century a new focus of romantic interest shifted from the Baroque palace, which began to be characterized as 'heavy', to Mary Queen of Scots' Apartments high up on its second floor, and they became the centre of Scotland's new tourist trade. Visitors were encouraged to believe that the discarded Baroque furnishings of the Hereditary Keeper, the Dukes of Hamilton, were the same that had witnessed the brutal murder of David Rizzio in 1566 in front of the Queen. Their Picturesque state of advanced decay made this more credible.

Weaver's shift of attention back to the Baroque palace and his reassessment of its importance depended on a careful reading of recently published documentation. The traditional division of responsibility between the practical Robert Mylne, the King's Master Mason, and Sir William Bruce, the King's Surveyor of

Preceding page (left): *The King's Bedchamber has sumptuously undercut plasterwork by Houlbert and Dunsterfield, framing an illusionistic ceiling painting by De Wet and matching woodwork by Alexander Eizat and Jan van Santvoort.*

Left: *The existing rooms in Queen Mary's Apartments were repanelled by Bruce to reflect his austerely classical taste. The Turkey-work chairs are survivors of a set supplied for the use of the Duke of Lauderdale in 1668.*

Above: *High above the Great Staircase is Houlbert and Dunsterfield's richly-modelled ceiling, with its concentric tiers of garlands of flowers suspended from plaster ribbons, and life-size figures brandishing trumpets and the crown and sceptre of Scotland.*

Royal Works and a gentleman-amateur, had been unbalanced by the publication in 1893 of a substantial work of Mylne family hagiography, which had overstated Mylne's contribution considerably. But at the time of writing Weaver had already seen Kinross House, whose photographs were promised as forthcoming in the Holyroodhouse article, and had no doubts as to Bruce's abilities; he reminded readers that Wren had also begun his architectural career as an amateur. Bruce's rooms were firmly grounded in classical architectural orders, and the more important chimney-pieces were framed with pilasters supporting cornices corresponding correctly to the order of the pilasters.

Although both George IV and Queen Victoria had commanded that the Queen's rooms must be preserved 'sacred from any alteration', Edward VII unwisely granted permission for moderate improvements, resulting through a series of modest but irreversible steps in the complete destruction of the rooms' patina of ages. *Country Life*'s view of the newly restored chairs encircling the bed give a foretaste of its impending massacre.

The magazine's unromantic photographs of Mary Queen of Scots' Apartments reflect the intervention of Sir Herbert Maxwell. Real problems had begun to develop in Mary Queen of Scots' Apartments when a more advanced and wide-spread knowledge of furniture history demonstrated that the bed could not possibly have been slept in by Mary Queen of Scots, as stylistically it dated from the seventeenth century. Sir Herbert, assisted by the School of Needlework at South Kensington and Whytock and Reid, began to repair the bed's associated furnishings, and, as the *Country Life* photograph shows, their new spruceness only had the effect of making the bed's pleasing decay all the more forlorn. Sir Herbert did, however, manage to dissuade the bed's custodian from reverently cleaning it each morning with a stiff bristle brush. The fact that the bed was down to its linings and not a scrap of silk was said to survive was also a testament to the persistence of souvenir hunters, who included Isabella Stewart Gardner. One of the smallest items on display amid the Venetian Gothic of Fenway Court in Boston is a small tortoiseshell box with a fragment of the fringe from Mary Queen of Scots' Bed, although how Mrs Gardner acquired it is not revealed.

It was only in the late 1970s during a research programme initiated by Iain McIvor that the original purposes of the rooms began to be understood. William Bruce's intentions had been long forgotten and their purposes overlaid by their occupation, after 1850, by Queen Victoria and Prince Albert. They had to endure

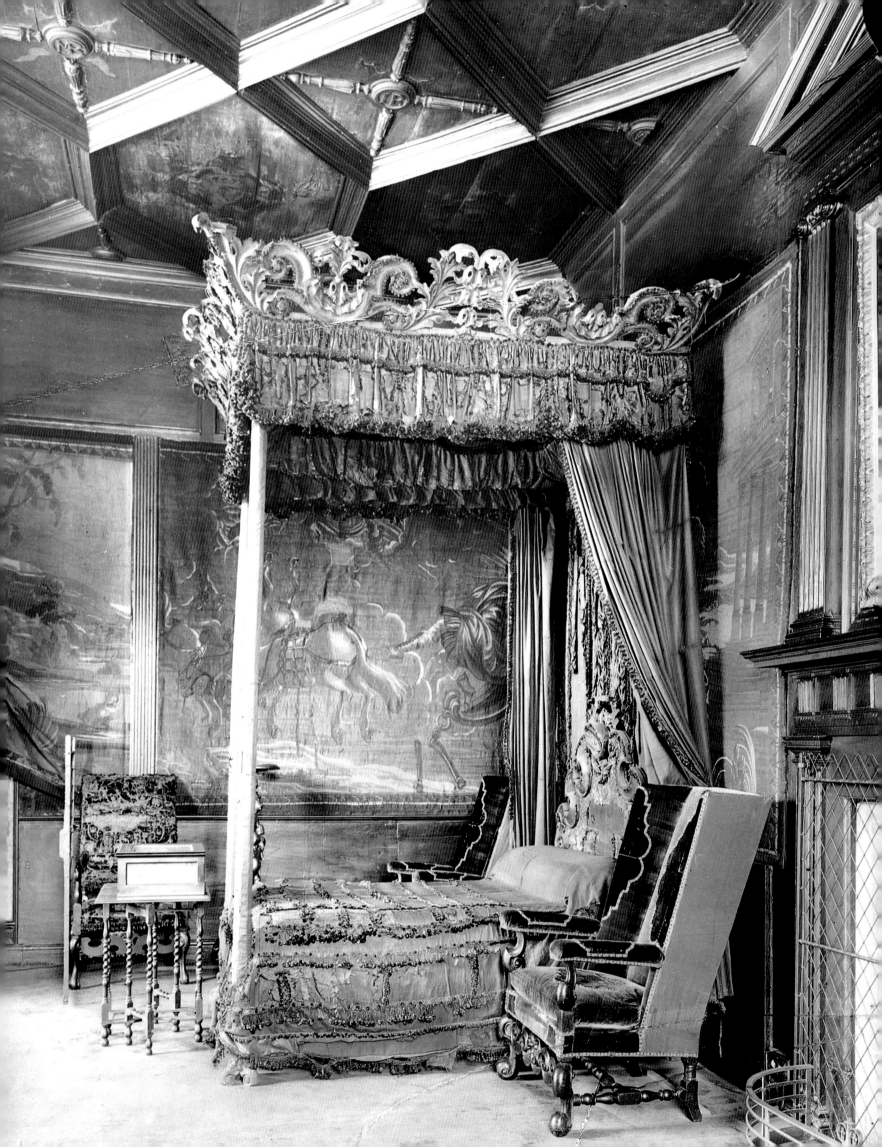

the Baroque discomfort of Charles II's Royal Apartments until the Queen was able to dislodge the many grace-and-favour tenants who overran the palace. The Queen's return to the palace had led to a campaign of decoration in an antiquarian spirit with imported sets of tapestries, and reparation of the existing furnishings, inspired as much by parsimony as sentiment. Research into the palace tapestries by Margaret Swain revealed that the Baroque furnishings of Mary Queen of Scots' Apartments had been supplied for the Duke and Duchess of Hamilton, after the Bruce rebuilding, when they occupied this area of the palace in their capacity as Hereditary Keepers.

Some lingering Victorianisms in the form of grates and the suites of Continental Exhibition furniture that had been despatched to the palace were captured by *Country Life*'s camera. D.R. Hay's richly chromatic decoration on Houlbert and Dunsterfield's sumptuous ceilings, carried out in 1850, was touched-out, where it was deemed too obtrusive by the magazine. *Country Life* did not illustrate Queen Victoria and the Prince Consort's Throne Room of 1856, with its heraldic crested and oak-grained ceiling and its

flock wallpaper, although it was arguably Scotland's premier room. It was a measure of Weaver's achievement in re-establishing the reputation of Sir William Bruce that by 1930 it had been swept away in favour of a late-Stuart refit.

Charles II was never to see the Scottish palace that he had so carefully planned; George IV was the first of his successors to pay a state visit to Scotland. Although Holyroodhouse was temporarily fitted up for Receptions, the ancient palace was deemed too uncomfortable for such a sybaritic monarch, and the King resided during his visit at Dalkeith Palace. These arrangements were repeated for Queen Victoria in 1842. The renaissance in the palace's fortunes was a result of the Queen's acquisition of the lease of Balmoral in 1848, when Holyroodhouse was identified as a strategic overnight stop to break the long journey both north and south. Since this use of her palace was viewed by the Treasury as a matter of the Queen's personal convenience, little money was spent; the eventual condition of the drains precluded residence by Edward VII. King George V and Queen Mary's state visit was to be the beginning of a happier phase in the palace's fortunes.

Right: *The most elaborate Baroque panelling in the Palace had been reserved for Charles II's Bedchamber. In 1850 the panelling had been chemically stripped of its eighteenth-century white paint, turning it a rich black, and was high-varnished. Bruce's original two-panelled Baroque doors were replaced by six-panel Palladian ones c.1740.*

Left: *Mary Queen of Scots' Bed was the most precious relic in the Palace and had been encouraged to fall into romantic decay by successive sovereigns.* Country Life's *1911 view shows the newly spruced up chairs.*

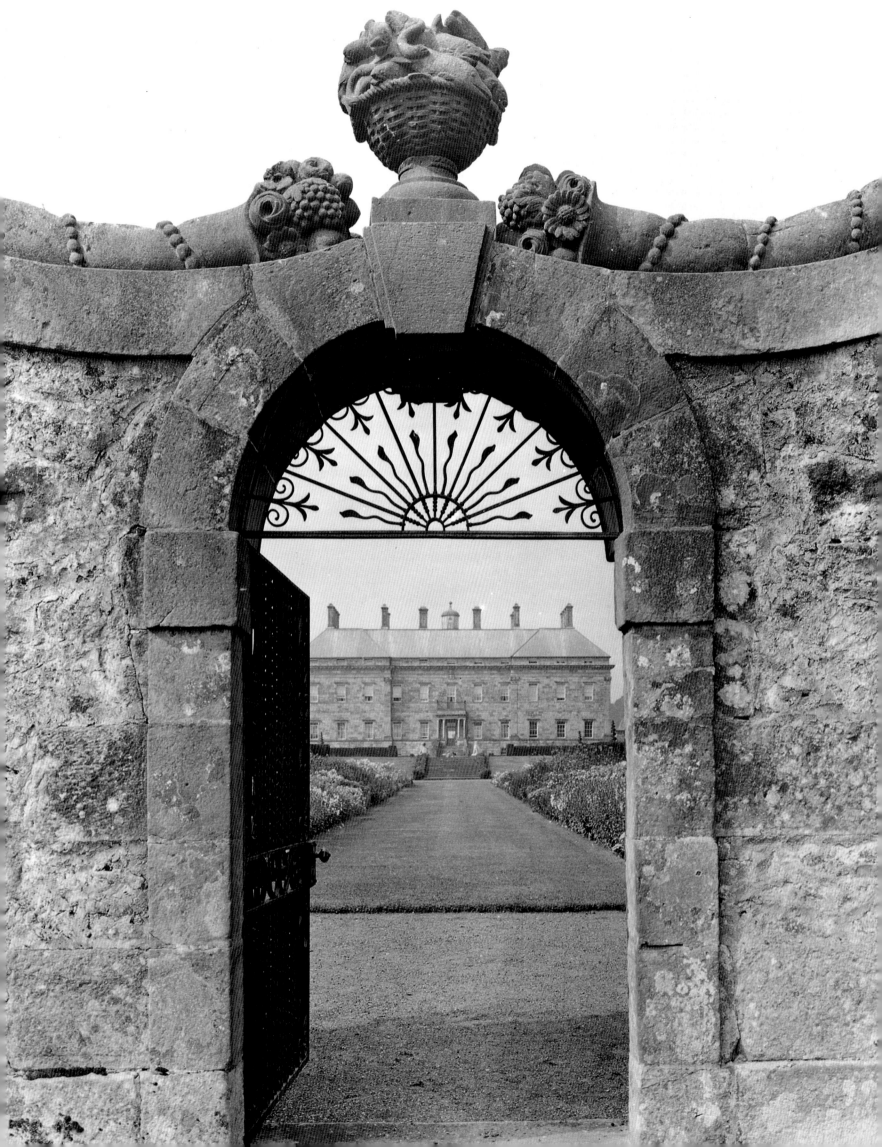

KINROSS HOUSE

KINROSS-SHIRE

Kinross is Scotland's noblest classical country house. From the moment one enters the domain from the town and glimpses the house on an axis at the end of the long avenue, there is a strong sense of being in the presence of a great work of art. This unity of conception arose because Sir William Bruce united the roles of patron and architect. Kinross was designed both for his own occupation and as the seat of the dynasty that this Carolean courtier-politician hoped to found. Bruce had gained experience in building for himself at Balcaskie in Fife, which he had purchased in 1665, and he had already begun to build up land in Kinross-shire during the 1670s, long before Balcaskie was sold in 1684. He owned both old Lochleven Castle, on an island in the adjacent Loch, as well as a 'new' house on the shore, but Bruce's ambition and striving for a harmonious overall effect is demonstrated by his decision to build afresh on a new site,

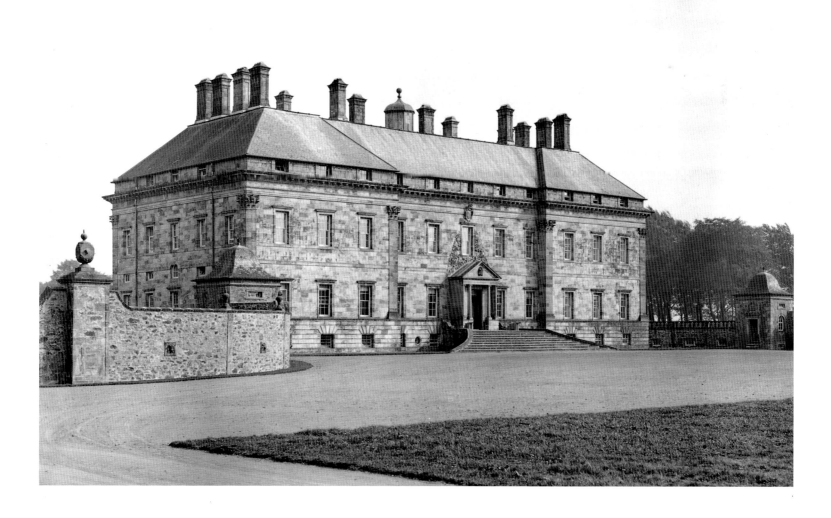

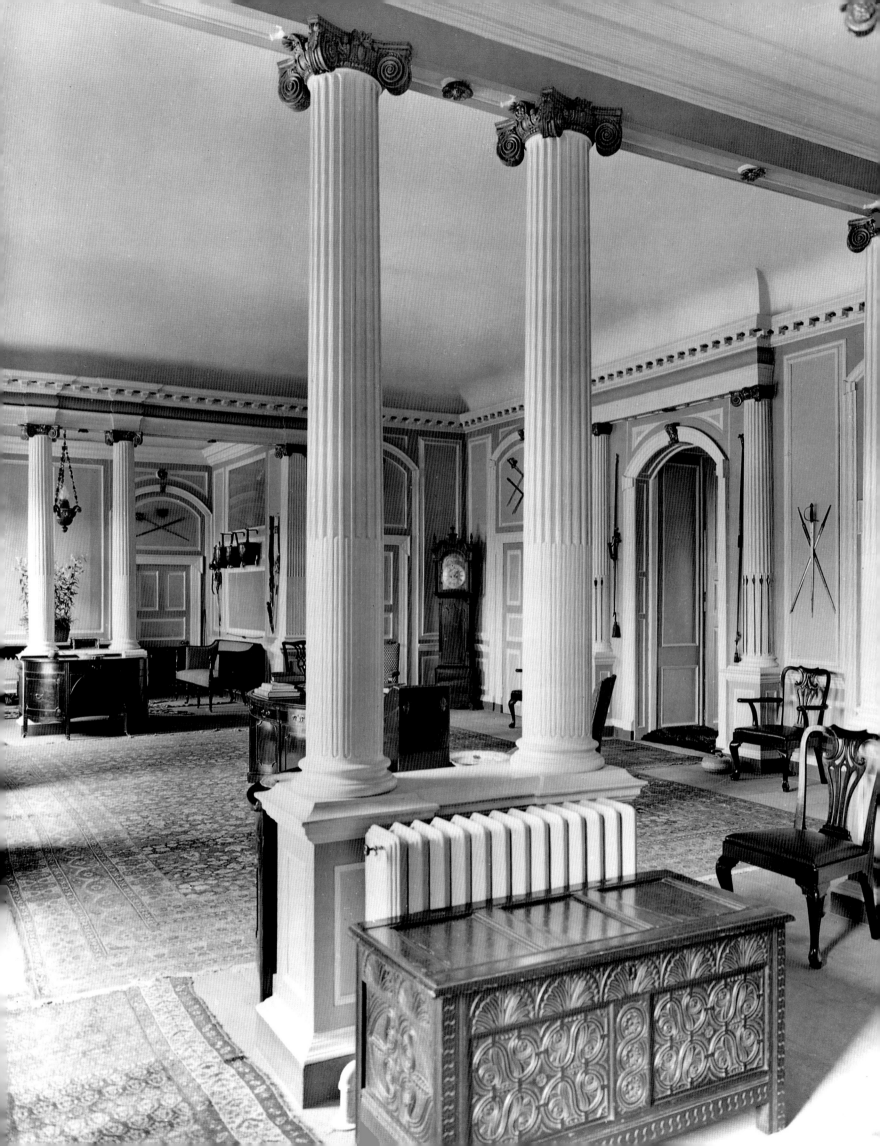

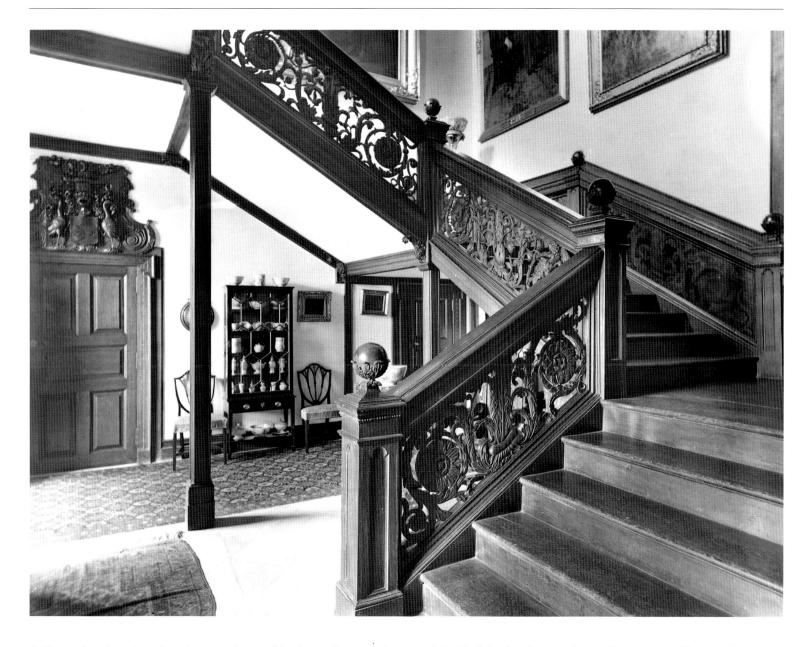

deliberately selected so that the central axis of both new house and surrounding gardens had a dynamic focus on the ancient castle.

Because of a long tradition of sound building in intractable stone, it is very rare and conspicuously extravagant in Scotland to abandon rather than remodel an existing house. Bruce took up residence in the existing 'new' house in 1679 and created the setting first. His ambitions for the new gardens with their parterres, terraces and orchards are set out in a remarkable contemporary plan. Although his design for the house owes something to contemporary English models, Bruce characteristically produced an ingeniously integrated plan in which the exterior is firmly controlled by his choice of the Corinthian order whose pilasters

tightly bind the façades together under an oversailing cornice. The walls of the basement storey were begun in 1686 and the house was roofed and slated during 1690-91, with the fitting up of the interior continuing the following year. Accounts from Alexander Brand, of Edinburgh, show that he supplied gilded leather hangings for the family rooms on the ground floor, which have not survived but must have been like those photographed at Melville in 1911. The Low Dining Room was hung with 'black and gold' leather and the Drawing Room in 'gold leather pearl ground', while the 'Little Tobacco roume' had 'blue gilded leather'.

The quality of the house was the result of Bruce's employment of some of the finest craftsmen of the period, including the mason Tobias Bauchop of Alloa. As Weaver wrote, 'Bruce was very well served by the craftsmen he employed'. Bruce's political reverses and financial difficulties ensured that the Great Apartment on the first floor was never completed and Bruce made his house over to his son and retreated back to the 'new' house. In 1777 Bruce's descendant sold the estate to George Graham, who had made his fortune in India.

Preceding page (left): *View of the garden front, glimpsed through the Fish Gate with its carved stone basket of newly caught fish.*

Left: *This photograph of Bruce's panelled Entrance Hall, with its screens of Ionic columns, captures the spatial complexity of one of Bruce's most architectural interiors.*

Above: *The Great Staircase which leads to the first floor state apartments.*

The photogenic perfection of Kinross in Weaver's 1912 articles, which re-established Bruce's architectural reputation, were the result of the recent restoration of the house and recreation of its surrounding gardens, after eighty years abandonment, occasioned by Helen Graham's marriage to Sir James Montgomery Bt., and the family's move to his Peebleshire estates at Stobo Castle.

In its abandoned state before 1902, with no resident owner to upset, Kinross had been the perfect subject for sketching parties of students from the Edinburgh School of Applied Art. A surviving set of photographs taken by one of the students, James Gillespie, now in the National Monument Record of Scotland, shows the students at work with drawing boards propped up on deck-chairs. Before he returned to live in the house, Sir Basil Montgomery allowed the Kinross-shire Volunteers, of which he was Honourable Lieutenant Colonel, to use the house as the officers' mess. The photographs show a strongly worded notice to ensure that Bruce's panelling was carefully looked after. They also reveal marbling on the columns of the door leading to the upstairs Great Dining Room, and Gillespie's finished drawing of 1901 shows that the Hall was painted in two tones of blue with gold enrichments.

In 1902, however, Sir Basil Graham-Montgomery resolved to return to Kinross, and he employed the architect Dr Thomas Ross, of MacGibbon and Ross fame, to affect a scholarly restoration of the original house, although the absence of so many later owners of the house meant that the integrity of Bruce's planning had never been compromised. This made Kinross an ideal subject for *Country Life*. It was characteristic of Weaver, a passionate enthusiast of Mary Queen of Scots, that almost the whole of the first of two articles he wrote on Kinross was devoted to a dramatic account of her imprisonment in Lochleven Castle; the romantic cult of the Queen imparted a new poignancy to Bruce's garden design.

During his restoration, Thomas Ross was assisted by Fred MacGibbon, the son of his late partner, who had died in 1902. Professor David Walker, the biographer of MacGibbon and Ross, has described their restoration as 'so supremely tactful that one is scarcely aware of it'. Bruce's surviving interiors, such as the remarkable Entrance Hall with its Ionic screens supporting pulvinated friezes, characteristic of his exacting classicism, were treated reverently by them. A larger Dining Room was created by carefully enlarging two smaller rooms and reinstating the panelling. The first floor 'Ballroom', Bruce's former Great Dining Room, is a further illustration of the attention with which MacGibbon and Ross worked. Bruce had been unable to complete the state rooms, but the pair adapted his Holyroodhouse-like ceiling over the Staircase, with its acanthus corner pieces, by repeating it in simplified form three times down the length of the room. The newly refitted room became a gallery for the Montgomerys' fine collection of portraits. Carefully chosen period furniture completed this meticulous restoration.

Weaver's article included the published plans from William Adam's *Vitruvius Scoticus*, allowing readers to grasp the three-dimensional ingenuity of Bruce's planning, with its additional mezzanine floor on the side façades and the Ballroom cove penetrating up into the roof-space in ways which were to be widely imitated in such later Scottish classical country houses as James Smith's Yester and William Adam's Duff House.

Sadly, Sir Basil Montgomery and Dr Thomas Ross did not have the benefit of Bruce's contemporary garden survey, now known to have been drawn by Alexander Edward, when it came to the restoration of the gardens, which are imbued with a far from unwelcome Edwardian spirit, perfectly captured by *Country Life*'s unknown photographer in 1912.

Right: *Sir William Bruce was unable to complete the state rooms, including the Great Dining Room on the first floor. In 1902 it was fitted up as a Ballroom by Dr Thomas Ross, with Raeburn's full-length portrait of Lady Montgomery in place of honour.*

Overleaf: *Bruce designed the walled gardens during the 1680s, with their dynamic axial focus on the island castle of Loch Leven, as a setting for his new house. In 1902 both the house and gardens were restored, with modern herbaceous borders.*

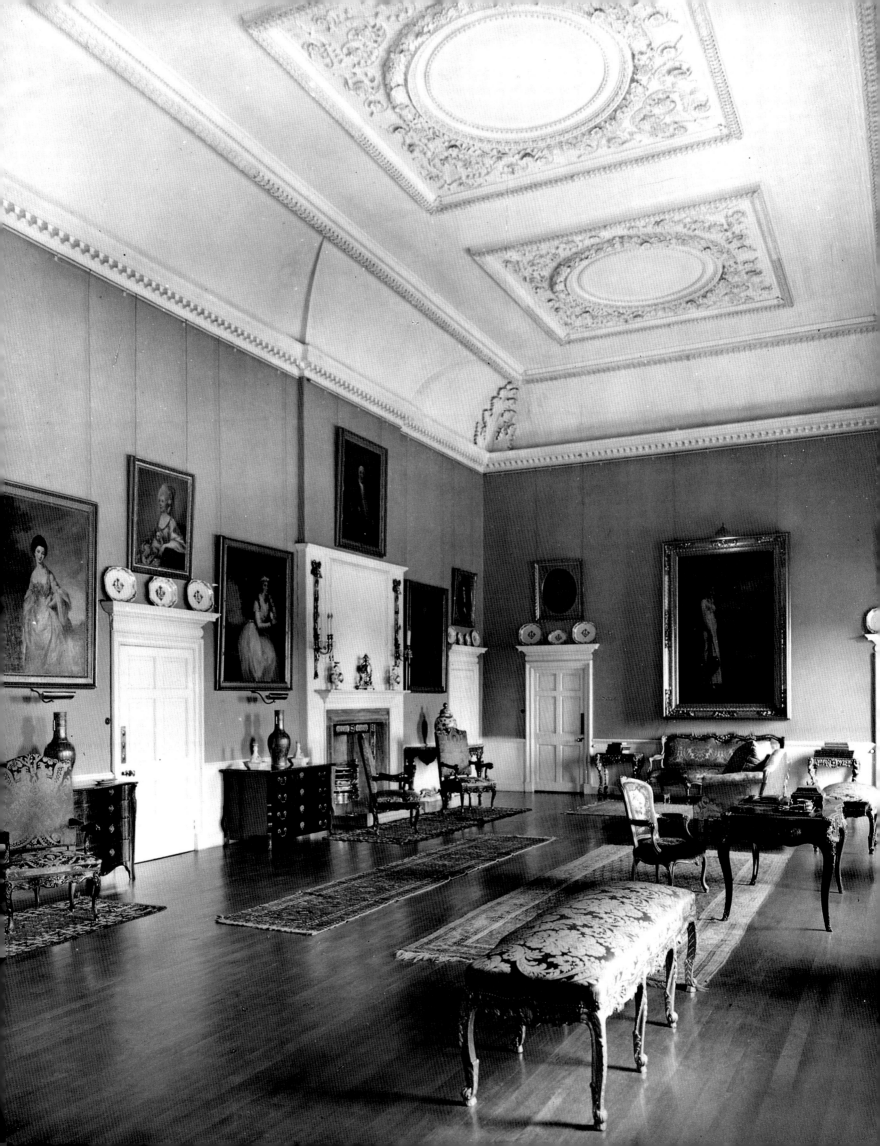

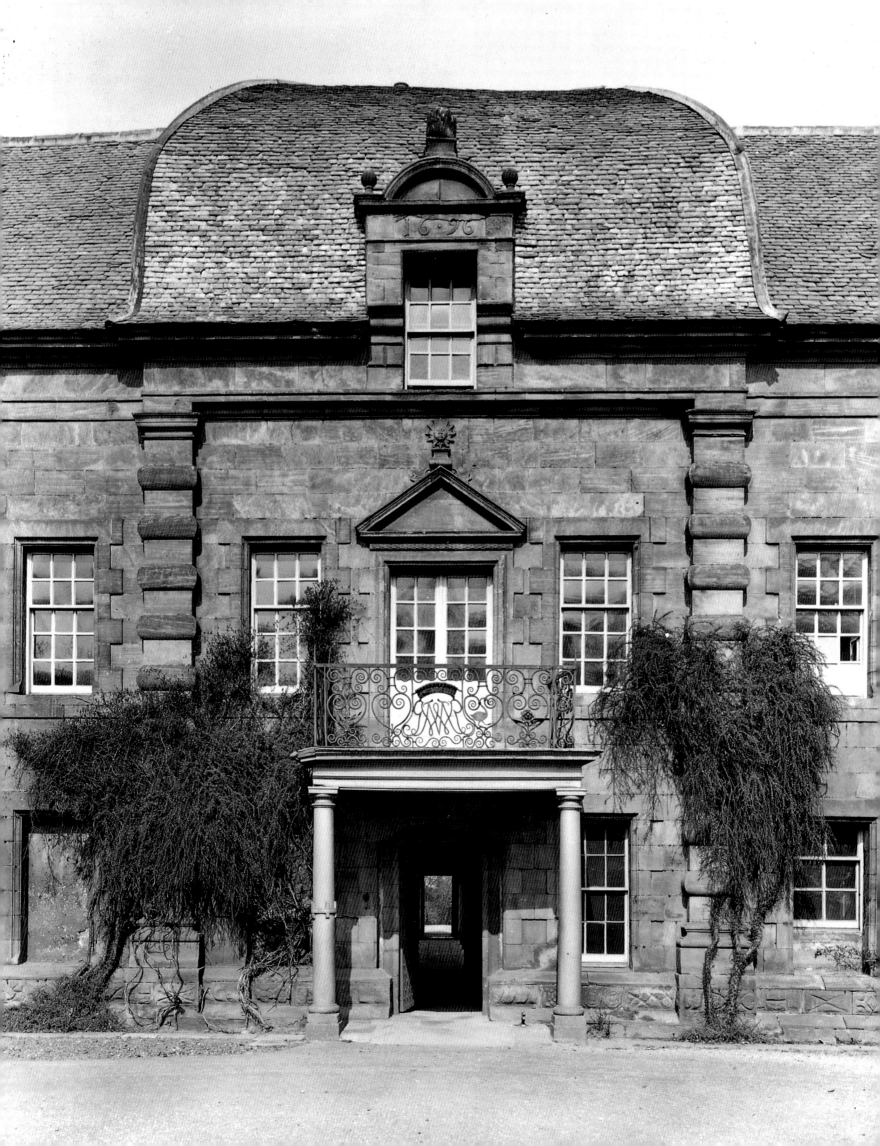

CAROLINE PARK

MIDLOTHIAN

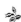

Caroline Park deserves its place in this anthology of *Country Life*'s Scottish Houses not only for its intrinsic merits, but also as
a memorial to Sir Lawrence Weaver's delight in Scotland's architecture. When he wrote the house up for the magazine in 1911 it was the
quintessence of romantic melancholy. In the late seventeenth century, it was the glamorous seaside pleasure villa of Sir George Mackenzie,
created Viscount Tarbat by James VII. By the end of the nineteenth century, however, the house's attractions had been dramatically
diminished by the adjacent growth of Edinburgh's Gas Works. Yet, such was its spell that it still had friends and admirers.
Fortunately, Caroline Park passed into the estate stewardship of the Dukes of Buccleuch through the marriage of the daughter of
the Duke of Argyll (who purchased the house in 1739) to the Earl of Dalkeith.

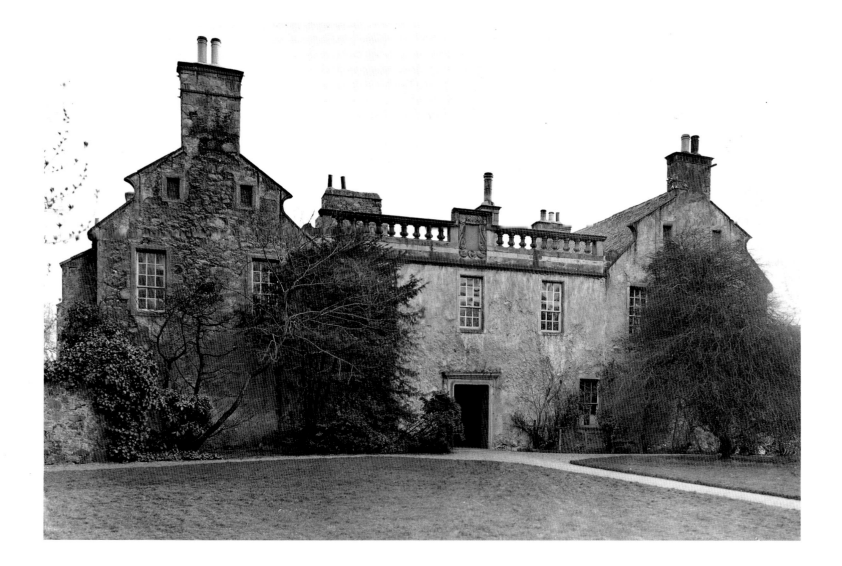

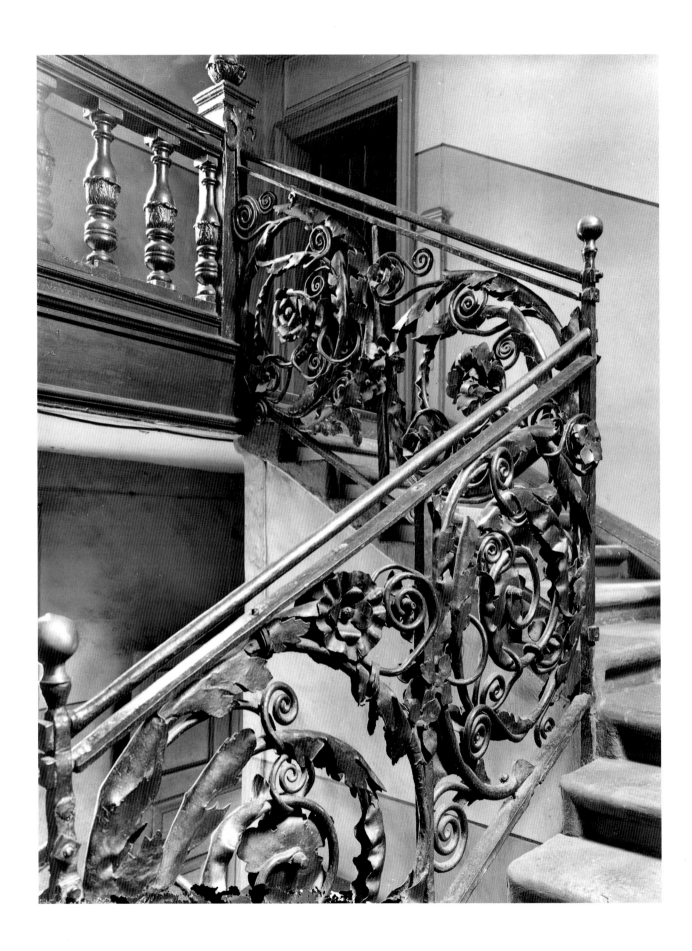

Viscount Tarbat's villa was known as Royston, but the Duke of Argyll renamed it after his daughter, the Countess of Dalkeith.

The Dukes of Buccleuch, who had no shortage of houses, were already lodged in princely splendour at Dalkeith Palace just to the south of Edinburgh, and Caroline Park was let to a succession of tenants. The Gas Works thrived at the expense of the Baroque villa, and the Dukes soon had to look to commercial tenants, which made Caroline Park one of the first country houses converted to office use to be photographed by *Country Life*.

The Duke was fortunate in his tenant, Messrs A.B. Fleming and Company, manufacturers of printing inks, who in Weaver's words 'took great pride in it and kept it in fine order'; the firm loved

the house so much that it produced a privately published illustrated account of its offices in 1896. Weaver drew heavily on this for the history of the house and acknowledged its author, Dr David Fraser Harris, as 'a reservoir of facts' in his article for *Country Life*. The book proudly illustrated Viscount Tarbat's elaborately plastered and frescoed state rooms filled with Fleming and Company's clerk's desks, high stools and filing cabinets; the *Country Life* photographs, on the other hand, focused firmly on the ceilings.

For Weaver part of the fun of his article lay in trying to work out how the house might have worked domestically, but this was a very minor facet of his attraction to Caroline Park whose beauty and strangeness simply bowled him over. The house possesses 'the most attractive roofs' he knew of in Scotland, and its 'rich fat curves make it particularly fresh to English eyes' since they were made up of 'little purple slates laid in great curved lines of singular beauty, and give a sense of having absorbed centuries of sunshine'. But this was just part of its appeal and Weaver felt that the south front as a whole 'had an extraordinary vitality and robustness' with its unusual rustication. Within there were wrought-iron staircases in a distinctively Scottish idiom 'of quite extraordinary beauty' and

Preceding pages: Much of the naive charm of Caroline Park lies in the unexpected contrast between the severe north front, dated 1685, which faces the sea (right) and the much more ambitious Baroque splendour of the new garden front of 1696 (left).

The interior delights of Caroline Park embrace some of the liveliest of Scotland's distinctive wrought-iron work (left), Baroque plasterwork and Norie's later landscape panels. The photographer must have been under instruction to avoid Fleming's office furniture (above).

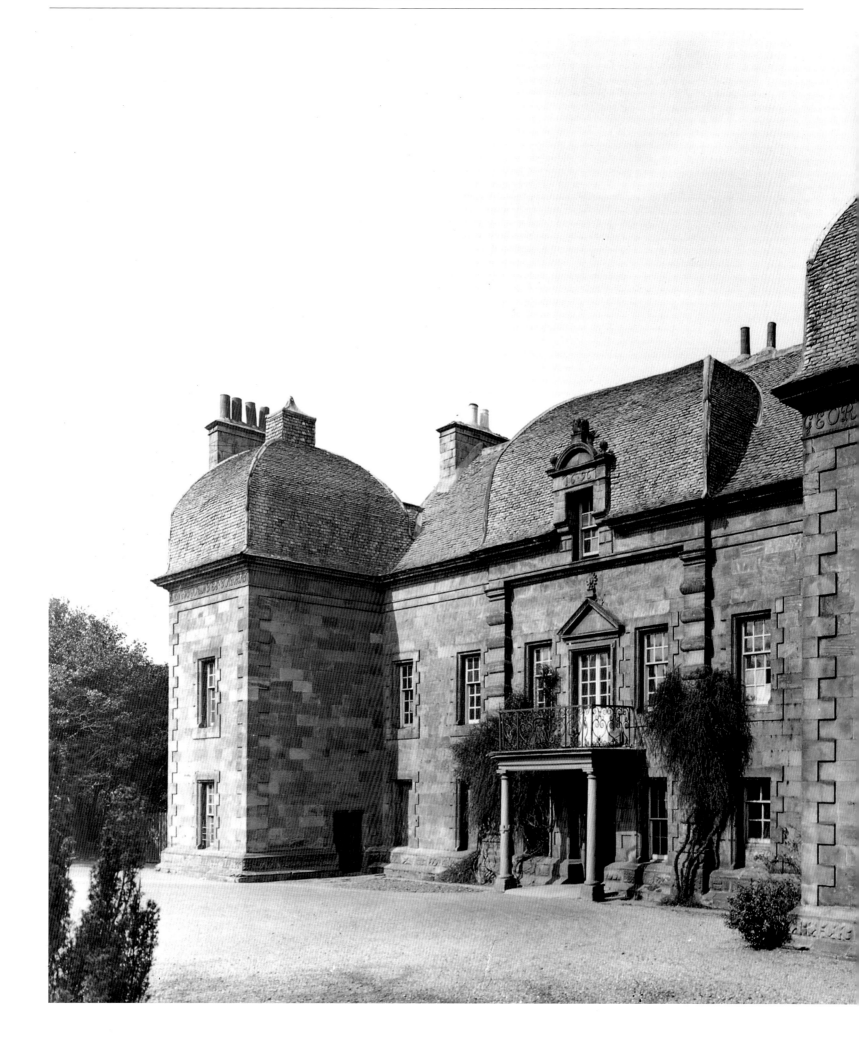

rooms 'with richly modelled ceilings with plasterwork of singular excellence', which framed illusionistic ceiling paintings, one of which, depicting Aurora, was signed 'N HEVDE, Inventor'. In addition, there were many examples of decorative painting by the school of the Norie family. Weaver, characteristically, gave short shrift to notions that the ironwork and plasterwork were by Germans and Italians, believing their vigorous quality betrayed the work of local hands.

In spite of much recent research in the family papers by John Gifford, the house retains its mystery, at least in as far as the identification of its architect and other craftsmen are concerned. If the surviving architectural features of Lord Tarbat's house seem unsophisticated, the original effect may have been very different when they served as the background to his splendid furnishings. In her book about Lord Tarbat's estates, *Two Houses* (1990), Monica Clough published extracts from the two inventories describing the contents of the house made between 1703 and 1712, when its plenishings were shipped north. There are descriptions of luxurious glasses, japanned furniture, china tea wares and imposing bedsteads decorated with ostrich plumes, one of which had come from his Lordship's quarters at Holyroodhouse.

The house certainly has a complicated genesis out of an existing tower house. The simpler north front has a Latin inscription straight out of Pliny, and the seaside locale may have underscored this allusion: 'Riches amassed are useless, but spent produce much good.... For the comfort of themselves, George and Anna, Viscount and Viscountess of Tarbat, have caused this shepherd's cottage to be built in the year of the Christian era 1685'. Their Graces, in the manner of Renaissance popes, repeated their names with rather greater prominence across the friezes of the corner closet towers of their new, and much fancier, Frenchified south front along with the date 1696. The balcony over the door has the monogram and heraldic swan of the Viscount's second wife, the Dowager Countess of Wemyss, whom he married in 1700, and must be secondary. It recalls similar features at Drumlanrig and especially Newhailes.

For all the house's bravura a great deal of its appeal lies in a certain engaging naïvety, a sense of just missing the Baroque effects at which it aimed. Its very considerable charm may have added to its appeal to Weaver, who always had half an eye on the needs of contemporary architects looking for suitable models; the light-hearted lessons of Caroline Park would have been more readily applicable to modern domestic architecture than the sober, classical rigour of Bruce's Kinross or Smith's Hamilton Palace.

Caroline Park has no shortage of admirers today, and the long and careful stewardship of the Dukes of Buccleuch has made possible its happy return recently to domestic use.

This view, by an unknown photographer in 1911, captures the curvaceous Baroque swagger of the 1696 Garden Front that inspired Weaver to write of 'the most attractive roofs in Scotland'.

MELVILLE HOUSE

FIFE

Country Life's photographic survey of Melville House and its contents for Weaver's 1911 article records this perfect Neo-Palladian country house in its prime. Although both house and contents survive, sadly they parted company in 1949 and the emptied house became a school. Melville is important because its patron, George, 1st Earl of Melville, commissioned the architect James Smith to design a new house on a fresh site in 1697. Melville's political career culminated in his appointment by William III and Queen Mary as Secretary of State for Scotland. The architectural history of the house is reasonably straightforward, by Scottish standards, and was readily available to Weaver because Colen Campbell had included an engraving of its design in his *Vitruvius Britannicus* of 1717 and described Smith as 'the most experienc'd Architect of that kingdom'.

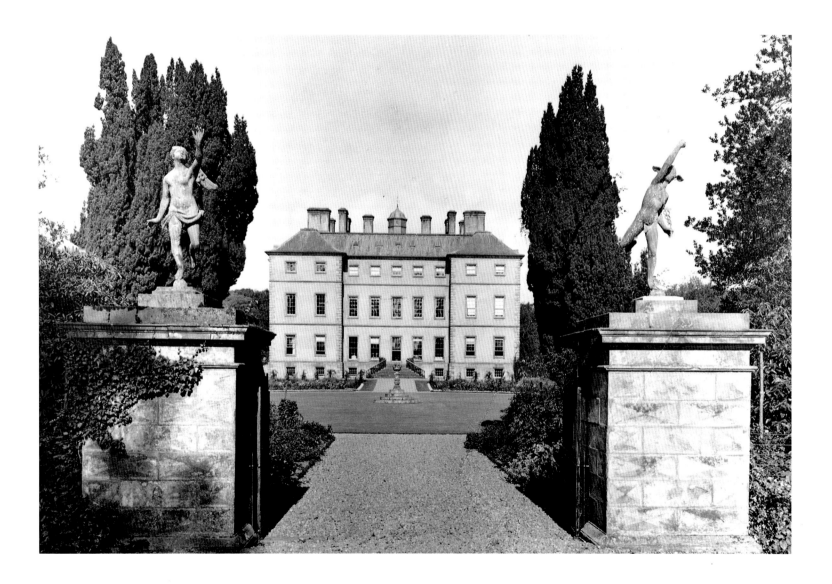

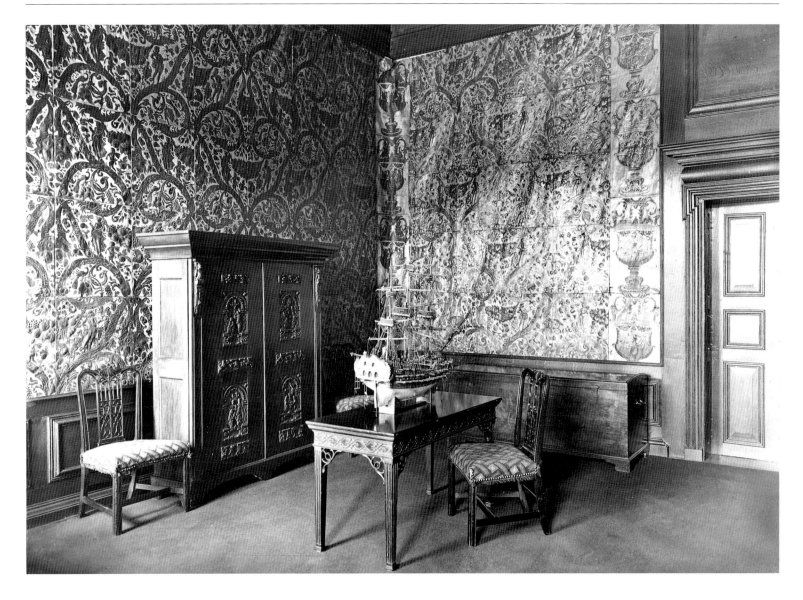

Because Weaver had set Sir William Bruce up so high, he failed to grasp the true measure of Smith's abilities. To Weaver in 1911, the whole point of Melville lay indoors rather than with the outside elevations: 'Smith's ability was shown rather inside the house than by the exteriors, which are rather unduly plain, and exactly the same back and front'. It was a disappointment to Weaver that he could find no evidence other than 'a strong family tradition' that Bruce had been involved, but recent research suggests that both architects had prepared independent designs.

It was the complete survival of its panelled interiors and the sumptuous original furnishings that was the primary attraction for Weaver. As always with *Country Life* at that date, however, Weaver only showed that which was in period synchrony and the nineteenth-century alterations to the house were not illustrated. There is a sense, as seen in details such as the ornaments and chimney-shelf added to the mantlepiece in the 'Large Room' or Great Dining Room, that the late seventeenth-century character had also been played up more recently. Weaver was exceptionally well served by his as yet unidentified photographer, who produced a long set of moody studies of this sequence of penumbral oak-panelled rooms. Melville held much that was exceptional even by

the richly stuffed and untouched standards of the Edwardian country house. The massed ranks of portraits on the staircase wall are astonishing and Weaver noted the inclusion of 'many Medinas and Jamesons, a Lely and three Knellers'.

The Great Dining Room possessed a contemporary long set of caned chairs of exceptional quality, which now survive in a nearby house. The wonders continued next door with the State Bed, in crimson silk velvet and lined with white damask in an exceptional state of preservation. The rarity of the bed led to its being presented by the family to the Victoria and Albert Museum in 1949. The bed was then in what had been intended as the With-

Preceding pages (left): *In the nineteenth century the House was re-orientated and the circular carriage sweep turned to lawn. The baluster sundial at its centre was transferred here in 1824 from Balgonie Castle.*
(right): *James Smith's pioneering Neo-Palladian façade of Melville was considered too plain by Weaver in 1911.*

Above: *The walls of the Ante Room at the head of the Staircase were hung with contemporary gilded leather. An exceptionally rare survival in 1911.*

Right: Country Life's *unknown photographer in 1911 perfectly captured the mood of Melville's interiors, where the rarest of Baroque furnishings were offset by Smith's penumbral oak-panelling. The simplicity of Smith's Staircase was transformed by a collection of family portraits hung edge to edge.*

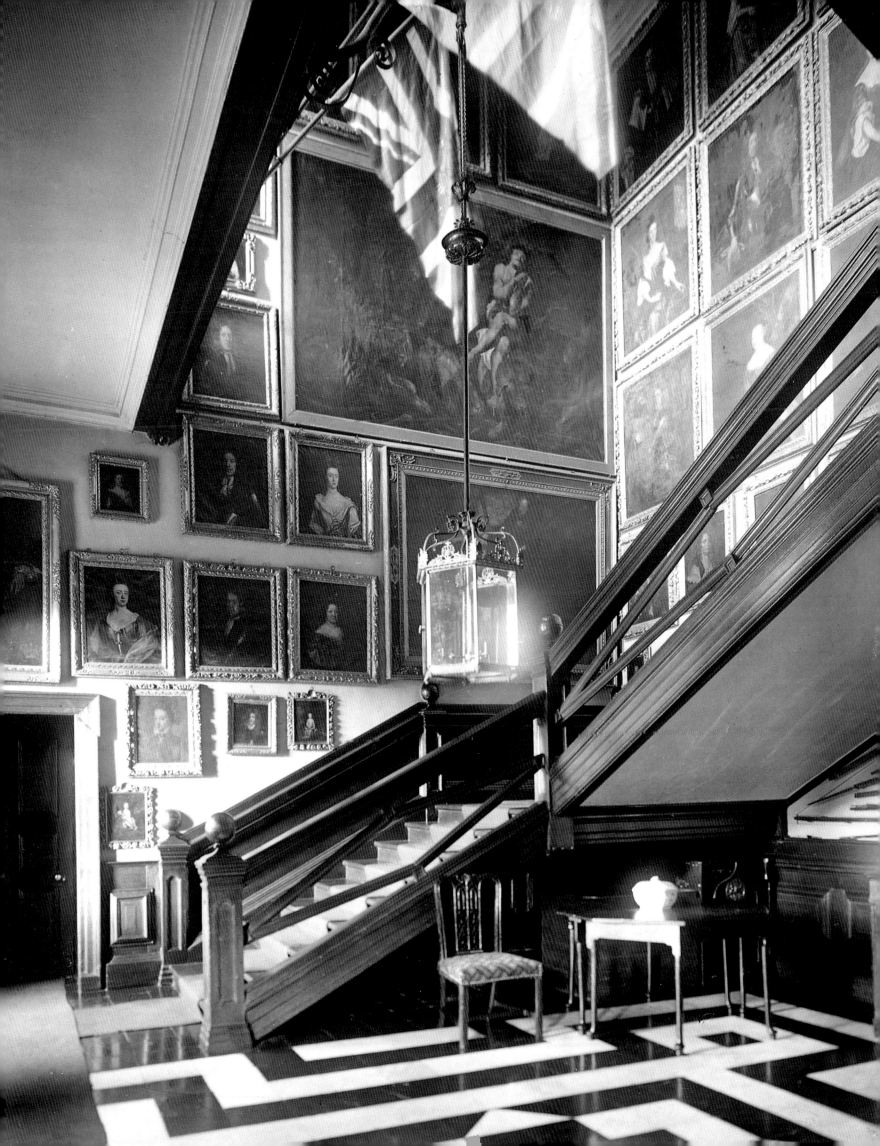

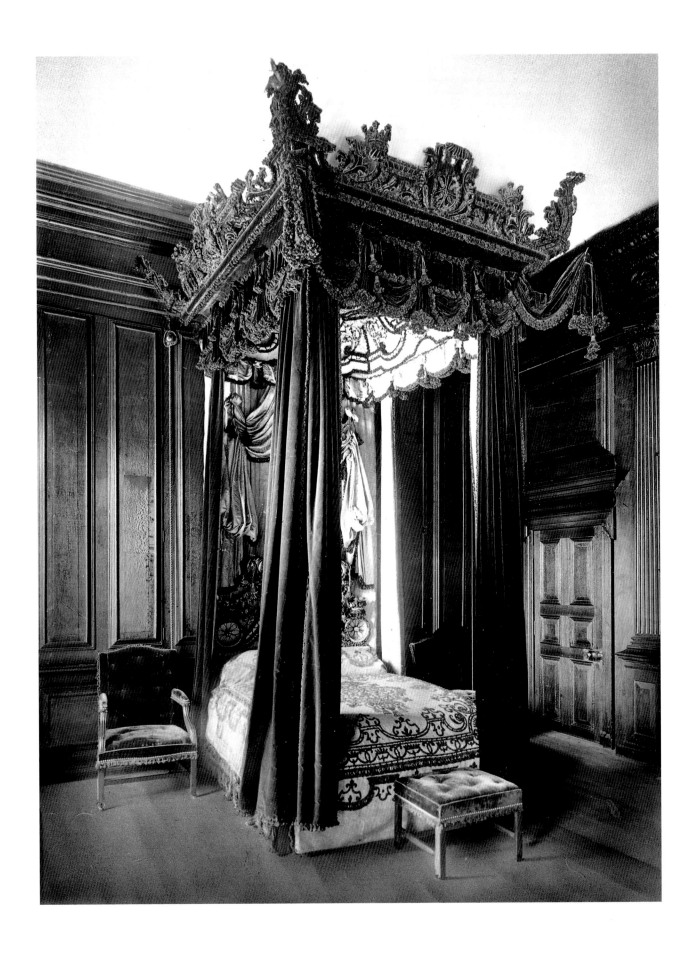

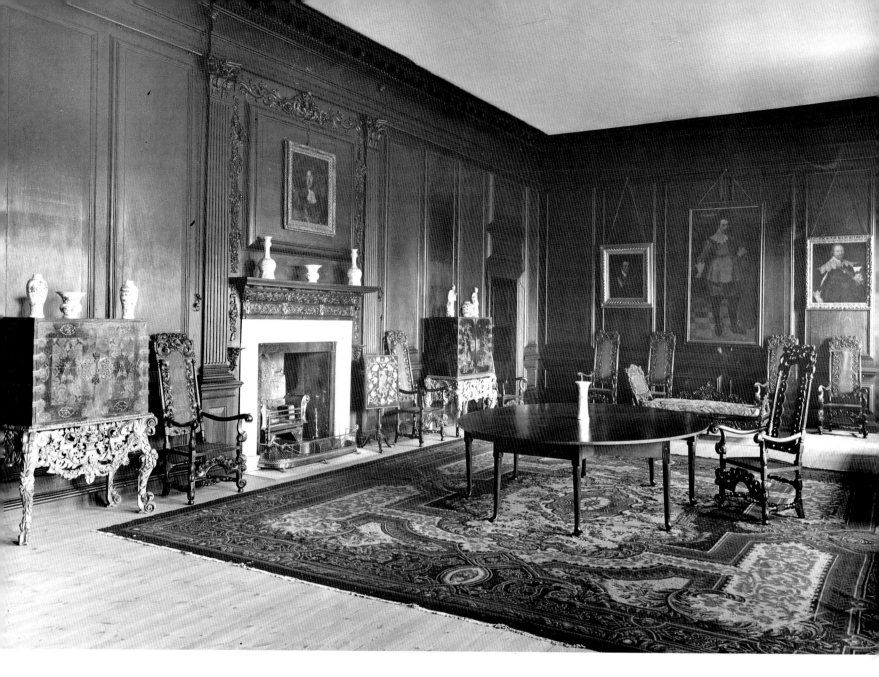

drawing Room, but the original bedroom retained its set of English *chinoiserie* tapestries that are now at Russborough in Ireland.

This romantic, timeless interior was approached through an equally unchanged setting. Although the house had been re-orientated in the nineteenth century, the original formal approach along a 'great avenue' of beech avenue survived as, more remarkably, did the forecourt flanked by a pair of pavilions. The circular carriage sweep had become a flower garden and a fine Scotch sundial made in 1627 was placed at its centre.

Great as the appeal of the romantically overgrown grounds and the rarity of the contents were in 1911, there is a strong sense of Edwardian disappointment when confronted by the exterior architecture of the house itself. So little, indeed, was Melville then understood that *Country Life* did not deign to include a photograph

Above: The principal state room on the first floor was the Great Dining Room, with an exceptional set of cane-backed chairs.

Left: The Melville State Bed, in crimson velvet lined with white damask, was probably made in London by Lapière during the 1690s. Like many Scottish state beds, it was probably intended for ceremonial use by the Earl of Melville in Edinburgh and later sent to Melville House.

of the house's no less chaste, symmetrical flanking office wings.

James Smith's reputation as an architect only began to soar in 1966, when John Harris discovered a cache of his drawings alongside designs by Colen Campbell in Yorkshire. Smith's drawings, which include projects for buildings with which he had been associated are distinguished by their obsession with bi-lateral symmetry. Although the Main Stair at Melville is set to one side, the State Apartment is balanced by an identical apartment on the other side of the central Great Dining Room. Smith and his executed works are important for the history of the Palladian revival in Britain because the context in which his drawings were found suggests that he must have been the mentor of Campbell, the key figure in the development of English Palladianism.

An unexpected effect of the loss of Melville's sumptuous contents is to concentrate attention on the crispness and weight of Smith's interior architectural profiles, which bring a distinction to his buildings that is lacking in the work of his contemporaries. Far from being a secondary figure to Bruce, as Weaver believed, Smith had a mastery of the practical part of architecture and its draughtsmanship that was second to none.

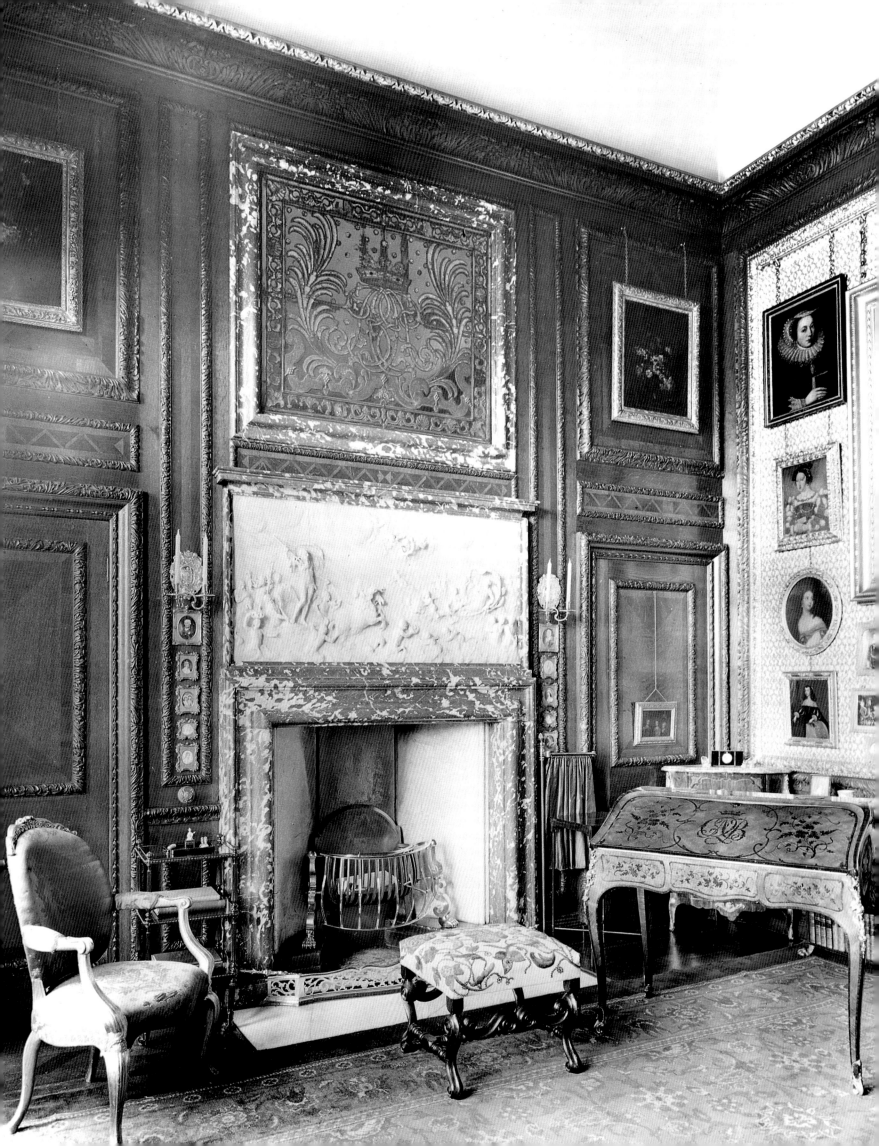

DALKEITH PALACE

EDINBURGH

Dalkeith is in the first rank of Scotland's most important country houses, but is surprisingly little known. This lack of awareness was as true in the past as it is today. The recently discovered list of Lorimer's 'Suggested Scotch Houses', which Weaver had requested in February 1911 to ensure that from the very start of his architectural editorship of *Country Life* Scotland was adequately covered, shows Lorimer's lack of knowledge about Dalkeith. This is surprising given the palace's close proximity to Edinburgh: 'Seat of the Duke of Buccleuch, near Dalkeith Town. Have not been there but have been told by various people who know it that it contains priceless treasures of every description. I imagine it is a sort of Ham House of Scotland. Regarding its contents, permission to view, I think, could be easily obtained'.

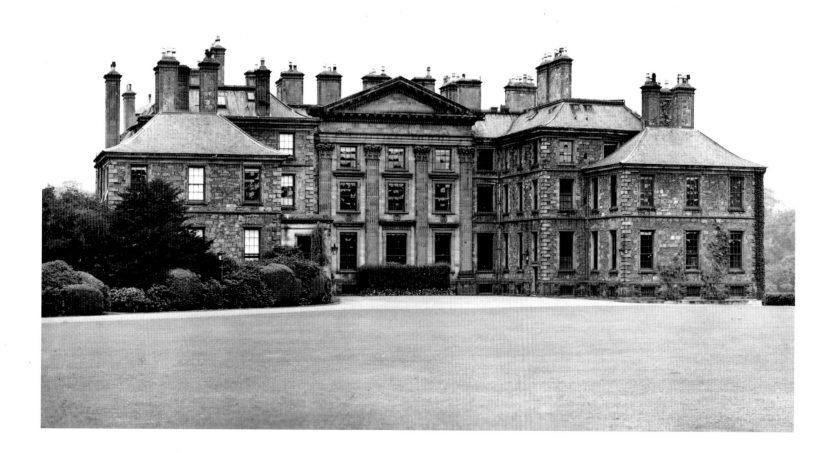

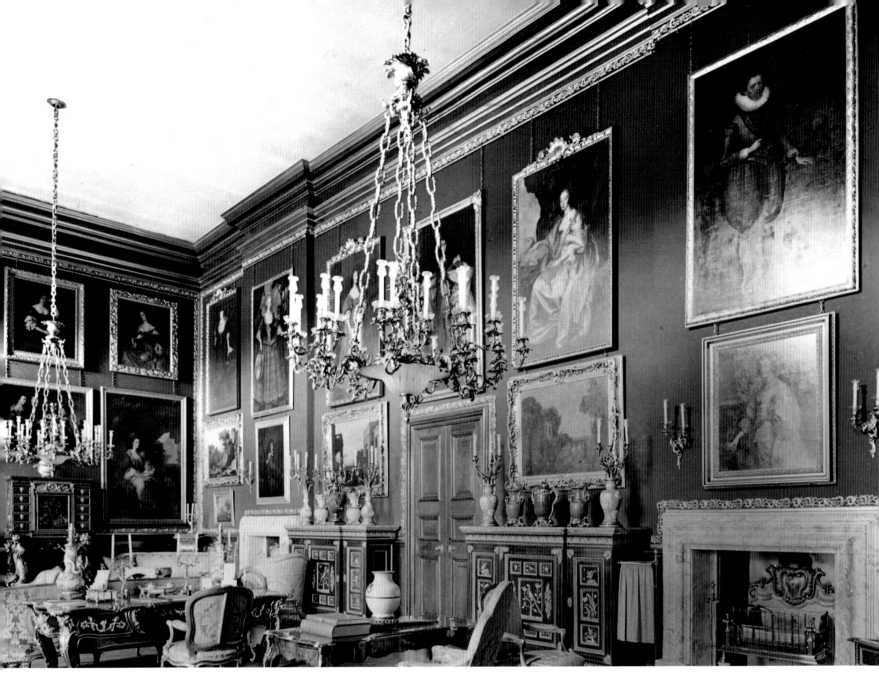

Dalkeith Palace is truly a royal palace. In 1701 Anne, Duchess of Buccleuch in her own right, and widow of Charles II's illegitimate son, the Duke of Monmouth (who had been executed after the failure of his Rebellion), returned to Scotland to oversee the management of her family's estates after many years at Court. The old castle at Dalkeith, just south of Edinburgh, was rebuilt in 1702 to the designs of James Smith, who was almost certainly recommended by Lord Melville, one of Her Grace's advisers.

Smith brought the castle up to date by adding a Palladian frontispiece, with Corinthian pilasters supporting a massive entablature finished with a pediment, behind which lay some of the most dazzling Baroque decorations in Scotland. But although Smith's personal taste tended towards the sober, the Duchess's was princely and the finishing touches reflected her determination to impress her exalted rank upon her fellow Scots. The Duchess shared a passion for marble with Louis XIV, and it abounds at Dalkeith to a degree that is startling in Scotland. There are marble doorcases and marble-topped tables, several of which have free-standing marble frames as well, and must be unique in Britain.

Not only are the steps of the Great Staircase made of marble, but it is approached through a marble screen with Corinthian columns, and has a built-in marble buffet below its upper flight. The Duchess reserved her grandest effects for the smallest rooms of her *petits apartements*, where she installed imported fittings from her English seat, Moor Park.

These recycled splendours combined her passion for marble with exotically decorated chimney-glasses, also framed in marble.

Preceding pages (left): *One of the rooms in the Duchess's* petits apartements *has a three-tier pink and white marble chimney-piece by Grinling Gibbons. Above it is a panel of mirror overlaid with blue glass.*
(right): *The old Castle at Dalkeith was transformed for Anne, Duchess of Buccleuch into a sober classical Palace in 1702 by James Smith with the addition of a grand Palladian Corinthian frontispiece.*

Above: *The Gallery was designed by Smith as the Duchess's Great Dining Room and achieved celebrity in 1842 when, at short notice, Queen Victoria's levée had to be transferred here from Holyroodhouse.*

Right: *The Staircase leading to the Gallery displays Duchess Anne's passion for marble. Thomas Campbell's 1828 marble statue of the Duke of Wellington gives the stairwell the quality of a shrine.*

The Duchess's Closet has a pink marble chimney-piece with a relief by Grinling Gibbons and a panel of mirror-glass overlaid with blue glass ornaments. An adjoining small closet has a large glass built up of small panes and is skilfully overpainted, with trailing flowers in a large vase, to disguise the joints. Later Dukes of Buccleuch put their energies into the creation of the landscaped Park, with the magnificent Montagu Bridge designed by Robert Adam and built in 1792.

Dalkeith's proximity to Edinburgh and Royal splendour made it the obvious choice for Royal residence when George IV made his state visit to Scotland in 1822. Although by day the King held his levées in long-neglected Holyroodhouse, he slept in a domed Polonaise bed amid the luxury of Dalkeith at night. In 1842 when identical arrangements were made for Queen Victoria's state visit, a sudden outbreak of scarlet fever at Holyroodhouse meant that the levées had to be transferred to the Gallery at Dalkeith.

With its intoxicating blend of the grandest French Royal furniture, the finest British eighteenth-century portraiture, and the rarest Baroque textiles, it was tragic that *Country Life*'s photographs of Dalkeith Palace were so disappointing. The photographs were taken for Weaver's 1911 article, which concentrated on the family history. A separate article in 1912 focused on the palatial furniture, underlining its importance by using colour reproductions from Ektachromes, then in their infancy. In spite of their poor quality, however, these photographs are a precious record, for the palace ceased to function as a family home after the First World War. Although the palace was carefully maintained under the stewardships of the Dukes of Buccleuch, the contents were transferred to other family seats. The Drawing Room at Drumlanrig thus still conveys something of the astonishing effects of the Gallery at Dalkeith by repositioning the two splendid Louis XIV Boulle cabinets at either end of the room, with the same chandeliers overhead. Today, the palace is let to the University of Wisconsin.

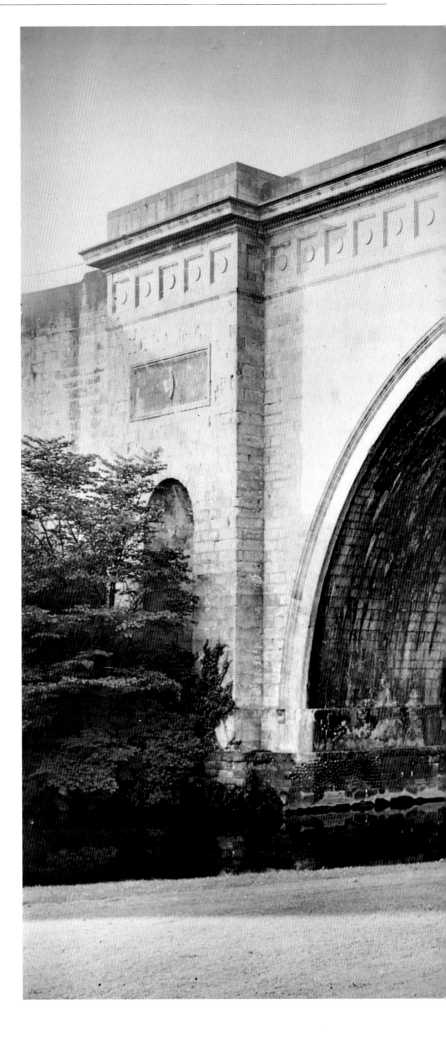

The most impressive feature of the Park's landscaping is Robert Adam's Montagu Bridge of 1792. Its monumental arch over the Esk frames the thatched Hermitage in the distance.

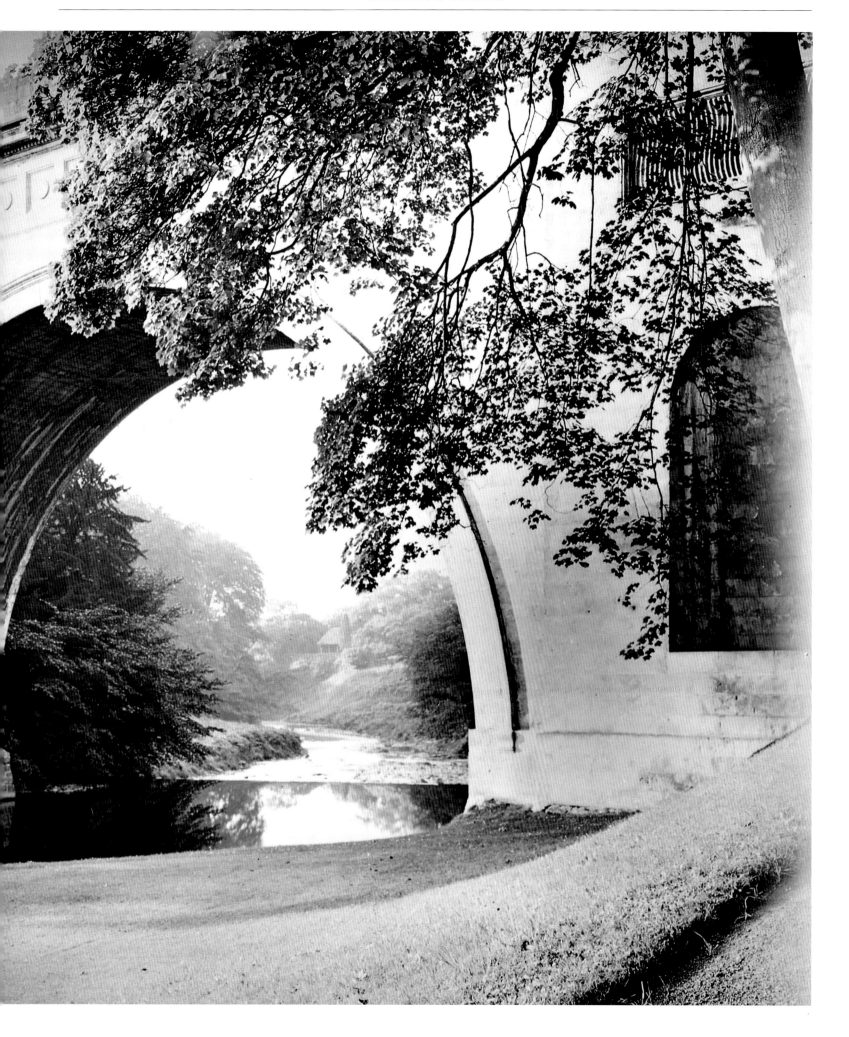

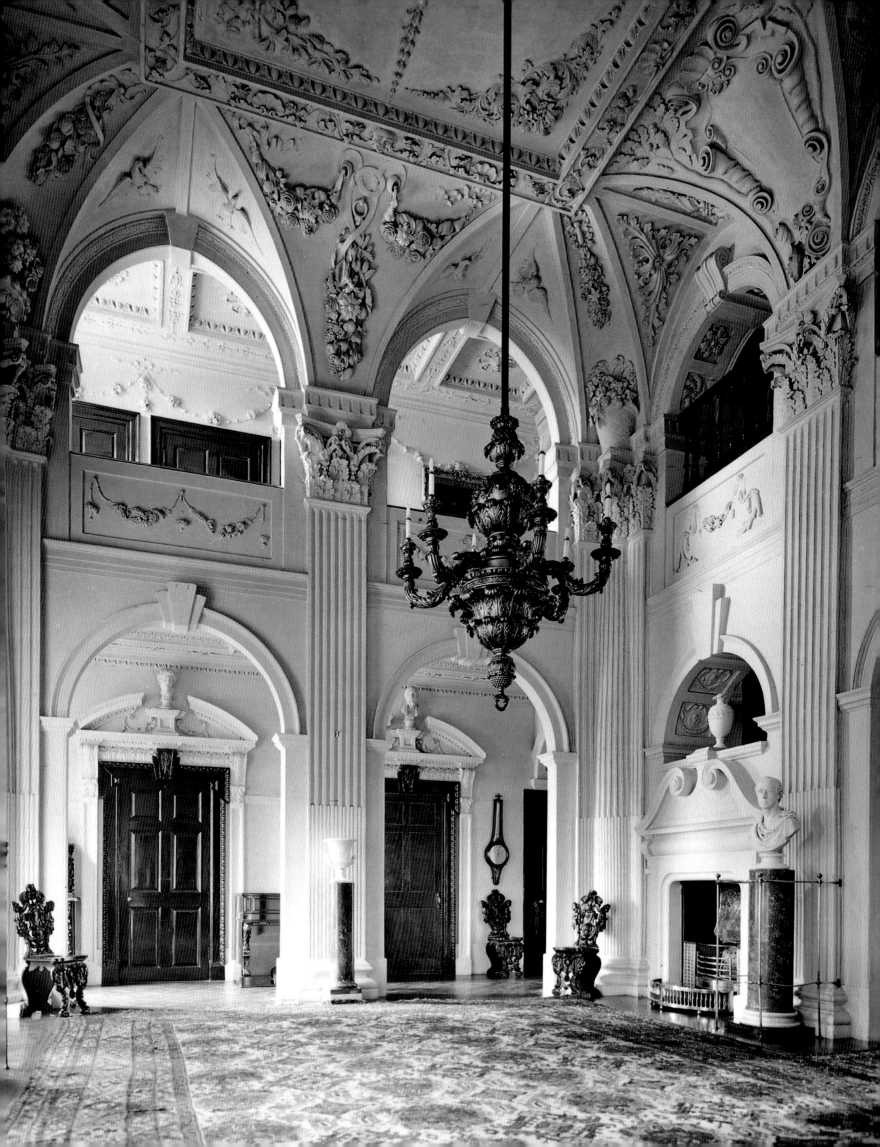

ARNISTON HOUSE

MIDLOTHIAN

Arniston has two claims for inclusion in this *Country Life* anthology. Not only does it shelter two of William Adam's most exciting interiors, but it is also an example of a very common Scottish type – the classicized tower house. When Christopher Hussey wrote about Arniston in 1925, its exterior had few admirers. The view of the entrance front reproduced here was disqualified from publication because of the commodious porch added by the Edinburgh architects, Wardrop and Reid, in 1872.

The old house had been acquired in the late sixteenth century by the Dundas family, who rose to become one of Edinburgh's greatest legal dynasties. The existing house must have conditioned the proportions of the new one, and Adam was to be adept at turning these to advantage.

Behind his centre-piece lay a soaring double-height Entrance Hall, whose exciting spatial complexities not only disguised the limitations of working within the existing dimensions, but had a first-floor balcony which had the practical purpose of comprising a part of the processional route to the state apartments (in the Scottish tradition these were to be on an upper floor). As in all Adam's interiors, the design had a very architectural character, with the space being paced out by giant Corinthian pilasters. Adam was a brilliant planner with a taste for Baroque effects and had little interest in the limitations that arose from following the kind of bi-lateral symmetry that had so obsessed James Smith at Melville and looked good on paper. Alistair Rowan has suggested that Adam's design for the Entrance Hall was inspired by a particularly flamboyant Baroque section proposed for a Royal Chapel in *Architectura Civilis* (1711), by Paul Decker, State Architect to the Margrave of Bayreuth.

The success of the Entrance Hall depended on Adam's ability to find a plasterer of distinction; in Joseph Enzer, who worked at the house from 1730 to 1735, he found an artist who could realize his effects to the full. Immediately above the Hall, at the top of the house, skied in the Scottish tradition, lies a no less original Library.

Adam was so proud of his library design that he had a section of it engraved for his *Vitruvius Scoticus c*.1726. Because it had to fit behind an Ionic frontispiece, the window-spacing would have worried a more timid architect, but Adam once again turned an apparent limitation to great advantage. As in the Hall below, the walls are articulated with Ionic pilasters under a correctly pulvinated frieze, with an arcade above relieved by appropriate classical busts, which ingeniously embraces the uneven window spacing. Any sense of being in an attic is relieved by the way in which the cove breaks up into the roof-space behind the pediment. Adam installed one of his favourite two-tier marble chimney-pieces framing an overmantel glass, but the most innovative and

Preceding pages (left): *The Gallery of the Entrance Hall was intended to form part of a processional route through the house to the first-floor state apartments.* (right): *This 1925 photograph by F.W. Westley remained unpublished by* Country Life *on account of Wardrop and Reid's 1872 porch.*

Above: *Westley's 1925 survey includes many views of the once extensive gardens in their prime.*

Right: *The antiquarian gateway to the walled garden incorporates fragments from the 1630s façade of Parliament House, Edinburgh, rescued when it was demolished in the early nineteenth century.*

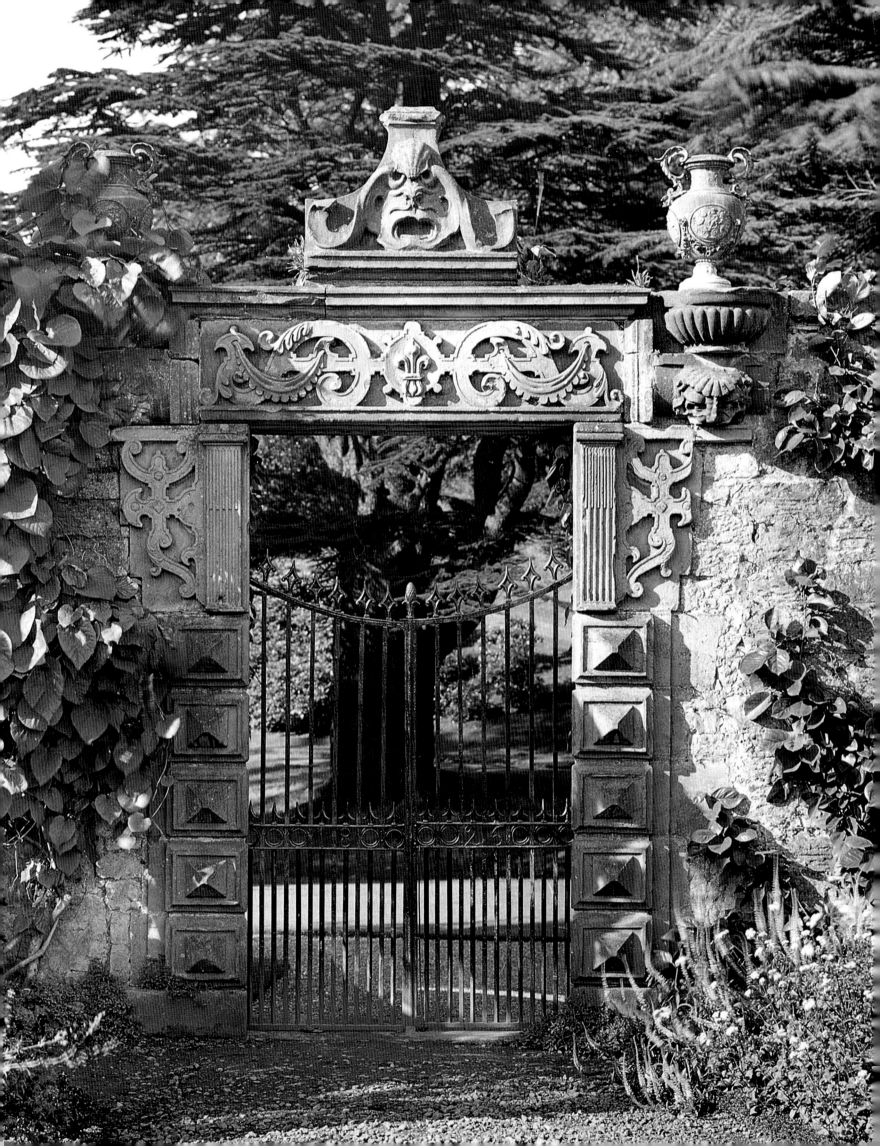

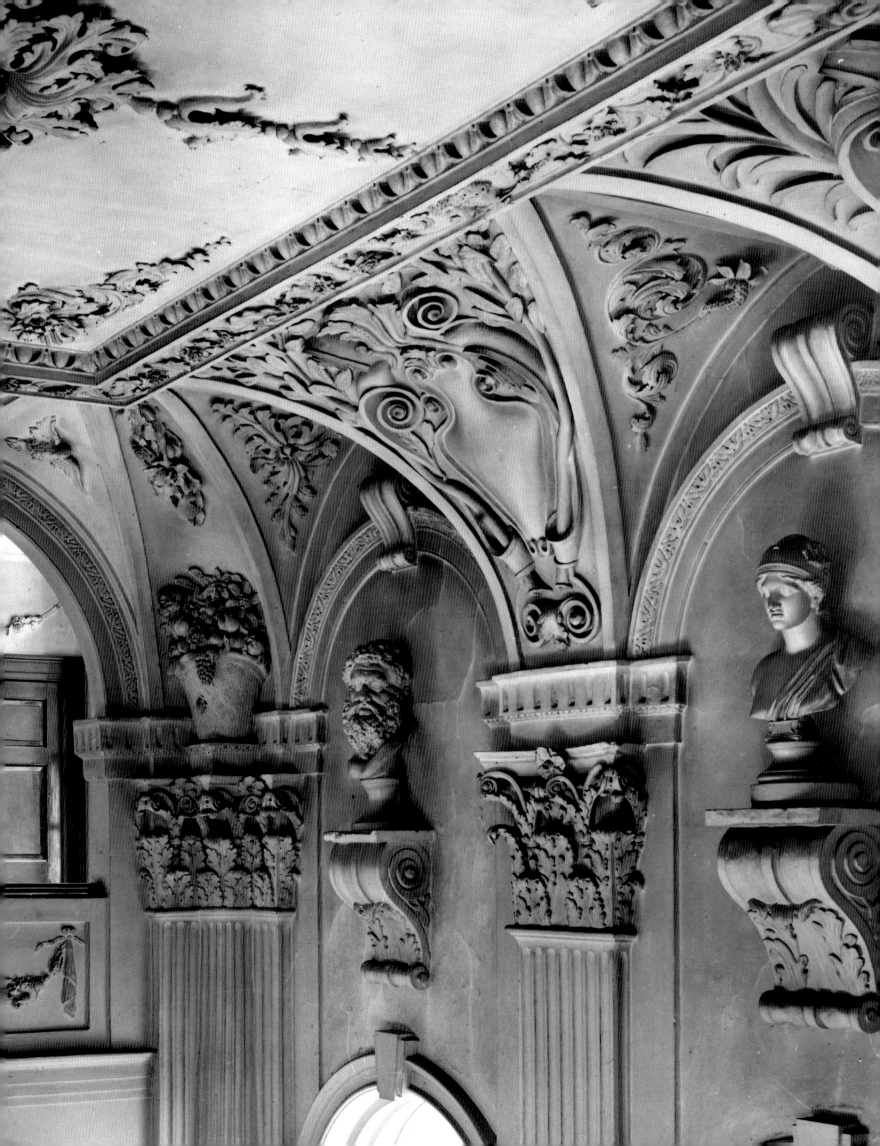

luxurious features of the room were the glazed doors protecting each case.

The building activities proceeded so slowly that Adam had died by the time it came to build on the block to the right of the front door, which was to contain the reception rooms. It thus fell to his son, John Adam, to complete the task, but fashion had moved away from state apartments, and in 1754 the family required a large modish new Drawing Room and smaller Dining Room, as at Inveraray, on the ground rather than the first floor. Because John Adam gave them coves breaking up into the storey above, the plan and floor levels at Arniston have never been easy to understand and must have defeated Hussey, who had less documentation to work from at that time. Drawing rooms, rather than the old withdrawing room of the state apartments, were a new innovation in Scotland. That at Arniston, with its rococo stuccowork and an India paper illustrating the cultivation of tea, must have set a trend. The smaller Dining Room was intended to have inset wall paintings collected by Robert Adam on his Italian travels, but was enlarged and simplified in the nineteenth century by demolishing the original service stair which had separated it from the Drawing Room.

The reception rooms in the west wing were fitted up in 1754, after William Adam's death, by his son John. In keeping with current fashion, he designed a larger, coved, Drawing Room on the ground floor (below) *and a smaller, plainer Dining Room* (above).

Left: *A detail of the Entrance Hall captures the exuberance of Enzer's stuccowork, executed in the early 1730s, bursting out of William Adam's formal architectural framework.*

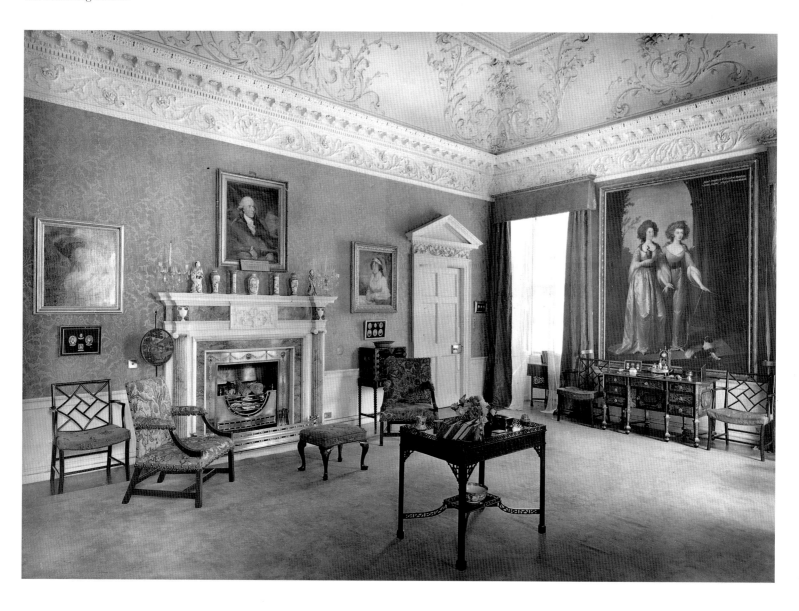

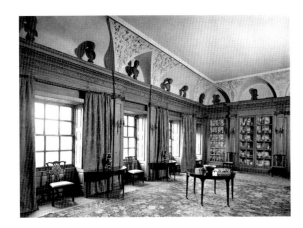

The survivors of the paintings by old masters that Robert Adam had purchased in Italy for Arniston still hang in the house, as Mary Cosh has shown. By 1927 both John Adam's Dining Room and Drawing Room had been redecorated as galleries for the family portraits, which in Hussey's view were the 'peculiar glory of Arniston'. The transformation of reception rooms into portrait galleries at the end of the nineteenth century was spurred by the Scottish cult of Raeburn, whose portraits – especially of pretty ladies – had begun to cut a figure in the international art market. Although the Drawing Room at Arniston had probably already long lost its distinctive India paper, at Newhailes a Chinese paper was painted out to make way for Raeburns; and at Paxton, the larger panels of superb French Neo-Classical paper were painted out in pale green.

A new Library was created in 1866 on the lower floor. With its original glittering white and gold decoration sobered under oak-graining, the old Library became a late Victorian china-maniac's paradise when books gave way to porcelain. Its greatest glory however is its carpet, which must have been made for John Adam's Drawing Room.

The complexities of Arniston's internal planning have been exacerbated in recent years by the ravages of dry rot, which led to the dismantling of both the Drawing Room and Dining Room. Althea Dundas-Bekker and her late husband, Aedrian, have showed great fortitude in pursuing a campaign to reoccupy the west wing. At the time of writing the Dining Room is back in commission and the Drawing Room is well under way.

Above and right: *William Adam's Library with its innovatory glazed cases, is skied at the very top of the house. Adam's engraved design c.1726 shows Library busts over each case.*

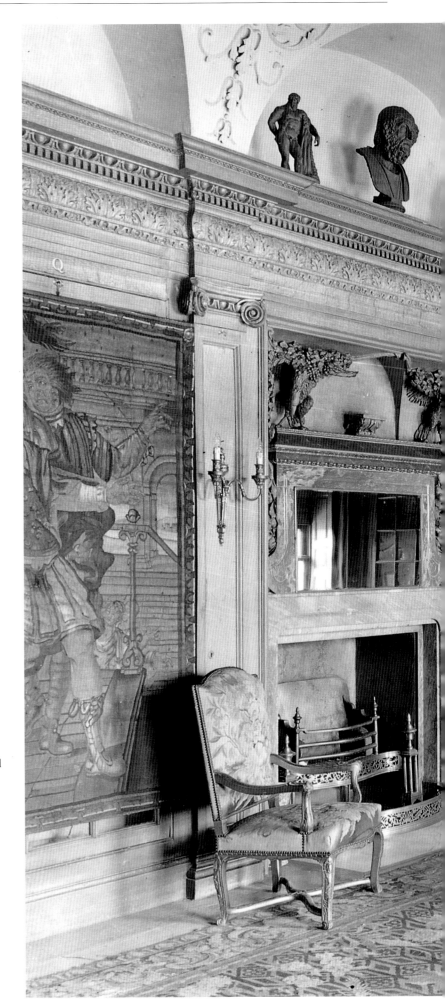

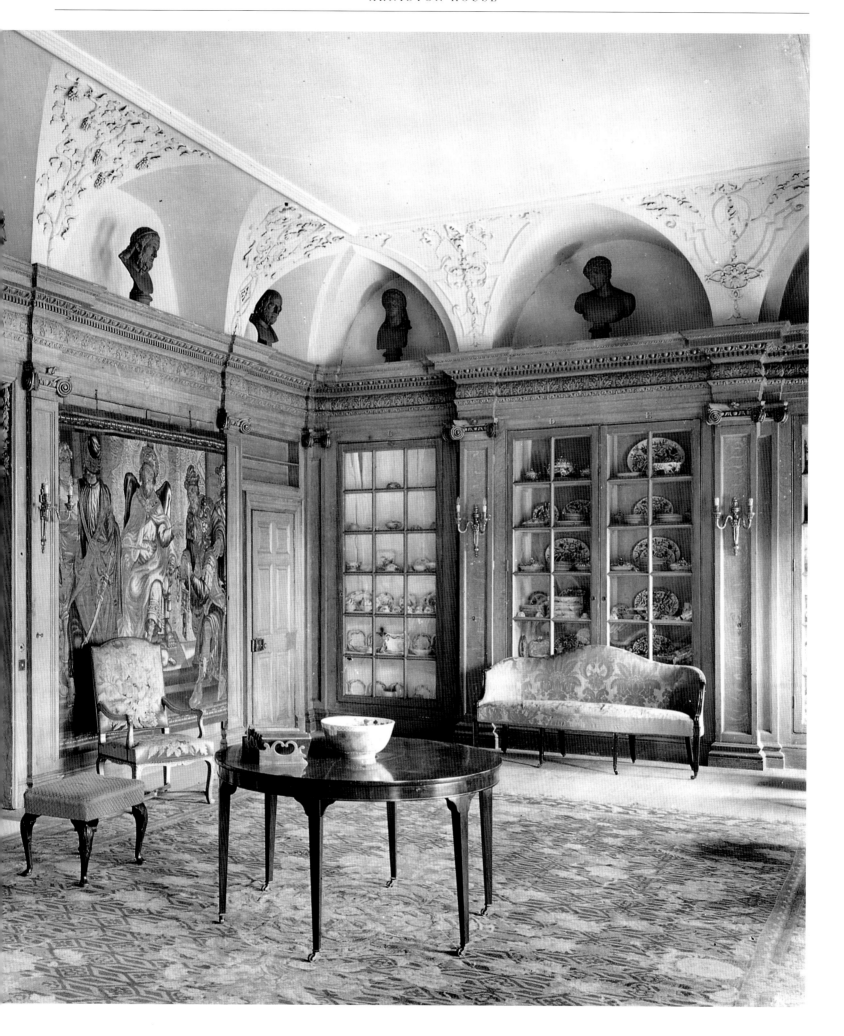

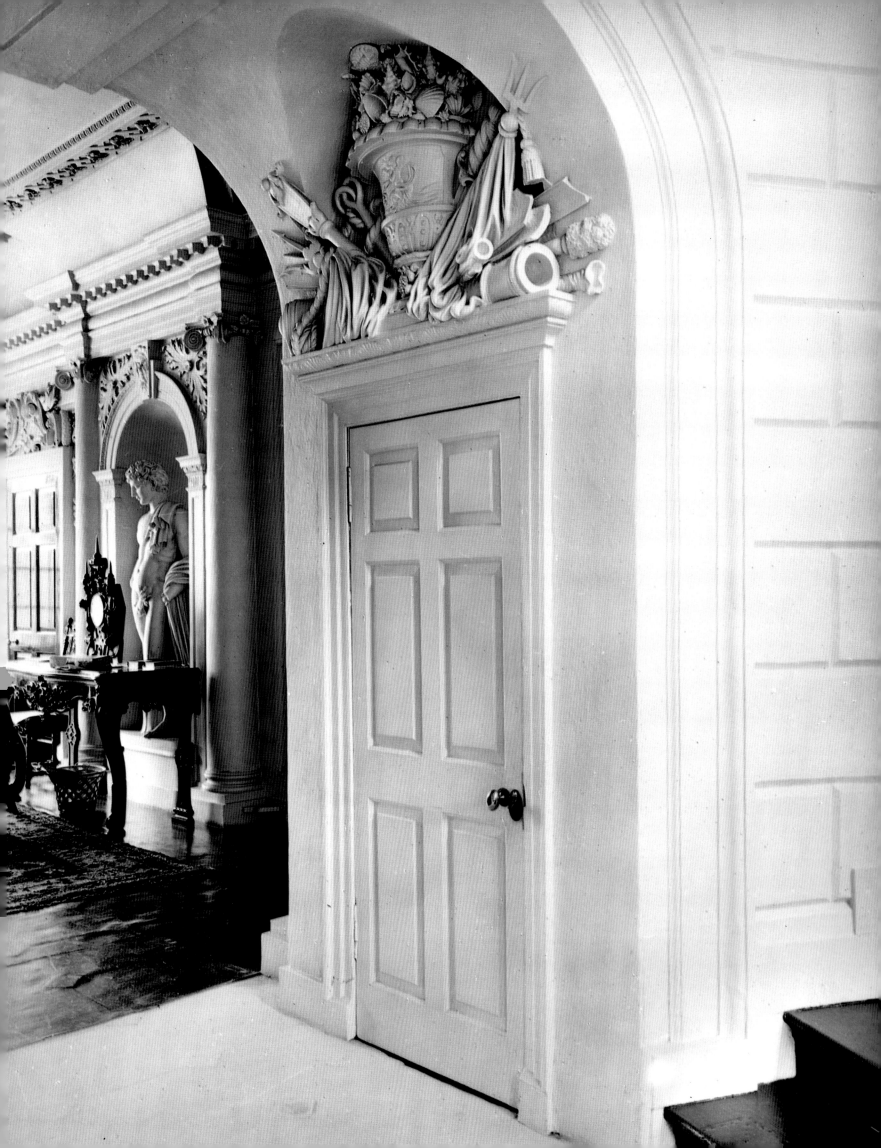

THE DRUM

MIDLOTHIAN

The Drum was designed by William Adam for James, 12th Lord Somerville, who was regarded by later generations of his family as the restorer of their fortunes and dignity. The Drum represents the results of his two successive marriages to wealthy heiresses and was almost certainly begun on his return to Scotland in 1726. Because the stuccowork of the Hall chimney-piece displays the arms of his second wife, whom he married in 1736, the interior decorations must have been embellished with her money. William Adam had intended his new house to be flanked by a pair of wings, but only that on the left was executed and in reality it was simply a remodelling of the existing tower house on the site.

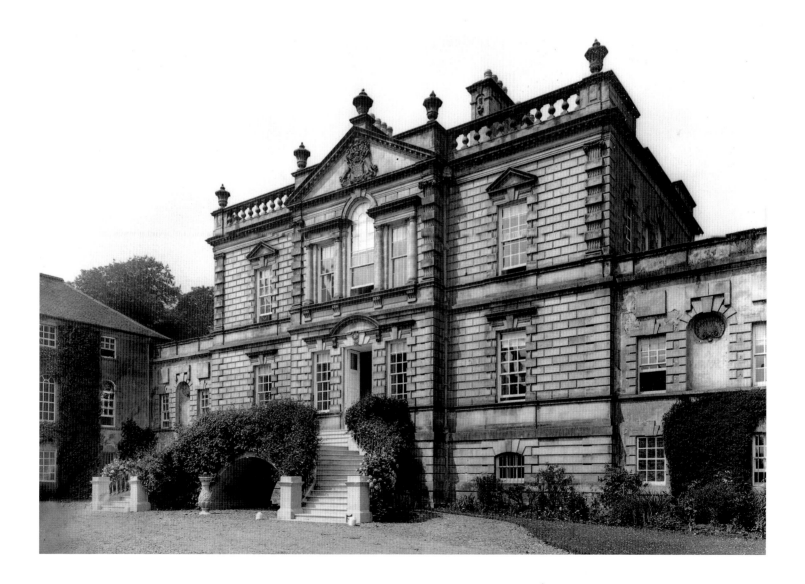

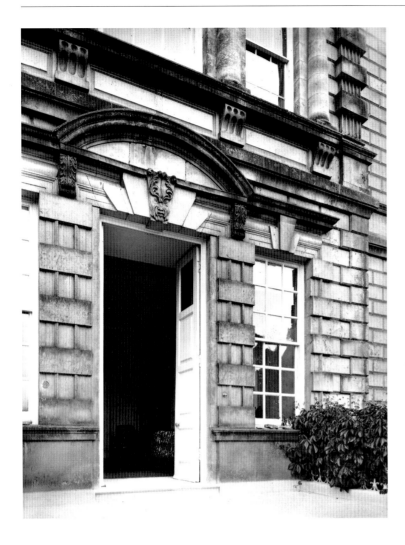

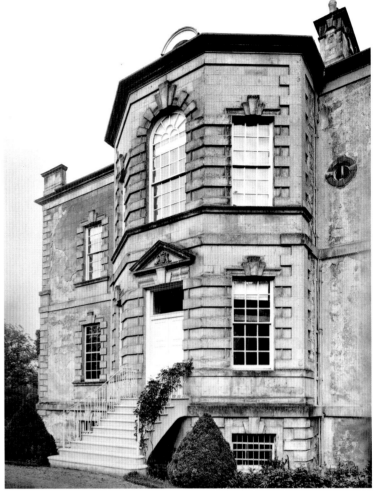

Preceding page (left): *An unpublished photograph of The Drum taken for Weaver in 1912 unusually left the Victorian furniture c.1860 in place.*

Above left and right: *Two unpublished photographs of 1912 capture the vitality of Adam's rustication on the entrance and rear façades.*

Weaver, who had visited the house as part of his survey of Scottish architecture, found it difficult to be enthusiastic about The Drum and William Adam. A.T. Bolton, sent to write up the villa in 1915 for *Country Life*, was more critical, despite his enthusiasm for the work of William Adam's son Robert. Like many later historians, Bolton was unable to appreciate the idiosyncratically Scottish nature of William Adam's *oeuvre*, and concluded that Adam's work must be inferior to that of his English contemporaries. He dismissed The Drum:

The main impression produced is that of a stolid, stodgy mass of work, painstaking and thorough, but disclosing few ideas and little originality. William Adam seems to have been influenced by the general work of the time and his designs will be found to be a compilation of ideas from various sources. He varies from Vanbrugh and Gibbs to Kent. His inside work is particularly heavy and ordinary, and is far removed from the brilliant effectiveness of his son Robert.

And he expressed the wish that Adam could have left well alone: 'One is inclined to wish that the restorer of the family had had the insight to prefer and reverence the work of that interesting and intense period of Scottish history the first third of the seventeenth century'. Making no effort to pander to the sensibilities of the owner, he added insult to injury by preferring the simpler rear façade to the grander front: 'the garden front of Drum suggests that William Adam senior would have succeeded better with the simple classic free of the Orders of which he had no real grasp'.

Today, The Drum is regarded by many as one of Scotland's most covetable country houses, although Bolton's rejection of William Adam's work was based only on his appraisal of this one villa, conveniently situated on the south side of Edinburgh. Bolton never visited either Hopetoun or Duff House at Banff, arguably more representative examples of Adam's talent since they were built for ambitious patrons with less restricted budgets.

The Drum's canonical status as William Adam's masterpiece dated back to its inclusion in MacGibbon and Ross's great survey of Scottish Baronial architecture and although, like Bolton, they were primarily interested in the earlier tower, they had been rather more enthusiastic about Adam in 1887:

Right: *Adam gave his Private Dining Room on the ground floor a sideboard recess, screened by Ionic columns bearing his distinctive basket arches. Here the contrast between Calderwood's old-fashioned ceiling stuccowork and Clayton's later livelier wall decorations is apparent.*

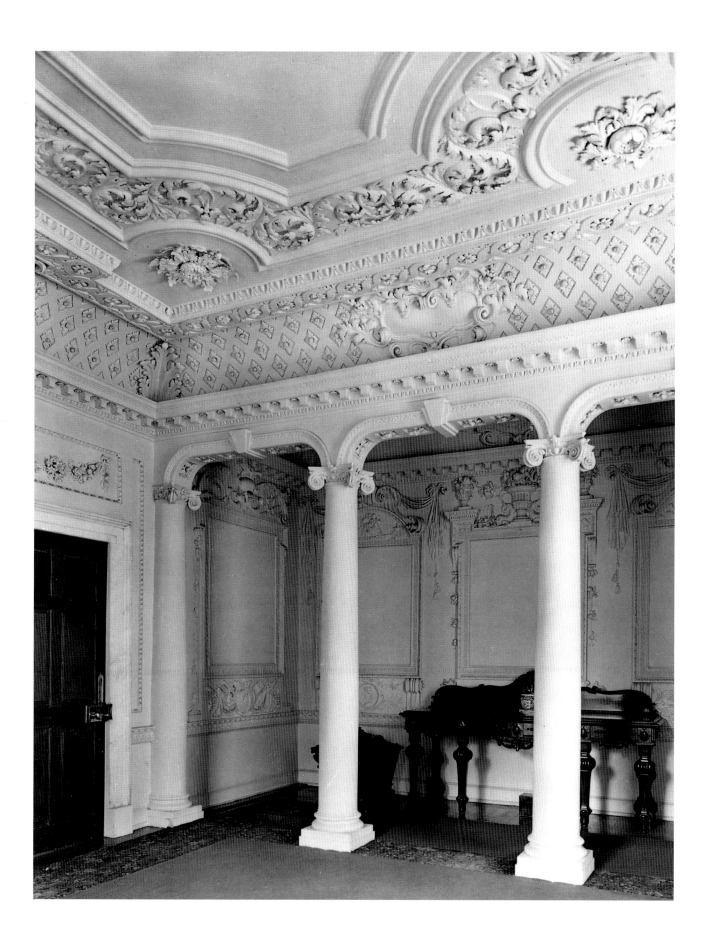

With this mansion we close for the present our review of domestic architecture of Scotland, and we select this edifice for the purpose, as it is a favourable example of the completely developed Renaissance style, in which not a single reminiscence of the Scottish forms and features is to be found. We might have chosen far larger and more imposing examples, but could hardly have found one where the spirit of the Renaissance is carried out with greater refinement and beauty of detail.

Lord Somerville may have called for a considerable repertory of architectural ornament to advertise his restored title and fortunes, but some features of Adam's design reflect distinctive Scottish requirements, such as the skied upper 'state floor' with its great apartment raised over the family's everyday rooms on the entrance floor. Adam expressed the importance of the principal upper floor with rusticated pilasters on the *piano nobile*. Inside, the great Venetian window (judged by Bolton to be too large for its position) lights the Withdrawing Room and is particularly exciting in the way that its entire south wall is thus daringly dissolved into glass, creating a prospect-room with views out over the formal gardens. Similarly, the pair of windows flanking the entrance door help to illuminate the deep Hall behind. The wooden staircase that connects this Hall to the state rooms above is given a generous spaciousness by breaking it out into a deep bay, relieved on its exterior by more of the lively rustication that Adam so obviously relished in this design.

The glory of The Drum, however, lies in its internal stuccowork. It is characteristic of Adam that its exuberance is contained within an architectural framework and the Hall is articulated in the Ionic order supporting a correctly detailed pulvinated cornice. The series of earlier photographs taken for Weaver in 1912 survive in the *Country Life* archives and are exceptionally dramatic in their depth of *chiaroscuro* and their unusual tolerance of the owner's robust Victorian furniture. It is fascinating to examine the plasterwork and detect the obviously distinct hands from the two phases of activity. In the family Dining Room, on the entrance floor, Adam incorporated a modish columnar service screen with Ionic columns supporting the distinctive Scottish 'basket' arches.

In 1928 Hamilton More Nisbett took his revenge on Bolton in his monograph on his family home, *Drum and the Somervilles*, where he refers to: 'the "superior" writer of a recent article in *Country Life*, who persists in regarding this fine house merely "as a source of innocent merriment".' His volume has a lightness of touch which Bolton could not match. Because he was also an architect, More Nisbett took a professional interest in the history of a particular rainwater hopper that had once decorated the exterior:

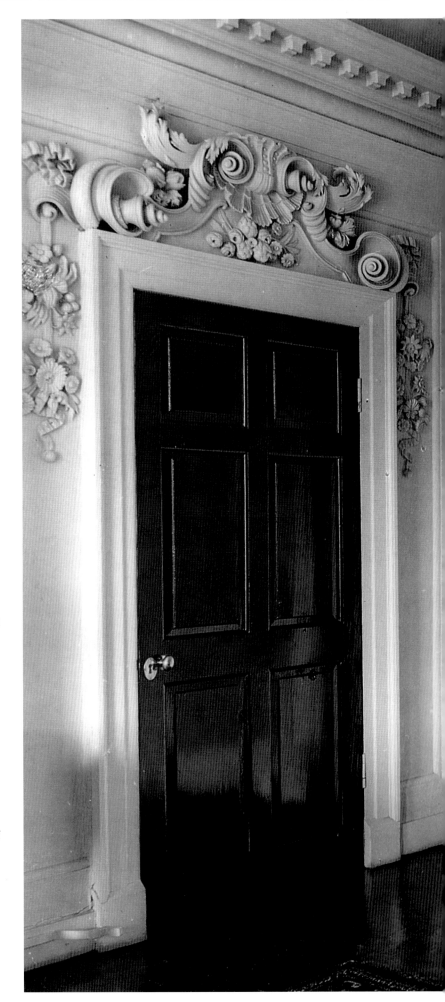

The Hall leads through a deep arch, whose inset doors are loaded with three-dimensional, stucco trophies, to the oval wooden Staircase, which rises to the first floor state rooms.

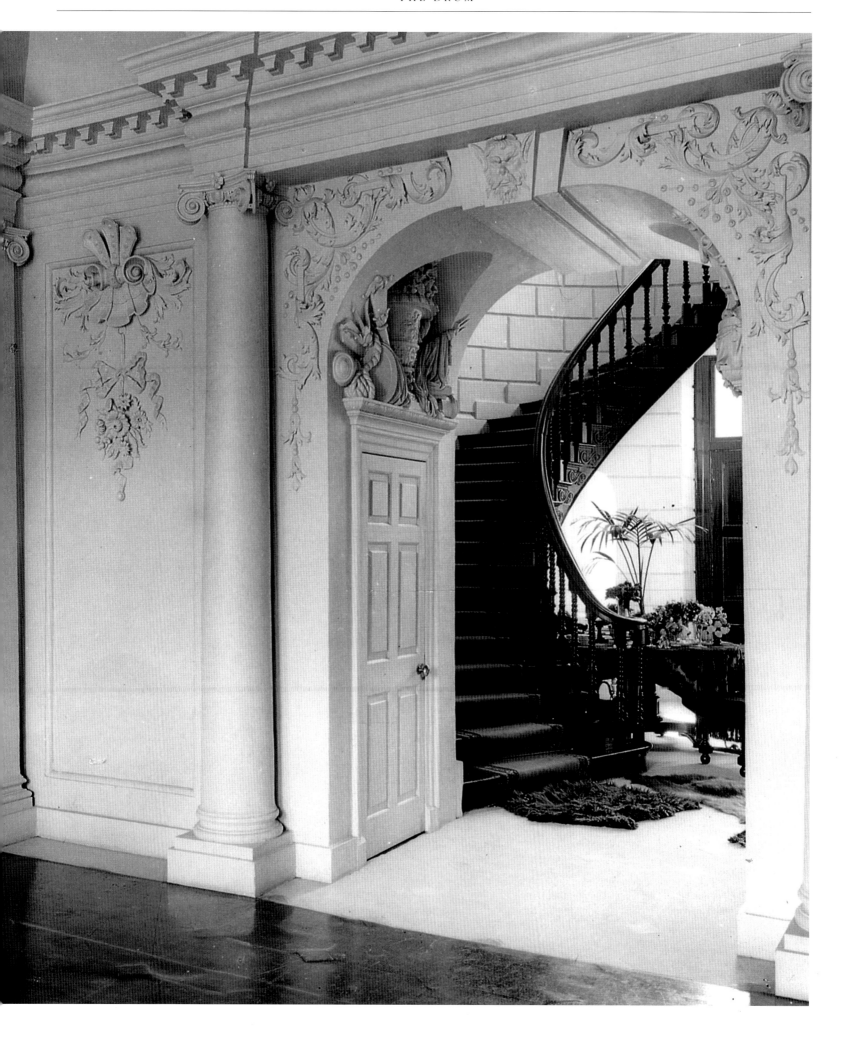

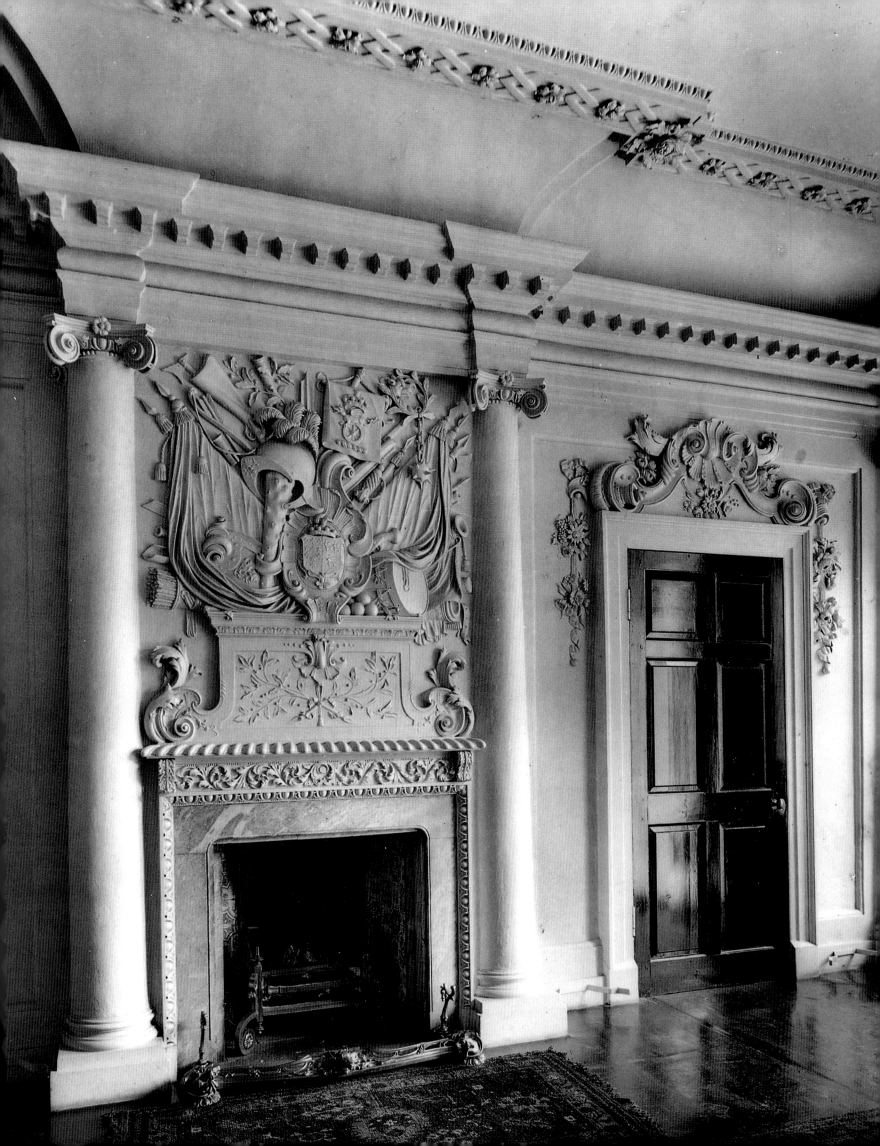

This was much admired by experts, and many a grey beard was waggled over it, pronouncing it to be "the finest bit of leadwork in Scotland". Somewhere about 1920 it fell down, and disclosed the fact that it was made of lath and plaster. This shows how carefully every detail was considered. We do not put up models of our rainwater heads nowadays, and, if we did, we would be far too self-conscious to forget about them.

The Drum headed Robert Lorimer's alarmingly vague and inaccurate 1911 list of suggested Scottish houses for Weaver to write up for *Country Life*: 'Eight or nine miles south of Edinburgh. A "Charles Adam" containing a considerable amount of interesting detail and plasterwork, sufficient, I think, to yield material for a good set of photographs, and an article'. Lorimer's list reveals that his primary interest in *Country Life* was visual and lay in the all-important photographs rather than the historical text padding them out. Like many contemporary architects, Lorimer would have viewed the magazine as a visual quarry to crib ideas from.

From *Country Life*'s point of view the major visual problem at The Drum was that the original Somerville contents had been lost and the house refurnished in 1862, when the More Nisbett family acquired it. This explains the emptiness of the Hall in 1915, although the earlier, unpublished, photograph taken for Weaver in 1912 shows some of its Victorian standard-issue hall funiture, including a rococo lobby table. Of the state rooms on the upper floor, only the chimney-piece of the State Dining Room was illustrated, because of the large gaps in the wall decorations of the room where paintings were presumably intended to have been inserted. Careful examination of the staircase decoration shows that this scheme, too, was meant to complement inset wall paintings. The State Bedroom, with its Victorian suite of furniture, also went unillustrated. Ironically, Bolton did not chose to mention the Drawing Room, which had been fitted up in the style initiated by his beloved Robert Adam.

In 1991 *Country Life* revisited The Drum to record the resplendent results that followed from the reinstatement of Adam's original decorative scheme – it had become obvious that his staircase ornaments had been gilded against a stone-coloured ground, and this scheme was reinstated in a pioneering attempt to recover the effect of historic lead paints. Now the exuberant façade is completely at one with a glittering interior, and the overall harmony of Adam's vision can be understood.

The landing at the top of the stairs gives access to the rooms of the Great Apartment, with an arch leading to the Drawing Room. The borrow-light illuminates the service stair.

Adam's very architectural treatment of the Hall, with Ionic pilasters below a pulvinated frieze, is enlivened by Clayton's later stucco decorations, which incorporate the arms of Lord Somerville's second wife.

NEWHAILES HOUSE

MIDLOTHIAN

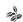

Weaver was right to guess, in 1917, that the original architect of Newhailes must have been James Smith, but he did not know that Smith had built the house, then called Whitehill, for his own occupation in about 1686. A design survives in the Smith drawings in the Royal Institute of British Architects for the seven-bay centre of the house. Much of the pleasure of a visit to Newhailes depends on the complete survival of Smith's little Neo-Palladian villa, whose tiny scale sets the character of the heart of the house, although the interiors have been overlaid and embellished with later decorations.

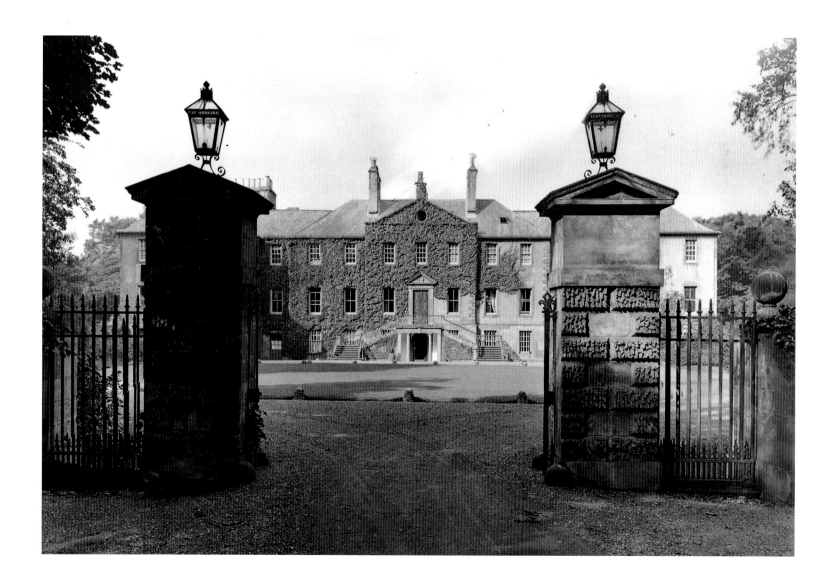

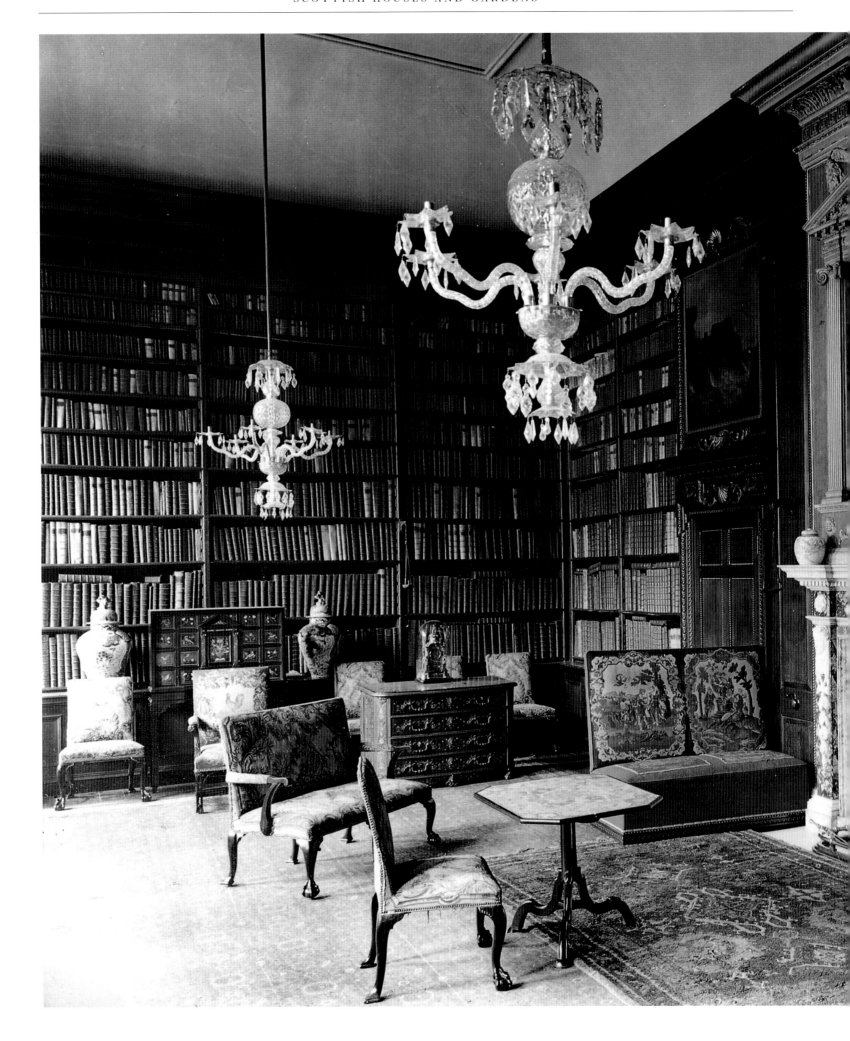

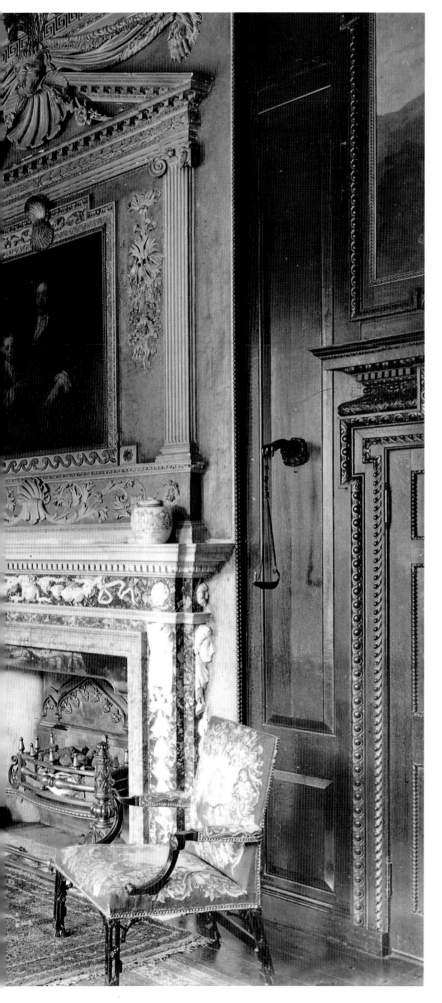

In 1917, when Weaver visited Newhailes, its unusual Sleeping Beauty qualities moved him to write:

No one familiar with the castles and neo-classic mansions of Scotland can fail to have been impressed with the ravages which were worked on them inside and out during the nineteenth century. Well proportioned fronts have been ruined by the addition of preposterous porches: beautiful rooms were stripped ruthlessly of their panelling to gratify Victorian fancies in wallpaper: rich plaster ceilings for reasons which it is impossible even to imagine. It is the more pleasant, therefore to be able to illustrate a house which shows the decorative art of the first half of the eighteenth century untouched by the hand of the "restorer".

Today, this exceptional atmosphere persists. Newhailes's magical qualities have led to a successful campaign by the National Trust for Scotland to save this most remarkable and beautiful of all Scottish houses. Part of the drama of the tiny house is the way in which its robust but handsome exterior shelters the most extravagantly fragile rococo decorations. Fanciful decorative painting, riotous stuccowork, gilding laid over a sanded ground for added sparkle, precious early silks and Chinese wallpaper have mellowed together, with real shells embedded at strategic points all over the panelling.

In 1709 the house was purchased by Sir David Dalrymple, the youngest son of the Earl of Stair, a lawyer-politician and one of the commissioners for the Union of the Parliaments in 1707. He gave

Preceding page (left): *The tiny dimensions of James Smith's Entrance Hall were transformed first in 1742 by Clayton's rococo stucco festoons with birds, flowers and shells, and then c.1880 by a Minton-tiled pavement.*

Above: *The Green Bedroom has preserved both its 1730s bed alcove and decorative architectural painting.*

Left: *The Library wing, completed for Sir David Dalrymple c.1720, lost its sober character in 1743 when Clayton added the stucco decorations to its chimney-breast. It is described as the Drawing Room in the 1873 Inventory. The suite of tapestry-covered arm chairs, with frames in the Chinese taste, had to be sold in 1928.*

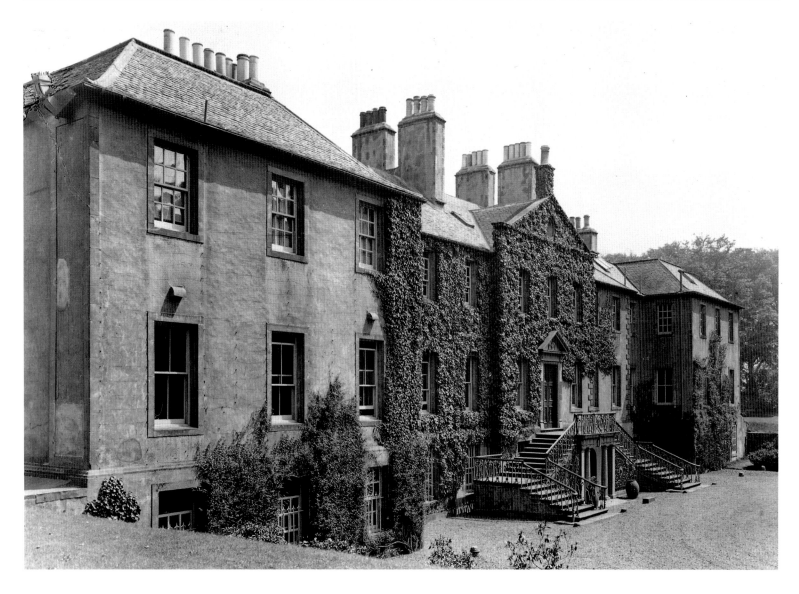

the house a new name, taken from Hailes Castle in East Lothian, another Dalrymple property. Sir David's contribution to the house was a Library occupying its own new wing, added to the left of the entrance door, and completed in about 1720. Its size was astonishing by Scottish standards, and still startles. It is flooded with light by its five great arched sashes when approached through Smith's tiny rooms with their smaller windows.

For Weaver 'the chief interest of the building centres in the library' and it remained imbued, for him, by the spirit of Lord Hailes, Sir David's grandson. Weaver's delight in old buildings arose in no small measure from their ability to act as a medium through which to make direct contact with their former occupants. It was thus especially moving for him to read on Lord Hailes' own library shelves manuscripts by 'Johnson, Boswell, Burke, Horace Walpole and other well known men of the day'.

Sir David's son, James, built a wing on the left containing a great apartment to balance the Library block. In 1742, Thomas Clayton, the stuccoist, redecorated the Hall and added the upper part of the Library chimney-piece at the same time. This frivolous dilution of the learned character of the Library suggests that it was already en route to its nineteenth-century transformation when it was

described in the 1873 inventory as 'The Drawing Room' – an effect heightened by the introduction of its pair of glass lustres, essential furniture in any Georgian Assembly room.

Not long ago, a workman discovered that the large painted panel on the right of the Green Bedroom was designed to be removed and concealed a set of shaped, display shelves for china, a few pieces of which had survived in situ, with pigeon holes for letters at each end. In any other house such a discovery would be an exceptional event, but at Newhailes – where eighteenth-century clothes still lie in trunks and a set of ebony drawers is lined with the rarest of late seventeenth-century French engravings depicting the design of an Edinburgh 'Hotel' for the Hope family – such finds are taken for granted. In recent years, the Sleeping Beauty charm of Newhailes has been meticulously preserved and nurtured by Lady Antonia Dalrymple.

Above: *This oblique view of Newhailes shows how it was extended by much deeper wings, and its austerity softened by late-Victorian creepers and window boxes. The Library wing is on the right.*

Right: *A study of one of the pair of lead Sphinxes, which no longer survive, but may have once graced the forecourt gate-piers, as at Chiswick House.*

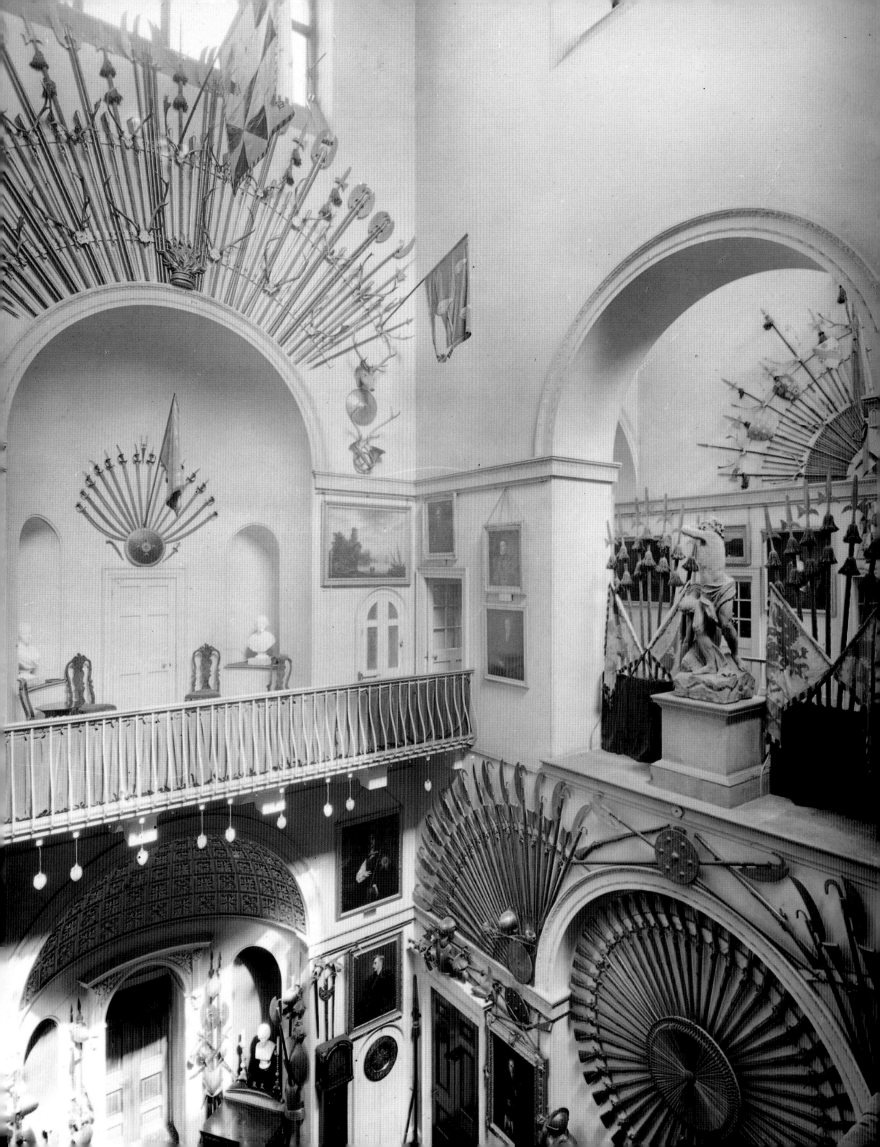

INVERARAY CASTLE

ARGYLLSHIRE

Country Life's luminous photographs of Inveraray, taken by the staff photographer Arthur Gill for Christopher Hussey's article in 1927, are a particularly compelling record of this 'princely seat' in its prime. The castle provides one of the most startling visual contrasts on offer in Scotland, for the Neo-Gothic exterior begun by the 3rd Duke of Argyll in 1744, so perfectly in tune with the rugged Highland scenery on the shores of Loch Fyne, shelters a set of interiors decorated by the 5th Duke and his Duchess during the 1780s with all the rarified elegance of Marie Antoinette's Paris. This contrast was not welcomed by *Country Life* on their first visit to Inveraray in 1899 and the article concentrated firmly on the grounds.

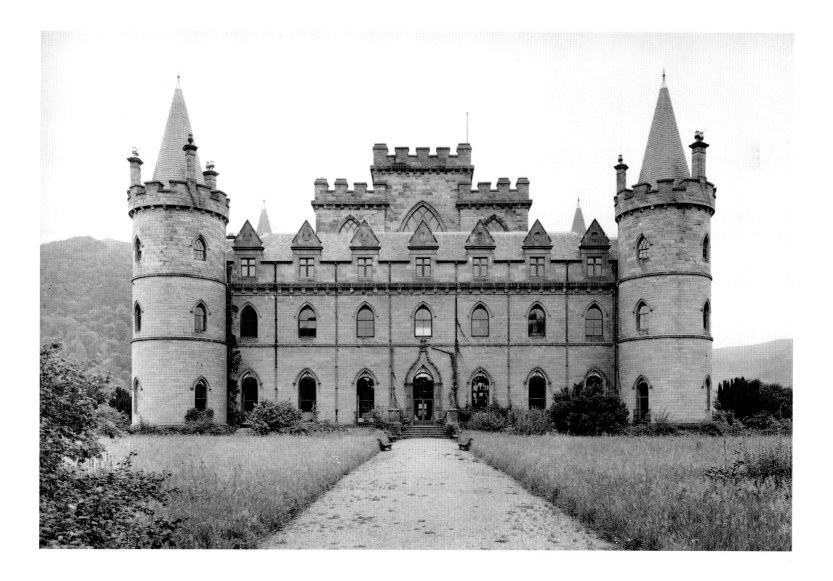

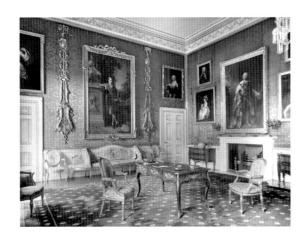

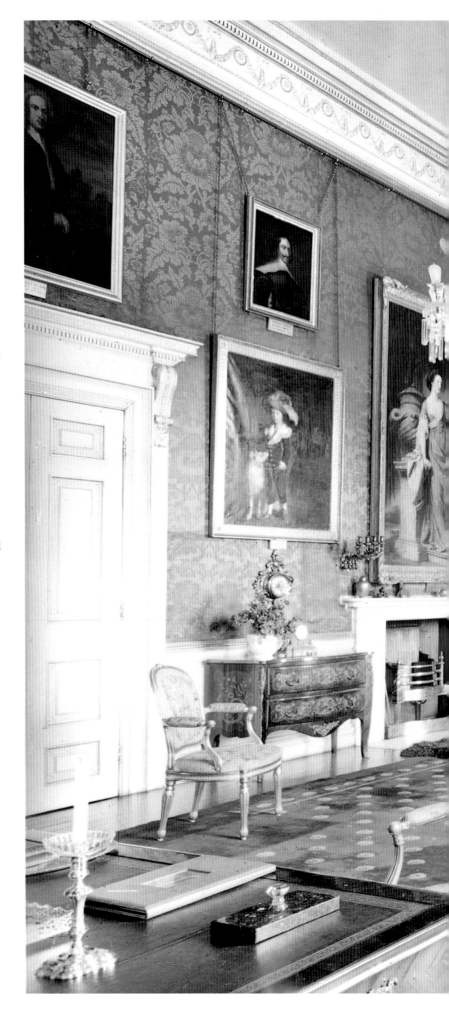

Although he was well aware of Inveraray's importance for the Gothic revival (even though its architect, Roger Morris remained obscure), the external architecture did not please Hussey and only a detail of the attractive bridge across the sunk 'fosse' to the garden door was illustrated. For Hussey, moreover, the Victorian restoration of the castle after the disastrous fire in October 1877 by the architect Anthony Salvin had detracted from its charms, since he disapproved of the subsequent additions of conical roofs to the corner towers and the new attic. But Hussey also took exception to the very stone from which Inveraray had been built: 'It was executed in a local stone – *lapis ollaris* or pot-stone quarried on the south shore of Loch Fyne and of a grim, grey-green hue, turning black when wet. Though soft when newly dug it becomes very hard and weathers not the slightest'.

Hussey's analysis of the sumptuous interior was dogged by a lack of reliable documentation, but he was rightly sceptical about the received view that Robert Adam had been involved. The attribution to Robert Adam can be seen as a tribute to the outstanding decorative finesse of the interiors. Hussey's late dating of the Dining Room to 1790, however, showed he did not know that the interiors were influenced by the owners' direct contact with Paris, an influence attributed to the 5th Duke's Duchess, Elizabeth, one of the beautiful Gunning sisters, and a double-Duchess, because her first marriage had been to the Duke of Hamilton. The 5th Duke succeeded his father in 1770 and employed Robert Mylne, rather than Robert Adam, to recast the

Preceding page (left): *The central Hall designed by Roger Morris in the mid 1740s. The original classical detail of the lower zone was subsequently overlaid by nineteenth-century Scotch Baronialization and bristled with theatrically-arranged weapons and armour.*

Above and right: *Inveraray's outstanding collection of eighteenth-century portraits, including a Gainsborough and (above) a Batoni of the Duke of Hamilton, was recorded for posterity in Westley's 1927 photographs of the Saloon. The expanse of red damask was paced out with appliqué festoons, gilded in 1788.*

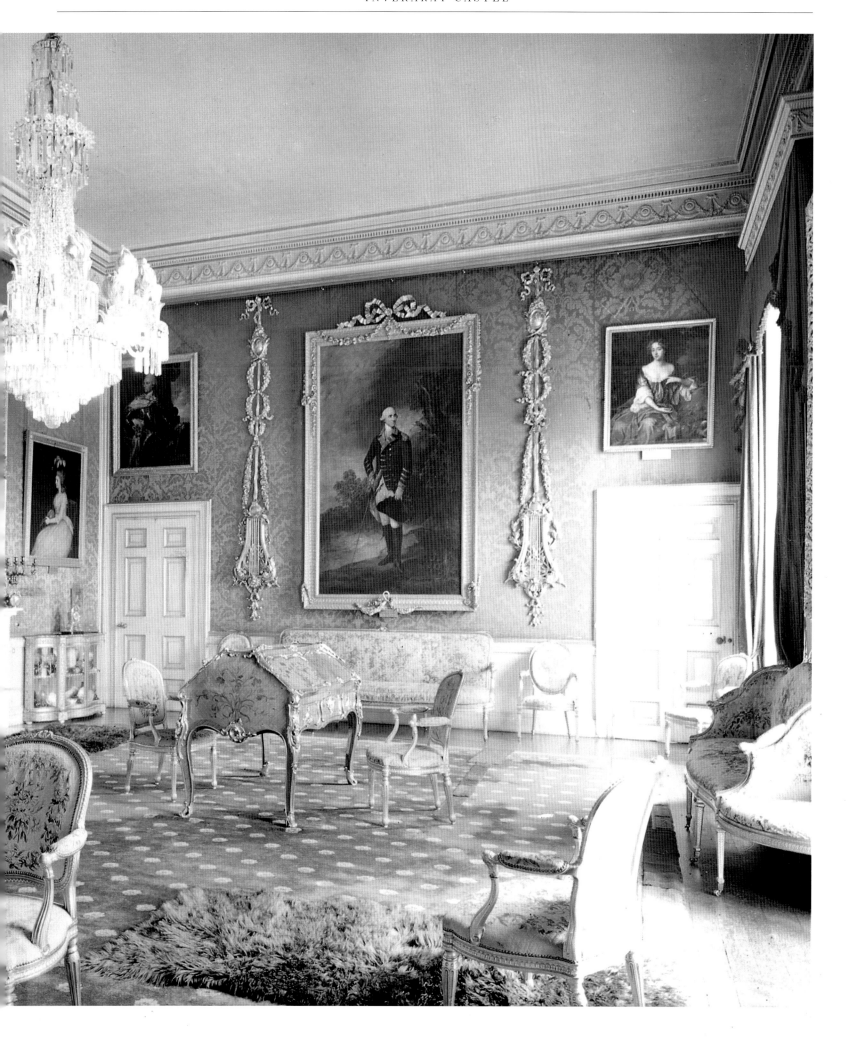

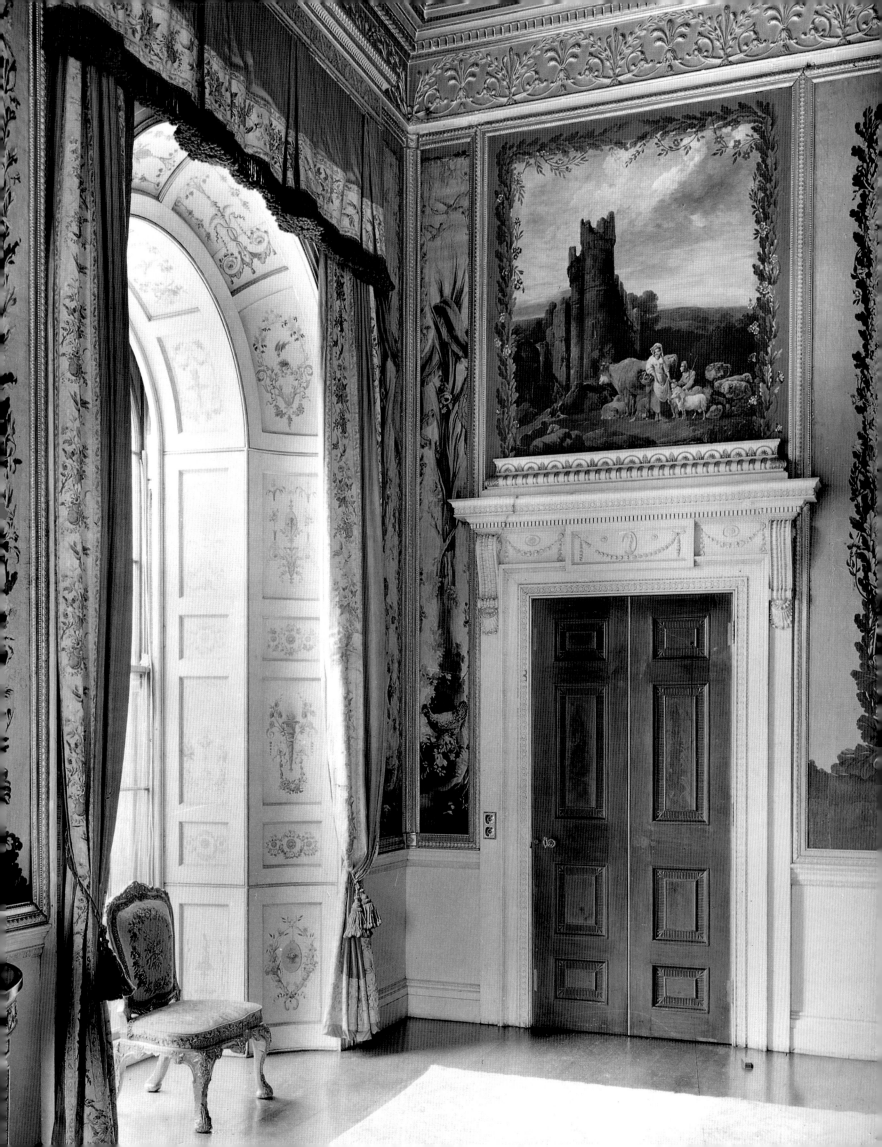

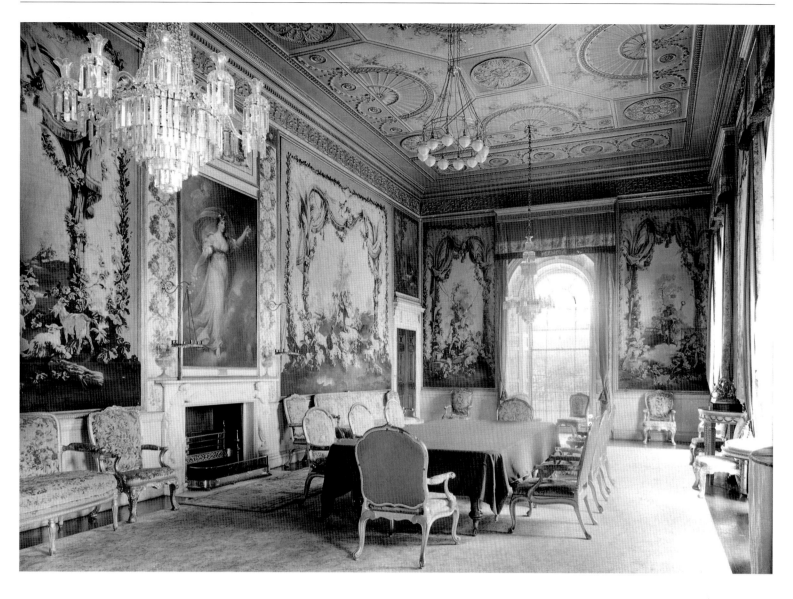

original but eccentric Gothic-revival castle into something more conventionally fashionable.

The two Mylne brothers, William and Robert, descendants of the long family line of Master Masons to the Crown of Scotland, had completed their architectural training with a spell in Rome and so were viewed as deadly rivals by their contemporaries the Adams brothers. At first it was William who was employed at Inveraray, but Robert became responsible for fitting up the principal rooms in the 1780s. Mylne's most striking, if wilful, visual alteration was to refashion the windows internally into circular heads, disguising their Gothick form. At the same time their sills were taken down to floor-level on the principal floor. The plan of the house was redesigned so that the original Entrance Hall became the Saloon and the proposed Long Gallery was divided unequally, to create an

Left and above: Robert Mylne designed the Drawing Room around the suite of Beauvais tapestries ordered in 1785; with the help of the resident French decorative painters, the entire room was imbued with Parisian elegance. In 1927 the Drawing Room was furnished to serve as the Dining Room. The chimney-piece was rescued in 1800 from an Edinburgh villa, Bellevue, that is now known to have been designed by Robert Adam and had been rented by the Duke of Argyll.

enormous Drawing Room and a smaller Dining Room on either side of a central smaller new Entrance Hall.

The great central Hall alone remained as Morris designed it, rising up to the attic clerestory, but its classical detail was muted beneath a dazzling display of Baronial weaponry. The French effects were achieved by a number of means. Firstly, quantities of decorative art were imported directly, such as the suite of *Pastorales à draperies bleues et arabesques* tapestries ordered from the Beauvais factory in 1785, around which Mylne had to plan his decorations. Secondly, French craftsmen were imported, among them two decorative painters, Guinand and Le Girardy, whose lighthearted arabesque ornamental painting in the Dining Room has such finesse that it alone justifies a journey to Loch Fyne. Lastly, Scottish craftsmen were trained to imitate the genuine French furniture and decorations. The *Country Life* photographs record the final effect, which must owe a great deal to Mylne's own decorative flair. His elegant ceiling designs for the circular turrets were executed in papier mâché.

It is fascinating to reflect on why Arthur Gill's photographs of the castle are so memorable. Certainly, he had an exceptional subject because few Scottish houses possessed interiors of such

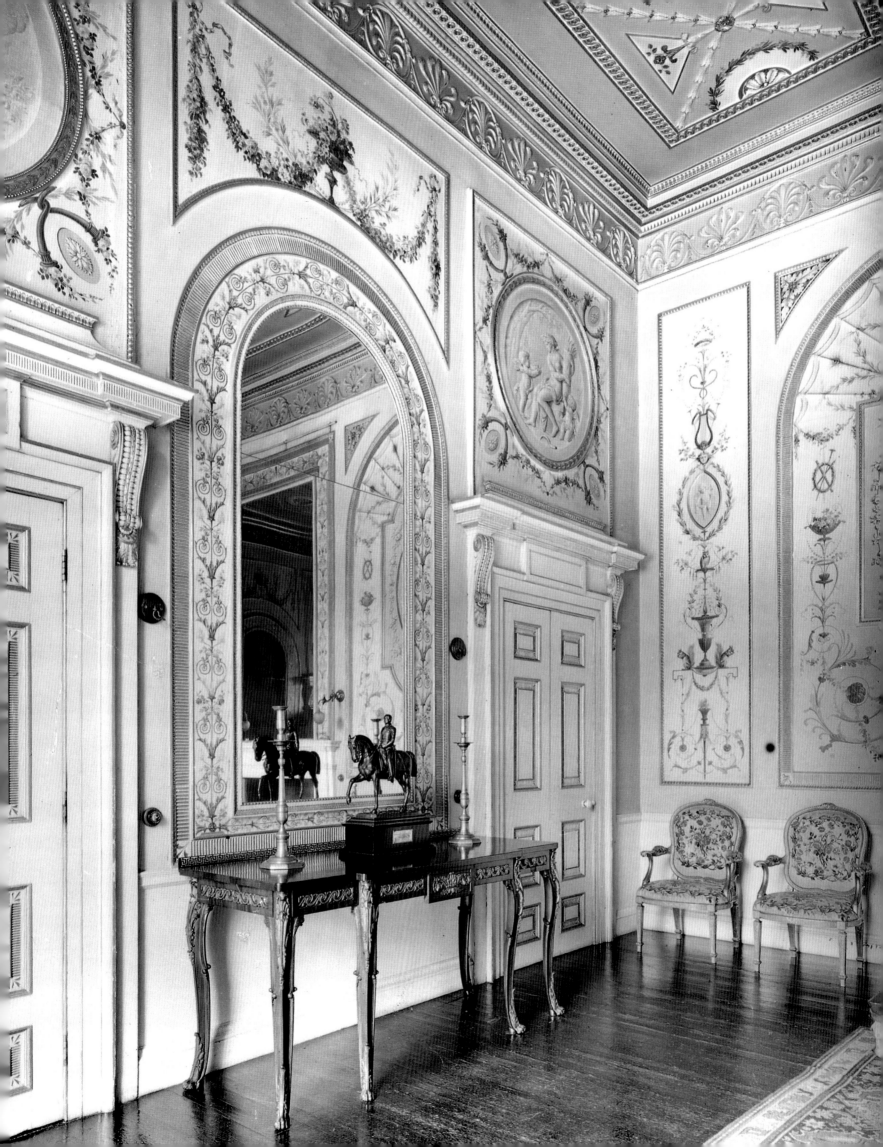

distinction. The best that Europe could offer in decorative art had been purchased and carefully integrated into an overall conception by an architect with a real flair for interiors. As Hussey wrote: 'It is necessary to stress the dour shell of Inveraray in order to appreciate fully the urbane, Georgian interior'.

According to John Cornforth in his *Search for a Style*, Gill had been chosen by Hudson to work on *Country Life's Dictionary of Furniture* and seems to have had a special sympathy for photographing furniture. In the published article, readers were presented with a pair of views of the Saloon, showing both ends of a room which even in the 1920s must have presented a rare and unusually balanced hang of exceptionally fine pictures. Although there had certainly been nineteenth-century alterations to the room, it retained an eighteenth-century effect. The Argyll family has never shown much interest in creating a gallery of fine paintings, but had excellent judgement in choosing artists to paint their portraits.

The Saloon was possibly conceived as a setting for the portrait by Batoni, commissioned by the Duchess of her son, the Duke of Hamilton, and painted in Rome in 1775. It is easy to see why a proud mother was inspired to build a room around this elegant, *controposto* image of her son. The portrait by Gainsborough of General Conway had to be enlarged to form a pendant. In 1927 portraits of the Duchess by Cotes and of the 4th Duke by Gainsborough were hung over the chimney-piece. A design by Mylne of 1780 survives, inscribed 'the Walls to be finished for Pictures', showing the outlines of the pictures. A greater formality was achieved, after the removal of the tapestries, by repeating dummy doors in the inside corners to balance the existing real ones on the enfilade along the window wall. The poise of the hanging scheme owes a great deal to the four gilt *appliqués*, known to have been gilded in 1788, which bear a prominent 'A' for Argyll and end in giltwood lyres. The polish of the Inveraray interiors owed a great deal to the services of M. Dupasquier, a gilder trained in Paris but in business in Edinburgh in 1775.

Hussey and Gill took three plates of the Saloon, including a wider view, revealing the central axial door, published here for the first time. The remarkable luminosity of these views, which look as though they were taken in sunlight, accented the sparkle of the gilded contents, including the superb French partner's desk, and was characteristic of the magazine's photographs of the 1920s and 30s. There can be little doubt, however, that the effect also owed a great deal to the skilful repositioning of the furniture to suit the magazine's stylistic requirements. The liveliness of the carefully angled single chairs in the foreground of this shot was typical of Henson's *Country Life* style.

Inveraray possesses such extensive examples of the most elegant French tapestry-upholstered gilt chairs that nobody seems to know which belonged where, but the convincing fit of the confidante sofa, supplied by the London furniture maker and designer John Linnell, seen beneath the portrait by Batoni, seems to confirm John Cornforth's suggestion that this suite was specially made for the Saloon. Although the overall effect of the room is mellow, Arthur Gill could not disguise the extent of the 'pleasing decay' then prevalent in the rooms, and the furry rug probably conceals a substantial hole. It is also clear that the additional ornamental swags on the lower corners of the elaborate picture frames are upside down.

The picture scheme for the Saloon was secondary because in the early 1770s it had been hung with the Teniers tapestries, which had been extended to fit by adding a frieze of French floral garlands. The Drawing Room and the State Bedroom were probably fitted up by John Adam as they have the rather solid, swirling rococo stucco he had used at Arniston. Although by 1927 the Tapestry Bedroom was described as the State Bedroom, the French bedstead, with its naturalistic painting, has no heraldic devices and is as likely to have been used by the Duchess herself since her Dressing Room adjoined it. The Drawing Room was clearly temporarily rearranged by *Country Life* because a contemporary photograph shows that the substantially upholstered chintz-covered sofas of the mid nineteenth-century had been edited out by a magazine in search of eighteenth-century elegance.

Hussey and Gill had difficulties photographing Mylne's original Drawing Room and Dining Room. The late eighteenth-century painted Dining Room proved too small for the nineteenth-century fashion for longer and wider dinner tables and so the tapestry-hung Drawing Room was annexed for the purpose. Gill's view of the room with the dinner table shows the pier table on the far right still protected with its case cover – a rare survival of old-fashioned

Left: Mylne's Dining Room, with its dazzling decorative painting by the French artists, Guinand and Le Girardy, had become a Billiard Room by 1927.

Above: The elegant ceiling decorations designed by Mylne for the circular turrets were executed in papier mâché.

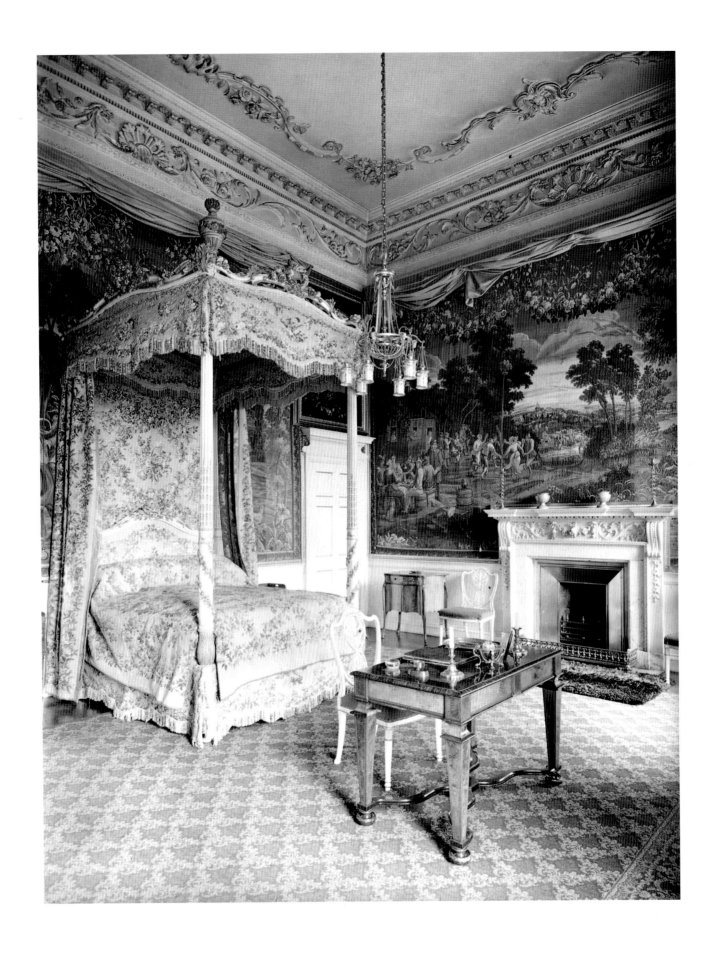

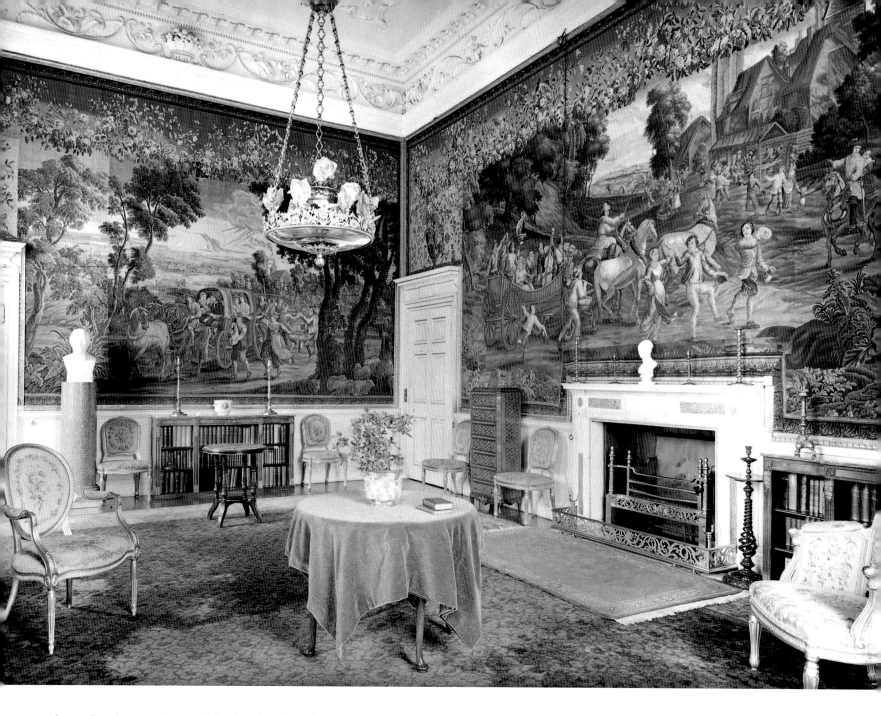

house-keeping practices, which played such an important part in preserving such precious rooms. The dinner table and the necessary brighter overhead lighting killed much of the effect of Scotland's most elegant room. But Gill resourcefully captured it in a series of detailed, table-less, studies which recovered the 5th Duke and Duchess's intended design. Its ceiling was Adamesque, but decorated by French painters with festoons of naturalistic flowers. The motif of interlinking circles of flowers on the backs of the large rectangular sofas shown in the *Country Life* photograph (*p.115*) may possibly be original to the room, for they relate to those on the ceiling. The former Dining Room now accommodated the billiard table.

Both the 1927 Drawing Room (above) and the State Bedchamber had Teniers tapestries that had been extended by deep borders of floral festoons and were first hung in the Saloon. Westley's photograph of the State Bedchamber (left), with its resplendent French bed, records the ruched-up case covers that protected the tapestries. The Drawing Room's furniture had been rearranged by Country Life *to exclude the room's comfortable sofas.*

Gill's study of Mylne's papier-mâché ceilings in the circular turrets may have remained unpublished then because of the prominent damp-stains. They are a reminder of the extent to which the untouched eighteenth-century quality of Inveraray in 1927, during its ownership by the 10th Duke of Argyll, was also the product of a more active neglect.

The extensive overhaul that both the castle and town of Inveraray required when the 11th Duke succeeded in 1949 is apparent from the *Country Life* photographs. The Duke's efforts were celebrated in the publication of *Inveraray and the Dukes of Argyll* in 1973 by his architect, Ian G. Lindsay, and Mary Cosh. It remains one of the most outstanding monographs on any British country house and has the particular interest of drawing together many accounts of visitors, which show how attitudes to this innovative Gothic revival castle and its dazzling interiors have changed over the last two hundred and fifty years. The present Duke and Duchess of Argyll have presided over another heroic restoration after a second disatrous fire in November 1975.

CULZEAN CASTLE

AYRSHIRE

English architectural critics often argue about whether Robert Adam should be considered primarily a decorator or an architect; the Scots have never had any doubts that he was an architect first and foremost, for their country is stocked with so many examples of his late masterpieces. Culzean has a very special place in this constellation because, poised between land and sea, it explores the delights of pure form, untroubled by the functional considerations that normally shackle architectural genius.

When Weaver's energies were redirected during the First World War and he was unable to continue to cover Scotland for *Country Life*, he encouraged A.T. Bolton to go northwards to carry out essential research on the Scottish roots of Robert Adam's early years for his monumental study, *The Architecture of Robert and James Adam, 1758-1794*.

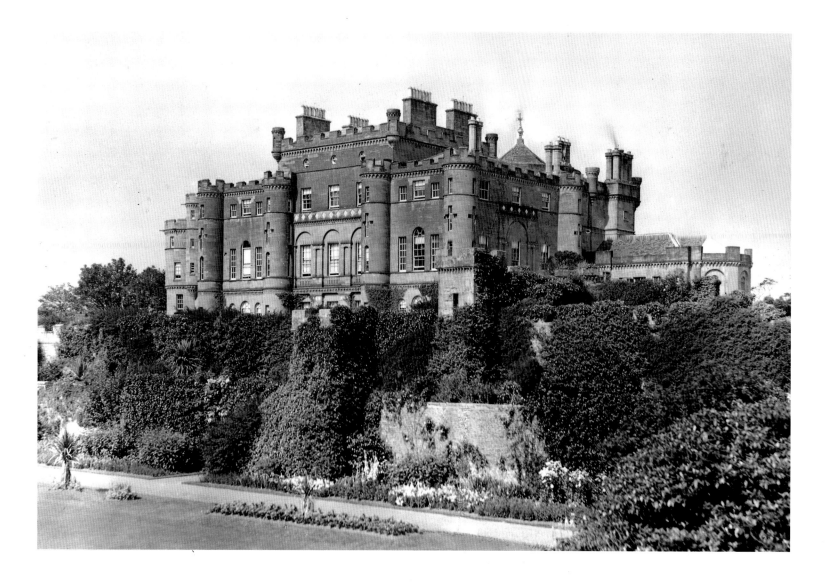

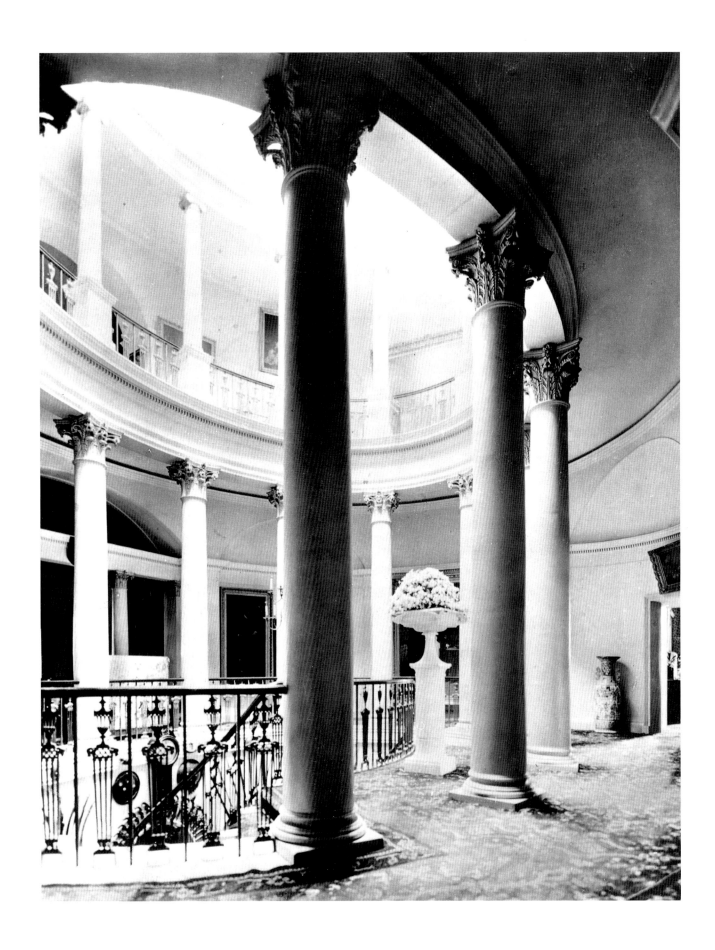

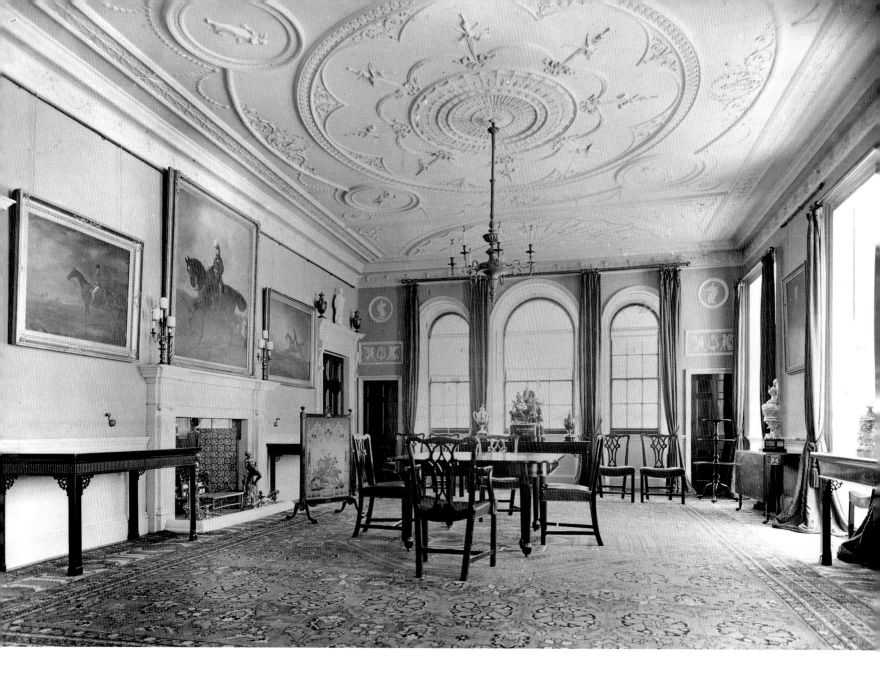

Bolton's interest in Adam had been stimulated by Weaver, who asked him in 1913 to write some articles on Adam's English commissions; as so often with Weaver, there was a book in view. The outbreak of war had left Bolton with time on his hands as his architectural practice dwindled, and his appointment in 1917 as Curator of the Soane Museum, happily, made him responsible for the Adam Office drawings that Soane had purchased in 1833.

Bolton did not warm to Scotland and whereas Weaver had found his Scottish forays intoxicating, Bolton was only sustained by his

Preceding pages: *In 1777, Robert Adam recased an old tower house in his Castle style to provide the centre-piece of a new house. The 1915 photograph shows the descending staircase of terraces (right), overgrown with shrubs that flourished in the mild seaside climate of the west coast. The Round Tower (left) on the edge of the cliffs was added in 1787.*

Left: *Adam inserted the great oval Staircase at the centre of the house in 1787.*

Above: *In 1878, the architects Wardrop and Reid were asked to join together Adam's original Library and an adjoining room to create a larger Dining Room. Although some of the detail was genuinely Adam, the éclat of the final result, with its papier mâché ceiling, probably betrays the intervention of Wright and Mansfield, the leading exponents of the Adam revival in London.*

unshakeable loyalty to Adam's major English palaces, such as Syon and Osterley. He was no admirer of the Adam Castle style, adhering to the Victorian conviction that its detail lacked archeological scholarship. Culzean prompted him to write: 'Fortunately Robert Adam seems to have been satisfied with external castellated effects, and for the interior followed his usual style of decorative finish'.

Culzean has to be experienced at first hand, and that experience loses nothing from a knowledge of its highly unusual genesis. It began conventionally enough when the bachelor 10th Earl of Cassills asked Robert Adam to make modest additions to the old square family tower house, set back from the sea, in 1777. These were to have the germ of some modest spatial excitement in the apsidal ends of its eating room on the ground floor. The potential of the cliff-top site, which overlooked a spectacular stretch of coastline, dominated by the rocky bulk of Ailsa Craig, led Adam and his patron to add the massive round tower in 1785, containing the circular Saloon, whose floor-to-ceiling windows opened onto a balcony, high above the cliffs and the pounding waves far below. The exhilaration of this room moved even Bolton to enthuse about

how the tight curve of its six windows, occupying almost half the available wall-space, flooded the Saloon with western sunlight.

The success of this venture inspired the Earl and Adam in 1787 to connect the old house and the new cliff-top bow-fronted Saloon by a central top-lit staircases with galleries ringed by columns. The constrictions of the existing space demanded that this should take on a dynamic oval form, creating thrilling vistas through the tight curves of its superimposed columns. So successfully does the Great Staircase pull the design of the entire castle together, that it seems almost inconceivable that it should have been an afterthought.

The architectural fireworks at Culzean extend far out into the seascape. A dramatic staircase of terraces drops away beneath the old house to the gardens; the house is approached by means of a theatrically ruined bridge; and almost for the sheer fun of it, along the cliff-line there is an extended line of geometrically-planned stable offices, to which a home farm stands in a fascinatingly and unexpected oblique axial relationship.

This costly execution of pure masonry form perhaps required a bachelor architect as well as a bachelor patron, but it is difficult to believe that it can ever have been an easy house for the families of the Earl's successors to live in; it is not difficult to understand why the third Marquess of Ailsa asked Wardrop and Reid, the Edinburgh architects, to supply much needed service accommodation in 1877. The arrival of a firm of Victorian architects might have spelled the end of these Neo-Classical fun and games, but rather unexpectedly, it seems to have sparked-off an Adam revival. In 1879 the same firm were retained to effect improvements at Haddo in Aberdeenshire, and found themselves caught up in the enthusiasms of Lord Aberdeen's father-in-law, Lord Tweedmouth, who through his pioneering passion for collecting Georgian Wedgwood jasperware had inspired a renewed interest in the art of Robert Adam. With characteristic thoroughness, he diverted a firm of Mayfair decorators, Wright and Mansfield, to execute not only furniture, but to realize entire Adam-revival interior architectural ensembles for him. Lord Tweedmouth and his decorators had a field-day at Haddo and it remains their masterpiece.

At Culzean Wardrop and Reid threw together two small Adam rooms on the ground floor to create a larger Victorian Dining Room. Because the drawings for their first scheme show a dull modern classical room while the executed scheme is a brilliant Adam pastiche, it is difficult not to believe that Lord Tweedmouth's artificers had a finger in this architectural pie. The new room took the existing genuine Adam decorations of the former Library-end as its starting point, but the new ceiling was executed, like those at Haddo, in papier mâché.

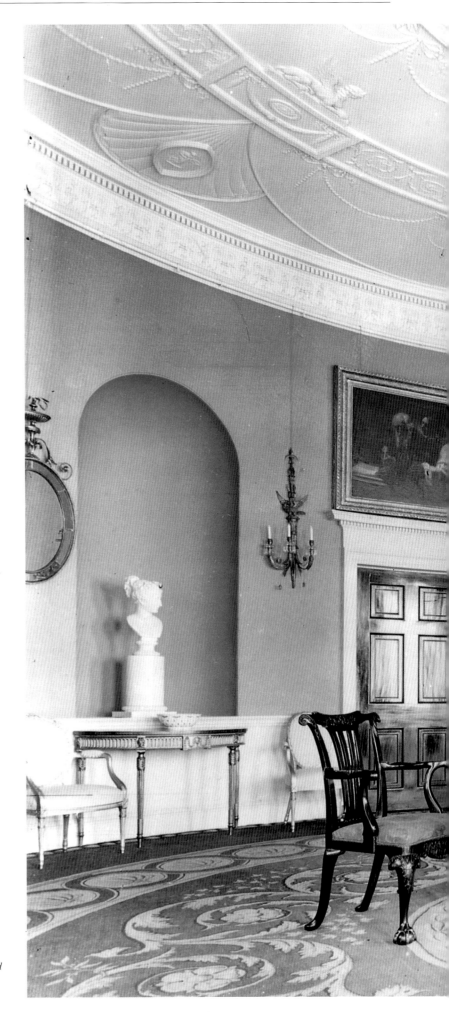

The 1785 Round Tower contains Adam's circular Saloon. Bolton's photograph shows how the Adam girandoles and mirrors had been rescued and displayed around the walls. The glory of Culzean was the great plum-coloured carpet, said to have been made locally especially for this room. The photograph also reveals that the carpet once had a matching hearth rug, which is now missing.

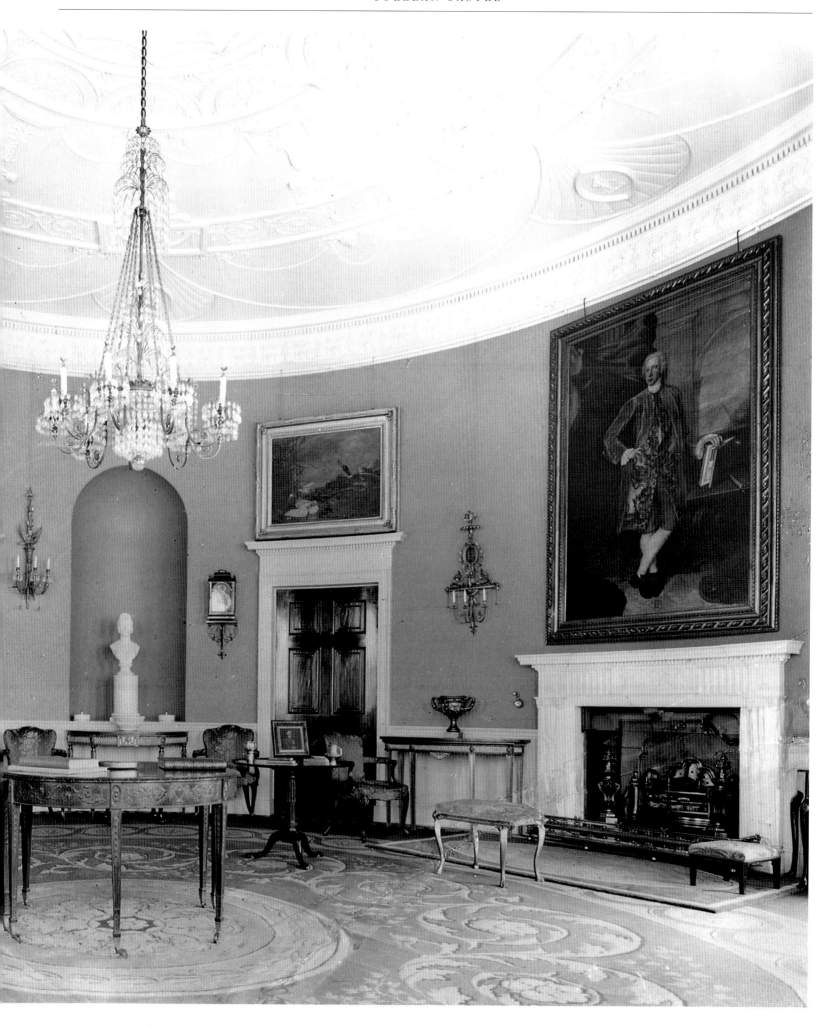

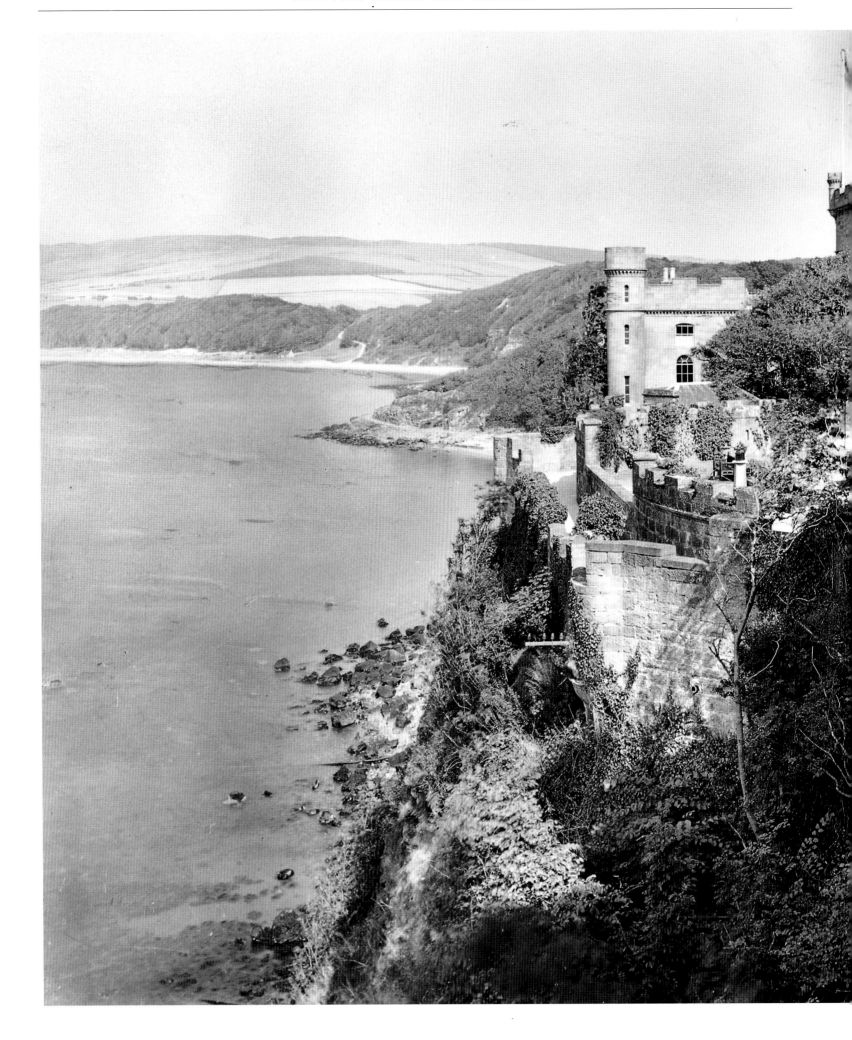

The Adam chimney-piece of the original eating room next door was reproduced and all the doorcases, both old and new replicas, were topped by Tanagra-like plaster statuettes and a harlequin set of Neo-Classical vases. A photograph of one of the Drawing Rooms shows opulent ormolu-mounted 'Louis' furnishings, possibly introduced in the nineteenth century by the 1st Marquess.

There is a sense in the *Country Life* views of Culzean that, for once, the carefully marshalled Adamesque furnishings were permanent and not the caprice of the magazine's photographer. In the Saloon, the original Adam pier-glasses and girandoles, alongside a bracket clock, were given place of honour once more on the wallface, and appropriately Adamesque gilt chairs and tables positioned around the room. A few items, such as the semi-circular pier-tables which stand below the niches, opposite the windows, in the circular Saloon, fit so snugly that they are surely Adam-revival creations. The great glory of the Saloon was the plum-coloured carpet, alleged to have been designed by Adam and made locally in Scotland. Sadly, the sheer numbers of visitors has led to its replacement by a copy.

In 1945, Culzean Castle was presented to the National Trust for Scotland. Although it has since given pleasure to millions on Glasgow's seaside doorstep, it must also have given the Trust many sleepless nights. The 10th Earl and Robert Adam could not have found a better way of exposing fragile sandstone exteriors to the destructive forces of salt air than through their design.

Not content with the Neo-Classical fun and games of the Castle itself, Adam and the Earl of Cassillis scattered geometrically-planned stable offices and a home farm along the cliff-top – a panorama that can only be fully appreciated from a boat.

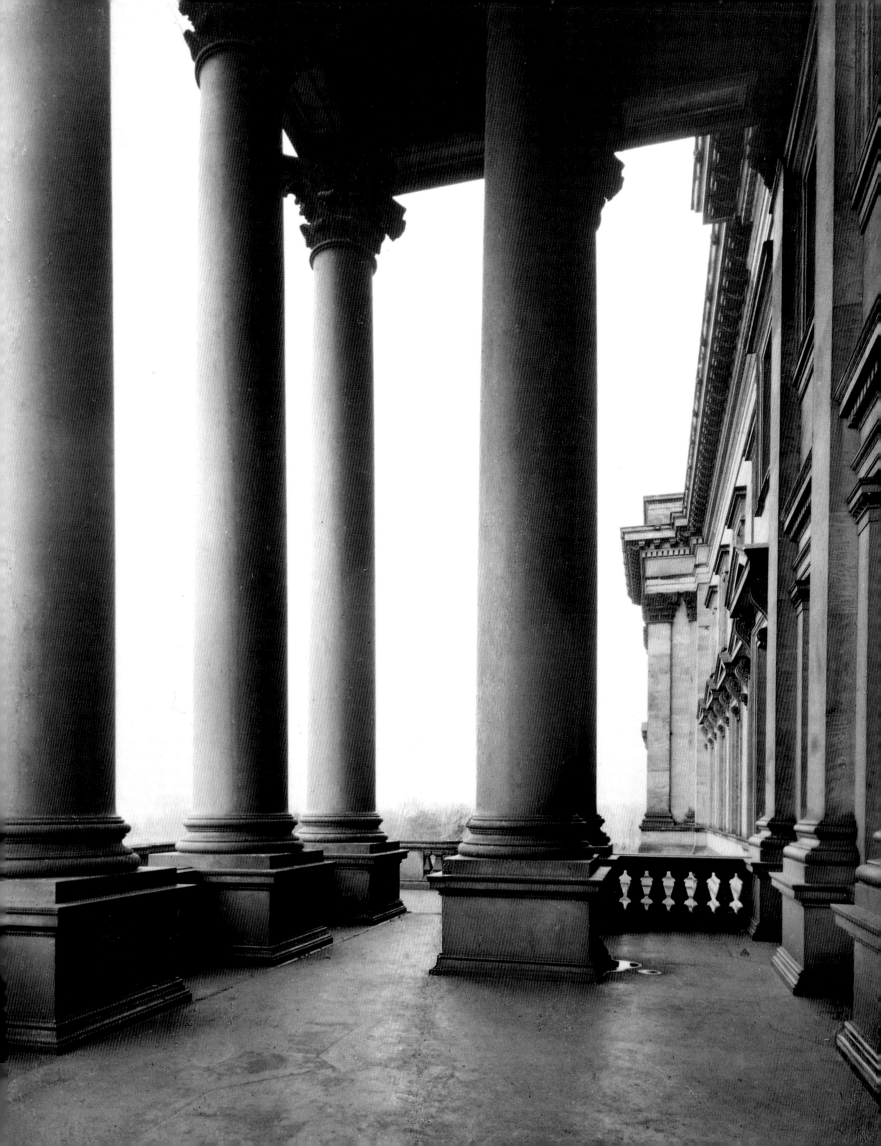

HAMILTON PALACE

LANARKSHIRE

Country Life's most outstanding service to Scottish architectural history comprises the one hundred and thirty three glass-plate negatives taken in 1919 before Scotland's largest and most magnificent country house was levelled with the dust. The magazine's ability to cope with such a demanding task at relatively short notice was an indication of the extent to which its coverage of Scotland had been brought into the mainstream of the London office. The three articles on the palace, with two more on the picture collections, were written by H. Avray Tipping and showed a competent handling of Scottish sources, if lacking Weaver's flair. But the quantity of photographic plates reflected the magazine's acquisition of an exceptionally able staff photographer in A.E. Henson.

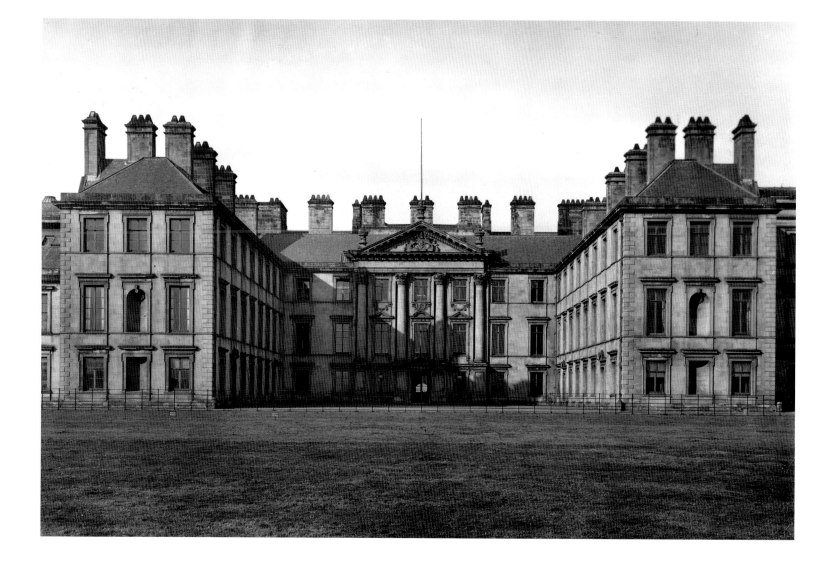

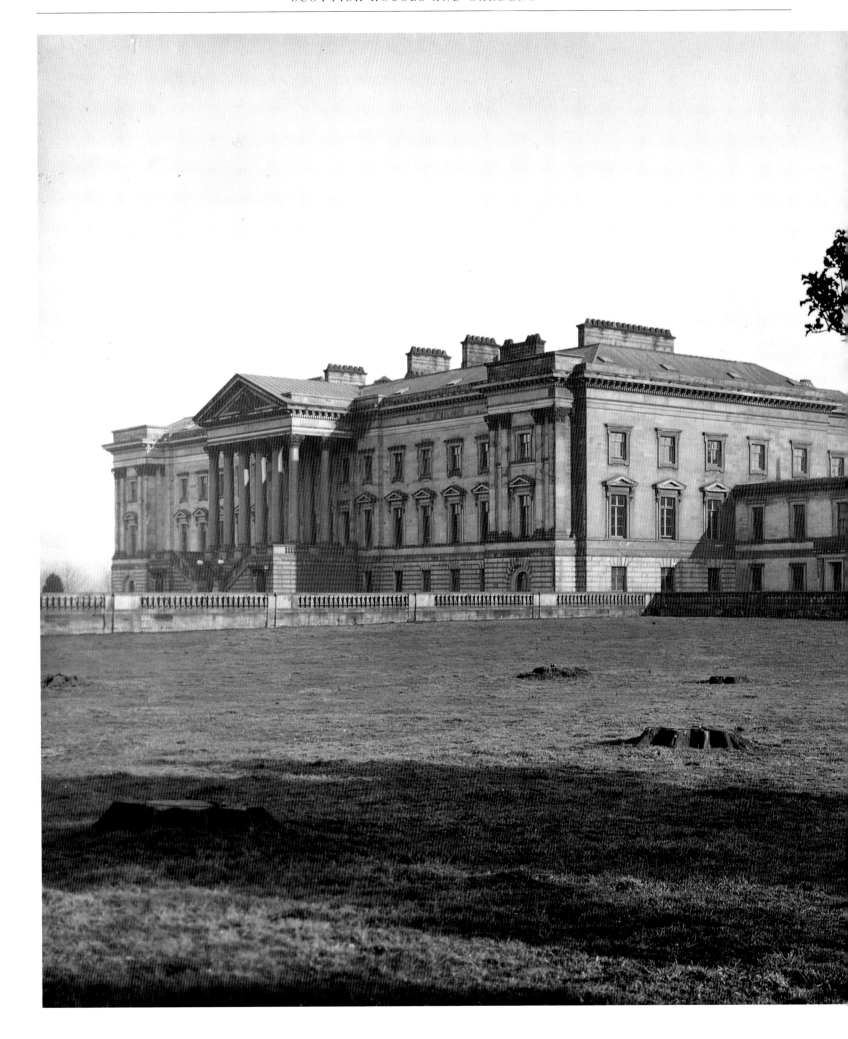

The demise of Scotland's grandest palace had not been sudden and had complex causes. The palace's aggrandizement during the second quarter of the nineteenth century had been in direct proportion to the exploitation of the immense mineral resources, principally coal, that lay under the lands of the 10th Duke. He died in 1852 and was buried in the princely Mausoleum, designed for him by David Bryce, that had been built alongside the palace. One of the Duke's motivations in transforming the palace had been to display the art collection, assembled with the help of agents posted throughout Europe, which joined the ancestral one he had inherited. A third great art collection subsequently arrived at the palace, when the Duchess inherited her father William Beckford's extensive treasures.

The first sign of the palace's unravelling came in 1882 when the 12th Duke was obliged to sell off some of the art to raise capital. The 10th Duke's manuscript Inventory, now in Hamilton Public Library, was heavily annotated during the decision-making process. As befitted the dignity of Scotland's premier Duke, the sale was handled with some discretion by Christie's and was held distinctly 'off the premises' in their London salerooms. Although the catalogue was illustrated with photographs, the location of works of art within the palace rooms was not given and no family portraits were exposed for sale. But denuded of their art, the great rooms had rather lost their point, in spite of the Hamiltons' extensive run of ancestral portraits. The 10th Duke was not especially sensitive to the patina of ages and had the historic zones of his palace repaired into a state of nineteenth-century perfection, which suddenly emerged as a rather hard-edged foreground when treasures such as lacquer cabinets that had belonged to Marie Antoinette and the two celebrated Boulle armoires began their long journeys to permanent rest in the world's greatest museums.

The final blow came with the First World War when the palace was requisitioned to serve as a Naval Hospital. By the end of the War the Duke had discovered that he 'rightly prefers a house of moderate size' and, perhaps understandably, felt no desire to move back to a vast and deeply unfashionable monument to family pride. But it was the loss of its amenity lands that doomed the palace to demolition. Tipping ably summarized the reasons that underlay its fate:

Preceding pages (left): *The 25-feet high monolithic columns of the 10th Duke of Hamilton's north portico of 1822 were each transported from the quarry in 'an immense wagon constructed for the purpose and drawn by thirty horses'.* (right): *The south front of Hamilton Palace, with its recessed Palladian pedimented frontispiece, was grafted onto a much older house by James Smith in 1693. The left-hand wing contained Smith's Great Apartment on the first floor, while the right-hand wing contained the Duchess's stuccoed suite, with the Duke's Apartment beneath on the ground floor.*

Left: Country Life's *1919 photograph shows the full extent of the 10th Duke's monumental north front with its attached Court of Offices.*

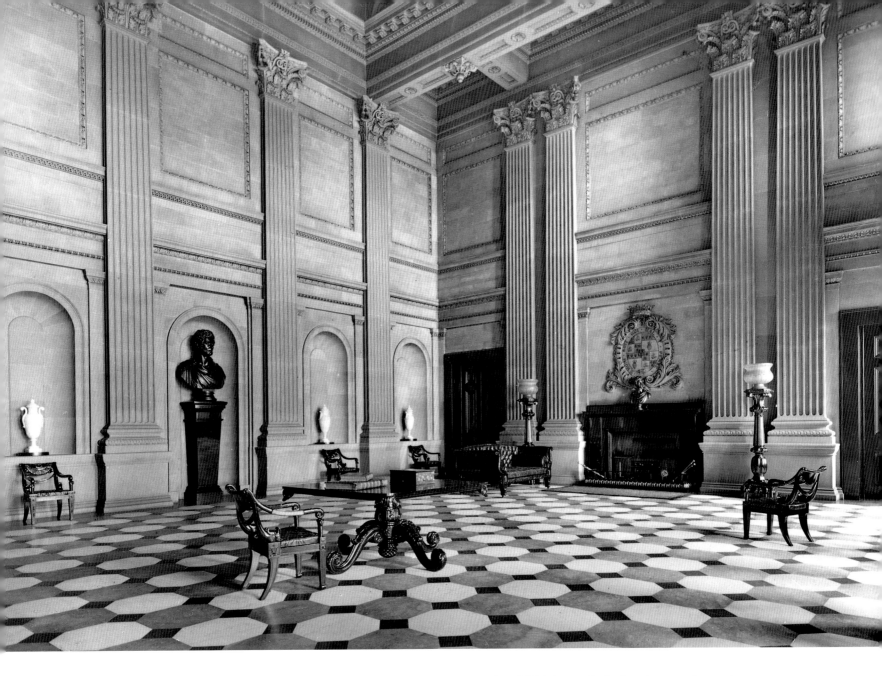

Whether decay and disappearance are to be the fate of the whole batch of our oversized country seats it is too early to decide, but the doom of Hamilton Palace is imminent. Its situation and condition join with its size in procuring its condemnation by general consent. It is in the midst of the Lanarkshire coalfield, and the numerous and proximate pits not only destroy its amenity, but actually threaten its structure. Subsidences in the park have been followed by ominous cracks in the walls. Pick and shovel work nearer and nearer, so that the time seems to be approaching when inhabitance may become not merely disagreeable, but dangerous. And so Hamilton Palace, with its history and traditions, its splendour and its treasures, may very soon pass finally away. The first blow, indeed, was struck thirty seven years ago, when masses of its most rare and costly contents were dispersed causing the *virtuoso* pulse to throb lustily, and adding a still unforgotten page to the annals of Christie's saleroom. Yet, how much remained over, how fine are still the decorations and the furnishings it is the purpose of these articles to show. They, have, therefore, the double interest of reciting and exhibiting the greatness and excellence of this ducal abode, and also forming its swan song, the final snapshot before dissolution.

How fortunate for Scotland that the 'snapshot' artist at the eleventh hour was A.E. Henson. Tipping and Henson's portrait is

a less than faithful record of what they saw in one important particular. With nobody on site to stop them, after the Duke had moved to his more manageable house at Dungavel, they indulged in a veritable orgy of furniture removals to compose, rather in the manner of professional morticians, a set of historically perfected images of the palace rooms. In spite of Tipping's apparently extensive coverage in three articles, contemporary prejudice against the 10th Duke's additions meant that large areas of the palace were not deemed worthy of photography by *Country Life* and were demolished without any record. The magazine eschewed the top-lit Tribune, the State Drawing Room and Bedroom in the south front and the marble-walled, 'Louis' furnished State Dining Room, the Duke's apartments and much more besides. It concentrated its

Above: *The Entrance Hall lay behind the north portico and its pilasters and entablature continued and matched precisely the proportions of the portico columns. The central niche, opposite the entrance, held an outsize bronze bust of the 10th Duke of Hamilton.*

Right: *The carved balustrade of Smith's original Great Stair leading to his State Apartment was preserved, but reset in a stairwell with nineteenth-century marbled walls and classical statuary in niches.*

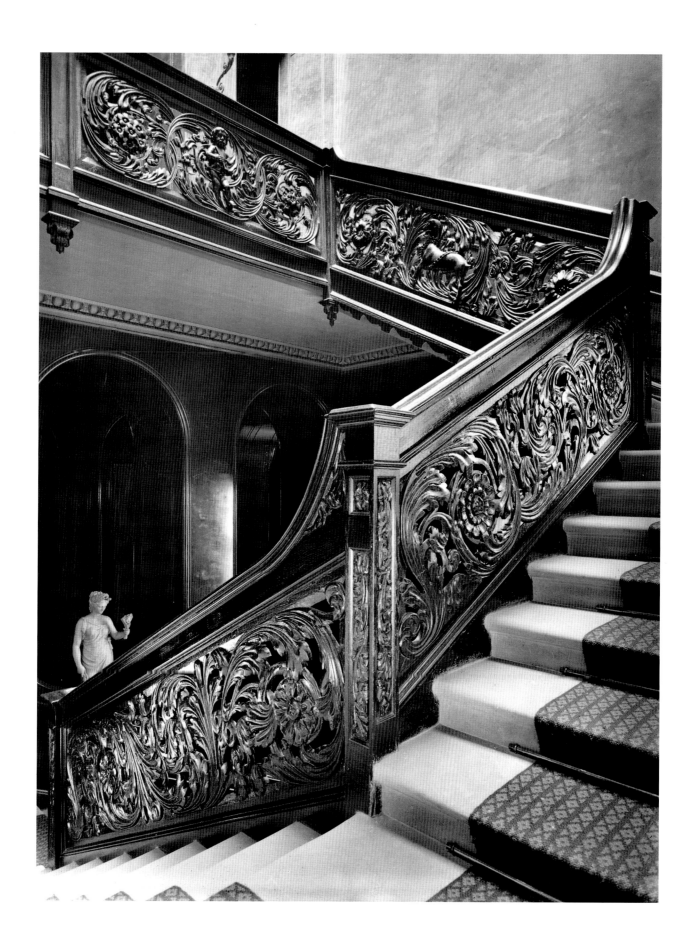

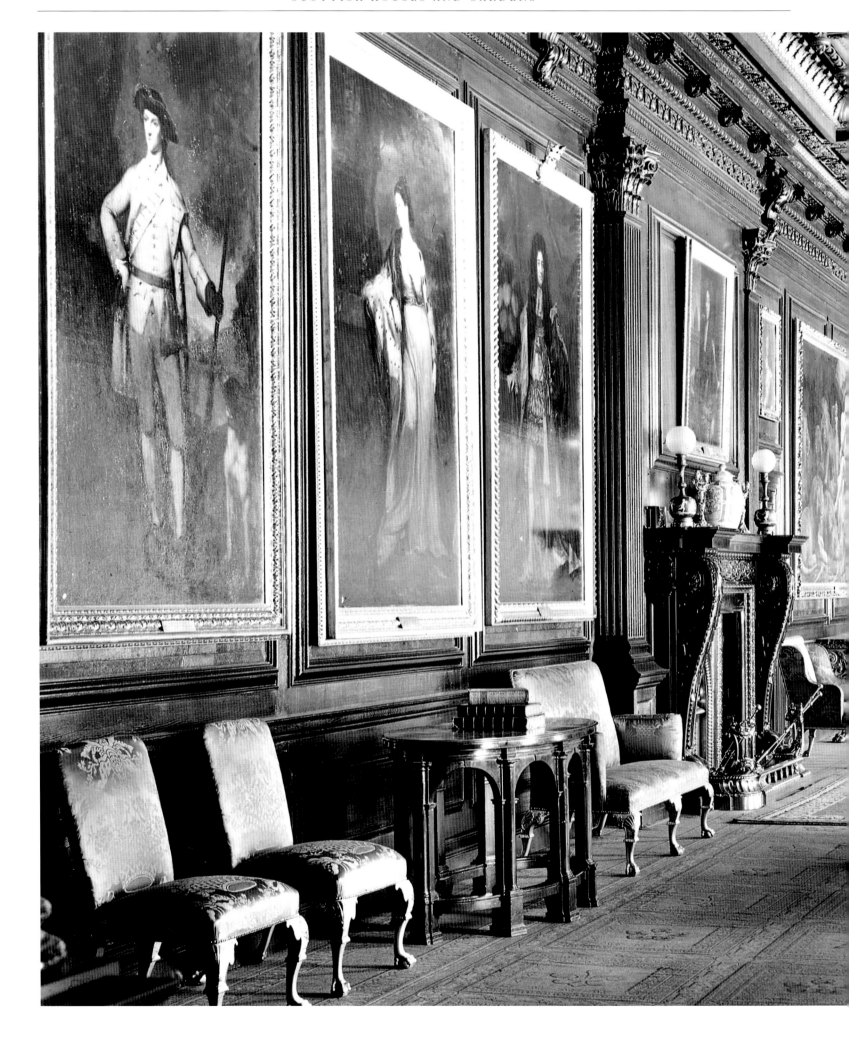

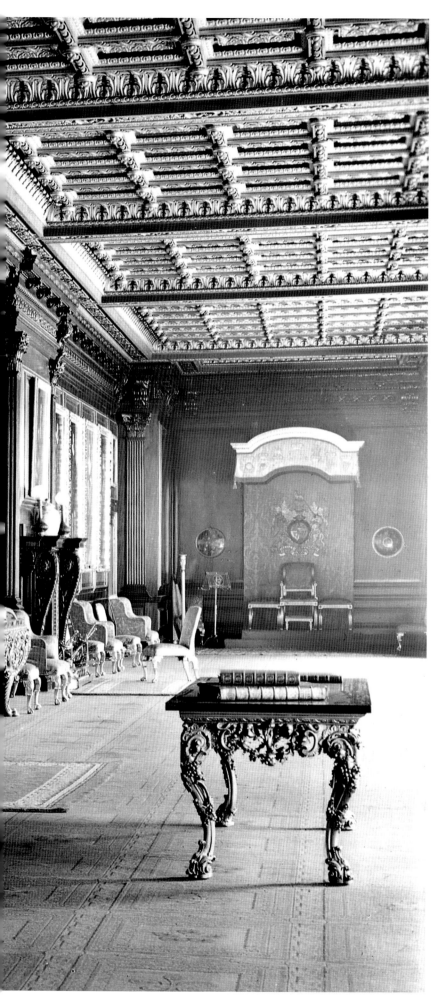

attention instead on the finest examples of Georgian furnishings in the bedrooms on the upper floor.

The first article dealt with the original, crimson-upholstered state rooms that lay behind the façades designed by James Smith during the 1690s. The second dealt with William Adam's rooms of the 1740s, with dazzling stuccowork by the Clayton family, which were subsequently occupied by the Duchess. The last article attempted to come to terms with the 10th Duke's monomaniacal additions with their elephantine scale (his portico columns were monoliths requiring an advanced degree in civil engineering to assemble on site), but perhaps unable to cope with such conspicuous consumption, Tipping perversely chose to view these works as merely a continuation of Adam's eighteenth-century designs. The article is accordingly illustrated chiefly by elegant late eighteenth-century bedroom suites. The Duchess's Rooms retained their eighteenth-century blue textiles while the apartments of the Duke's daughter-in-law, Princess Marie of Baden, had green upholstery. Tipping was aware of the part played by the Glasgow architect David Hamilton, but rightly divined that the 10th Duke, *Il Magnifico*, had strong opinions of his own that were reflected in the rooms' designs.

In fact, there was hardly a square inch of the palace that had escaped the 10th Duke's improvements. The Gallery was entirely nineteenth century in its fittings and Smith's state rooms had been embellished with monumental *trompe l'oeil* ceilings by D.R. Hay which Henson tried to ignore. The extent of the *Country Life* furniture removals can be seen by comparing Henson's photographs with the few other existing photographs of the rooms. The palace had been photographed by Annan of Glasgow before the 1882 sale, but after the departure of the art collections it must have appeared much less attractive to photographers. The collections at Hamilton District Libraries include a small album of photographs by Lafayette, which reveals how the Louis XV commode in the Princess's Bedroom, sold in 1882, had been replaced by a very ordinary and ugly mahogany chest of drawers.

H. Avray Tipping and A.E. Henson's visual improvement of the palace, to make it fit the sensibilities of *Country Life* readers, included editing out such un-ducal infelicities. A comparison with the Lafayette photograph of the 10th Duke's Breakfast Room (*p.20*) shows that Tipping and Henson left only the paintings untouched. The 10th Duke's voluptuous suite, including the 'richly carved Mahogany sofa in morocco' of the 1876 Inventory, designed specifically to serve the Breakfast Room's purpose, was deemed to be out of period with the late seventeenth-century panelling and was temporarily hidden. Lafayette's photograph shows that the original 'bordered Turkey Carpet' had been replaced by the

The Gallery ran the full 120 feet across the first floor, immediately behind Smith's south front portico. Although it was clear H. Avray Tipping knew the chimney-pieces had been replaced by the 10th Duke, he may not have realized that all the panelling and the ceiling had been embellished at the same time.

opulent 'Louis' carpet from the 10th Duke's Tapestry Drawing Room on the north front. This was deemed to be too distracting by *Country Life* and so what its readers actually saw was the carpet's protective drugget, with its less offensive tiny repetitive pattern. The deep-buttoned Grecian-inspired sofa from the Breakfast Room was replaced by one with a Georgian frame from the Gallery; a set of silk-upholstered walnut chairs, dated *c*.1710 by Tipping and much admired by him for their chased and gilt metal mounts, was positioned around the room. This suite of furniture also featured in *Country Life*'s view of the State Dressing Room.

The Gallery sofa was part of a very long set of cabriole-legged chairs evicted from the room by Country Life because the 10th Duke had:

kept the legs but reconstituted the upper part with deplorable results: the entry in the Inventory for insurance reading: "the Alterations to frames of arm and single chairs, restuffing and covering the whole with New Aubusson Tapestry... £180.00". To our present way of thinking that sum was subtracted rather than added in the process.

The entire suite was therefore removed from the Gallery, and chairs with purer Georgian lines were introduced. Tipping and Henson's search for period synchrony culminated in their transfer of the 10th Duke's Breakfast Room suite to the Great Hall. All the *Country Life* photographs show a tendency to choreograph the newly introduced chairs and tables to create a 'lived in look'.

Above: *At the end of Smith's Great Apartment lay the former State Bedroom with more of Smith's panelling that had been 'thoroughly repaired' by the 10th Duke. The State Dressing Room lay beyond; all were refurnished by* Country Life.

Right: *Smith's Great Dining Room became the 10th Duke's Breakfast Room and had voluptuous Neo-Classical furniture, but was entirely refurnished by* Country Life *with more appropriate 'period' furniture. Smith's plain plaster ceilings were painted in* trompe l'oeil *by D.R. Hay, the Edinburgh decorator.*

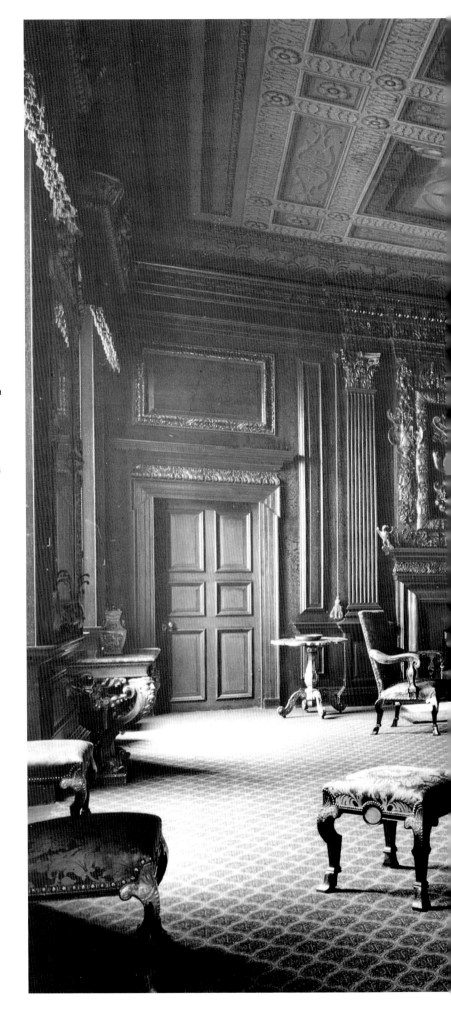

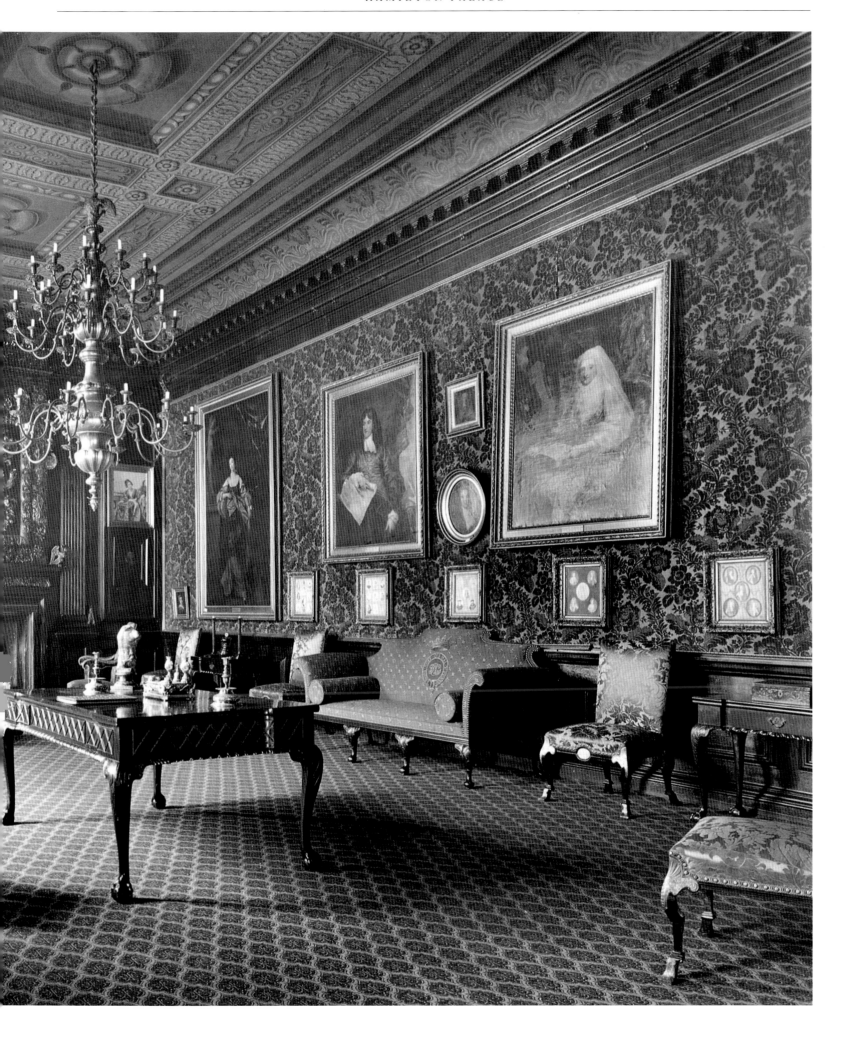

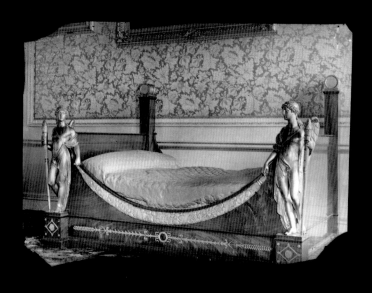

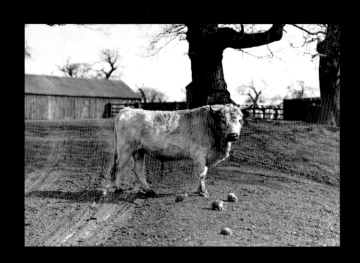

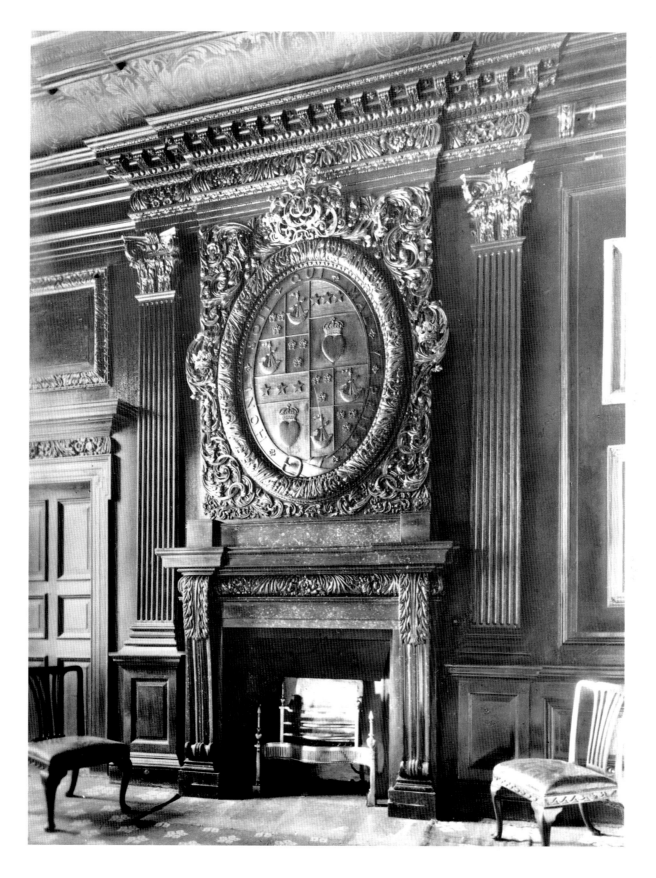

Left: Country Life's *photographic record of the Palace included everything*
that was about to come under the hammer: the remaining treasures
and sculpture, the furnishings, the ceramics, silver and glass, and even the
celebrated Cadzow cattle.

Above: *Detail of Smith's Great Drawing Room chimney-piece, originally carved*
by the English craftsman William Morgan, but repaired by the 10th Duke.

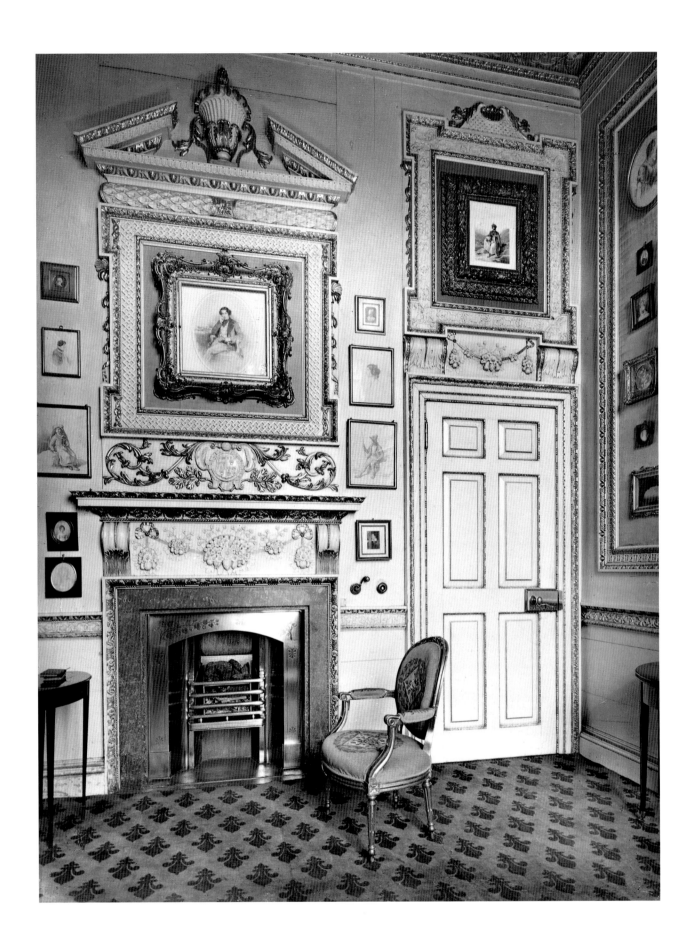

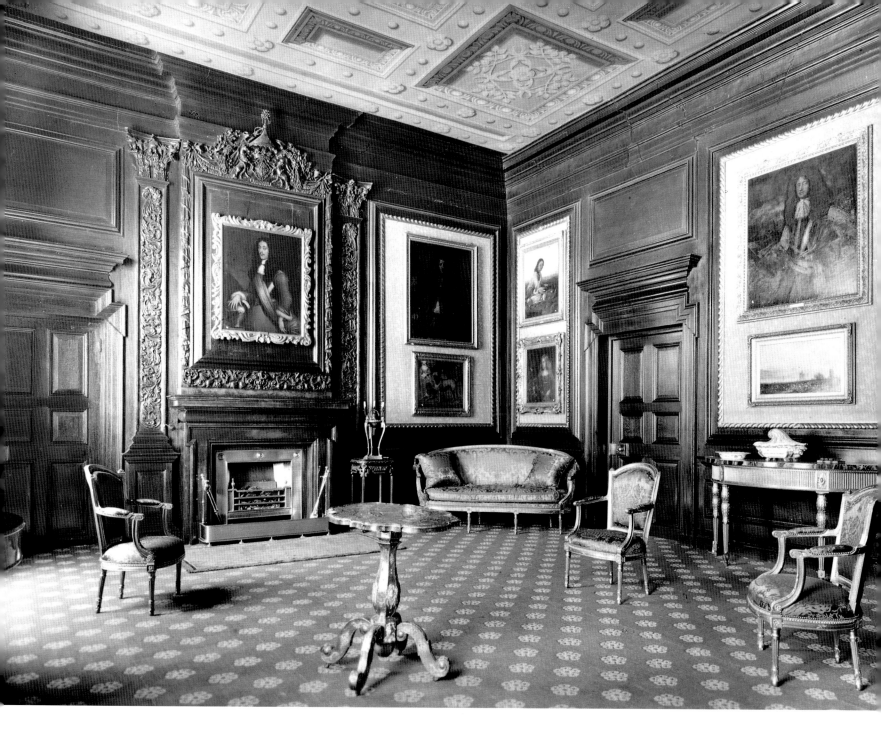

We can now view the *Country Life* photographs differently and relish the 10th Duke's heraldic games with his carpets and fabrics, and Hay's gigantic painted ceiling ornaments. And if the rooms they appear in have to be treated with caution, the photographs of the furnishings can easily be related to the surviving Inventories.

One of the most vivid descriptions of the impact of the 10th Duke's palace was published by Dr Waagen, Director of the Royal Picture Gallery in Berlin, who had come to inspect the collection of paintings for his *Treasures of Art in Great Britain* (1854), and whose widely travelled eye was astonished by this palace in the west of Scotland:

Above: *At the right-hand of the Gallery lay the Withdrawing Room or Music Room leading to the Duchess's Suite, with a carpet pattern bearing the Hamilton cinquefoil.*

Left: *Detail of the Duchess's Dressing Room at the end of her Suite.*

As the Duke combined in equal measure a love of art with a love of splendour and was an especial lover of beautiful and rare marbles the whole ameublement was on a scale of costliness with a more numerous display of tables and cabinets of the richest Florentine mosaic than I had seen in any other palace. As a full crimson predominated in the carpets, a deep brown in the furniture, and a black Irish marble, as deep in colour as the nero antiquo, in the specimens of marble, the general effect was that of the most massive and princely splendour; at the same time somewhat gloomy, I might also say Spanish in character.

If the authors of the New Statistical Account of Lanarkshire in 1845 lacked Dr Waagen's depth of knowledge about art, their statistical approach painted a no less vivid picture of the palace as it moved towards its zenith. 'The back was now the front' as a result of moving '28,056 tons, 8 hundredweights and 3 quarters of stones' that 'had been drawn by 22,528 horses [sic]' to create the 'gorgeous pile'. If by 1919 the palace was in decline, in 1845 it was still ascending: 'the collection of paintings, now greatly in the

increase, has long been considered the best in Scotland' and was estimated at two thousand items. The Duke's prints in the Library were never shown to visitors and many of the parcels had not even been unwrapped.

The Statistical Account gave a complete geological breakdown of the Duke's marblemania. Purple porphyry was a particular passion and abounded in the costliest table tops in the largest available pieces. At the end of the Picture Gallery opposite the Duke's throne was a doorway in black marble with columns of the rarest green porphyry. The throne was supported on each side by red porphyry busts of Augustus and Tiberius and had been 'the present Duke's ambassadorial throne, brought from his embassy in Petersburg'. This must also have been a useful reminder to visitors of the Hamiltons' strong claim to the throne of Scotland. The plate used in the State Dining Room was valued at £50,000.

Statistics were to come into their own again to describe the 1882 Hamilton Palace sale, which raised a grand total of £397,562. The final sale, when panelling, chimney-pieces and the very building materials of the palace came under the hammer, was held on Wednesday 12 November, 1919 and Christie's 'Catalogue of the

Remaining Contents of the Palace including woodwork and fittings' opened with a précis of Tipping's articles. A new paragraph was added to the end of it, almost certainly contributed by the auctioneers:

It is a thousand pities that so great and historic a house should disappear. That being inevitable, one must hope for the preservation and adequate use of the splendid materials and choice fitments. Within and without the Palace offers us the best that the seventeenth, eighteenth and nineteenth centuries produced, and the present dispersal yields a very unusual opportunity of acquiring sumptuous examples of all three periods in the finest possible state of preservation.

Below and right: *The rooms of the Duchess's Suite were designed by William Adam and sumptuously stuccoed by the Clayton family of plasterers in the second quarter of the eighteenth century. The Duchess's Boudoir, like the other rooms of her Suite, retained Adam's white and gold stucco with blue upholstery.*

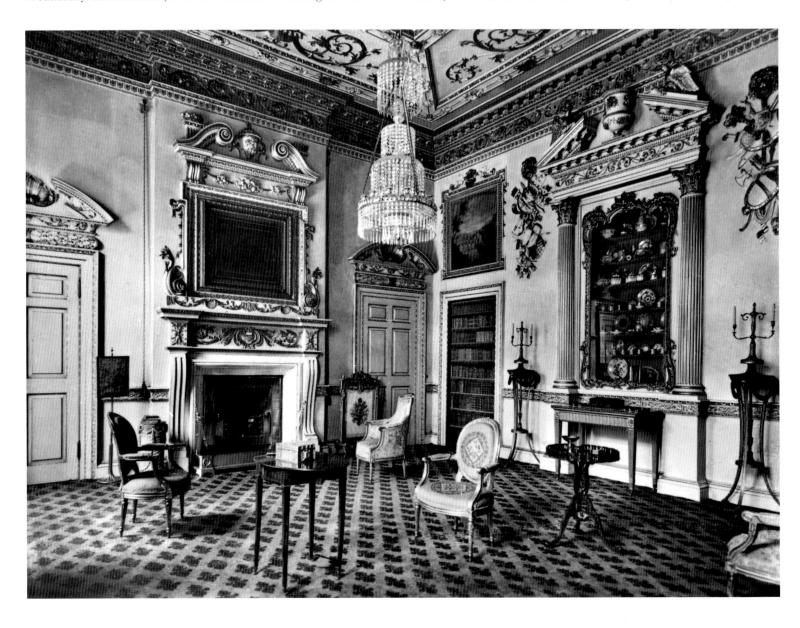

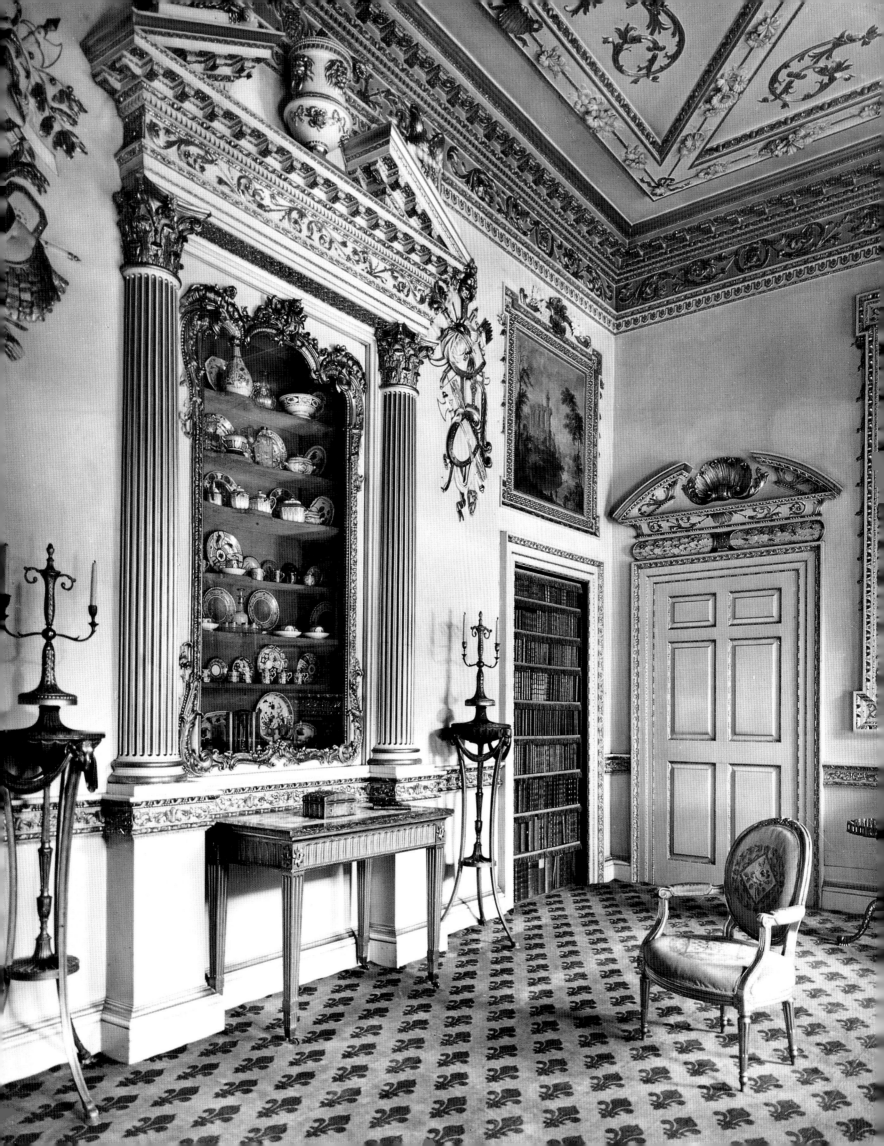

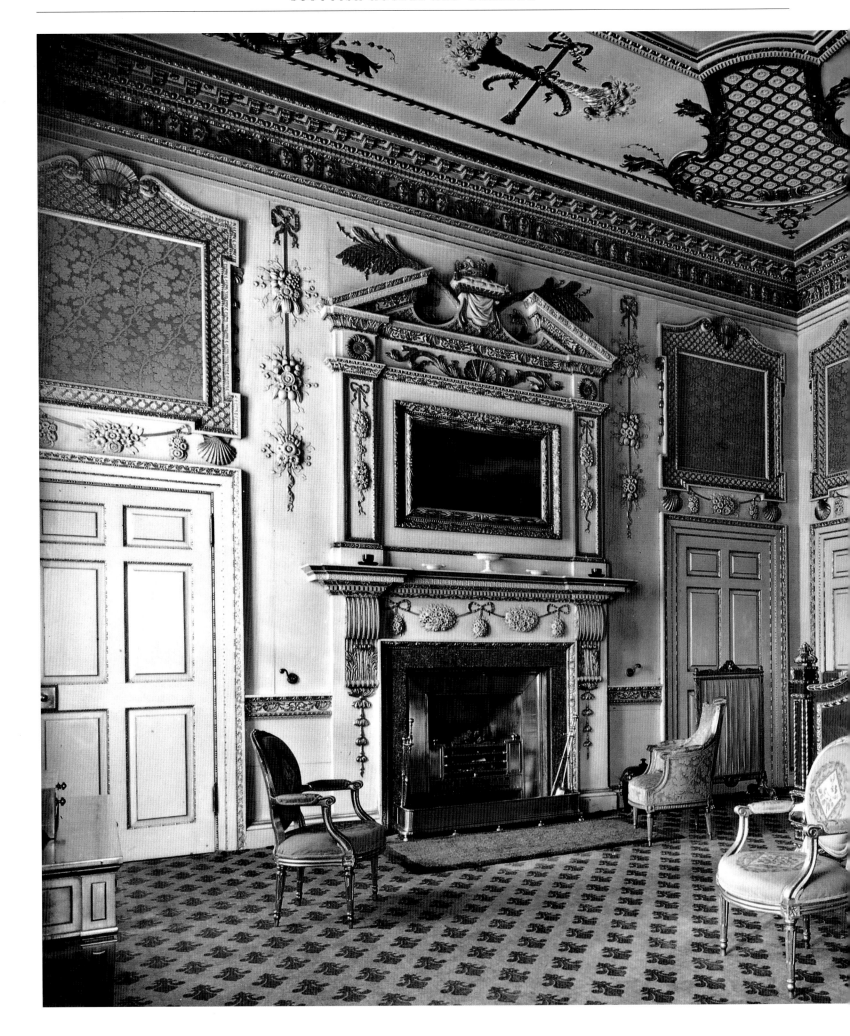

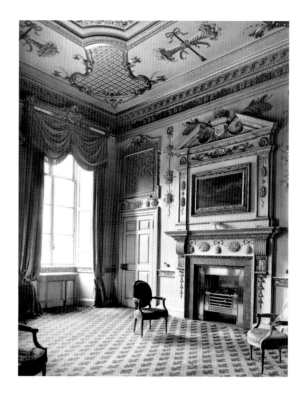

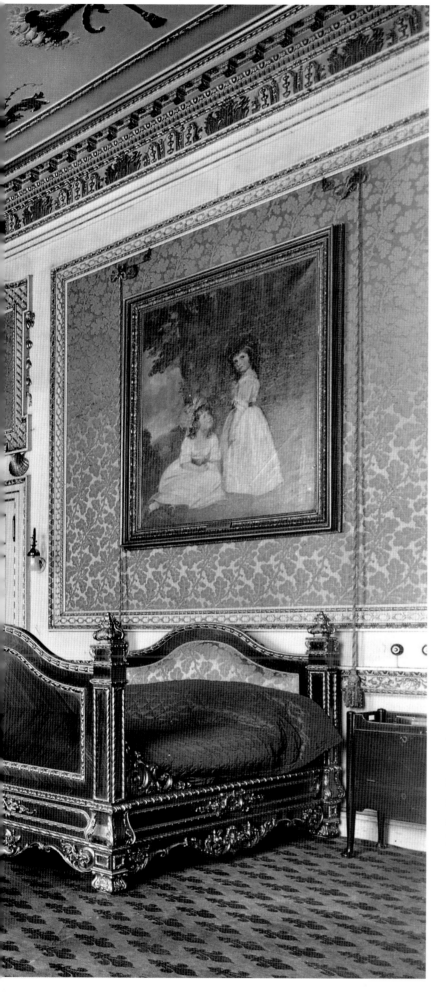

Country Life's photographs of the rooms were immediately re-used by Christie's to illustrate their sale catalogue and potential purchasers were referred to Tipping's articles for further illustrations. Now it was the very rooms that were for sale:

Lot 561: THE WOODWORK AND PANELLING OF THE OLD STATE BREAKFAST ROOM, with carved foliage borders to the over-door panels and chimney-piece boldly carved with the Hamilton Arms, trophies, flowers, fruits and eagles, with black marble chimney lining – *15ft 6 in high, 36ft by 22 ft* – late 17th Century.

The contents of the room comprised Lots 264-267 and ranged from the steel fender and fire irons through the pair of Georgian mirrors, 9ft.9 ins high, and the Large Bronze Chandelier, to end with the banality of the 'crimson felt surround for the room'. The interior fittings were covered by a separate instruction: 'the following lots cannot be removed until Monday, November 24, and must be finally cleared away by January 1, 1920'. This does not seem an unduly long time to remove such a weighty mass of materials. *Country Life's* unexpected role in this final act of the story of Hamilton Palace is a reminder of the unique place Hudson's magazine had achieved in the national consciousness.

Left and above: *The Claytons' designs for the plasterwork of the Duchess's Bedroom survive in the Hamilton Muniments. The fleur de lis carpet in the Duchess's apartment alludes to the family's close French connections.*

Some of the palace's components have found their way into museums: Smith's Great Dining Room is now beautifully displayed in The Boston Museum of Fine Arts, which has courageously recreated the 10th Duke's *trompe l'oeil* ceiling in plaster; Smith's Withdrawing Room was recently acquired by the National Museums of Scotland and might conceivably find its way back to Hamilton.

Eighty years later it all seems an unnecessary tragedy. The 10th Duke's Mausoleum sits in lonely isolation in a public park while Chatelherault, William Adam's substantial garden pavilion which closed the vista down the avenue from the palace, has been lovingly restored by Historic Scotland.

The 10th Duke's Black Marble Staircase lay to the left of the north portico and led to the first-floor state rooms across a landing supported by gigantic bronze caryatids. The Empress Eugénie of France, whose portrait hangs in the stairwell, was related to the Hamiltons by marriage and visited the Palace in November 1860, travelling incognito as the 'Countess of Pierrefonds'.

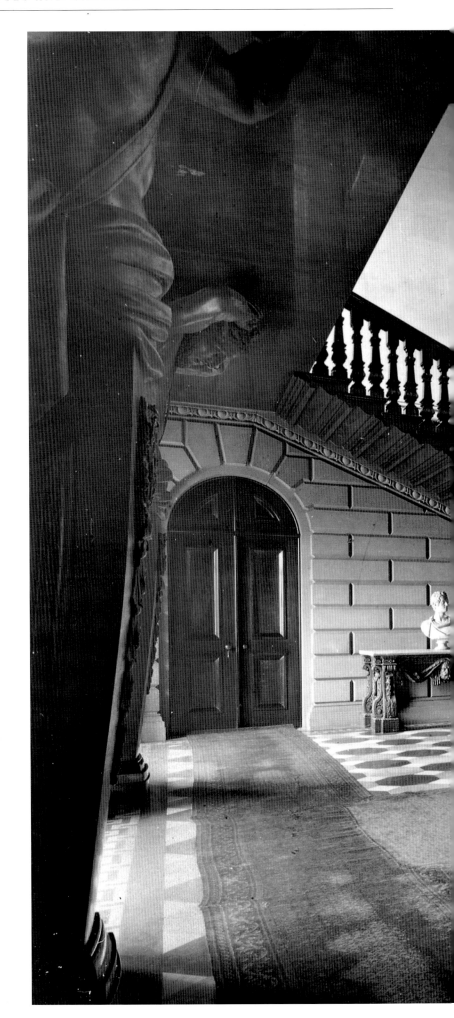

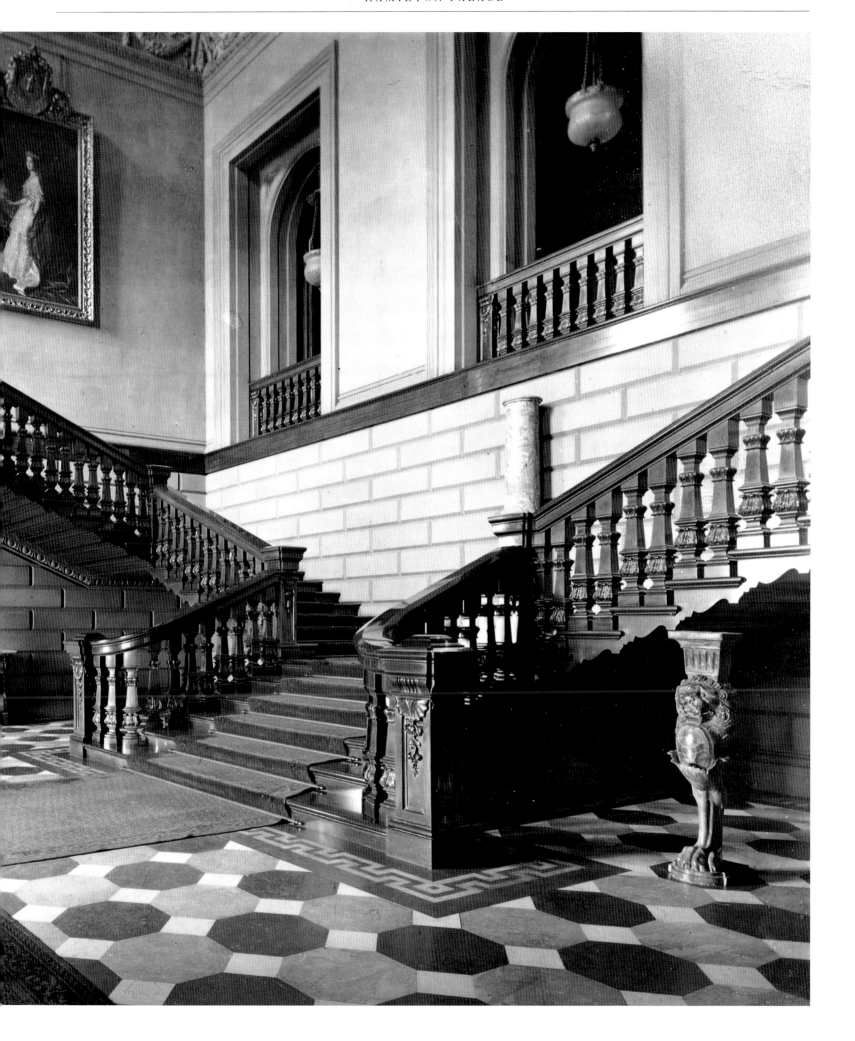

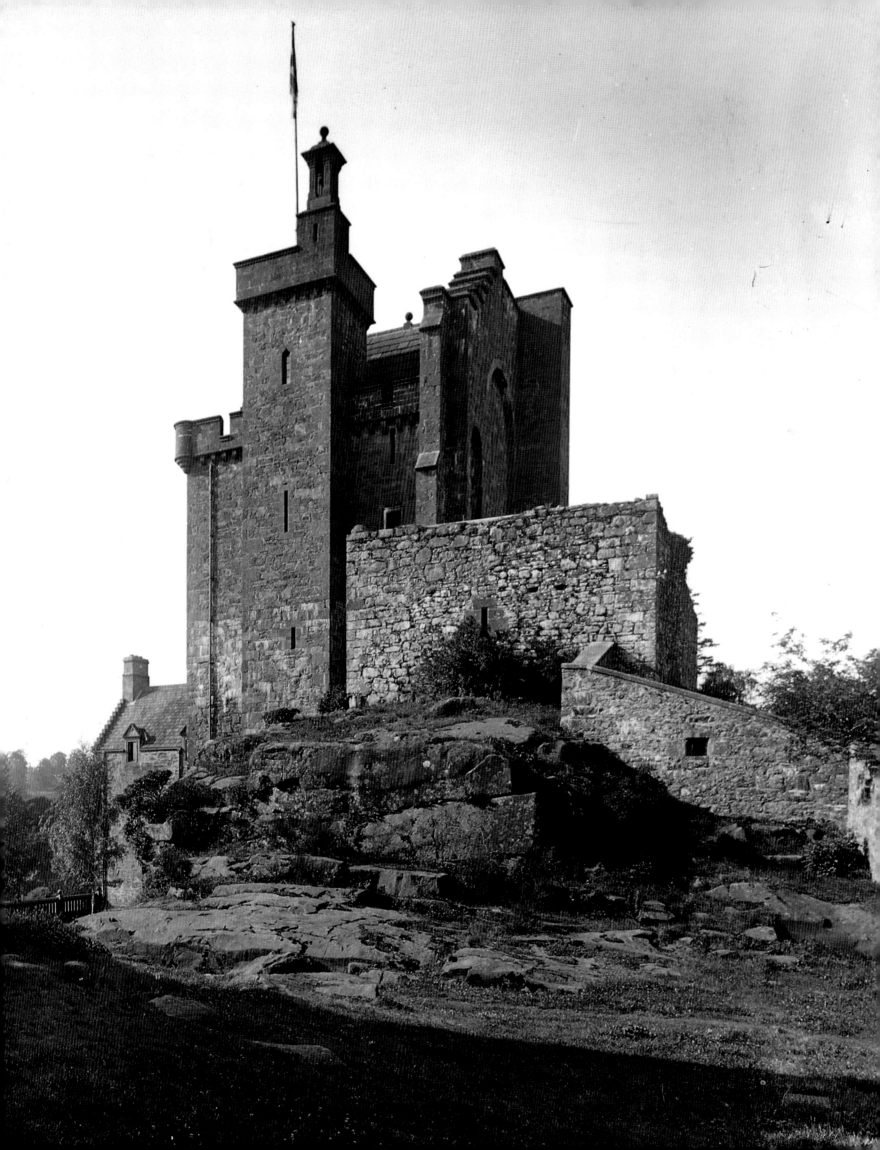

DRUMMOND CASTLE

PERTHSHIRE

Country Life's leisurely and majestic survey of Scotland's formal gardens, running throughout 1901-1902, awarded the distinction of two articles to the gardens of Drummond Castle alone. Perhaps the best preserved today of all of those recorded during that survey, the Drummond Castle gardens are outstanding, and were so famous during the nineteenth century that they were held to be 'the finest gardens in Great Britain'.

Country Life's homing-in on this Scottish group of formal gardens had the effect of establishing them as a distinctive Scottish type. While all surrounded genuinely ancient houses, these gardens were modern creations, although 'restorations' might have been the approved term at the time. Generically they can be seen as a further manifestation of the Scotch Baronial revival.

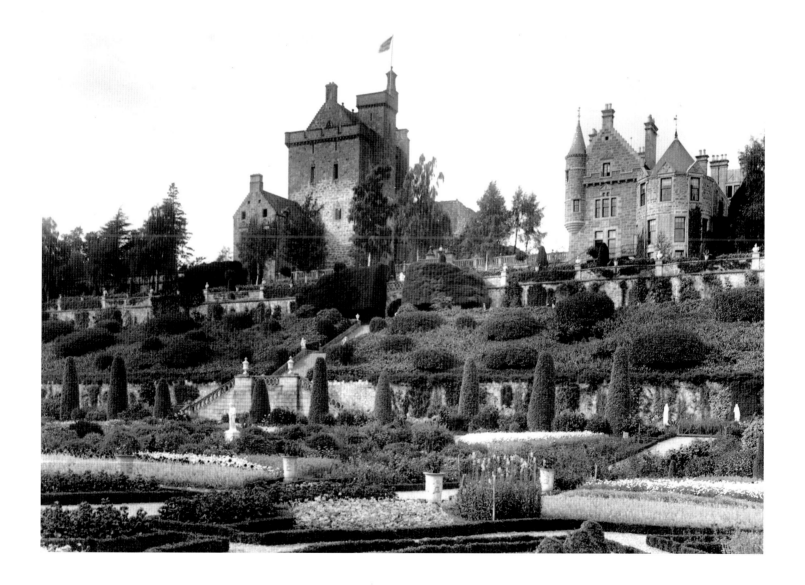

The author of this *Country Life* series, Thomas North Dick Lauder, was well placed to identify the type, because like Christopher Hussey later, his family had embraced the Picturesque aesthetic with enthusiasm. His family tree included Sir Thomas Dick Lauder who had been Scotland's leading exponent of the genre, and had pioneered its application in the gardens at Relugas, his wife's Morayshire seat.

Because *Country Life* would not have willingly included modern Scotch Baronial houses anywhere other than on the property advertisement pages, the lavish amount of space it devoted to the modern Drummond Castle gardens seems contradictory, but was assisted by a certain degree of delusion about their true date. The gardens at Drummond were part of an ancient stronghold, whose history evoked an impressive cast of Scottish historical characters with a focus on its historic holders, the Drummond family and their descendants the Earls of Perth. This colourful past had come to an abrupt halt when the castle sustained extensive damage during the Jacobite Rebellion, but this was turned to its romantic advantage, by Victorian standards, because the tower was said to have been levelled by the Jacobite Dowager Countess of Perth in 1745 to prevent its ever being held again by unwelcome Hanovarian troops.

As the *Country Life* photographs show, the old tower subsequently acquired a Picturesque silhouette and attracted an adjacent modern house, which were both Baronalized into harmony in a campaign initiated by Lord Willoughby de Eresby, who had married the Drummond heiress in 1807. His descendants, Lady Willoughby de Eresby and the Earl of Ancaster, the owner at the time of the article, continued the task.

Thomas North Dick Lauder's first article attempted a summary of the old-fashioned Scottish garden, using John Reid's *The Scots Gardener* of 1683 (the first Scottish gardening manual), and Sir Walter Scott as guideposts. But although Lauder could obscure, he could not wholly disguise the conclusion that the stupendous Drummond garden with a saltire format of intersecting alleys, topiary, and exotic sculpture from foreign climes, was a modern creation with its focus on the ancient, indigenous, Scottish sundial at its centre. If it had a slender silhouette, the design of the sundial, with its rusticated obelisk form, multiple facets and seventeenth-century family heraldry (carved by the King's Master Mason, John Mylne, and executed for the 2nd Earl of Perth in 1630), was well able to hold its own at the centre of the vast parterre.

Preceding pages (left): The old tower was given a more romantic silhouette in the early nineteenth century and fitted up with a Picture Gallery and an Armoury. This photograph of 1902 was entitled 'The Living Rock'.
(right): The old tower and the modern house at Drummond sit alongside above a series of terraces, and enjoy elevated views of the great parterre.

Left: The unusual inclusion of a human being in a Country Life *photograph is a reminder that the continuing elaboration of the gardens had an appreciative audience in the many tourists who flocked to nearby Crieff to enjoy the mild Perthshire climate.*

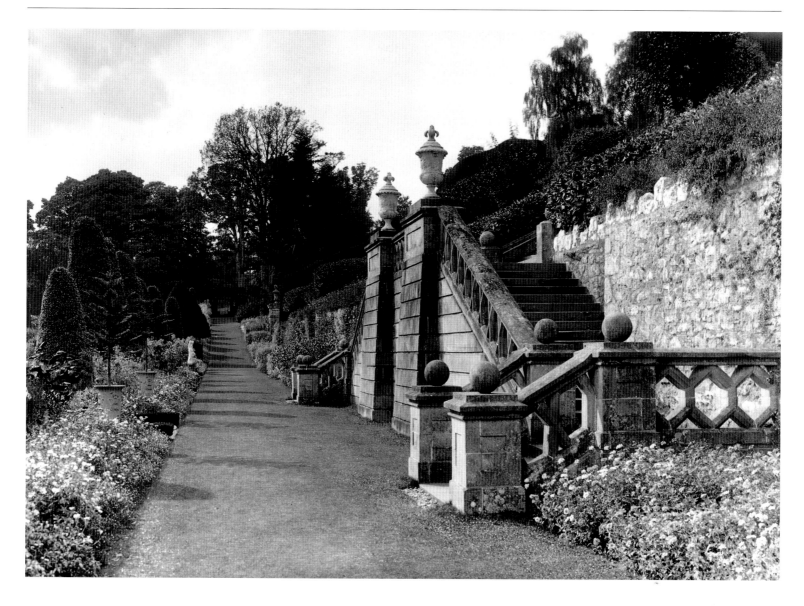

Although created for the family's own pleasure, the development of the gardens into an outstanding showplace also reflected the growth of an appreciative tourist audience of invalids, retired army officers, and sportsmen who flocked to nearby Crieff to enjoy the clement Perthshire climate. The favourable effects of the climate were vaunted by a *Country Life* correspondent in April 1898, who sent in a photograph of blooms flourishing in the unheated spare room of her house at Meigle, and claimed that the 'clear bright air of Perthshire' was 'far more beneficial than the so-called foreign health resorts she used to try'.

The arrival of the castle's most illustrious visitors, Queen Victoria and Prince Albert, in 1842 was a further spur to ostentatious gardening, and they were gratifyingly appreciative.

Above: *Stone steps lead down from the Castle to the parterre.*

Left: *At the heart of the great parterre was a slender, distinctively Scottish sundial dated 1630, topped by a rusticated obelisk, bearing multiple faces, around which the entire garden had been generated in the nineteenth century.*

Overleaf: *A view looking down from the Castle reveals only part of the total extent of the great parterre, a wonderland of topiary, pencil-clipped trees, and imported marble statuary and vases.*

The old tower was converted into an Armoury and Picture Gallery. The Royal Apartments, in the Queen's words 'small but nice', were preserved unaltered. As an additional attraction Prince Albert's Dressing Room had the distinction of being the chamber in which Bonnie Prince Charlie was said to have slept. The Queen felt the terraces were French. More recently, Professor Tait has shown that the restoration of the garden derives from early French gardening manuals in the castle's library.

The practical work of recreation was supervised by two generations of garden designers, Lewis Kennedy and his son G.P. Kennedy. The father had previously run a nursery of exotics, while his architect son subsequently worked in the office of Sir Charles Barry. The mild climate in combination with the father's skills led to remarkable effects – like the American aloe that shot up to twenty three feet in 1832. The *Country Life* photographs, despite being in sober black and white, convey a vivid impression of the startling scale and dramatic effect of the permanent green architecture, studded with a profusion of colourful flowers that set off the ever-growing collection of imported sculpture and vases, adding expensive flashes of pure white statuary marble to the already intoxicating design.

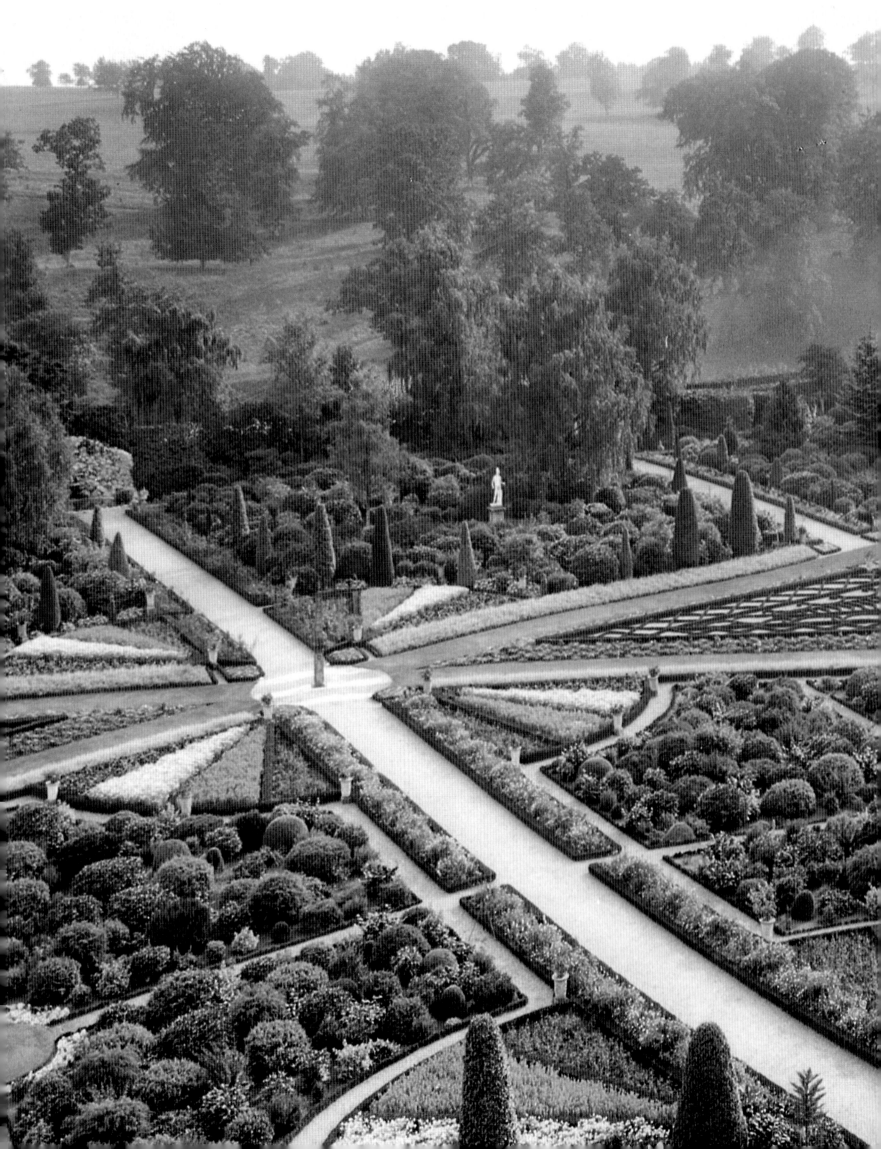

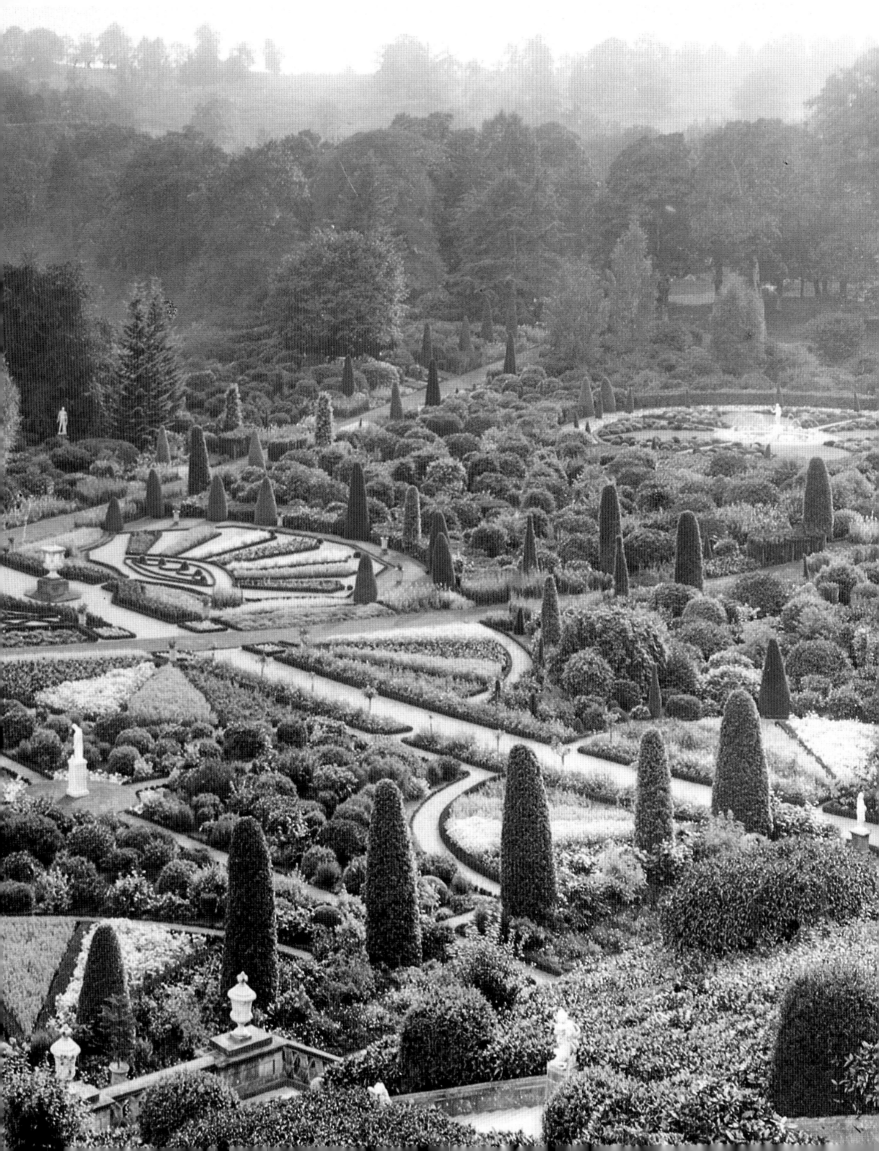

Although there were to be other topiary-filled Scotch Baronial gardens in Perthshire, such as those at Murthly and Fingask, it was the stupendous scale of the Drummond gardens that was so overwhelming, an effect intensified by the architectural inadequacy of the house, whose dominant position high above was its only seeming advantage. The sense of space and scale is enhanced by the cyclorama of mountain ranges that surround the castle. Sir Charles Barry prepared designs for recasting the castle in monumental Neo-Norman style, which could certainly have held its own against the landscape.

The Scottish topography imparted rises and falls to the Drummond parterre that anywhere else would have been laid out on level terrain. Although the garden is studded with distinguished sculpture and four handsome doorways (said to be from a church

Below: *A detail of the clipped box borders at the centre of the great parterre.*

Right: *Part of the aesthetic thrill of Drummond in the nineteenth century was provided by flashes of pure white statuary against the dark green of the yew hedges.*

that formerly stood in the Strand in London), engagingly none of it matches the scale of the parterre itself. The importance of the ornaments had to be inflated, therefore, by other means, such as the wavy-pavement of coloured stones under the obelisk sundial, taken from the family crest, or the quartz-machiolations around the bases of the sculpture.

Fortified by many old guidebooks, twentieth-century tourists can retrace their predecessors' steps today, still approaching the castle down the remarkably narrow avenue and emerging through a side door to find themselves on the uppermost terrace, with the gardens falling away beneath them towards the distant mountains. Although these most labour-intensive gardens suffered during two World Wars, the family have courageously brought new life to this great showplace. Understandably, there has had to be some simplification and adaptation to twentieth-century gardening tastes, and some of this may reflect the frosty opinion of *Country Life*'s own gardening correspondent Gertrude Jekyll, who had taken exception in 1901 to the lavish use of quartz that was used to highlight details in the overall design.

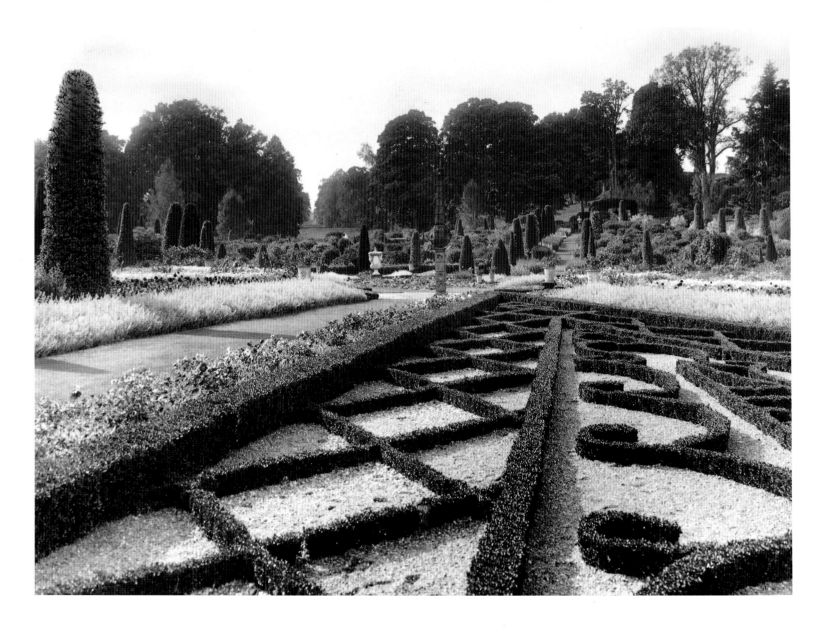

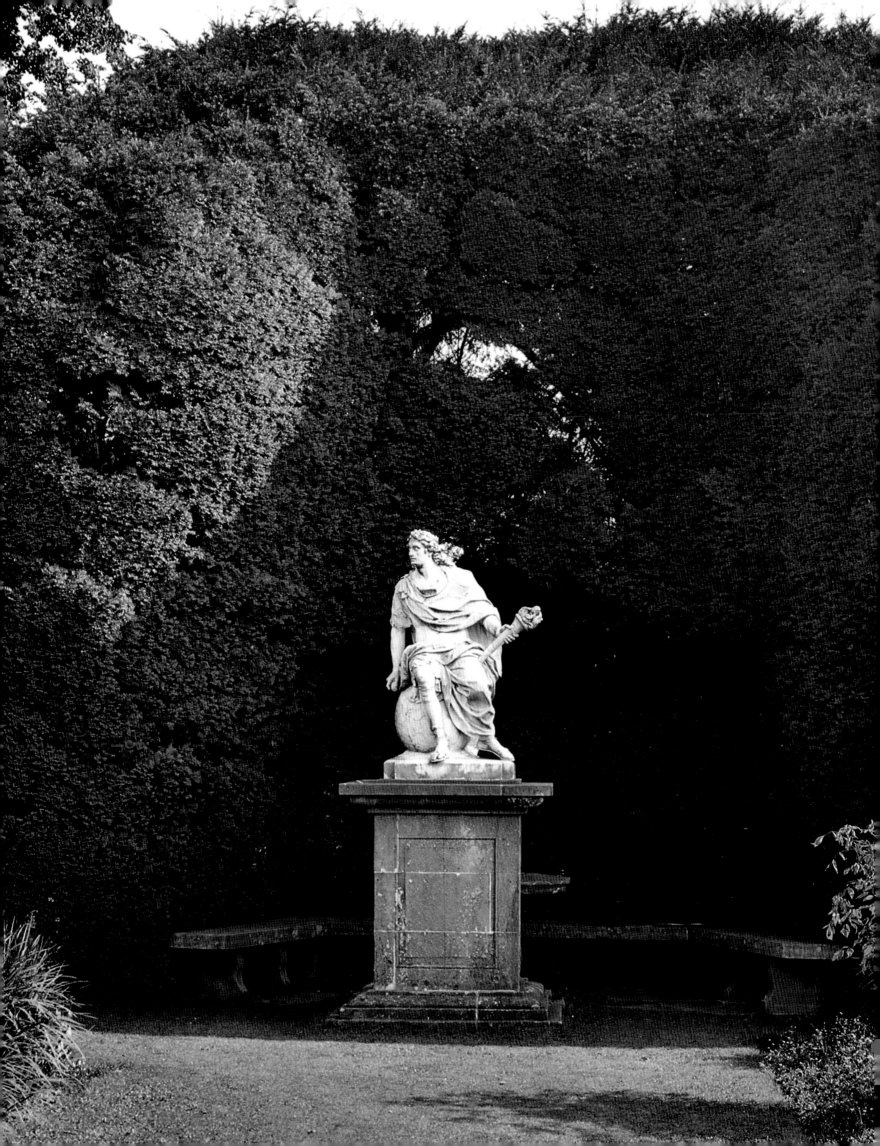

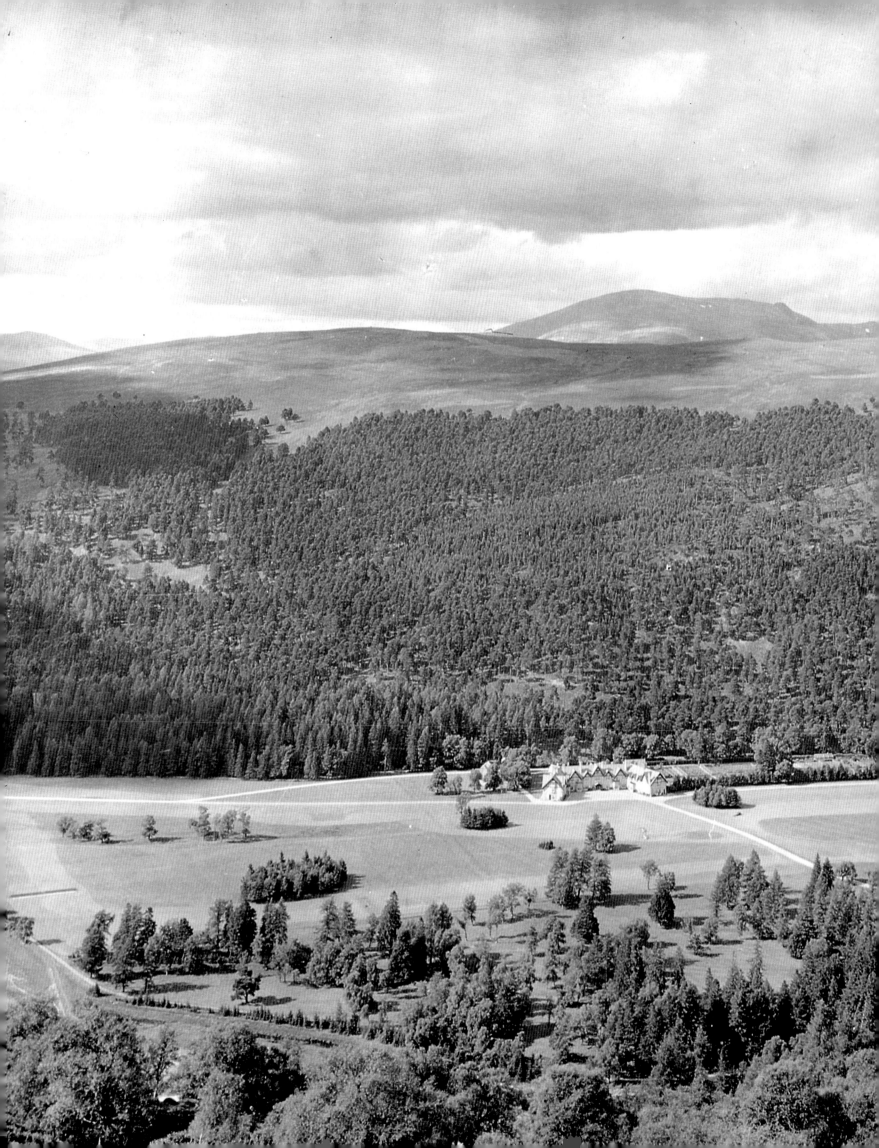

MAR LODGE

ABERDEENSHIRE

Mar Lodge is of the first importance for Scottish architecture because it is the grandest, indeed royal, expression of the Shooting Lodge, an architectural type that became an endangered species in the mid nineteenth century when its natural habitat was threatened by a population explosion of Scotch Baronial revival castles throughout the Highland landscape. Unlike neighbouring Balmoral, to which Mar was to be intimately linked, this part of the estate was left castle-less and carved up among speculators after the failure of the Jacobite cause, and the attainder of the Earl of Mar, in the 1715 Rebellion. The new owner in 1735, the entrepreneurial future 1st Earl of Fife, was probably investing in its forests, and certainly timber from Mar was intended to be used in the construction of Duff House, the new seat of the future Fife dynasty, that William Adam was asked to design at the heart of their ever-growing estates in Banffshire.

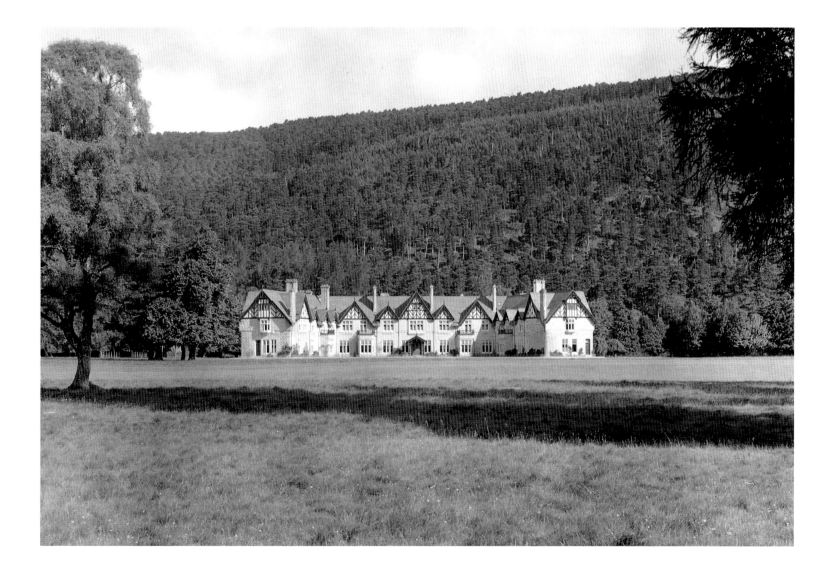

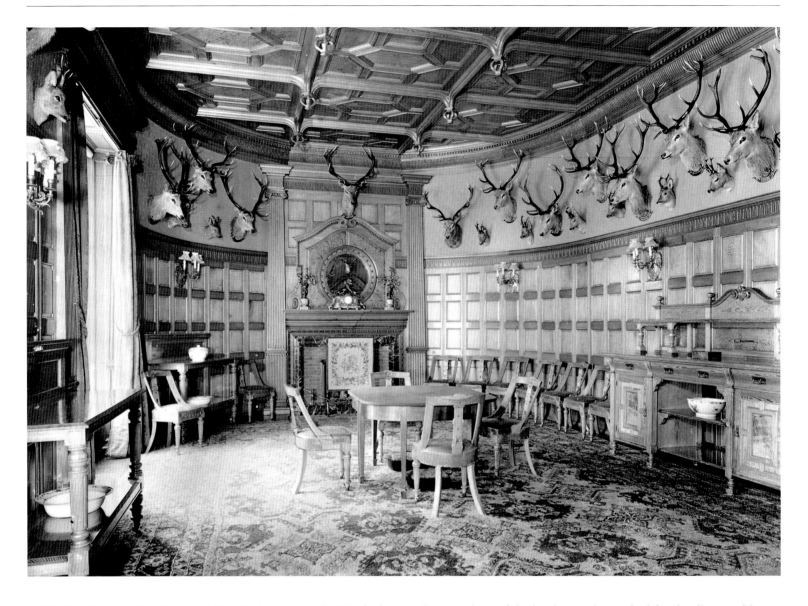

The key figure in the history of Mar Lodge was the 2nd Earl of Fife, a maniacal collector, who came to love his father's investment. Because his father dragged William Adam through the law courts in pursuit of value for money, leaving the grand house unfinished, it fell to the son to fit up the interior. But this was put on hold after the theatrical failure of the Earl's marriage, when his neurotic Countess, Dolly, drew attention to her unhappiness by trying to shoot herself with a gun she had earlier purloined from her husband's armoury. Happily she failed to harm herself. Work was suspended and the marriage ended in separation. They had no children, although the Earl had had several born out of wedlock earlier. The Earl eventually completed Duff House very economically as a gallery for his ever-expanding collection of portraits, both of this own family and other people's.

The Earl found deer stalking at Mar a welcome break from marital distractions and made additions to the existing modern shooting box. With his particular taste for French furnishings, natural gardening and Gothick garden buildings, it is difficult not to view his Mar Lodge as a Highland equivalent of Marie Antoinette's Hameau at the Petit Trianon. At Mar the red deer in the immediate vicinity of the house were treated as pets, while

other members of the herd were despatched for the dinner table on remote areas of the estate.

Lord Fife's domestic arrangements had important repercussions for his future estates because the collector in him aggressively entailed his collections against dispersal, while in his role as indulgent father he asset-stripped the estates to benefit his illegitimate offspring. In 1829, during the disaster of the 'Muckle Spate', the Dee flooded the house and a new cottage, named Corriemulzie after a neighbouring burn, was securely sited higher up the valley hill-side: it may have been built for the eldest son, Sir James Duff. It came into its own as the home of the future 4th Earl of Fife and his Countess, while they waited to inherit the titles from his uncle. Agnes was the illegitimate granddaughter of William IV and Mrs Jordan, and enjoyed royal status. With no

Preceding page (right): This unpublished exterior view shows the Lodge after the removal of a verandah, which was made of natural tree-trunks and interwoven branches. This was to allow more light into the rooms, in keeping with the 1930s alteration.

In 1937, both the Dining Room (above) and the Billiard Room (right) retained most of their original late 1890s furniture and decoration, but the dominant element was the frieze of stuffed stag heads with realistic glass eyes.

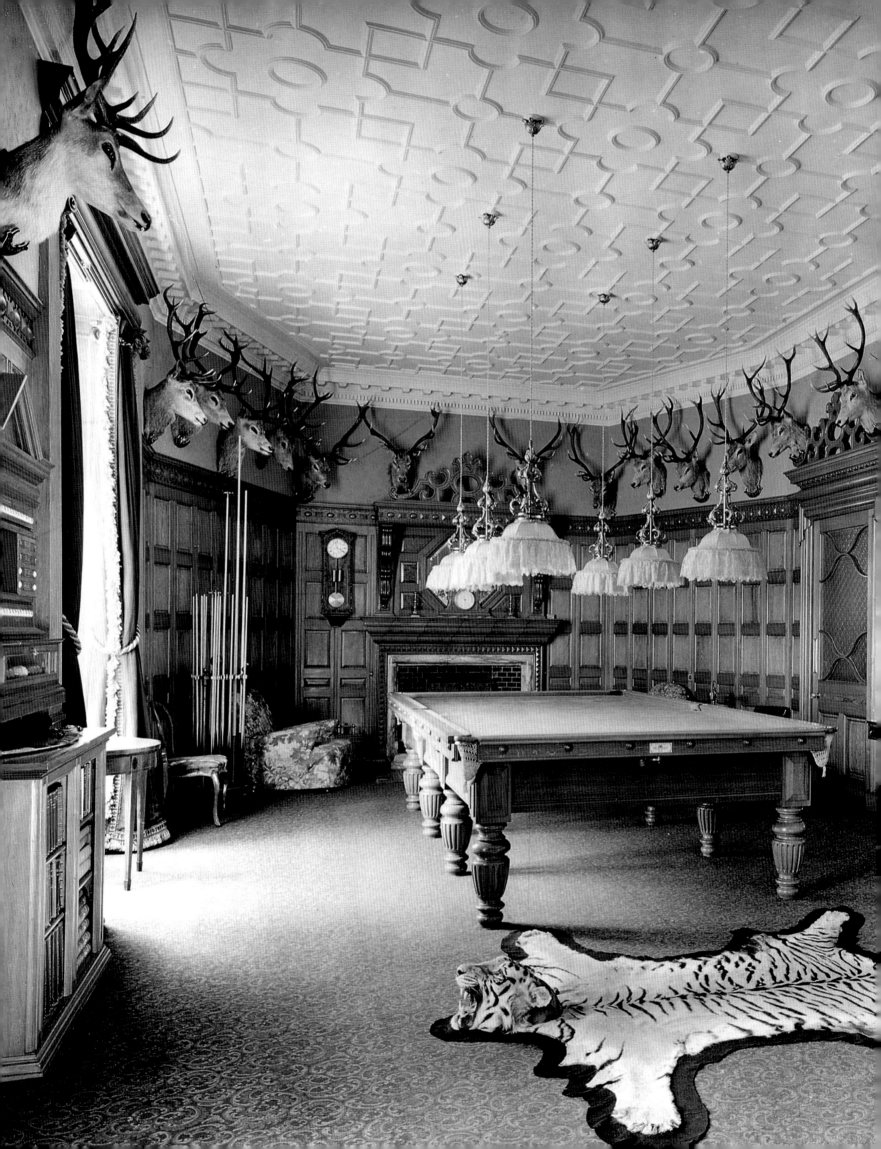

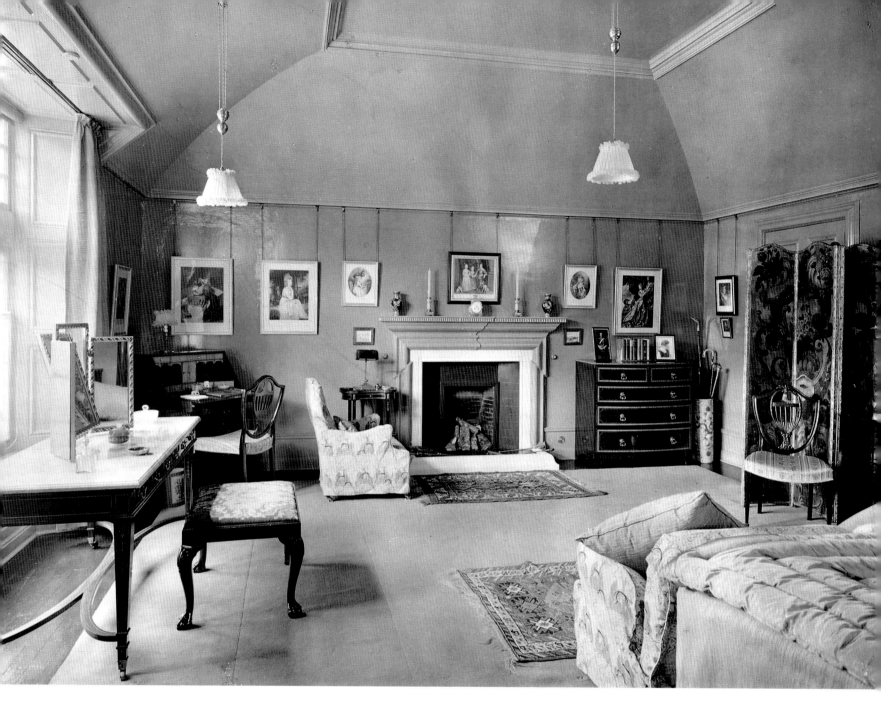

money for fancy architects, Agnes used her considerable skills as a pioneer lady interior decorator to turn Corriemulzie Cottage into the model for subsequent Deeside decoration, lining the walls of the rooms with stag heads.

Corriemulzie Cottage, in spite of its architectural innocence – 'a rambling structure between a Swiss Chalet and an Indian Bungalow' – was a much loved family home and had its high-point in 1863 when in their first public engagement the newly married Prince and Princess of Wales were entertained there. The tented Ballroom prepared for the occasion was unable to withstand the challenge of the weather and the Highland reels had to resume in the old house. Sadly, Agnes died young after an accident in 1879

and so did not have the satisfaction of seeing her son raised to a Dukedom on his marriage to the Prince and Princess of Wales's eldest daughter, Princess Louise, in 1889.

After Corriemulzie Cottage was damaged by fire, the Aberdeen architect A. Marshall Mackenzie was asked in 1895 to replicate it on the site of the original house, but with the ancillary accommodation a future Princess Royal could expect. This resulted in the present extensive gingerbread cottage. The Princess is, rather unreliably, credited with the unusual butterfly plan which opens every room in the house up to the landscape in a particularly exciting way. The tented Ballroom survived in permanent weather-proof and detached form, but is merely the support for one of Scotland's most staggering sights, as three thousand deer heads with interlocked antlers line the walls of this room.

When Christopher Hussey visited on behalf of *Country Life* in 1937, his subsequent article had a strong sense of his having dutifully found a subject for yet another issue in the long succession of annual 'Scottish (or Shooting) Numbers' that the

advertisers required. However Mar Lodge had by then been anaesthetized into a modern blandness by the next generation, Prince and Princess Arthur of Connaught.

The indoor herd of stuffed red deer continued to increase, thanks to the steady aim of the crowned heads of Europe, in what Hussey chose to describe as the 'unaltered' parts (the Dining Room and the Billiard Room) of the Lodge. But elsewhere the original decoration gave way to the historic Fife family portraits and a long run of eighteenth-century mezzotint portraits that now graced the walls of Mar Lodge. The newly rebuilt Mar Lodge must have been a preferable and certainly more comfortable seat than the awkwardness and discomfort of eighteenth-century Duff and the Princess preferred the Deeside air to that of Banff, where she complained of feeling unwell.

In 1906 Duff House was presented by the Duke and Duchess to the local towns of Banff and McDuff and so it became one of the first country houses to have to find a new, non-domestic role in the twentieth century. The Princess's aversion to Duff may also have been promoted by the Duke's insistence on preserving his late mother's high Victorian decorations as a memorial to her taste.

The palatial scale of Mar Lodge resulted in its having to seek new uses and new owners in the late twentieth century. In 1991, during extensive building work, when all the doors were temporarily removed, fire took out the centre of the house. Happily the contents (including the deer heads) had been stored in the detached Ballroom, and survived. Thanks to the Lottery in 1995, the Mar Estate has found a new future based on its outstanding environmental importance. Ironically, the sheer numbers of the descendants of the 2nd Earl of Fife's pet deer are proving the enemy of efficient management of this precious remnant of the Caledonian Forest. The importance of caring for the ancient landscape has put the historical and architectural interest of the estate into second place, but with a growing tolerance of the vagaries of Shooting Lodge architecture by the young, Mar Lodge may yet nudge its way more into the foreground as the deer recede into the middle distance.

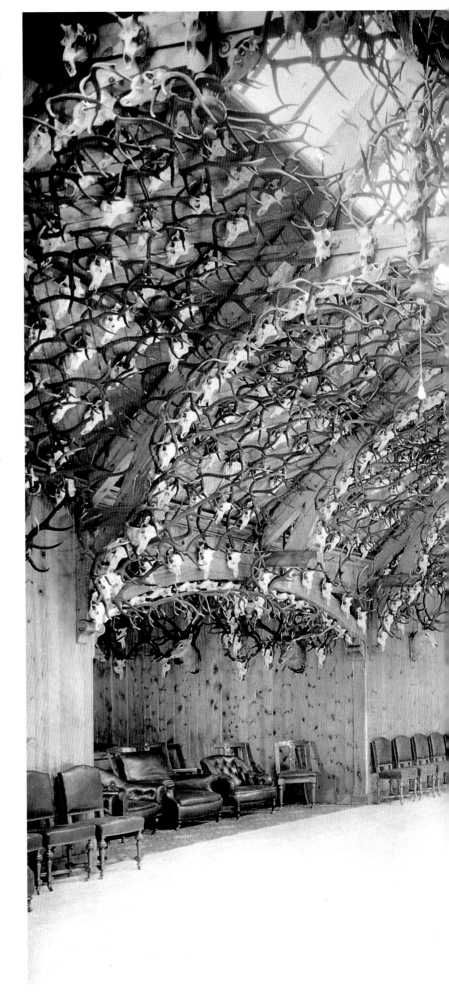

Right: The detached Ballroom preserves the memory of the temporary tented Ballroom erected for the visit of the Prince and Princess of Wales in 1863. The iron frame of the new timber structure enables it to support three thousand interlocked sets of antlers.

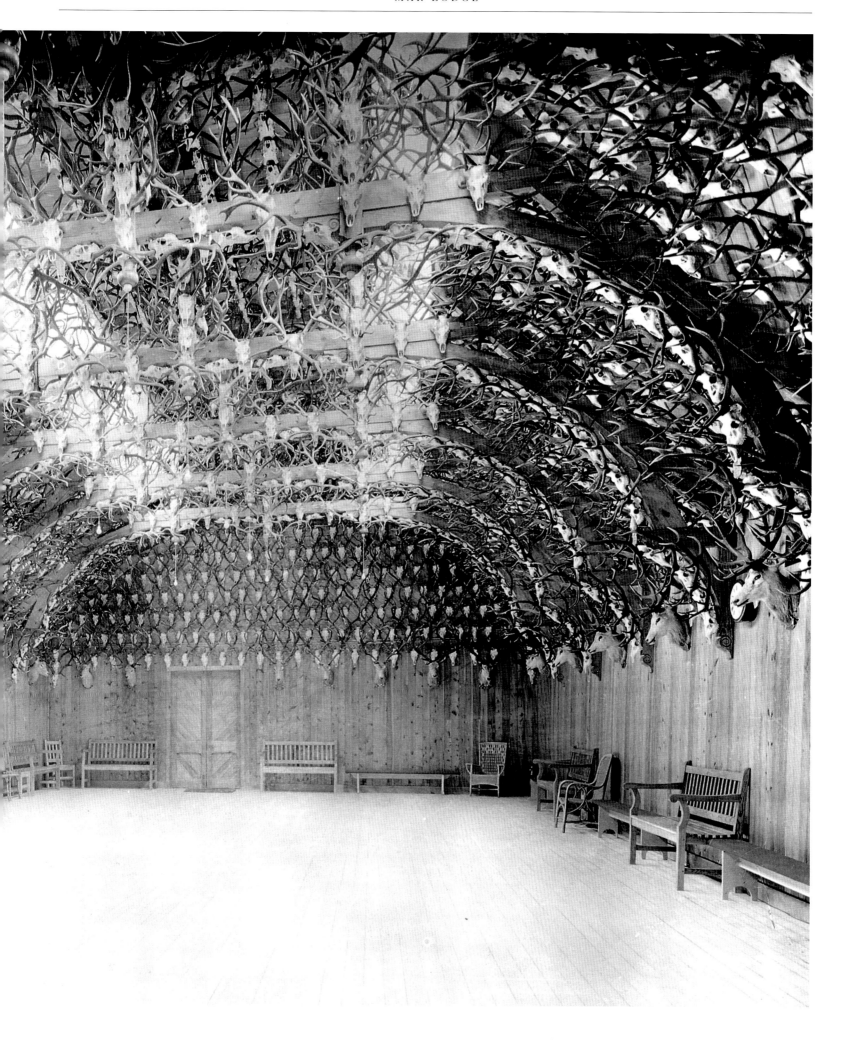

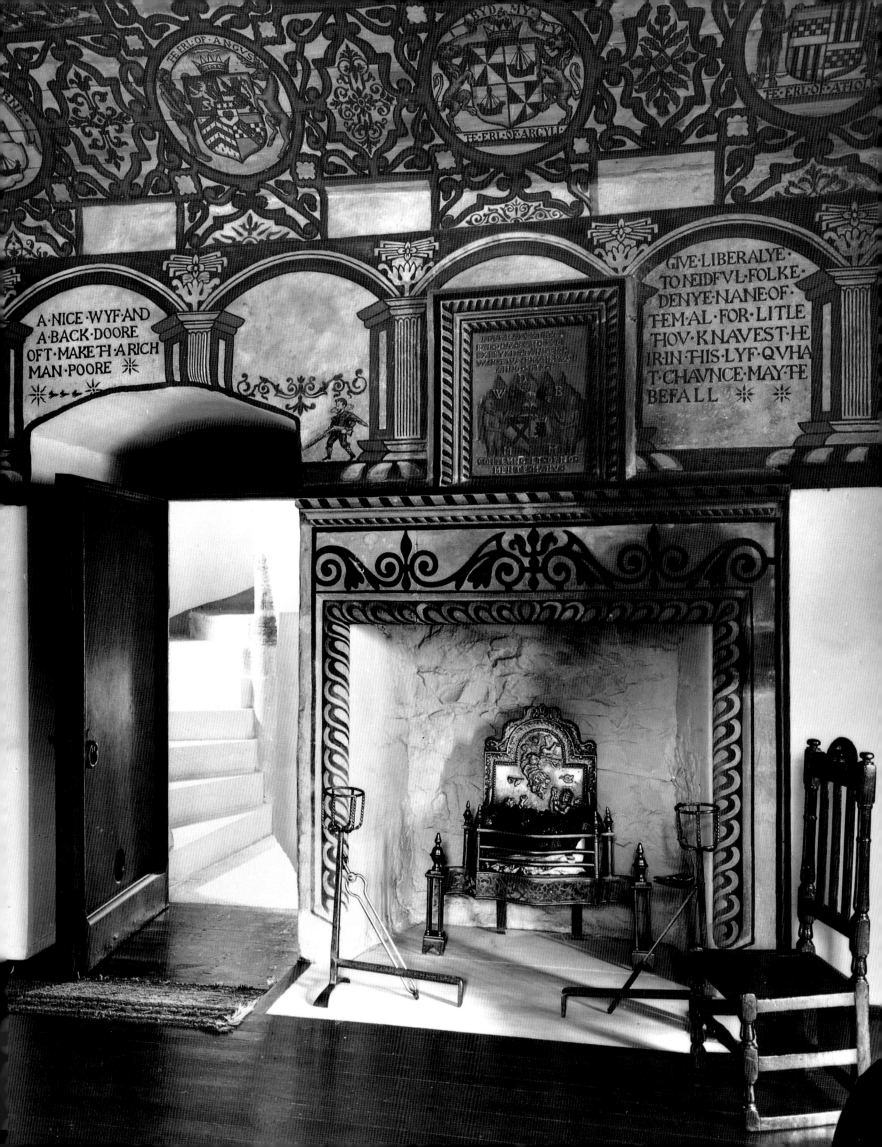

A·NICE·WYF·AND
A·BACK·DOORE
OFT·MAKETH·A·RICH
MAN·POORE ✳

✳

GIVE·LIBERALYE·
TO·NEIDFVL·FOLKE·
DENYE·NANE·OF·
TEM·AL·FOR·LITLE·
THOV·KNAVEST·HE
IR·IN·THIS·LYF·QVHA
T·CHAVNCE·MAY·TE·
BEFALL ✳ ✳

TE·ERL·OF·ANGVS

TE·ERL·OF·ARGYLE

TE·ERL·OF·ATHOL

EARLSHALL

FIFE

Few of *Country Life*'s weekly fare of country-house articles can have been as potent as that of July 1, 1905 devoted to the restoration of Earlshall, though the effect was the more remarkable because neither architect, photographer nor author was credited. The Earlshall article was only the first of a series that raised *Country Life*'s Scottish coverage to a new professionalism, and also introduced to the magazine, for the first time, three important figures, who were to transform it. Superficially, the text is true to the magazine's now established traditions, with an emphasis on the remote past rather than the recent hyperactivity of the house's repair and transformation. The only named figure in the article was the patron W.R.M. Mackenzie. The identities of the team emerged by degrees. The first to pop up was that of the architect, Robert Lorimer, whose name was dropped in a subsequent article on Kellie on July 28, 1906.

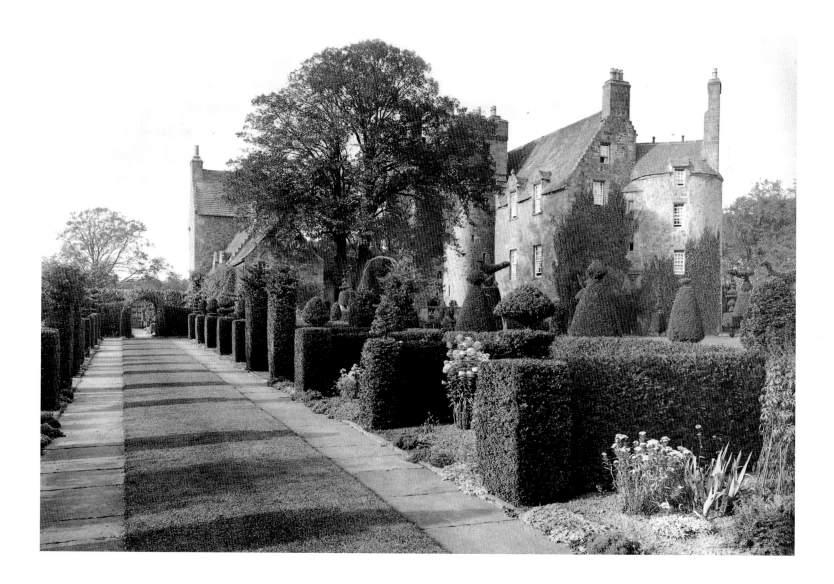

The series began with Earlshall, which was the first article written for *Country Life* by Lawrence Weaver, and it both signalled his interest in the Scottish and heralded his far-reaching shake up of the magazine's architectural coverage in general.

The name of the photographer was last to emerge and remains the least well documented; it depends on the assumption that if Frederick Evans, by far the most talented of the freelance photographers retained by Hudson, was despatched to record Craigievar for the issue of February 1906, as the inscription on its negative envelopes confirms, then he was retained for the entire Scottish series. Hudson may have been so delighted with Evans's response to Scotland's castles that in 1906 he commissioned his monumental survey of French châteaux, celebrated in Marcus Binney's companion volume in this series.

Lorimer got the job because Mackenzie knew his parents from their pioneering joint rescue of the similarly ruinous Kellie, which was nearby. For *Country Life* readers, the attraction of a semi-derelict house or castle, which had sunk in the social scale to shelter tenant farmers, was that it had never had money wasted by its land-lords on Victorian comforts of dubious aesthetic worth. Mackenzie, whom Lorimer always addressed as 'the laird', needed an

Preceding page (left): *Detail of the painted decoration of the Gallery, dated 1617, with its quaint mottoes restored by Lorimer's craftsmen, Moxon and Carfrae of Edinburgh.*

Above: *The wrought-iron well-head with topiary peacocks beyond epitomizes the fairy-tale character with which Lorimer imbued Earlshall.*

Right: *The apparently instant topiary garden was a result of replanting established yews said to have come from an abandoned Edinburgh garden. Mackenzie's gardener allegedly was tipped for every successful transplant.*

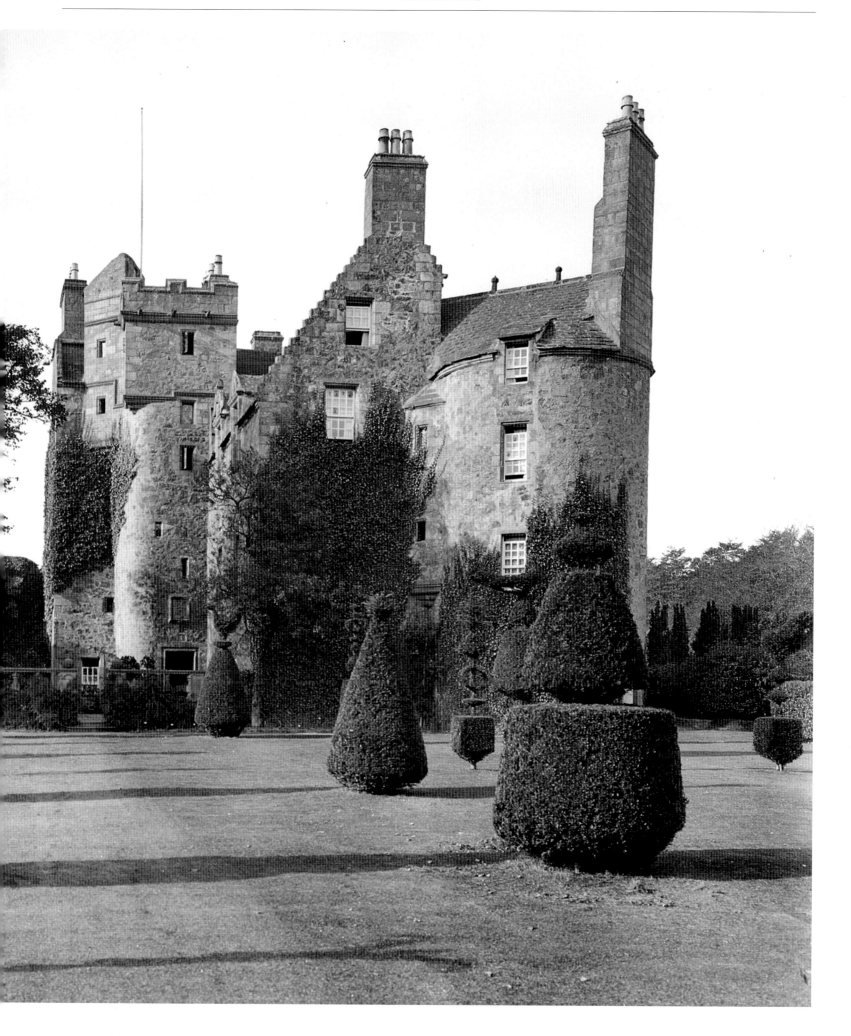

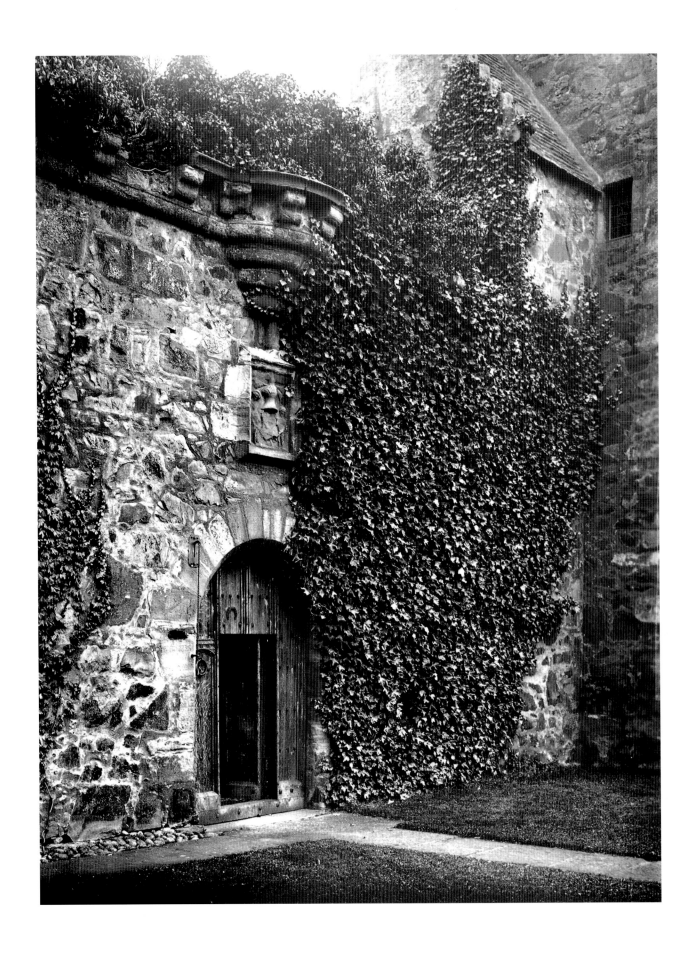

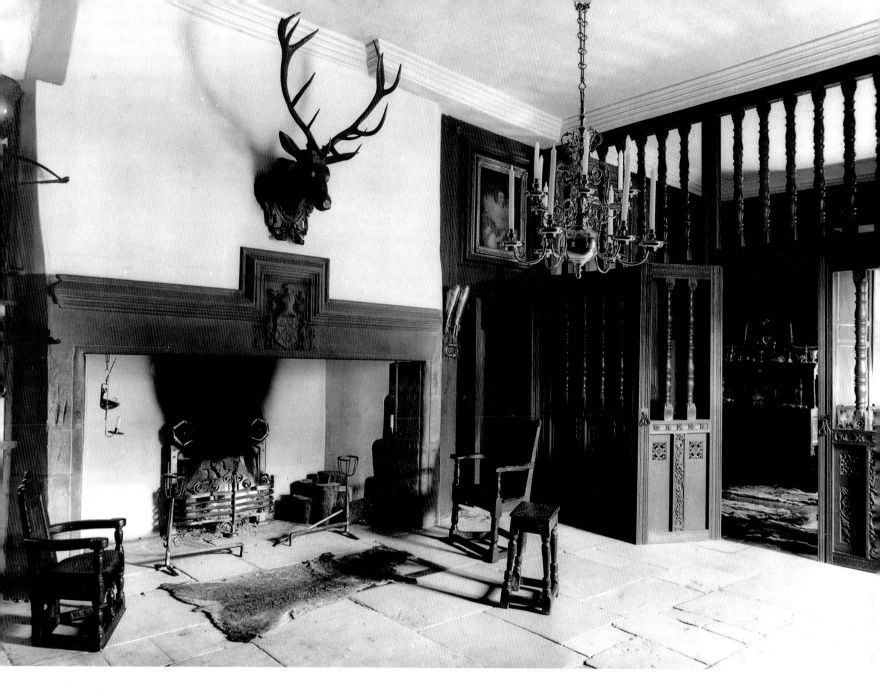

appropriate home to show off his antique collections, with their special concentration on textiles.

Although Mackenzie had trained as a lawyer, he went to work for a bleaching firm in Perth and developed a deep interest in the qualities of fabrics, particularly tapestries. Lorimer's furniture scrapbook illustrates a Dutch-looking tip-up tripod round table that Whytock and Reid, his cabinet-makers, made up to frame a piece of needlework. The rich but fussy patchwork that was created at Earlshall was the antithesis of Lorimer's personal approach.

It is still not clear how Weaver entered the *Country Life* scene, but his principal interest in the house was the dramatic restoration of the characteristically Scottish painted tempera decoration of the Long Gallery, which bears the initials of the then-owner, William Bruce of Earlshall and the date 1617. Weaver explained how:

Above: *The spirited carving of the new Hall screen, copied from that at Falkland Palace, was created by Lorimer as a backdrop for Mackenzie's growing collection of old Scots oak chairs.*

Left: *Frederick Evans made many studies of Earlshall's rubble walls in 1905.*

All this painted work, once falling into abject decay, has been carefully restored by the present laird of Earlshall. The story of its restoration by Mr. Mackenzie, who bought half-ruined Earlshall in 1891, is deeply interesting to those who know at what pains a beautiful and curious thing has been saved for Scotland. The painting was all on timber, which the rain through the roof had made too rotten for a nail to stay in, and much had already fallen. Piece by piece the surface was sliced away and glued to sound wood, which could then be secured as in former times to the upper couples of the roof. This achieved, the painting, still clearly to be seen, was slowly brought back to its original colours with distemper.

With his deep love of the poetic character of the old Scots tongue, Weaver also relished the Gallery's mottoes and quaint heraldic devices:

Other round panels bear the arms of the Scottish earls and nobles. Above the fireplace we have the gyrons and galleys of THE ERL OF ARGYLL, whose word is I BYDE MY TYM, the Douglas heart of THE ERL OF ANGUS, and the chequered fesse of THE ERL OF ATHOLL. Above these are some square panels of the strange and marvellous beasts,

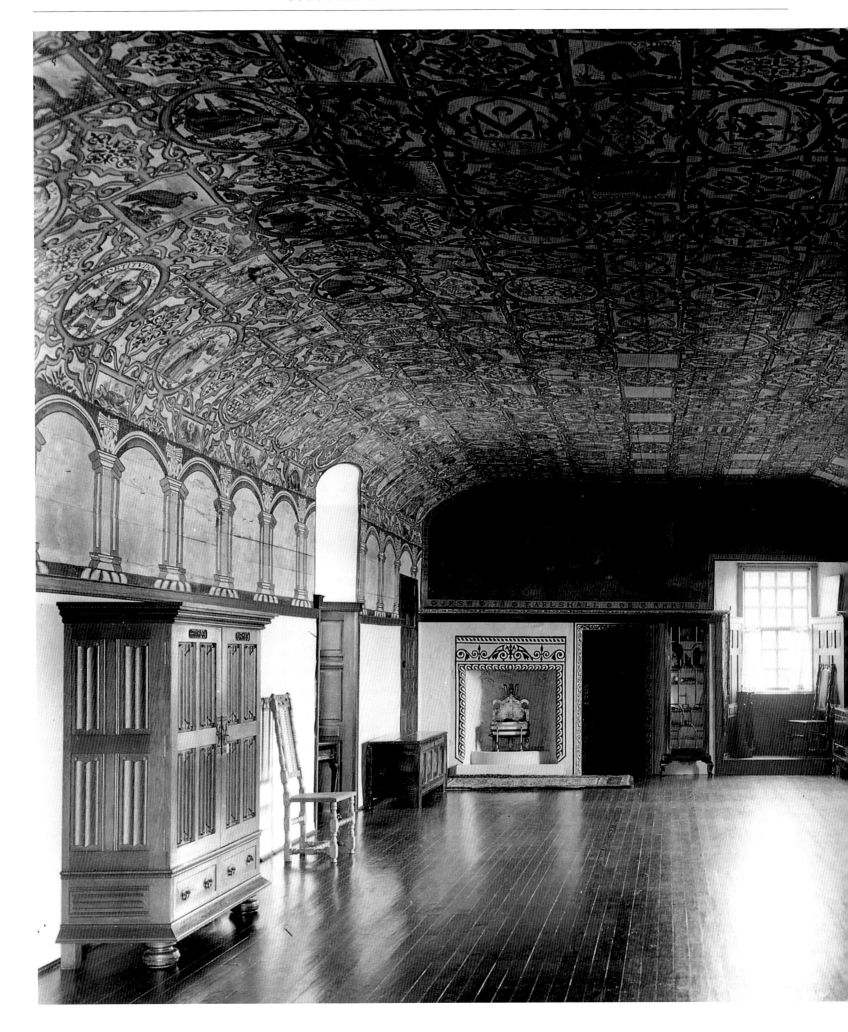

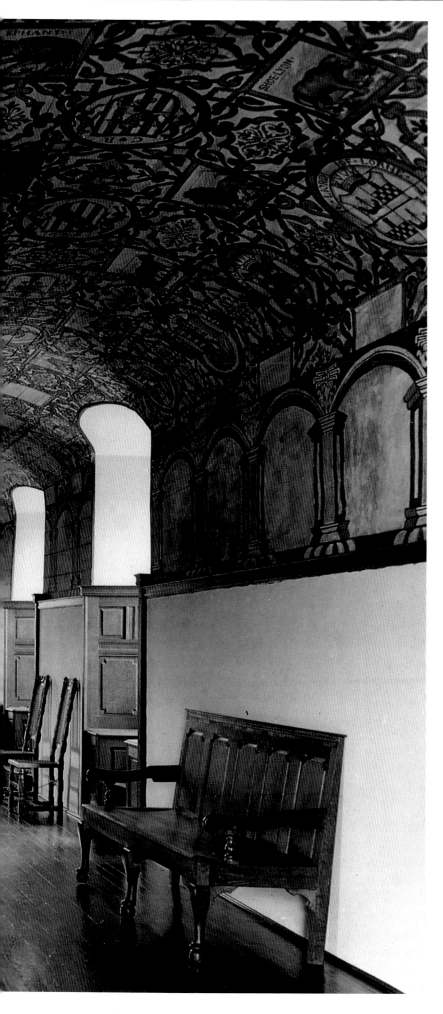

THE MOUSE OF ARABIA, the SHOE LION and the MUSKET. In the frieze are many wise sayings for the admonishing of the lords and ladies of Earlshall. From them we learn that: A·NICE·WYF·AND·A·BACK·DOORE·OFT·MAKETH·A·RICH·MAN·POORE.

This reveals Weaver's enthusiastic delight in a uniquely Scottish form of decoration, whose vital role in the true historic Baronial interior was only just beginning to be understood. In the published *Country Life* photograph, however, the 1890s painting of the dog, introduced by Lorimer and the 'laird' over one of the fireplaces, was lost in deepest shade, probably on Hudson's instructions. Weaver did not explain in detail how Lorimer had copied the turned Hall screen from that at Falkland Palace. The mature topiary of the equally old-fashioned garden was also second-hand and had been rescued recently from an abandoned Edinburgh garden.

With the assistance of Frederick Evans, the Earlshall article revealed Lorimer as a promising Scottish architect with impeccable taste who could be trusted to work on other sensitive restoration work. It is fascinating to compare *Country Life*'s timeless image of Earlshall and its hard-edged austere interiors with other contemporary photographs that show the same rooms with a rich upholstery of textiles. If it painted a rather misleading portrait of Earlshall, the published result in *Country Life* was perfectly attuned to Hudson's pursuit of visual clarity to spotlight a house's history.

Lorimer's painstaking restoration of the almost ruined Long Gallery's 1617 painted tempera decoration, across its boarded ceiling, was central to a new appreciation of this distinctive Scottish school of decoration.

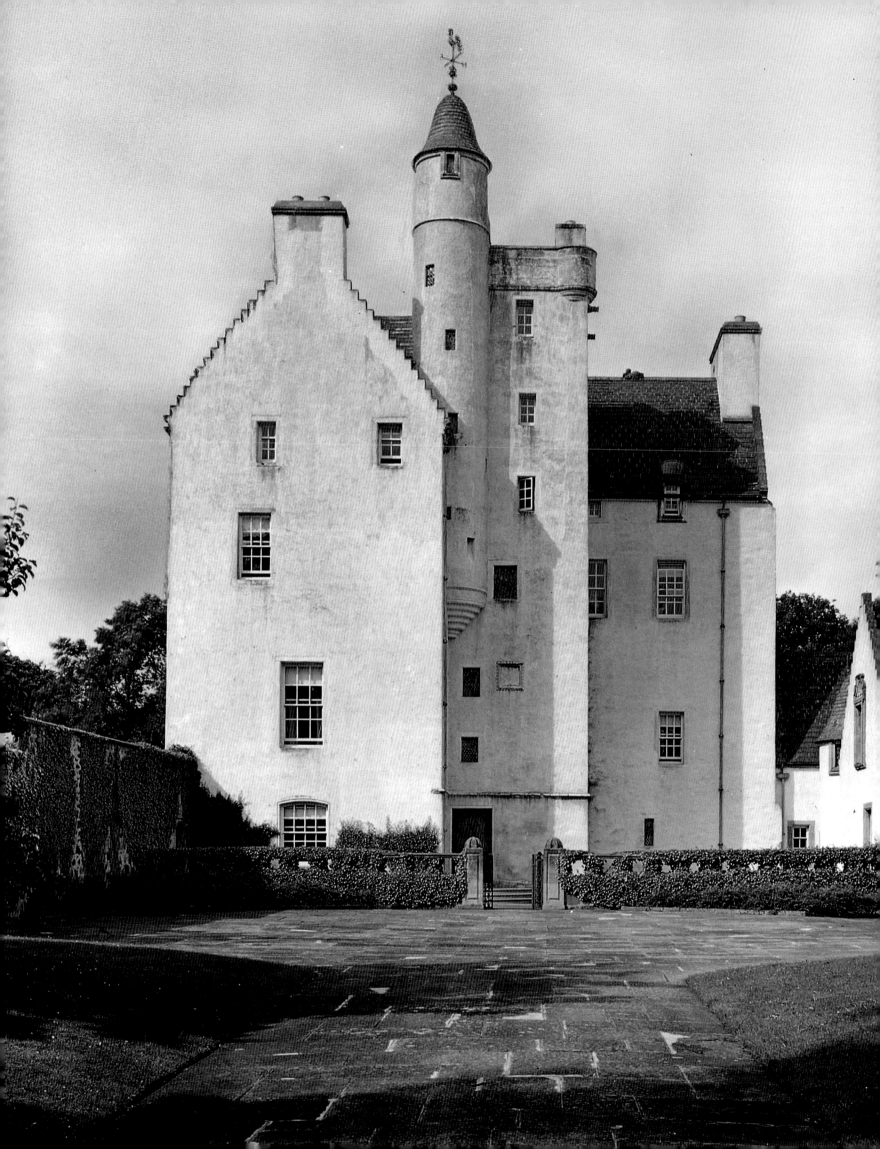

BALMANNO CASTLE

PERTHSHIRE

Surprisingly, Balmanno was published in *Country Life* only in 1931, when Christopher Hussey wrote about the castle's extensive restoration by Sir Robert Lorimer, two years after the latter's death. The occasion for this late coverage was Hussey's research for his memorial biography of the architect. His article has thus the character of an obituary, as he tried to assess Lorimer's wider significance to Scottish architectural history and gave the Balmanno restoration a new status as the Lorimer archetype.

Hussey quoted the received opinion that Lorimer used to say of Balmanno, that of all the houses he had built or repaired it was the one he would most like to live in. This gives a flavour of the unusual circumstances that surrounded this commission from an unusually detached patron who gave Lorimer a free hand not only in the building and its surroundings, but also in the provision of all the furniture.

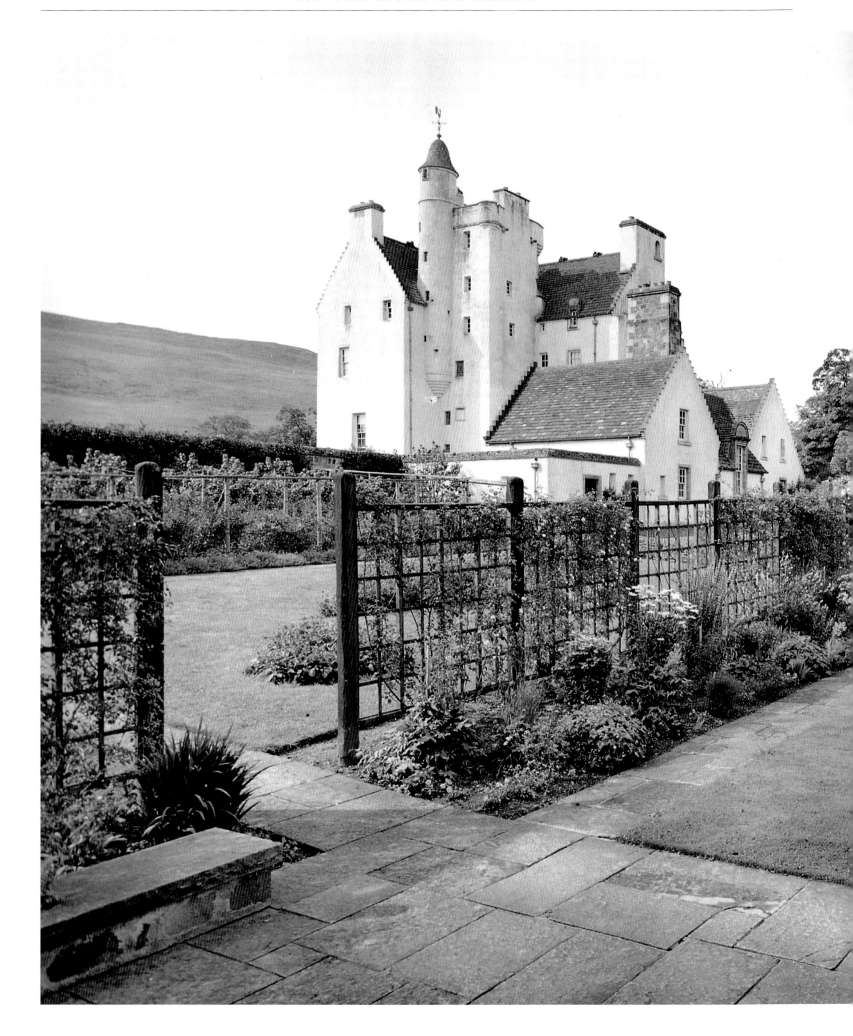

Lorimer's own office files reveal that intimation of the commission had come in a letter of 1915 from a lawyer acting on behalf of William S. Miller, a Glasgow shipowner, who desired to 'reconstruct and preserve' the old tower house of Balmanno, after an ignominious spell as a farmhouse, in order to create a 'summer residence' and that Lorimer's name had been recommended as 'the best authority' Miller could hope to find. It was an offer Lorimer could not refuse. Lorimer's papers, now in Edinburgh University Library, contain a letter from Miller to Lorimer seeking information for a profile of himself for *The Baillie* and asking for details of Balmanno's architectural history. Miller was apparently unaware of Lorimer's distinction as Scotland's most famous architect and he requested Lorimer to supply the names of some of his previous jobs, adding airily that the article 'may do you some good'.

The architectural results at Balmanno could easily have been dull and formulaic, in the absence of a patron with strong views, but the castle's potential caught Lorimer's imagination. The castle had been built by George Auchinleck in 1570-80, and Hussey published photographs of the castle's pre-restoration state but dismissed it as 'grim and grey'. Because of its small size, by contemporary standards, Lorimer added a modest service block, which was ingeniously counterpoised by a forecourt, screened by a new gatehouse, whose dark rubble-work contrasted with the glistening white harl of the restored castle.

Preceding pages: *In 1931 Christopher Hussey wrote poetically about the contrast between the new natural stone of the gatehouse (right) and the glistening white-harled Castle (left) that lay through its central archway across the paved courtyard.*

Left: *When Lorimer restored Balmanno for William S. Miller in 1915, he gave careful thought to the surrounding walled gardens, which were recreated in the Old Scots tradition. The low office wing was added to preserve the integrity of the original Castle.*

Above: *The roofline was enlivened with playful carvings by Louis Deuchars.*

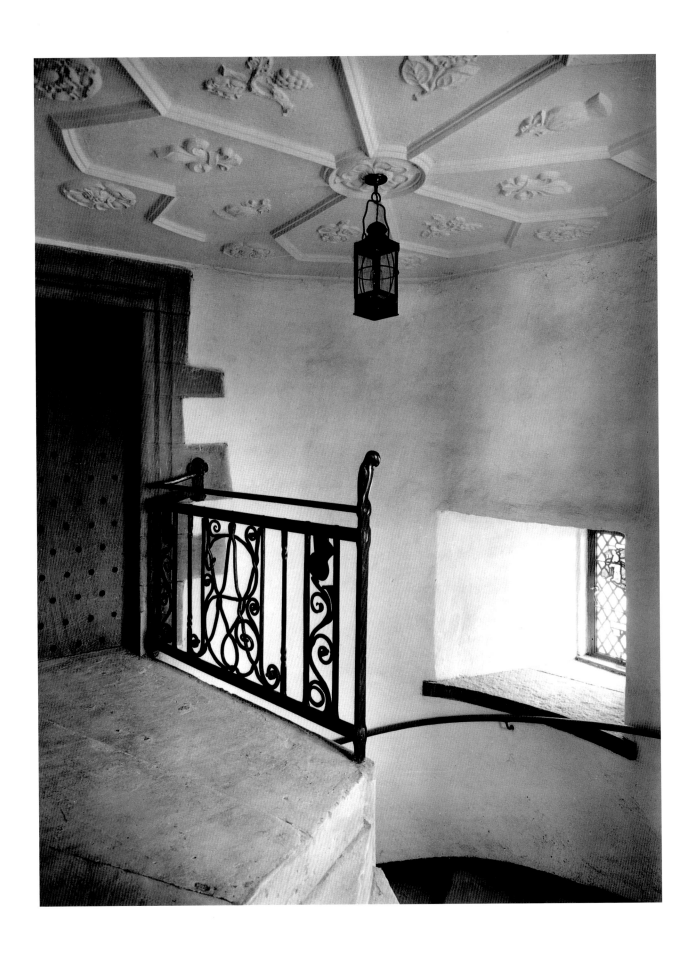

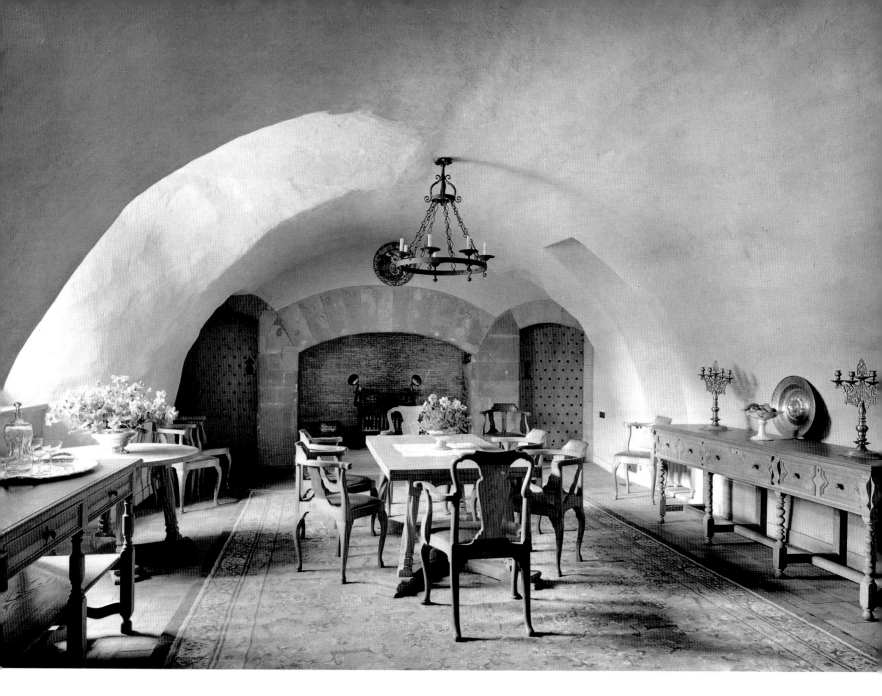

The First World War may have delayed completion of the house into the 1920s and necessitated a new layer of bureaucratic permissions, but some tasks were executed more rapidly, since the tradesmen were underoccupied. Scott Morton, Lorimer's architectural woodworkers, had writing paper stamped to show that 'The Ministry' was in occupation, and wartime austerities meant that Whytock and Reid, who carried out Lorimer's furniture and upholstery, had to execute their design drawings on brown wrapping paper, showing precisely where each item was to be placed.

Left: The spiral stairs, passing stained glass windows depicting 'The Months' on its way, ends in an ironwork grille bearing the Millers' monograms by Thomas Hadden and resolves in a tactile cockatoo.

Above: Lorimer skilfully created a new Dining Room by converting the vaulted former kitchen much admired by Hussey: 'the rough whitewashed vault, the wrought oak in tables and dressers... and the more luxurious handling of the walnut chairs combine to make an elementary sensuous appeal'.

It is difficult not to view the overall effect of this 'castle of a dream' (in Hussey's words) as Kellie revisited and lovingly refined. Balmanno has a few trace Lorimer Gothicisms, such as the vaulted Hall and Old Kitchen, which became the Dining Room, but the upstairs public rooms have Bruce-like detail and Holyroodhouse pilasters and lugged-panel doors. The wrought-iron screen at the head of the stair recalls the liveliest Scots work and resolves in a cockatoo, reflecting Lorimer's love of animals. The stair windows were given stained-glass depictions of 'The Months' by Walter Camm. The division of labour between Lorimer's two plasterers is less clear, but, as in his other houses, Sam Wilson was sent to the Drawing Room and Thomas Beattie did the Parlour. The panelling of the Parlour was the work, unusually, of Edinburgh's smart builders John Watherston and Sons, while Scott Morton and Company carried out that in the Billiard Room. Balmanno abounds in the ultimate refinement of many Lorimerisms such as the whimsical, pierced oak radiator covers, deriving from medieval aumbry cupboards, and his idiosyncratic divan beds with veneered headboards set a trend.

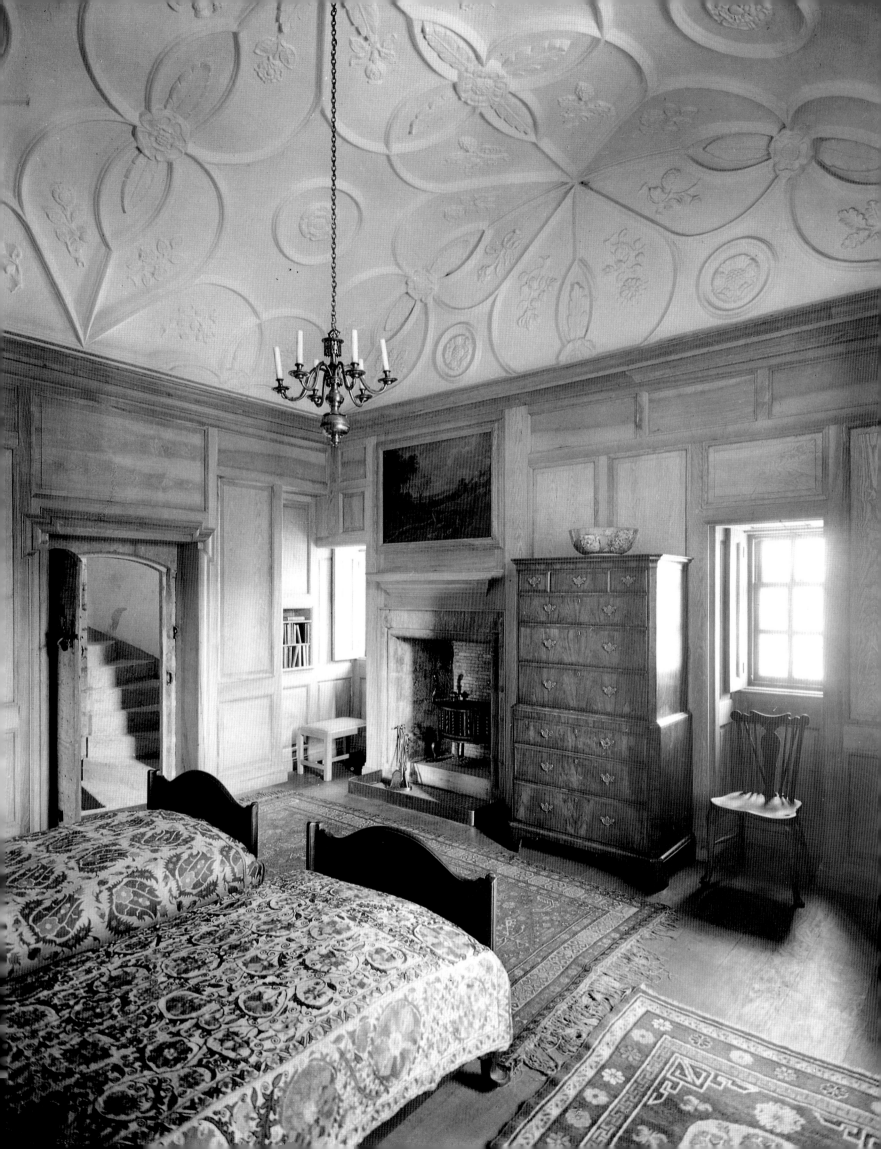

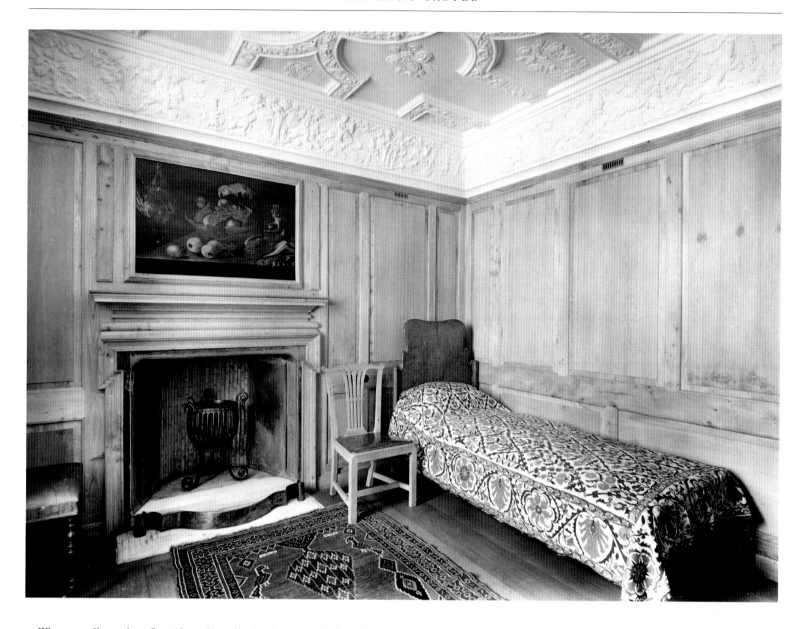

The overall result reflects how literally Lorimer carried out his client's instruction to 'furnish' Balmanno. Although many modern items came from Whytock and Reid and had stock names derived from the many works on which they had collaborated with the architect, such as 'Greywalls' and 'Melville Street' – after Lorimer's Edinburgh home address – the majority of the contents were collected together by Lorimer in an energetic trawl of antique shops not only in Edinburgh, but Harrogate, and London as well. The shop names have a strong period flavour, of which the most vivid is Lares and Penates of Duke Street in London. Lorimer's fastidious eye bought in tapestries, brassware, candlesticks, panels of needlework and all the paintings that were to be built in to his panelling. The furniture was gathered at Whytock and Reid's premises and the rooms were designed around this Lorimer

Left and above: In the bedrooms, Lorimer most nearly recreated the character of Kellie with decorative plasterwork, architectural panelling, and framing paintings he had collected.

Right: Lorimer's eye for detail extended to covers for the modern radiators that made the vaulted Dining Room bearable.

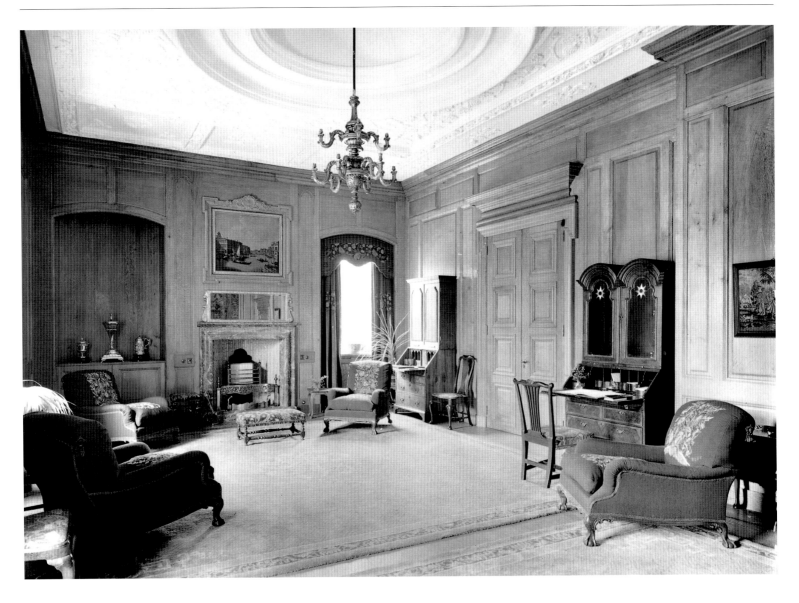

collection. All the Millers had to do when they arrived for their summer holidays was to unpack a suitcase of clothes and a toothbrush. Lorimer's throughness at Balmanno extended to the upper floors, as Hussey wrote: 'each bedroom has something individual about it. For the wainscot a variety of Scottish woods have been used, ranging from elm and ash to kauri pine and larch, and the ceilings in every case are of a different design'. Each bedroom also had running water and Lorimer gave careful attention to the design of their tiled wash-hand basin recesses. The rooms show that Lorimer was successful in his ambition to bring life to his interiors: 'I consider there is nothing more dull

than the commercial type of "period room" that one so often sees added on to houses of this period without a particle of real thought or freshness of design'. Sadly, all this care was to be shortlived because when the house passed to new owners after the Second World War, the furniture parted company with the house.

Now that so few of his houses have their original contents, carefully selected to complement his architecture, Lorimer's houses can often only be appreciated in *Country Life*'s photographs. There are many of his admirers today who concur with his view that Balmanno, as recorded by *Country Life*, is the castle they should most like to live in.

Above: *The Drawing Room on the first floor was the Castle's grandest room, and was supplied with 'comfortable easy chairs made by Messrs. Whytock and Reid of Edinburgh under Sir Robert Lorimer's guidance'.*

Right: *The door to the left of the Dining Room chimney-piece leads to the garden loggia created in the modern service wing.*

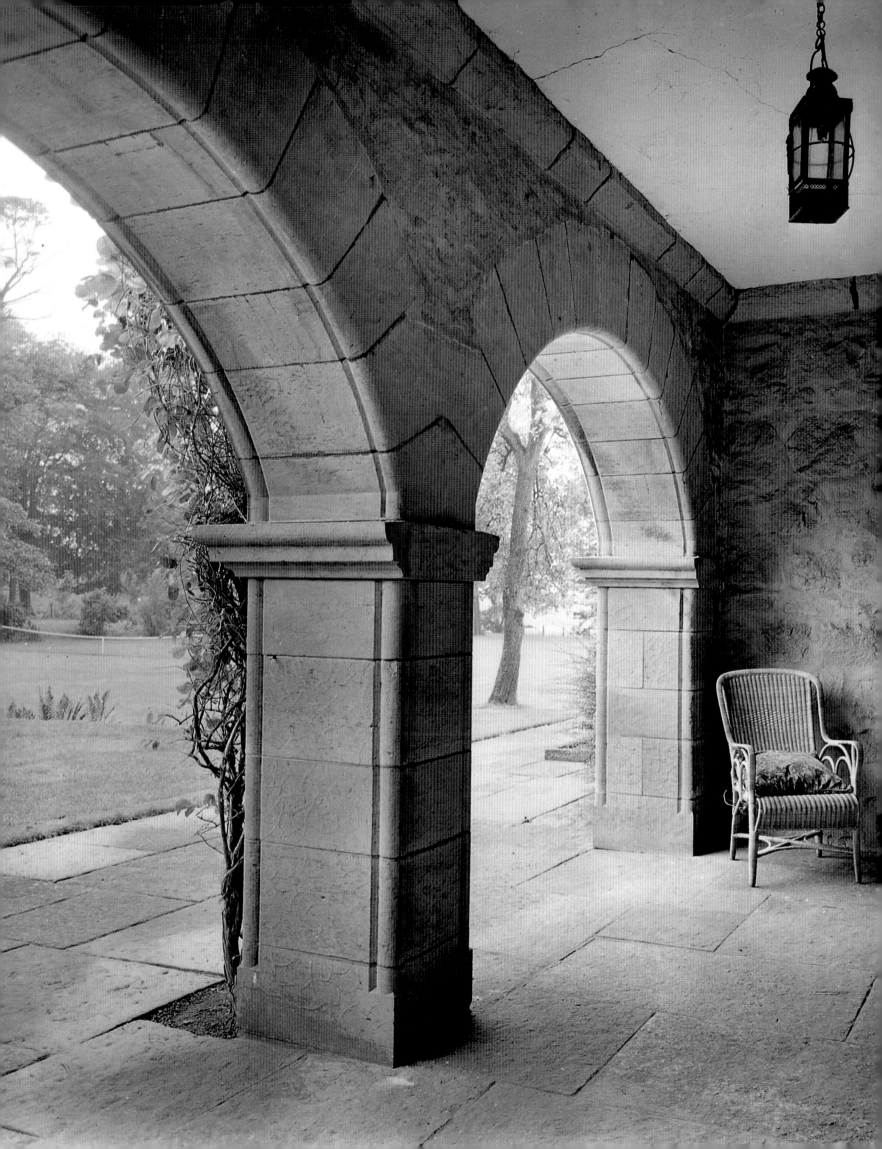

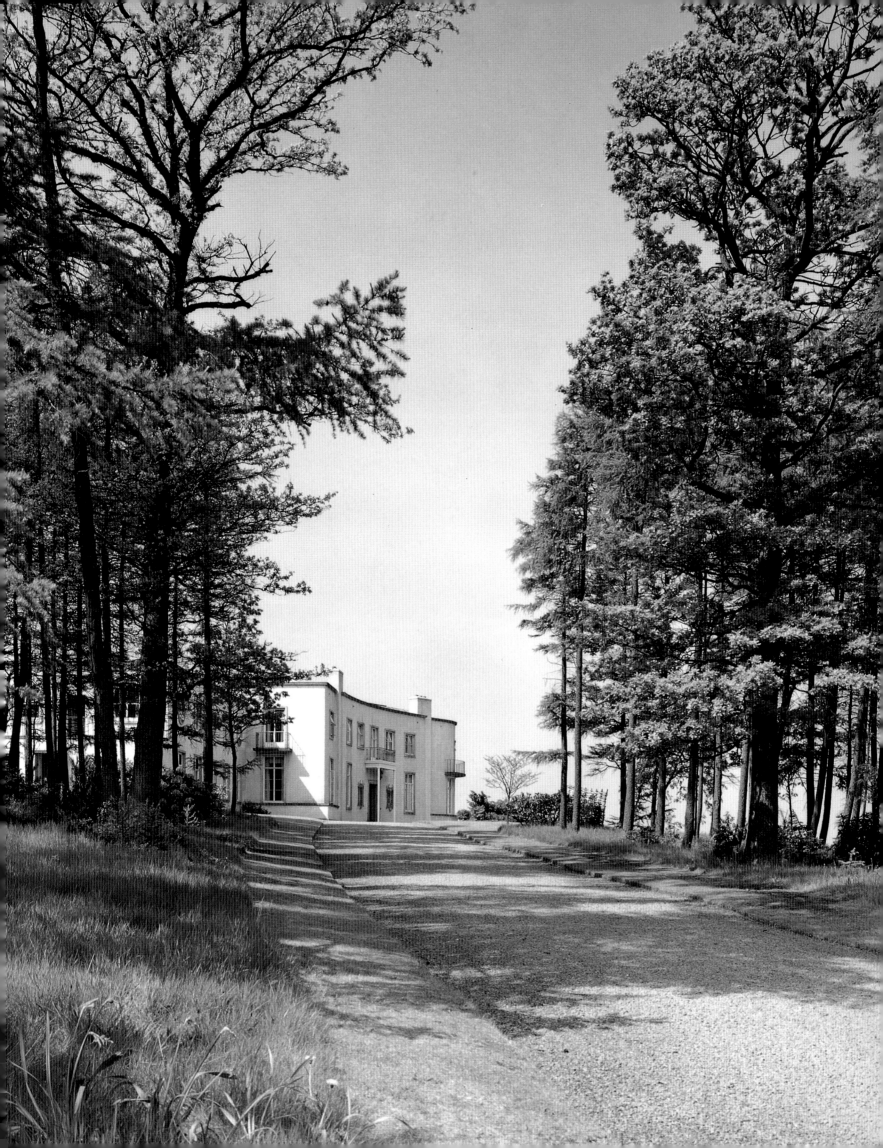

GRIBLOCH

STIRLINGSHIRE

Put simply, Gribloch was built on the eve of the Second World War by the architect Basil Spence for John Colville, a Scottish steel magnate. But there was to be little that was simple about a particularly complicated commission that involved many people. Fortunately, the house is very well-documented thanks to the researches of Caroline MacGregor. Colville had married Helen Markillie of San Francisco in 1934, and Mrs Colville brought many modern American ideas to bear on the building of their dream home. Their need for a new house resulted from a fire that destroyed their earlier home in 1937. Colville was active in the Scottish activities of the Council for Art and Industry and met Spence during the planning and design of the 1938 Glasgow Empire Exhibition, but he was also related to the Erskine-Hills, for whom Spence had just designed Quothquhan.

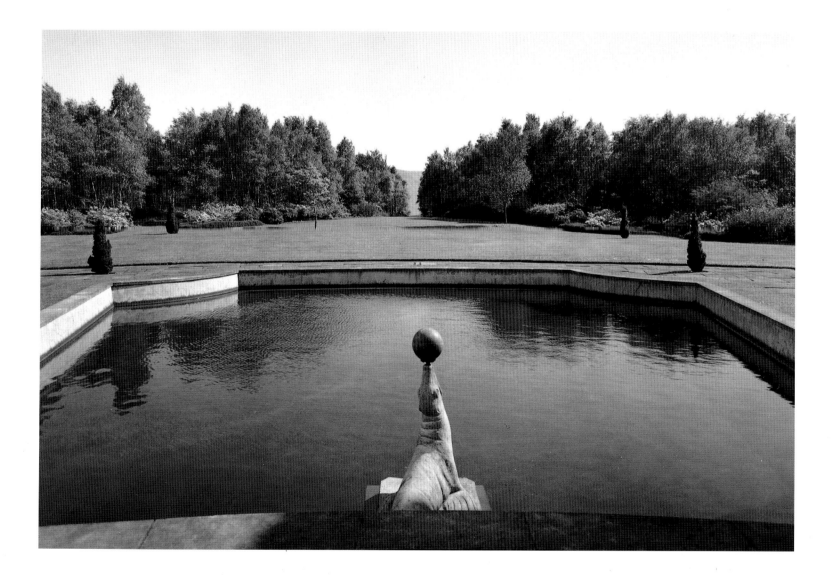

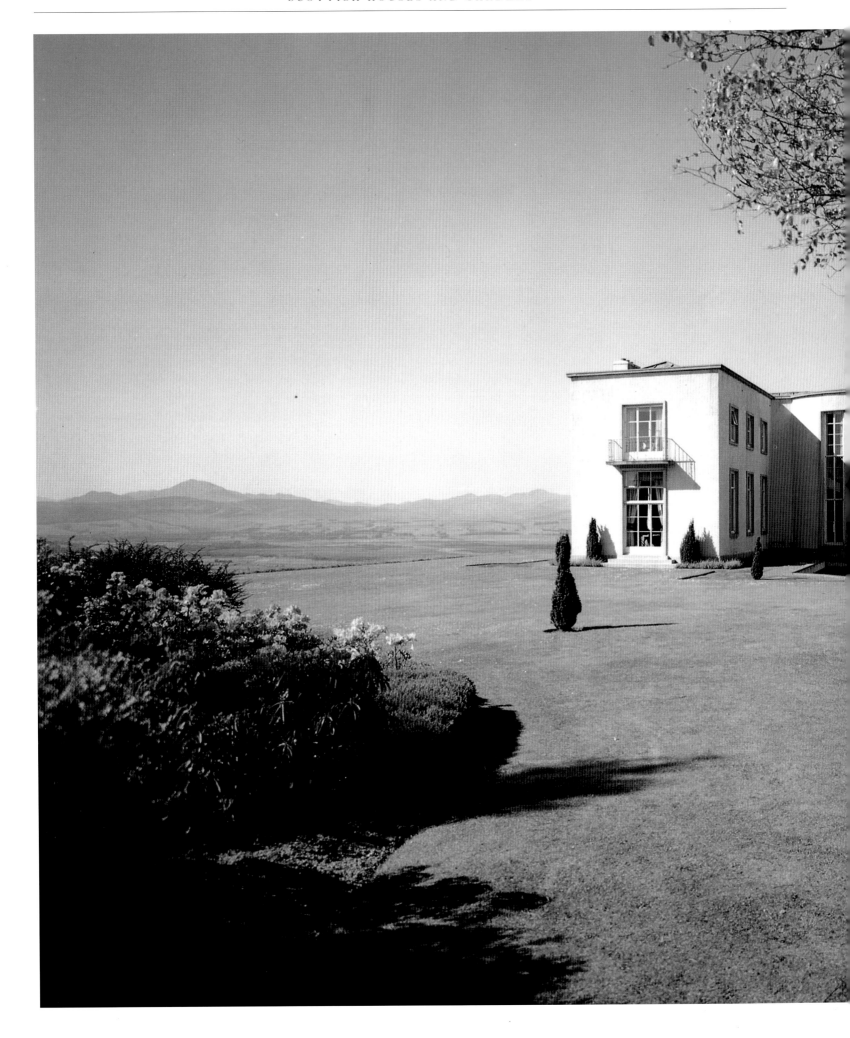

The site of Gribloch, near Kippen, named from its moor, enjoyed a quite exceptional panorama of some of Scotland's best-loved mountains, including Ben Lomond. Gribloch thus satisfied the ultimate Glasgow industrialist's fantasy of toiling by day in an urban factory while dining and sleeping in the pure Highland air.

Perhaps because Spence was distracted by the ephemeral needs of the Exhibition, the Colvilles also retained a New York architect, Perry Duncan, to speed up the design of the house. It seems to have been Spence alone who evolved the house's distinctive plan, with its splayed wings first embracing the Swimming Pool then meeting in the subtly curved entrance front. By opening up the plan in this unusual way, Spence was able to satisfy the Colville's desire to have rooms with maximum exposure to the sun during the day and taking best advantage of the views.

Although Gribloch is often classified as a Modern Movement house, Spence was not capable of being confined within any stylistic strait-jacket, and the house reflects many features of 'Regency' design, as the architect himself admitted. The Colvilles did not hold back from bombarding Spence with ideas, and Mrs Colville not only maintained cuttings files from American magazines but also culled the weekly property advertisements of *Country Life* for fresh inspiration. Colville even prepared his own designs for the iron grilles over the windows either side of the front door, which Spence dismissed as 'the kissing birds'.

Spence's collaborators included the Parisian Raymond Subes, who designed the elegant staircase balustrade, although it was executed in aluminium by an Edinburgh firm. This Staircase, contained within in its elliptical hall, and cutting across the tall window lights, is one of the happiest outcomes of this team effort. If it is obviously Federalist American in inspiration, it also derives from the popular international culture created by the movies. Its witty nautical overtones, carried through in the shell and seagull carpet and the Baroque shell-chair, and finishing in the shell and rope cornice, reflects the contribution of yet another talented collaborator, John Hill. He was a Director of the London decorators, Green and Abbott, and brother of Derek Hill, the artist. By the time that *Country Life* tackled Gribloch in 1951, Arthur Oswald could look back on the 'monotonous tyranny' of 1930s decoration with its 'off-whites' and 'drabs' and view Hill as 'among the first to revolt against the ban on colour'. The Staircase Hall had pale turquoise walls with white enrichments and a mauve stair-carpet, while the large rug picked up the same shades.

Preceding page (left): *The entrance front of Gribloch, built to the designs of Basil Spence in 1938-39, with its elegant curve captured in F.W. Westley's 1951 photograph.*
(right): *Between the fan-shaped wings lay the Swimming Pool, with its appropriately aquatic sea-lion indulging in water-sports. In deference to the Scottish weather 'warm water' could be laid on.*

Left: *The exterior of Gribloch was designed to give its interiors maximum exposure to the views and the sun. It was so unusual that Arthur Oswald gave* Country Life *readers a numbered sequence to explain how the exterior shots fitted together.*

Although the house had furniture in traditional antique styles, including the Hepplewhite shield-back chairs in the Dining Room, several items were contributed by Betty Joel, whose celebrated furniture with simple modern lines was realized in luxury materials. The stripped-down cornice-less 'Living Room', with its commanding view and challenging palette of pale blue, oyster and plum followed through in matching curtains with accents of pink and lime-green, was the most modern and least traditional interior, as the finishing touch of the painting depicting the New York skyline by Algernon Newton over the fireplace underlined.

Country Life's writer for the two articles on Gribloch was Arthur Oswald, who had joined the magazine in 1928 to assist Christopher Hussey. Because most of the principals, who had been involved in the realization of Gribloch, were still alive in 1951 when Oswald came to write it up, no research was required, but his articles are remarkable for the trouble he took to unravel this eclectic commission, in a way that made its history appear logical to his readers. He went so far as to number the way in which a visitor would see the façades shown in the photographs so that they could relate them more easily to the diagrammatic plan published in the first article.

Oswald did not flinch from the challenge of trying to submit the house, designed by a Scottish and an American architect with French and English collaborators, to stylistic analysis, with a grace that could not offend the Colvilles:

Here one is conscious of a Regency touch, and in some respects the house is a development of Regency ideas without any explicit allusions in Regency detail. The grilles of the windows flanking the entrance set Spanish or American echoes stirring, while the porch with its slim, fluted colonettes, and wood entablature has American Colonial affinities.

Below: *The bow window of the Living Room framed a panorama of the encircling mountains. It had modern furniture by Betty Joel and an 'adventurous colour scheme', in Arthur Oswald's view, of 'pale blue ceiling, plum carpet, oyster walls'.*

Right: *The elegant curve of the Staircase, cutting across the windows that flood its oval well with light, is the outstanding success of Gribloch. John Hill gave it a nautical theme and a lively colour scheme of blue, mauve and white.*

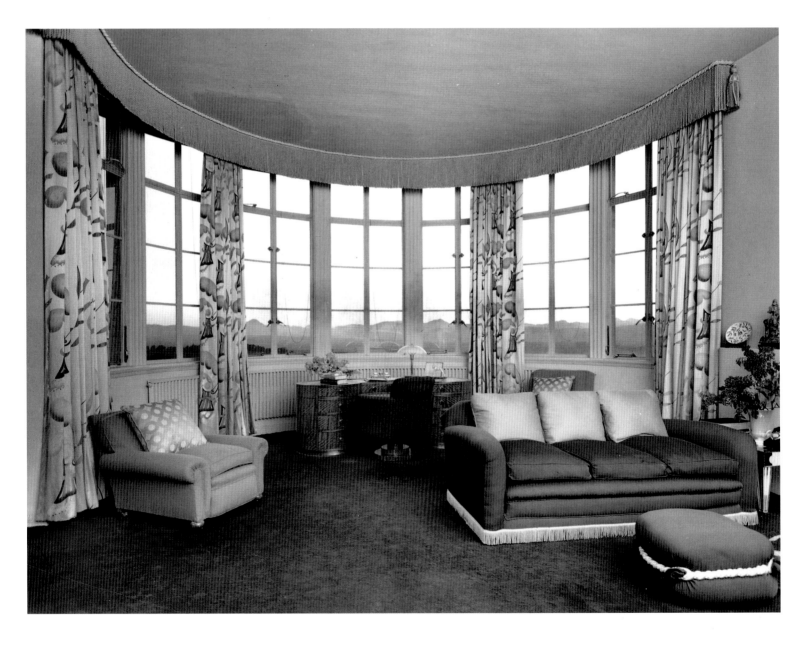

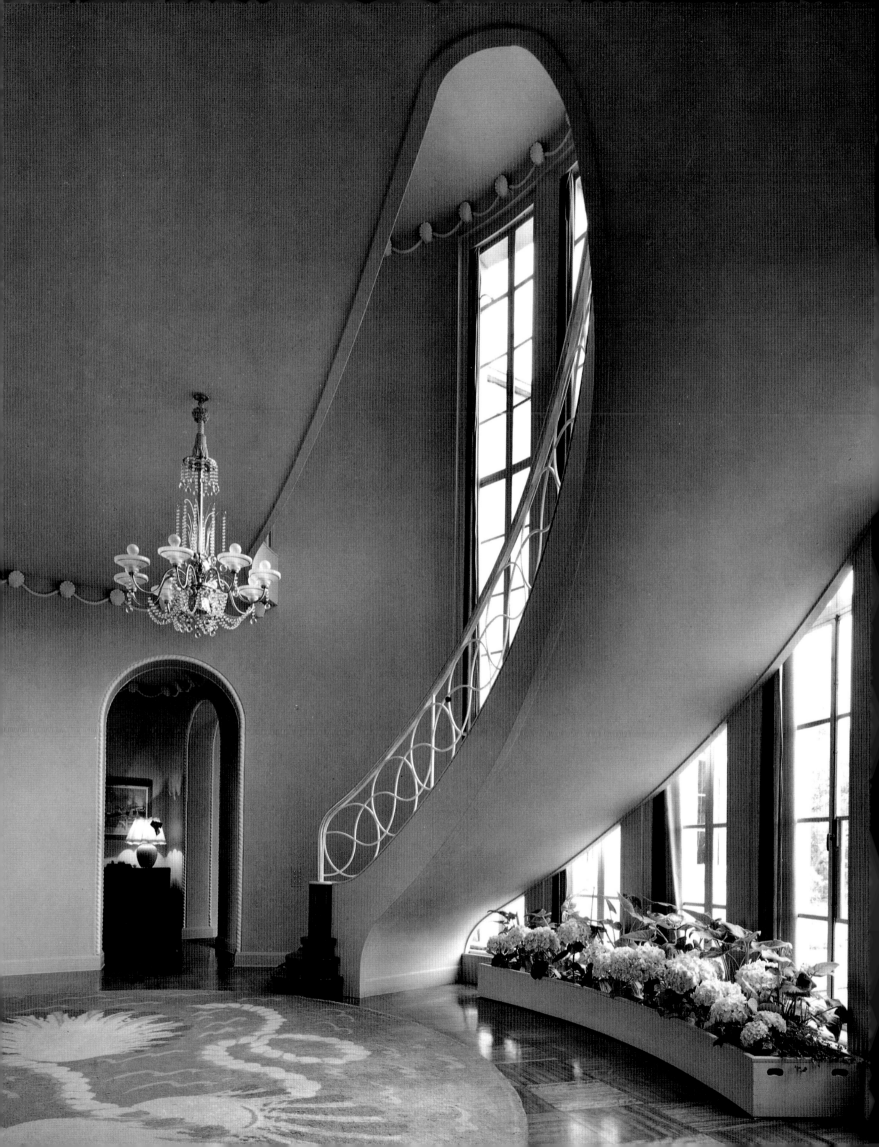

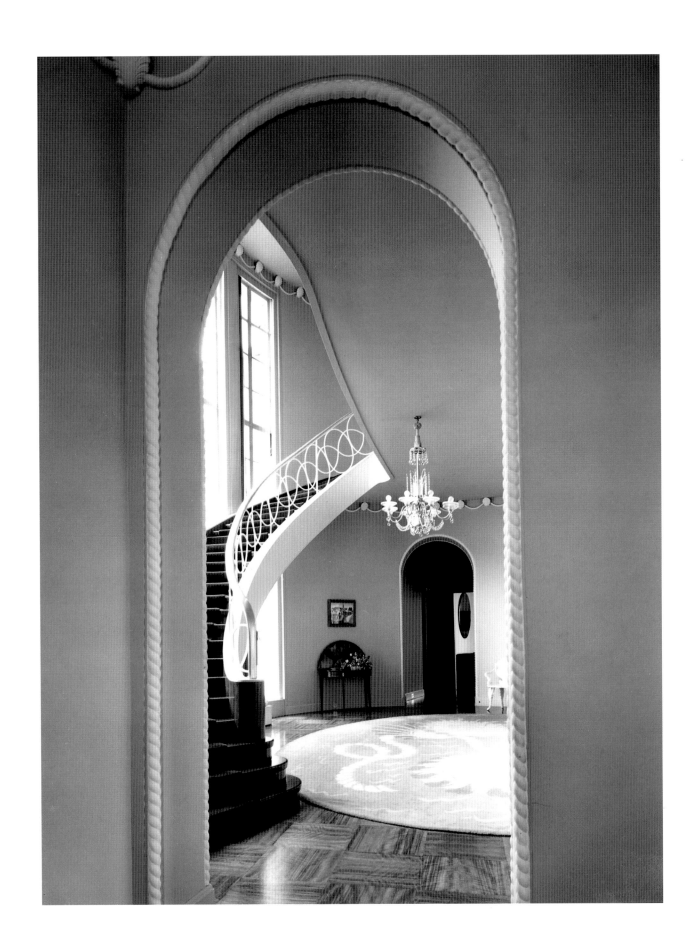

Perhaps happiest when unravelling the intricate histories of more conventional houses, the scholarly Arthur Oswald was nonetheless clearly fascinated by the labour-saving technology incorporated into Gribloch. The fireplaces were connected by chutes to an ash-bin in the basement, and the fan-shaped garage allowed any of the six cars to be moved individually without disturbing the others. The fitted Kitchen and Pantry, 'on American lines', reflected a particular enthusiasm of the Colvilles that was later taken up in more ordinary houses, while the projected external fireplace that was to enable the sunset to be enjoyed in comfort proved too zany even for Gribloch.

This most important and international of modern Scottish houses was photographed in its prime by *Country Life*'s staff photographer F.W. Westley. The extravagant number of shots in the archives suggests that the photographer had found this job unusually challenging, particularly in trying to capture the cyclorama of the landscape, the complexity of the house's shapes and the naturalism of the garden, designed by J.E. Grant White.

Top: *The principal Bedroom in gold, copper and deep brown, with John Hill's Regency-revival drapery.*

Above: *The fitted kitchen.*

Left: *A view of the oval well of the central Staircase.*

Page numbers in *italic* refer to captions to the illustrations

Aberdeen, 1st Marquess of 124
Abbotsford 9, 10
Adam, James 20, 121
Adam, John 93, *93*, 94, 117
Adam, Robert 17, *20*, 20, 23, 86, *86*, 93, 94, 98, 103, 112, *115*, 121, 123, *123*, 124, *124*, 127, *127*
Adam, William 11, 18, *19*, 20, 66, 89, 90, 93, *93*, *94*, 97, 98, 100, 103, 135, *142*, 146, 159, 160
Ailsa, 1st Marquess of 127
Ailsa, 3rd Marquess of 124
Albert, Prince 59, 61, 153
Ancaster, Earl of 151
Annan of Glasgow 135
Architectural Association 17
Ardinglas 15
Argyll, 3rd Duke of 71, 73, 111
Argyll, 4th Duke of 117
Argyll, 5th Duke and Duchess of 111, 112, 119
Argyll, 10th Duke of 119
Argyll, 11th Duke of 119
Argyll, 12th Duke and Duchess of 119
Arniston House 23, 46, 88-95, 117
Auchencruive 23
Auchinleck, George 177

Balcarres 12
Balcaskie 19, 63
Balfour House 24, *24*
Balgonie Castle *78*
Balmanno Castle 174-183
Balmoral Castle 10, 36, 39, 61, 159
Barncluith 12
Barry, Sir Charles 153, 156
Batoni, Pompeo *112*, 117
Bauchop, Tobias 65
Bayreuth, Margrave of 90
Beattie, Thomas 179
Beckford, William 131
Biel 12
Billings, R.W. 9, 20
Binney, Marcus 53, 168
Blackwood, publishers 9
Bodley, G.F. 13
Bolton, A.T. 20, 23, 24, 98, 100, 103, 121, 123, *124*
Borthwick Castle 18, *19*, 20
Boston Museum of Fine Arts 146
Brand, Alexander 65
Brodick Castle *10*, 11
Bruce, William 171
Bruce, Sir William 11, 15, 17, *17*, 18, 19, 45, 49, *50*, 57, 59, 61, *61*, 63, 65, *65*, 66, *66*, 75, 78, 81, 179
Bryce, David 131
Buccleuch, Anne, Duchess of 84, *84*
Buccleuch, Dukes of 20, 71, 73, 75, 83, 86
Burn, William 36, 45, *45*
Burns, Robert 8

Calderwood, Samuel *98*
Camm, Walter 179
Campbell, Colen 77, 81
Campbell, Thomas *84*
Caroline Park 19, 20, 70-75
Cassills, 10th Earl of 123, 127, *127*
Castle Huntly 31

Cawdor Castle *4*, 7, 8, *8*, 10, 13, 23, 27
Charles I, King *29*
Charles II, King 9, 57, 59, 61, 84
Chatelherault 146
Christie's 131, 132, 142, 145
Clayton family 132, 135, *142*, *145*
Clayton, Thomas *98*, *103*, *107*, 108
Clough, Monica 75
Colville, Mr and Mrs John 185, 187, 188, 191
Connaught, Prince and Princess Arthur of *163*, 164
Conway, General Seymour 117
Cornforth, John 15, 17, 41, 117
Corriemulzie Cottage 160, 163
Cosh, Mary 94, 119
Country Life, history 7-24
Country Life Books 19, 23, 41, 45
Craigievar Castle 13, 19, 20, 34-41, 59, 168
Crathes Castle 19
Culzean Castle 20, 120-127
Currie, John 50

Dalkeith, Countess of 73
Dalkeith, Earl of 71
Dalkeith Palace 19, 61, 73, 82-87
Dalzell 12
Darwin, Bernard 7, 23
Dalrymple, Lady Antonia 108
Dalrymple, Sir David 107, *107*, 108
Dalrymple, Sir James 108
Decker, Paul 90
Deuchars, Louis *177*
De Wet, Jacob *53*, 54, *59*
The Drum 18, 96-103
Drumlanrig Castle 12, 13, 20, 75, 86
Drummond Castle 12, 148-157
Duff, Sir James 160
Duff House 18, *19*, 66, 98, 159, 160, *163*, 164
Duncan, Perry 187
Dundas family 89
Dundas-Bekker, Althea and Aedrian 94
Dungavel 132
Dunglass Castle 7, 23

Earlshall House 13, 20, 46, 166-173
Edinburgh Castle 59
Edinburgh School of Applied Art 66
Edinburgh University Library 177
Edward, Alexander 66
Eizat, Alexander *59*
Elizabeth, Queen (the Queen Mother) 32
Enzer, Joseph 90, *93*
Erskine, Thomas 50
Erskine-Hill family 185
Eugénie, Empress *146*
Evans, Frederick 11, 13, *15*, 29, *29*, *31*, *32*, 35, *36*, *39*, 41, 49, *50*, 53, 168, *171*, 173
Eyre-Todd, George 11

Falkland Palace 18, *171*, 173
Fenway Court 59
Fife, HRH the Duchess of 23
Fife, Dorothy, Countess of 160
Fife, 1st Earl of 159
Fife, 2nd Earl of 160, 164
Fife, 4th Earl and Countess of 160, 163

Fintray 36, 39, 41
Fleming, A.B. and Company 73, *73*
Fleming, John 23
Floors Castle 10
Forbes, Arthur 36, 39
Forbes, Sir John 36, 39
Forbes, Sir William 35, 39

Gainsborough, Thomas *112*, 117
Gardner, Isabella Stewart 59
George IV, King 9, 59, 61, 86
George V, King 15, 17, 57, 61
Gibbons, Grinling *84*, 86
Gibbs, James 98
Gifford, John 75
Gill, Arthur 23, 111, 115, 117, 119
Gillespie, James 66
Glamis Castle 7, 8, 10, 11, *11*, 13, 19, 23, 26-33, 59
Glasgow, Earl of *19*
Gosford 17
Gourlay, Charles 20
Graham, George 65
Graham, Helen 65
Green and Abbott 187
Greywalls 16, *16*, 17, 181
Griblock 23, 24, 184-191
Grose, Francis 8
Guinand and Le Girardy 115, *117*, 119

Hadden, Thomas *179*
Haddo House 124
Hailes Castle 108
Hailes, Lord 108
Hall, Michael 8
Ham House 83
Hamilton, David 135
Hamilton District Libraries 135
Hamilton, Duchess of 131, 135, *141*, *142*, *145*
Hamilton, Duke of *112*, 117
Hamilton, Dukes of 59, 61
Hamilton, 10th Duke of 131, *131*, 132, *132*, 135, *135*, 136, *139*, 141, *141*, 142, 146, *146*
Hamilton Palace 20, *20*, 24, 59, 75, 128-147
Hamilton Public Library 131
Harris, David Fraser 73
Harris, John 81
Hatfield House 45
Hay, D.R. 61, 135, *136*, 141
Henson, A.E. 20, 23, 35, 117, 129, 132, 135, 136, *163*
Hill, Derek 187
Hill, John 187, *188*, 191
Hill, Oliver *8*, 23, 41
Historic Scotland 146
Holyroodhouse, Palace of 9, 10, 17, 20, 56-61, 75, *84*, 86, 179
Hope family 108
Hopetoun 11, 98
Houlbert and Dunsterfield *59*, 61
Hudson, Edward 7, 8, 10, *10*, 11, 13, 15, 18, 19, 20, 32, 41, 53, 117, 145, 168, 173
Hudson, Henry 7
Hudson and Kearns 7
Hussey, Christopher 23, 41, 89, 93, 94, 112, 117, 151, 163, 175, 177, *177*, 179, *179*, 182, 188

Inglis, Francis Caird 19, *23*
Inveraray Castle 9, 11, 15, 23, 24, 93, 110-119

James V, King 18, 59

James VI, King *29*, 43, 59
James VII, King 71
Jekyll, Gertrude 7, 15, 156
Joel, Betty 188, *188*
Jones, Inigo 18
Jordan, Mrs 161

Kelburne Castle 19, *19*
Kellie Castle 13, 15, 20, 48-55, 167, 168, 179, *181*
Kennedy Castle 12
Kennedy, G.P. 153
Kennedy, Lewis 153
Kent, William 98
Kinross House *4*, 17, *17*, 18, 45, 57, 62-69, 75
Kinross, John 17

Lafayette *20*, 135
Lang, Andrew 57
Larsson, Carl and Karin 54
Lauder, Sir Thomas Dick 151
Lauder, Thomas North Dick 12, 151
Lauderdale, Duke of 59, *59*
Lennoxlove 19
Leyland, John 10
Lindsay, Ian G. 119
Linnell, John 117
Lochleven Castle 63, 66, *66*
Loretto School 46
Lorimer family 50, *54*
Lorimer, Hew 54
Lorimer, John 15, 50, *50*, *53*, 54
Lorimer, Louise 50
Lorimer, Mrs 20, 53, *53*
Lorimer, Professor 15, 50, 53
Lorimer, Sir Robert 13, *13*, 16, 18, 19, 20, 23, 24, *24*, 49, 50, *50*, 53, *53*, 57, 83, 103, 167, 168, *168*, 171, 173, 175, 177, *177*, 179, *179*, 181, *181*, 182
Loudon, J.C. 12
Louis XIV 84
Louise, Princess 163
Lutyens, Edwin 7, 15, 16, *16*

McEwan, Robert 23
MacGibbon, David 10, 18, 20, 66, 98
MacGibbon, Frederick 66
MacGregor, Caroline 185
McIvor, Iain 59
Mackenzie, A. Marshall 163
Mackenzie, Sir George 71
Mackenzie, W.R.M. 167, *168*, 168, 171
Macquoid, Percy 19
Mar and Kellie, Earl of 15, 50, 159
Mar Lodge 23, 24, 158-165
Marie, Princess of Baden 135
Marie Antoinette, Queen 111, 131, 160
Markillie, Helen 185
Mary, Queen (wife of William III) 77
Mary, Queen (wife of George V) 15, 17, 57, 61
Mary, Queen of Scots 57, 59, *59*, *61*, 66
Matthew, John 16
Matthew, Stuart 16
Maxwell, Sir Herbert 12, 15, 59
Mellerstain 20
Melville, 1st Earl of 71, *81*, 84
Melville House 19, 59, 76-81, 90
Melville, Lord 39
Melville Street, Edinburgh *24*, 54, 181

Midmar Castle 19
Miller, William S. 177, *177*, 182
Monmouth, Duke of 84
Montagu Bridge 86, *86*
Montgomery, Sir Basil 66
Montgomery, Sir James 66
Montgomery, Lady *66*
Monzie Castle 15
Moor Park 84
More Nisbett, Hamilton 100, 103
Morgan, William *139*
Morris, Roger, 112, *112*, 115
Moxon and Carfrae *168*
Mylne family 59
Mylne, John 151
Mylne, Robert 59, 112, 115, *115*, 117, *117*
Mylne, William 115

Nasmyth, Alexander 23
National Monuments Record of Scotland 8, 15, 23, 24, 66
National Museums of Scotland 24, 146
National Trust for Scotland 41, 54, 107, 127
Newbattle 12
Newhailes House 19, 46, 75, 94, 104-109
Newliston 20, *20*
Newton, Algernon 188
Norie family 53, *73*, 75
Nuttgens, Patrick 15

Oliphant family 50
Osterley Park 123
Oswald, Arthur 23, 187, *187*, 188, *188*, 191

Parliament House, Edinburgh *90*
Paxton House 94
Perth, Dowager Countess of 151
Perth, Earl of 151
Perth, 2nd Earl of 151
Pinkie House 19, 42-47
Platt, Mrs J.E. 11
Playfair, William Henry 10

Quellin, Arnold *29*
Quothquhan 185

Raeburn, Sir Henry 94
Reid, Charles 11
Reid, John 151
Relugas 151
Richardson, Harriet 50
Riddell, George 7
Rizzio, David 9, 59
Ross, Thomas 10, 18, 20, 66, *66*, 98
Rowan, Professor Alistair 90
Roxburghe, Duke of 10
Royal Institute of British Architects 105
Russborough 81

Salvin, Anthony 112
Savage, Peter 13, 23
Scotney Castle 23
Scott Morton and Company 179
Scottish National War Memorial 15
Sempill, Gwendolen, Lady 41
Sempill, Lady 20, 41
Sempill, Lord 39
Sempill, 19th Lord 41
Seton, Alexander (Earl of Dunfermline) 43, 45, *45*, *46*

Shakespeare, William 8, 10
Shaw, James Byam 10
Sherbrooke, Mary 39, 41
Smith James 15, 19, 66, 75, 77, 78, *78*, 81, 84, *84*, 90, 105, *107*, 108, *131*, *132*, *136*, *139*, 146
Smith, John 36, *36*
Soane, Sir John 20
Soane Museum 20
Somerville, 12th Lord 97, 100, 103, *103*
Spence, Sir Basil 185, 187, *187*
Stair, Earl of 107
Stobhall 19
Stobo Castle 66
Strathmore and Kinghorne, Patrick, Earl of *29*, 31, 32
Strathmore family 32
Subes, Raymond 187
Swain, Margaret 61
Syon Park 123

Tait, Professor A.A. 153
Tarbat, Viscount 71, 73, 75
Tarbat, Viscountess 75
Thistle Chapel 15, *23*, 57
Tipping, Henry Avray 20, 23, 129, 131, 132, 135, *135*, 136, 142, 145
Traquair *4*, 13, *15*
Tweedmouth, Lord 124
Tyninghame 11, 12, *12*

University of Wisconsin 86

Valentine of Dundee 7, 8, *8*, 29
Vanbrugh, Sir John 98
van Santvoort, Jan *59*
Victoria, Queen 9, 10, 36, 59, 61, *84*, 86, 153
Victoria and Albert Museum 78

Waagen, Doctor 141
Wales, Prince and Princess of 163, *164*
Walker, Professor David 66
Wardrop and Reid 89, *90*, *123*, 124
Watherston and Sons, John 179
Weaver, Sir Lawrence 7, 13, 15, 16, 17, *17*, 18, 19, *19*, 20, 23, 24, 29, 31, 32, 41, 43, 45, 46, *46*, 49, 50, 57, 59, 61, 65, 66, 71, 73, 75, *75*, 77, 78, 81, 83, 86, 98, *98*, 100, 103, 105, 107, 108, 121, 123, 129, 168, 171, 173
Wellington, Duke of *84*
Wemyss, Dowager Countess of 75
Wemyss, Earl of 17
Westley, F.W. 7, 23, *90*, *112*, *119*, 187, 191
Wheeler family 53
White, J.E. Grant 191
Whitehill 105
Whytock and Reid 171, 179, 181, *182*
William III, King 77
William IV, King 160
Willoughby de Eresby, Lady 151
Willoughby de Eresby, Lord 151
Winton 19
Wordsworth, Dorothy 11
Wren, Sir Christopher 18, 59
Wright and Mansfield 124
Wylie, Mary McLeod 54

Yester 23, 66